Races on Display

Races on Display

French Representations of
Colonized Peoples
1886–1940

Dana S. Hale

INDIANA UNIVERSITY PRESS
BLOOMINGTON AND INDIANAPOLIS

This book is a publication of

Indiana University Press
601 North Morton Street
Bloomington, IN 47404–3797 USA

http://iupress.indiana.edu

Telephone orders 800-842-6796
Fax orders 812-855-7931
Orders by e-mail iuporder@indiana.edu

Library of Congress Cataloging-in-Publication Data

Hale, Dana S.
 Races on display : French representations of colonized peoples
during the Third Republic / Dana S. Hale.
 p. cm.
 Includes bibliographical references and index.
 ISBN 978-0-253-34854-8 (cloth) — ISBN 978-0-253-21899-5 (pbk.)
1. France—History—Third Republic, 1870-1940. 2. Indigenous
peoples in literature 3. Indigenous peoples—Public opinion. 4. Public
opinion—France. 5. France—Colonies—Africa. 6. France—Colonies—
Asia. 7. France—Foreign relations—Africa. 8. France—Foreign
relations—Asia. I. Title.
 DC337.H35 2008
 305.8009171'24409041—dc22

 2007032950

1 2 3 4 5 13 12 11 10 09 08

In memory of my aunt, Pola N. Patterson,
who passed on to me her love of books
and fascination with France

CONTENTS

ACKNOWLEDGMENTS

I am indebted to many individuals and organizations for the help they provided with this book. *Races on Display* began as a doctoral thesis at Brandeis University. I would like to thank the faculty at Brandeis who helped me give birth to the initial research project, especially Paul Jankowski, who was my dissertation advisor and has remained a source of encouragement. The Graduate School of Arts and Sciences at Brandeis gave me the opportunity to spend a year in France doing research and attending seminars through its exchange program with the Ecole Normale Supérieure in Paris. The Ford Foundation awarded me with a dissertation fellowship that enabled me to write for a year in France. I owe thanks to Catherine Hodeir and Emmanuelle Sibeud, who met with me as I started on the project and gave me practical information and direction. Marie-Albane de Suremain and Yannis Constantinides supported me with their friendship and scholarly input during my time in France. Alice Conklin, Herman Lebovics, and Allison Blakely offered invaluable input, as did the late William B. Cohen. The members of the Capital Area French History Group reviewed chapter 7 and provided helpful feedback.

I would like to thank my former colleagues at Howard University, especially Emory Tolbert, for supporting my research plans, and Jean-Michel Mabeko Tali, who helped me with passages in some of the primary sources I used. Howard University supported my work with a New Faculty Grant and a Reginald F. Lewis Travel Fund award, and the American Historical Association's Bernadotte E. Schmitt Grant allowed me to extend the endpoint of this study from 1931 to 1940.

I appreciate the help and direction I received from the staff at the archives and libraries where I did research in the Paris region, in Provence, and here in Washington, D.C. Brigitte Lainé from the Archives de Paris directed me to the collection of registered trademarks that became an important part of this study. Staff from various departments of the Archives Nationales, Bibliothèque Nationale de France, Institut National de Propriété Industrielle, Bibliothèque Municipale de l'Hotel de Ville, Centre des Archives d'Outre-Mer, Chambre de Commerce et d'Industrie de Marseille, Service Historique de l'Armée de Terre, and the Bibliothèque Municipale de Marseille answered my questions and provided helpful direction that

moved my research forward. I am especially grateful to Lien Huong Fielder in the Asian Division of the Library of Congress for pointing me to useful resources on Indochina and to Hélène Chollet of the Musée Cernuschi in Paris for her assistance in evaluating trademarks with Asian themes.

Finally, my family and friends have helped make the challenge of this journey bearable these last years. Pamela McQuide, Elizabeth Blood, Isabelle Lemoine, and Jacqueline Celestin André offered their listening ears and gracious hospitality time and time again. Many others too numerous to name here have cheered me on. I could not have reached my goal without them or without the editors at Indiana University Press who labored on this project, especially Robert Sloan, Miki Bird, and Kathleen Babbitt.

Races on Display

Introduction

Races on Display addresses a fundamental issue in modern European history—how a state defines (or redefines) its own identity and the identities of peoples recognized as ethnic and cultural outsiders. Are these identities static or can they be easily modified? At the beginning of the Third Republic, the new leaders of France sought to establish a secular republican state in a complex environment of competing political ideologies. When it became impossible for France to stake a claim to power on the European continent after its humiliating loss to Germany in 1870–1871, constructing the image of a powerful nation based on the possession of overseas territories validated the French state. Politicians and imperialists learned to adapt republican values of brotherhood and universality inherited from the Revolution to the new reality of an empire with millions of subjects. The expanded *plus grande* France provided a sense of national pride in the *métropole* even as it relied on actions that subjugated and denigrated the peoples and cultures it engulfed. Alice Conklin's work on republican values and the administration of the civilizing mission in French West Africa illuminates the imperial mindset of the Third Republic.[1] *Races on Display* contributes to a fuller understanding of the manipulation of universalist values by French officials who sought support for the overseas empire.

Although this study focuses on the "new imperialism" of the late nine-

teenth and twentieth centuries, it holds relevance for contemporary concerns about race, national identity, and intercultural relationships. In the past few years, terrorist attacks against westerners by groups with Islamist ties and political movements in France and the Netherlands that elevate and seek to protect the "white race" have demonstrated the pertinence of examining the proliferation of racial ideas. Social tensions exploded in neighborhoods throughout France in the fall of 2005 as marginalized youth, mainly the French-born children of immigrant parents, used violence to draw attention to their plight. The framework for discussions in the west on immigration, culture, and citizenship since the 1980s has grown out of stances European governments took in the early twentieth century. Ideas about the character and culture of Africans, Arabs, and Asians from the colonies were developed or solidified in the first half of the century before the era of decolonization. And after the end of empire, when the French recruited workers from North or West Africa, they treated the laborers much as they had overseas—with disdain, as inferiors who needed "civilizing" and integration into French culture and the French lifestyle.

Races on Display explores France's imperial identity by examining the uses of racial ideas in French world's fairs, colonial expositions, and commercial trademarks. It draws inspiration from three fields—comparative studies of expositions, cultural anthropology, and French colonial history. In the last two decades, scholars have turned to the study of national and international fairs and expositions as indicators of political and cultural values. Robert Rydell helped pioneer this work in his study of how early American international fairs helped create racial and social cohesion in the United States.[2] Several years later, in *Ephemeral Vistas*, Paul Greenhalgh examined the organization and impact of the major world's fairs and expositions before World War II.[3] Cultural anthropologists Raymond Corbey and Burton Benedict, among others, have analyzed the display of nonwestern races at various expositions, fairs, and circuses as reflections of western ideas about (national) identity, race, and power.[4]

Scholars interested in colonial history recognize the impact the growing empire under the Third Republic had on French culture. Herman Lebovics and William H. Schneider have written about the presentation (and manipulation) of the colonial world government officials, colonists, and impresarios brought to France.[5] Previous studies on French colonial expositions or world's fairs by Sylviane Leprun, Pascal Ory, Catherine Hodeir and Michel Pierre, Charles-Robert Ageron, and Shanny Peer have contributed to general knowledge of the political, architectural, and exotic dimensions of these events.[6] My aim in *Races on Display* is to provide a comprehensive study of the major colonial expositions during the Third Republic and demonstrate the prevalence and complexity of ideas about "race" and empire in the government and business world of France.

This work is divided into two major sections that span the period from

the "scramble for Africa" in the mid-1880s to the fall of the Third Republic during World War II. The first half examines how government officials and business-owners portrayed the three major colonial "races" from 1886 to 1913; the second considers the transformations in the French outlook on colonial subjects during World War I and in the years that preceded the fall of the republic in 1940. Based on evidence from major colonial expositions in Paris and Marseilles and commercial trademark images, *Races on Display* contends that a new national identity for France that was centered on republican values and a growing consumer economy functioned within the framework of France as an imperial power. Entrepreneurs, supporters of colonialism, and government officials adopted a variety of forms to manifest French military, economic, and cultural power in the overseas context. In their visual and literary representations of colonized peoples they inevitably placed the French "race" on display. The display of the French "race," at least by the final decade of the Third Republic, stressed cultural supremacy, modernization, technological achievement, national responsibility for the advancement of other "races," and fruitful cooperation with colonized peoples. One could argue that the same principles continue to form the framework of political and cultural links between France and its former colonies.

Chapter 1 provides the background for an understanding of the development of empire during the Third Republic and the use of racial imagery in the realms of commerce and government. It begins by outlining France's acquisition of territories in Africa and Asia, presenting the basic reasons actors involved in the process gave for expansion and the official propaganda surrounding it. It traces the history of the French *expositions universelles* (world's fairs) beginning in the mid-nineteenth century and the incorporation of colonial exhibits at those events. The final portion of the chapter introduces a survey of trademarks registered in Paris and Marseilles and the concurrence of commercial images of race in the empire with images promoted by the government. These diverse sources offer a unique picture of empire as an expression of political, military, and economic power.

Chapter 2, "Sub-Saharan Africans: 'Uncivilized Types,'" examines French views on sub-Saharan Africans in its overseas territories and "blacks" (*les noirs*) in general. The material in this chapter highlights two images of Africa—as a primitive region controlled by many vicious rulers and as a rich land with tremendous economic and labor potential. These findings from exposition sources coincide with Schneider's conclusions about the dual image of Africa in the French popular press. Both images etched out a role for France as the salvational power that would provide development and stability.

The first portion of the chapter examines the image of blacks in French commerce that evolved during the late nineteenth century and the similarities of those images to portrayals of enslaved Africans in the Americas. Pri-

3

marily, the trademarks focus on the labor people of African descent could provide as agricultural workers and as servants in European households. The second part of chapter two examines the presentation of sub-Saharan Africans in the official propaganda of the 1900 Exposition universelle in Paris. I focus on the African colonies featured at the exposition in imitation villages and in official publications that included ethnographic descriptions and portrayals of ostensibly "African" character traits.

Chapter 3, "North Africans: Mysterious Peoples," delves into French views of the Arab and Berber peoples of North Africa. Depictions of North Africans on trademark illustrations and in exposition propaganda demonstrate the influence of exotic Oriental imagery. Islam appeared as a cultural force that was both respected and maligned, and France's North African subjects were classified as a mysterious race. The beginning of the chapter presents the main categories of images of North Africans and the generic "Arab," Near Easterner, or Oriental. The remainder deals with the vision of North Africans presented at the 1900 Exposition universelle. Thousands visited the North African pavilions and the amusement section that was granted to a Franco-Algerian concession company. This arrangement relieved government officials from the responsibility of organizing entertainment, but it hindered their effort to present "authentic" depictions of North African culture and to control colonial propaganda at the exposition.

The fourth chapter presents French representations of Asians in trademarks and in the Indochinese sections of the 1900 Exposition universelle. The material presented reveals a stereotypical image of Indochinese as "gentle subjects" who acquiesced to French rule. I analyze commercial images of Indochinese and the generic Asian in French trademarks registered between 1886 and 1913. French organizers of the Indochinese section at the 1900 exposition emphasized the glories of ancient Southeast Asian civilization by erecting five Indochinese palaces and temples, modeled after existing structures, as exhibit halls. They also shipped dozens of Indochinese artisans, soldiers, and performers to give a colonial ambience to the section.

The second half of the book deals with changes in racial images and in the use of these images emanating from the role of colonized people in the Great War. Chapter 5 addresses French visions of sub-Saharan Africans from World War I to 1940. By 1914, the French had firmly established their rule in much of West Africa; the peoples they had vilified as a military threat in the 1890s were transformed for the public into a military asset. *La force noire,* a phrase imperialists used to emphasize the strength and potential number of colonial soldiers, became a theme they used to persuade French citizens of the empire's ability to contribute to the peace and prosperity of metropolitan France. The trademark segment of chapter 5 considers how images of Africans and diaspora blacks on registered trademarks from 1914 to 1940 differed from those of earlier decades. Much of chapter 5 explores the idea of Africans as a *force noire* in the government exhibits, pub-

lications, parades, and varied performances of colonial expositions in the 1920s and 1930s.

Chapter 6, "North Africans: *'Fils Aîné'*" (eldest son), extends the treatment of French stereotypes of Arab and Berber peoples in the empire that was introduced in the third chapter. The use of the kinship metaphor that casts North Africa as the firstborn son indicates the privileged position the region (especially Algeria) held in the minds of supporters of colonialism. This position was due in part to geographical proximity but was also attributed to the idea that French people and North Africans had more in common because they practiced monotheistic religions. Trademark images during this period continued the prewar trends presented in chapter 3. Business-owners portrayed North African men as turbaned fighters and devout Muslims and women as simple peasant girls or beauties hidden behind veils. I discuss the events at the expositions that emphasized the theme of the Maghreb region as the eldest son in the colonial family. Chapter 6 also considers the commercial significance of this region and the representation of Arabs and Berbers as commodity producers for France, particularly at the Exposition internationale des Arts et Techniques dans la Vie Moderne in 1937.

Chapter 7 treats the French image of Indochina as the colonial family's gifted child. Exposition organizers reiterated this depiction of the region in their focus on regional history, culture, and architecture. Indochinese troops did not play a major role in the war effort, so French officials directed public attention to the potential for developing agriculture and industry in the region. During the period 1914 to 1940, some entrepreneurs used drawings that distinguished French Indochina from the Far East by including workers who wore the traditional wide-brimmed straw hat and were assigned Indochinese titles. Many trademark labels depicted Asians in workshops where they packaged, painted, cleaned, and dyed products or labored outdoors carrying items on pole balances. These examples portrayed Asians as diligent and skilled laborers the French could rely on as they built their empire in the east. The remainder of chapter 7 discusses how the French government presented Indochina and its cultural heritage at the colonial expositions of the 1920s and 1930s.

The last chapter of *Races on Display* provides an analysis of the three groups displayed by the French and considers the imperial self-image created during the Third Republic. I gear the final reflections to three related concerns: the representations and their coherence, validity, and modification over time; the identity of Greater France as part of the French political system; and the immediate and long-term implications of the creation and use of representations of Africans and Asians for France's imperial self-image. These concerns bring us to consider the impact representations of colonized peoples had in France and the legacy of empire from the end of the republic to the demonstrations and wars that led to decolonization.

Part I

ON THE PATH TO CIVILIZATION, 1886–1913

1
Overseas Empire and Race during the Third Republic

By the beginning of the twentieth century, advocates of colonialism in the Third Republic had created what they referred to as "Greater France" by acquiring territories in Africa and Southeast Asia. France's control over its empire came in gradual stages and in various forms. Troops spread out from older colonial posts in western Senegal to subdue the entire Niger River area to the north, south, and east. In Indochina, France began with the fertile Mekong Delta region, asserted its influence in Cambodia, then acquired the remainder of Vietnam and Laos. Protectorate treaties with the leaders of several colonized countries allowed indigenous rulers to keep their titles and a form of ceremonial power. In Africa following World War I, the French received League of Nation mandates to administer the German territories of Togo and Cameroon. France gained some colonies through the exploratory travels of men such as Pierre Savorgnan de Brazza. In other cases, it acted out of political and economic motivations to attack and annex countries, such as Madagascar, that were already part of the protectorate system. But in remote areas of the empire, in parts of Mauritania and Vietnam, for example, the French struggled continually to assert their control.

As it was expedient to do so, French officials administered their territories in cooperation or "association" with local rulers without attempting to "civilize" or replace aspects of the indigenous culture. Yet in the original Senega-

lese colonial cities (Gorée, Dakar, Rufisque, and St. Louis) , for example, assimilation was the policy the French adopted and maintained.[1] Residents of these cities had to obtain a certain level of Frenchness to earn civil rights and privileges among their colonizers. Back in France, government officials and advocates of colonialism regularly debated how to best utilize the people and resources of this vast empire, which by the end of World War I amounted to twenty-five times the land surface of metropolitan France.

Creating the Empire: France, the New Power

North Africa

The history of French influence in North Africa goes back to the reign of Charles X. Thousands of French children in the twentieth century were taught about the diplomatic insult in 1830 that set into motion the invasion and eventual annexation of Algeria.[2] The French army finally gained complete control over the region after several decades of struggle. With the Turks defeated and resisting Arab forces subdued, the French encouraged emigration to Algeria from France and Europe and offered concessions of fertile land taken from the indigenous people. Since the climate and the terrain in Algeria is much like that of southern France, the government and advocates of colonialism promoted the new colony as a part of France that was separated from the continent only by the Mediterranean. By 1930, over 550,000 French were living in Algeria—the largest number of colonists in any territory of the French empire.

France obtained a protectorate over Tunisia without the armed struggle that was required to gain Algeria. The awful state of Tunisian government finances in 1880, a threat from a group of Tunisian warriors (Kroumirs) at the Algerian border, Bismarck's diplomatic encouragement, and the failure of the Italians to intervene (they wanted to influence the Tunisian government but were distracted by internal affairs) gave the French the excuses they needed to demand a protectorate arrangement with the bey of Tunis in 1881. Under French rule, Tunisia's trade and investment with France developed, though never at the level of France's commerce with Algeria.

The French also hoped to obtain concessions from the Moroccans in the 1880s, further consolidating their strategic hold on the western portion of North Africa. France gradually exerted more influence over Morocco as internal disorder grew and the sultan called for its assistance. After two diplomatic disputes with Germany over Morocco, one in 1905 and the other in 1911, the western powers ceded France the right to intervene and it declared the country a protectorate in 1912. But numerous ethnic groups fought bitterly to hold on to their territory for another decade. Because Morocco and Tunisia were protectorates and not fully controlled settlement colonies, the

French did not target them for the same level of development and investment as they did with Algeria.

Sub-Saharan Africa

Before the scramble for African territories occurred in the late nineteenth century, the French were well established along the Senegalese coast. In order to penetrate inland areas where there were opportunities to control markets, acquire laborers, and spread civilization to indigenous peoples, the French had to defeat two particularly resistant adversaries. Samory Touré, the leader of a Muslim state on the upper Niger River, battled against the French twice in the 1880s and 1890s. His forces resisted the colonizers along the western Niger from 1885 to 1895, when he was forced to retreat by General Archinard. Samory then moved his state to the northern region of the Ivory Coast region and continued to fight there until he was captured in 1898. News about Samory's military resistance appeared in the French popular press, and at several expositions he became a symbol of "savage" African resistance and repression of native populations.[3] But to the French, the real African villain in the 1890s was Dahomean ruler Behanzin, who opposed the French from 1892 to 1894. The French press and government officials portrayed him as extremely cruel and bloodthirsty and claimed that the Dahomeans made human sacrifices and used Amazon warriors.[4] After Behanzin was defeated, the French exiled him to the Caribbean.

The French organized their captured African territories into administrative subdivisions (*cercles*, *sous-cercles*, and *cantons*) where officials could maintain order, collect taxes, and procure laborers for different public works projects to improve the transportation of peoples, products, and materials.[5] The regions of West and Equatorial Africa were organized to provide raw materials such as wood, cotton, rubber, and cocoa for export to the *métropole*. Government administrators and European businessmen who obtained concessions for land and resources ruled over the indigenous population. Unlike the North African colonies, few civilians settled in these regions.[6]

Madagascar was an ethnically diverse island dominated by a Merina monarchy when the French decided to assert their power there in the 1880s. European traders, missionaries, and teachers had begun to influence the Merina government significantly as early as the 1700s. In the 1840s, the French obtained treaty rights and a protectorate arrangement over a small northwest section of the island. But after the Merina queen Ranavalo threatened to rescind French privileges, French officials brought in the navy, forcing Merina leaders to accept a full protectorate arrangement in 1890. In time, the French invaded Madagascar, making use of their West African forces, and annexed the island after a hard-fought campaign in 1898. Madagascar provided numerous export crops such as cotton, cocoa, and minerals.

Indochina

France encountered two dynastic empires in Southeast Asia when it began to assert its influence around the middle of the nineteenth century. In Vietnam, the Nguyen dynasty ruled the country through a highly organized bureaucratic system. In Cambodia, King Norodom led a weakened kingdom that was threatened by Thailand to the north and Vietnam in the east. In 1863, France arranged a protectorate treaty with the Cambodian king that shielded the country from its aggressive neighbors.

The French moved into Indochina in the 1850s and 1860s to come to the aid of persecuted Christian missionaries in Vietnam, secure trade relations, and explore the Mekong River as a possible alternate route into China. With these aims in mind, French naval forces entered Cochinchina (southern Vietnam) and fought to control Saigon and the delta region from 1858 to 1862, when they signed a treaty with the Vietnamese rulers that gave France control over the region. It was not until 1884, after several highly publicized and disastrous campaigns in Tonkin, that the French negotiated a protectorate arrangement with the Vietnamese ruler and moved into northern and central Vietnam. The French reinstated the term earlier Chinese rulers had given to the region, "Annam," which means "the defeated land." Adjacent Laos with its Mekong River areas became a protectorate of France in 1893, and in 1898 the French obtained a lease for the southern Chinese city of Kwang-Chow-Wan.

French colonization in Indochina, especially Vietnam, focused on developing a vibrant export economy. The French seized land and French colonists received concessions that enabled them to run profitable rice, tea, and rubber plantations with indigenous labor. A complex French administrative system in each of the three territories of Cambodia, Laos, and Vietnam provided lucrative employment for French settlers from all social levels. For the average Vietnamese, however, a harsh taxation system brought down the standard of living, producing widespread discontent and numerous uprisings.

The Meaning of Race in the Third Republic

Concern with human differences determined by ethnic origin and culture was an important theme of intellectual discussions and scientific inquiry in nineteenth-century France. Scholars, writers, and social critics turned to "race" as a way to account for physical and mental aptitudes and social behavior.[7] The new field of physical anthropology provided an academic framework for delineating and documenting human difference that encouraged thinkers to present "scientific" assessments of "inferior" Asian and African races in a way that contrasted them with the "stronger" Caucasian race. Progressivist philosophy and the philosophy of primitivism contributed to

an ideology that classified colonial natives as both capable of responding to civilizing efforts and as members of backward and unchanging races.[8]

The idea of "race" in France during the age of imperialism had three fundamental dimensions. First, the French continually redefined the concept of "race" in a way that was contingent on political situations and on the perceptions of government officials, the press, and influential writers. In this racial ideology, the physical traits that distinguished a "race" or the moral qualities of a "race" were not static. As the French acknowledged broadly defined racial categories, they delineated differences among groups as their knowledge about traditional societies grew. Imperialists in France constructed racial images and modified these images as conquest and "pacification" ensued and relationships between colonizer and colonized evolved.

Second, race determined an individual's and a group's potential for "civilization." The French supported a hierarchy of racial and evolutionary development that placed themselves at the pinnacle. Below them were Asians, who earned respect for their ancient artistic and intellectual traditions. Arabs followed primarily (in my view) because of a French disdain for Islamic culture and the adversarial relationship westerners had with Arabs that grew out of the Crusades. Sub-Saharan Africans ranked at the bottom of the scale—a "race" the French perceived through travelogues with misleading or false accounts and from their knowledge of trans-Atlantic slavery. The French felt that Africans, Arabs, and Asians could improve through civilizing action, but only white Europeans could be truly civilized.

Third, the concept of "race" appealed to the desire of humans to experience difference as exoticism and to define and redefine self and others. French denigration of the Other appears in commercial trademark images before World War II and in demeaning and racially motivated portrayals of colonial soldiers at public events. The public could interpret the use of colonial subjects in multicultural or bicultural events, however, in various ways that could subtly undermine French efforts to uphold its role as a great civilizing power in possession of a vast overseas empire.

Promoting the Empire:
Expositions in the Nineteenth Century

European Imperialism and the French World's Fairs

World's fairs have from early on both reflected and fueled international rivalries. The British world's fair of 1851, the Crystal Palace Exhibition, launched a new era of international competition. The palace, itself an impressive demonstration of British industrial talent, drew many crowds to exhibits that showcased technological advances in machinery and agriculture. Visitors from other countries marveled at what the British had accomplished. The French press praised the British effort. But President Louis-

Napoléon refused to let his neighbors across the channel outdo him. In March 1852 he issued a decree concerning his intention to erect a Crystal Palace–like structure, noting that "in Paris there exists no such edifice appropriate for public expositions which could serve the purpose of elevating national sentiment, the magnificence of art and industrial developments."[9] The French Exposition universelle in 1855 received about the same number of visitors as the 1851 London event had, and in both 1855 and in a later exposition in 1867, the French surpassed the British in number of registered exhibitors.[10]

The colonies participated in a limited way in these early fairs. Only with the advent of the Third Republic did the colonial sections of the French expositions take on increased stature, and even then changes were not made without a certain amount of bureaucratic conflict. In 1878, 1889, and 1900, as France's expositions grew in size and significance, colonial exhibits changed dramatically. The official colonial section in 1878 began as a walled-off section of an exhibit building with a separate greenhouse for a display of colonial horticulture. The focus was on displaying important aspects of colonial commerce, history, and administration. By 1900, French colonial sections were comprised of individual exhibition pavilions for each colony; colonial villages populated by native artisans and their families, entertainers, and soldiers; and cafés, restaurants, and shops where the visitor could purchase exotic food, beverages, and souvenirs. A small group of government officials and some enterprising businessmen transformed the character of the first expositions of the Third Republic and influenced other expositions in the twentieth century.

In 1876, the minister of the navy and the colonies named a fourteen-man delegation to organize the colonial section of the 1878 Exposition universelle in Paris. This commission coordinated with the head commissioner of the exposition to choose the site and determine the technical arrangements for the colonial section. The governor general of each colonial territory formed committees in his jurisdiction to select and prepare the items for exhibit in Paris. These groups then communicated their space and building requirements to the metropolitan colonial commission. In general, each colony was responsible for funding its own exhibit.

The Third Republic's first colonial exposition is noteworthy for three developments: 1) the beginning of separate structures to house colonial exhibits; 2) an increase in concessions with exotic themes; and 3) the inclusion of colonial troops. Governors from two overseas territories set aside funds to construct their own colonial pavilions at the Champs de Mars and Trocadéro exposition sites. Algeria, France's largest African holding, constructed a palace with Moorish and Oriental decor measuring 35 × 55 meters. A detailed description of the palace that highlighted its four towers and beautiful façades, entranceways, and galleries appeared in the October 3, 1877, issue of the *Journal officiel*. The author of the article emphasized that charac-

teristics of Algerian mosques had been reproduced in the palace's design.[11] Cochinchina also built a separate Annamite (Vietnamese) pavilion next to the colonial greenhouses.

The 1878 exposition spurred a growth in food and vending concessions with colonial or exotic themes. Commissions appointed by colonial governors in each territory granted concessions to eager businessmen who understood the potential profitability of these events. Final approval of concessions, however, had to be given by the Paris colonial commission and the commissioner general of the exposition. In the Algerian section, thirteen vendors were permitted to sell authentic Algerian food and wares. By July, the authorities had had to expel many others who had illegally set up businesses around the Algerian Palace. Some of the authorized concessions included Hédiard's vegetables and fruits, Picon's African bitter stand (a small pavilion where the public could sample a variety of liquors sent to France by Algerian chiefs), and Sifico's Café Maure, which included a bazaar with indigenous workers the public could observe.[12] Although monitoring food and product vendors near the official exhibition pavilions meant more work for the commissioner general's staff, the extra effort paid off because the colonial products and the North African workers on display added to the success of the exposition.

African colonial troops made their first appearance at a French exposition in 1878 in spite of opposition to the idea from the commissioner general of the exposition and other administrators. The governor general of Algeria gained permission directly from the French council of ministers to send indigenous troops to the exposition to guard the Algerian exhibits. Nevertheless, the Algerian Exposition Commission in Paris, which apparently had not been informed of that decision, rejected the idea. In a resolution issued after the troops had already arrived in France, the commission stated that such a guard did not promote "the agricultural, industrial and commercial nature" of the Algerian exposition. The minister of war wrote to the minister of agriculture and commerce on May 21, 1878, to explain how the request for the regiments had come about and why the men should be allowed to complete their service. He wrote that the real desire of the governor general of Algeria was that the presence of the troops aid in the success of the section, "adding by their presence to the interest and picturesque side of this exposition." The minister explained:

> It is with this in mind that General Chanzy chose the most handsome types from the indigenous races serving France; and I don't have to point out to you the impact sending these natives back to our colony would have, especially when the Governor General is getting ready to come to France to visit the Exposition, escorted by several highly esteemed Arab chiefs from the colony. Considerations of the highest order compel us, moreover, under these present circumstances, to avoid giving any cause for disturbance among the populations of Algeria won over [to our side].[13]

Under orders from his superior, Commissioner General J. B. Krantz was forced to accept the two detachments of Algerian soldiers—eleven Algerian *tirailleurs* and eleven *spahis*. These colonial troops took orders from the military governor of Paris and served honorably from late May until the first of November. The *tirailleurs* were housed in Paris at the Latour-Maubourg barracks and the *spahis* nearby at the Ecole militaire.[14]

In summary, the 1878 Paris exposition inaugurated a period of innovation for colonial expositions. Organizers sought to highlight the colonies by erecting unified colonial exhibits and pavilions that were separate from the rest of the exposition's structures. Delegates from the colonies received funding from the general budget of the exposition to build dividers between their exhibits and the metropolitan displays in the large pavilion halls. In addition, French government ministers determined that it would be advantageous to have ethnic Algerian troops participate in the exposition. In 1878, for the first time, officials in the colonies and members of commissions in France thought of an exposition an opportunity to draw more attention to France's colonial territories.

The 1889 Exposition universelle

The next international exposition in Paris, in 1889, marked a revolution in the concept of government-sponsored colonial expositions. The attitude of metropolitan and colonial officials toward this exposition produced an event without precedent. Beginning with the centennial celebration, supporters transformed French colonial expositions from informative (if somewhat boring) commercial and historical exhibits into diverse displays of overseas products, cultures, and peoples. Government organizers began to incorporate entertainment "spectacles" and "attractions," which heretofore had not been part of official events, into their exposition programs. Funding, recognition, and respect for the colonial sections of fairs grew.

These changes can be linked to political and administrative developments in the 1880s. First, France had expanded its colonial empire considerably since 1878. The advocates of overseas expansion were winning the debate that followed the Franco-Prussian War, triumphing over the *revanchards* who had no realistic plan for regaining the lost provinces of Alsace and Lorraine.[15] France had acquired protectorates over Tunisia (1881), Tonkin (1884), and the Merina kingdom in Madagascar (1885). By 1881, General Galliéni had conquered the West African Sudan. In addition, explorer Pierre Savorgnan de Brazza had made several trips to the Congo River basin region. During a special government mission from 1879 to 1882, he established a French post and signed a protectorate treaty with King Makoko (of the Bateke people) that enabled France to establish a colony on the Congo River. In 1886, Paris named de Brazza the governor general of the colony.

Because of the growing importance of the empire, government offi-

cials appeared more focused in their plans for the 1889 exposition. Eugène Etienne, the undersecretary of state for the colonies, played a pivotal role in planning the exposition as president of the organizing commission. Louis Henrique served as the commissioner for the colonial exposition. In the minutes of the commission's first meeting, the members stated their plans to highlight the growth in France's colonial empire since 1878. They believed that the public's "hopes would be disappointed, it would have difficulty understanding the utility of colonial policy" if the 1889 exposition did not present a better vision of the colonies than the preceding event had.[16] Various deputies and administrators from the colonies served on the organizing commission. Etienne selected a ten-man commission to plan special celebrations in the colonial section; these fêtes, which made use of colonial troops and entertainers, represented a major change from past programming.

Overseas preparation for the 1889 colonial exposition began in the fall of 1886 with a request from the minister of the navy and the colonies that territorial governors and commanders form local committees that would plan the participation of their colonies in the grand event. Upper-level administrators were asked to "make an urgent call for the participation of industrials, agriculturalists and businessmen" in the committees and as exhibitors.[17] Residents general in the French protectorates collaborated with state officials to organize their expositions, with varied results. The beylical government of Tunisia, for example, asked to be included in the organization of the exposition and agreed to fund the Tunisian section. It was then able to name its own delegates to the commissioner general in Paris and select a North African architect to design the Tunisian palace. Madagascar, on the other hand, agreed only to provide samples of products and produce for exhibit in France.[18] In February 1887, the exposition administrators in Paris sent further instructions for the layout of the colonial section. They explained that there would be a central pavilion for state holdings and geographical and statistical information and a series of buildings in styles characteristic of the colonial delegates' territories. Each colony was asked to respond with an estimate of the space it needed for its exhibit and the amount of funds it would devote to the exposition.[19]

Unlike previous fairs, the 1889 French colonial exposition presented the cultures and societies of the overseas territories with vivid displays of architecture, artistry, and indigenous peoples. In addition to the centerpiece Algerian palace of Moorish design, there were pavilions or separate buildings for Tunisia, Cochinchina, Annam and Tonkin, Senegal, Madagascar, and Gabon. The colonial administrations shipped workers to France to decorate these buildings. Twenty Vietnamese and Chinese artisans settled in Paris several months before the exposition opening to do decorative painting, sculptures, and carvings for the Annamite pavilion at the Esplanade des Invalides.[20] At the end of the exposition, pavilion sections were sold to public buyers.

Special villages made it possible for western visitors to get a glimpse of life among colonized peoples. In 1889, for the first time, colonial governments as well as private entrepreneurs sponsored indigenous villages at the exposition, filling them with dozens of employees from Indochina, West Africa, Equatorial Africa, and the South Pacific territories.[21] Each group lived in a type of transplanted environment that supposedly represented its home region. For instance, the local committee from Saint-Louis, Senegal, sent a variety of Africans to populate the Senegalese village in Paris, including blacksmiths, weavers, shoemakers, musicians, singers, and griots.[22] The Indochinese section was inhabited by a combination of tirailleurs, militiamen, and civilians. Artisans and entertainers, many of whom were accompanied by their wives and children, demonstrated their crafts before the French public.

Bringing large contingents of colonial subjects to France to participate in the exposition appealed to administrators for several reasons. Organizers in the *métropole* and overseas were convinced, and rightly so, that the native villages would attract masses of visitors. The *Bulletin officiel de l'Exposition universelle de 1889* regularly lauded the presence of the "exotics" on the Esplanade des Invalides as worthy of the public's attention. It reported 20,000 visitors at the second Colonial Night Festival, where crowds gathered to watch a parade that included Tunisian and Arab cavaliers, African dancers, and a Vietnamese group enacting the famous procession of the dragon.[23] Nearly fifty canoers from Senegal and Gabon rowed along the Seine in long African crafts from the Pont d'Iéna, drawing the attention of passersby. Exposition attendees could enjoy plays performed by a Vietnamese theater troupe and rickshaw (*pousse-pousse*) rides given by seventy "coolies" from Hanoi.

Many of the people brought to France for the exposition came as contracted workers with European concessionaires. Businessmen in the colonies and in Paris heeded the call issued by the governors general to participate in the expositions by proposing services and attractions. Concessionaires signed agreements issued from the commissioner general's office that outlined their responsibilities for the establishment and operating costs of their concession and the percentage of the concession's revenues that would be paid to the government. Running a concession at a colonial exposition could be a lucrative venture, but businessmen who contracted with the government took great financial risks. For instance, setup expenses for an Indochinese theater involved security deposits, construction fees, utility costs, and wages for staff. The owner had to transport the performers and matériel from Indochina and relocate to Paris for a six-month period. Then there were food and housing costs for his employees. Furthermore, the owner had little control over many aspects of the success of his business since the location of his theater, advertisement, and general hours of operation were determined by the commissioner general's office. Still, many businessmen were eager to participate in the colonial expositions by running exotic food

concessions, theaters, and shows. Famous attractions at the 1889 exposition were the Rue du Caire, which was staffed by over 250 Egyptians (including belly dancers), and a female Javanese dance group.[24]

During the planning stages of the 1889 exposition, administrators affirmed that the participation of colonial peoples was not only good for the metropolitan public but also would result in increased loyalty to France within the colonies. They believed that the "natives" who were exposed to the marvels of French civilization were destined to praise all they had seen and experienced in Europe when they returned to their local communities. At their first session, the members of the organizing commission for the exposition felt that colonial participants could serve as models of character that would have "an excellent effect on the spirit of the indigenous population."[25] Moreover, they saw the exposition as an occasion for advancing the *mission civilisatrice*. The meeting's report states that the "Colonial Administration should profit from the occasion provided by the 1889 Fair to put into direct contact with our civilization populations whom it is our responsibility to win over to our views."[26] Officials stressed the benefits that could result from the inclusion of colonial peoples at state-run expositions.

Nevertheless, there were certain drawbacks to the presence of Africans and Indochinese at these events, not the least of which was financial. The costs of paying for transportation, food, lodging, and clothing for hundreds of exposition workers from the colonies could be very high. In 1889, the colonial administration exceeded its budget for the indigenous workers by 120,000 francs—three times the amount of funding it had originally requested. Health issues were another concern. "Natives" had to be immunized so as not to be a public health risk and they needed access to health care during their stay in France. Rumors of widespread illness among the colonials began to circulate in spite of the precautions officials took.[27] Exposition organizers had to address health concerns seriously because African and Indochinese workers experienced dramatic changes of environment and had lengthy stays in France, generally from three to eight months. With each new exposition during the Third Republic, administrators found new ways to handle these challenges. The men who organized the colonial expositions never considered excluding nonwhite soldiers, artisans, and performers from exposition programs after the success they experienced at the 1889 Exposition universelle in Paris.

Colonial expositions in France were often the backdrop for national and international congresses and visits by foreign dignitaries from overseas territories. As support for the French colonial empire developed throughout the Third Republic, organizations such as the Alliance française arranged special conferences to coincide with the expositions. These meetings were not always held at the exposition site but were generally acknowledged and supported by the government as an example of public-private cooperation in the colonial endeavor. One significant meeting was the 1889 Congrès colonial

international, a meeting of scholars, politicians, and advocates of colonial expansion, that took place during the first week of August during the Exposition universelle. Lectures and discussions about ruling over native peoples were high on the agenda. For example, Gustave le Bon, a French doctor who promoted various racial and behavioral theories, spoke about the influence of European instruction on indigenous races. The congress ended with over three hours of special entertainment by African, Indochinese, Polynesian, and Javanese performers at the Esplanade des Invalides.

The French public saw a version of indigenous societies that differed from the display of artisans and farmers they saw at the exposition's villages when foreign dignitaries from the colonies traveled to France to visit the expositions. Stately rulers such as Guinean king Dinah Salifou (who was described as being from Senegal) and the prince of Annam toured the exposition grounds and the sites of Paris in the summer of 1889. Celebrations were organized in their honor and government officials and exposition staff presented them with special gifts. The press followed their activities and commented on their majestic attire and impressive entourages. But underneath all the pomp, to observers these visitors remained foreign, exotic, members of lesser races. A writer from the *Bulletin officiel* gave the following description of King Salifou:

> Dinah Salifou is a man between 35 and 40 years old; his face is completely black, but he has neither the thick lips nor flat nose of the southern races of Africa. His eyes, which are alert, always seem if they are looking for an explanation for what they see. The king wears a beard trimmed along the jaw line, rather long at the bottom of his chin. Dressed in a blue and white *burnous,* wearing polished ankle boots, holding a cane, he walks majestically and seems proud of his royal dignity.[28]

The *Bulletin officiel* staff reported almost daily on the agendas of the foreign dignitaries in Paris. Staff writers for the newspaper focused on the cultural and racial differences of colonial visitors in their articles. One of their favorite subjects was the response of Africans and Indochinese to the Eiffel Tower. The *Bulletin* reported that when a Moroccan mission ascended the tower, its members cried out in admiration and praise. "Overall," the author said, "the effect was excellent."[29] The tower became a symbol of the superiority of French civilization before which colonial peoples would stand in awe. Through this structure and other technological advances, native dignitaries would be convinced that their societies benefited from the guidance of their French rulers. In this way, world's fairs and colonial expositions served a dual propaganda purpose for French authorities. Once colonial peoples recognized their inferiority and the French public understood the value of the colonies and their responsibility to these "primitive" races, the organizers of colonial expositions believed they could feel confident that they had begun to attain their goal.

20

Sustaining a Racial Image:
French Marques de Fabriques

Although the colonial expositions provide a special opportunity to examine the government's representation and display of colonial races, the study of races on display in the commercial realm provides insight into the images French citizens might see daily and over long periods of time. For this reason, I chose to examine the abundant collection of registered trademarks from Paris and Marseilles for the period 1886 to 1940. These trademarks were usually drawings and names that a business owner used on labels for his or her wares. The trademarks I identified from the government registration books included drawings that specified peoples from the three geographical groups in this study and generic images of blacks, Arabs or Orientals, and Asians.

Identifying marks and insignias for trades and commercial products have a long history.[30] Evidence from the Roman empire indicates that some artisans and shopkeepers used sculpted or painted symbols with names representing their businesses on the fronts of their shops. It was not until the seventeenth century that these insignias, such as blades of wheat for bakers or a cow's head for butchers, were regularly hung in the streets to mark different trades.

The industrial revolution and the evolution of a market society spurred the development of the modern trademark in France. Products that circulated from the producer to the middleman to the consumer needed marks to distinguish them clearly from other shipped goods and from similar items produced by different manufacturers. Manufacturers and merchants identified their products by a particular name and sign.[31]

According to Andréa Semprini, modern trademarks began in the mid-nineteenth century.[32] In France, a new law concerning trademarks (*marques de fabrique et de commerce*) was decreed in 1857. It applied to all types of agricultural products, foods, liquors, wines, and manufactured goods. Under the new law, entrepreneurs had no legal right to claim exclusive ownership of the names or illustrations associated with their products if they did not register their trademarks, in duplicate, with the clerk at one of the regional French commerce tribunals (Tribunaux de Commerce).[33] The registration was valid for fifteen years and could be renewed.[34]

Because trademarks have commercial and legal significance, it is useful to examine the types of images merchants chose to identify their products. The trademarks evaluated in this study indicate the impact of French imperialism in the commercial realm and the presence of stereotypes of the Other in western culture. In the French trademark labels from 1886 to 1940, sub-Saharan Africans, North Africans, and Indochinese typically filled set roles and represented limited categories of products. Because these races

were displayed on trademarks as exotics or laborers, they reminded the public of France's civilizing mission and economic interests abroad. Ultimately, race-based trademark labels and state colonial expositions in France functioned to both accentuate human differences and establish a French identity of superiority.

(handwritten marginalia:)
Expos +
col. trademarks
– human
differences
– Fr. superiority

2
Sub-Saharan Africans: "Uncivilized Types"

Western stereotypes of Africans and peoples of African descent developed out of opinions of their status expressed primarily in intellectual and business communities and disseminated widely in various forms. Because of the Atlantic slave trade, early visions of Africans focused on bondage and freedom. Europeans presented Africans as laborers on their own continent, as slaves, or as people under the control of rival African groups. They usually viewed sub-Saharan African kingdoms and their rulers as tyrannical and belligerent. The thinking of some Europeans about Africans was shaped by the idea of the "noble savage" who was untainted by the corrupt forces of advanced civilization. In the early nineteenth century, many western abolitionists supported the end of the slave trade and plantation slavery as a means of ensuring that black Africans could be properly educated in the Christian religion and elevated from their "savagery" and "ignorance" in an environment free from abuse and hypocrisy.[1] Slave-owners argued just the opposite; they believed that the Caribbean plantation was an ideal setting in which to convert and civilize Africans. Neither argument won the support of the largely disinterested French population. France's abolition of slavery in 1848 was the result of the initiative of a few inspired republicans rather than a reflection of a change in public attitudes toward Africans and blacks in the Caribbean.[2]

The European "scramble" for territorial conquest in Africa in the last decades of the nineteenth century led governments to articulate racial justifications for western aggression. In the half-century before World War I, the general image the French held of sub-Saharan African peoples was of primitiveness and backwardness with regard to material culture, customs, and moral values. Many considered African nudity or near-nudity in various societies to be a reflection of savagery. This view was expressed in the press, in works by scientists, in illustrations in travel books, and in commercial advertisements and trademarks. Even when government officials, military leaders, scientists, and scholars began to recognize vast differences in regions and ethnic groups on the continent, they continued to hold to this stereotype.

Anthropologists of the period argued that Africans were inferior because of their physical differences from Europeans. Often these men supported polygenism (the belief that ethnic groups or races have separate origins), rather than the monogenist view that all humans originated from one set of ancestors. French scientists such as Paul Broca ranked racial groups and claimed that there was a link between physical traits such as head shape or lip size and intellectual and moral qualities. For example, the larger lips (in comparison to those of Europeans) characteristic among West Africans allowed such scholars to posit their "proof" that blacks were morally deficient.[3] Broca and others from the Société d'Anthropologie sought out racial "specimens" to gather empirical evidence for their theories. In 1877, the Paris Jardin zoologique d'acclimatation's popular display of Nubians—who were brought to Paris with a variety of animals from East Africa—provided such an opportunity.[4]

These scientists continued on a broader scale the anatomical study of exotic peoples that had been punctuated in France in 1815 with the tragic case of Saartje Baartman. Baartman, a South African Khoikhoi woman with very large buttocks, became engaged to an impresario who showcased her as the "Venus Hottentot." She was displayed nude at venues in England and France and examined by scientists. When she died before the age of 30, she was studied and dissected by Georges Cuvier and staff at the Paris Musée d'histoire naturelle. Novelists, filmmakers, and playwrights have all been riveted by Baartman's tragedy, which finally reached some closure in 2002 when France returned her remains to South Africa after numerous protests. Scholars such as T. Denean Sharpley-Whiting identify Baartman's saga as central to an understanding of Europe's obsession with sexuality and the black (female) body.[5]

The French public rarely had an opportunity to observe or interact with Africans other than at the rare ethnographic show or at the periodic world's fairs, so they built their opinions mainly on characterizations in writings and circulated images. In *An Empire for the Masses*, William H. Schneider examines popular views of Africa in the press and describes how artists modified drawings of African scenes, vilifying their subjects and creating "sav-

ages." In the 1890s, during Africa's wars with French forces, artists offered engravings with exaggerated depictions of Dahomean warriors. Contemporary images in the press, notably in *Le petit journal,* tended to confirm a centuries-old vision of Africa as uncivilized and buttressed propaganda to justify French conquest. Ethnographic exhibitions of Africans at the Jardin d'acclimatation in the 1870s and 1880s also provided the public with an inaccurate image of African peoples. The Jardin stressed the supposedly primitive exotic nature of Nubians, Ashanti, Pai-Pi-Bri (from Ivory Coast), and Dahomeans brought in to entertain audiences, and they exhibited them behind barriers much like they did their collection of exotic animals.[6]

The perception of sub-Saharan primitiveness in France was always coupled with the belief that the African could be civilized or freed from his savage nature through prolonged and meaningful contact with French culture. French trademarks and portrayals of Africans at colonial expositions before World War I clearly reflect the idea of the primitive black and the hope that he would progress. This chapter explores the French characterization of sub-Saharan Africans as uncivilized types as reflected in early commercial trademarks and the official colonial sections of the 1900 Exposition universelle in Paris.

Trademark Images, 1886 to 1913:
Facets of the Generic "Noir"

Near the turn of the century, French businessmen and businesswomen used images of Africans and blacks in trademarks to communicate three different messages. Trademark designs stressed exoticism, symbolic blackness, and the socioeconomic relationship between Europeans and people of African heritage. Sometimes trademark labels portrayed two or all three of these messages simultaneously, but usually one remained predominant. These themes and images closely echo American trademarks and advertisements of the same period. The system of plantation slavery in the Americas impacted business culture for decades to come by impressing disdainful images of blacks on the minds of entrepreneurs and artists on both sides of the Atlantic.

The idea that blacks were exotic governed their likenesses on a variety of trademarks. Businesses used images of the "Noir"—which included blacks in both sub-Saharan Africa and the Caribbean—in trademarks for items traditionally produced in these regions and for a wide range of manufactures and foodstuffs. The names of products such as Le Dahoméen or L'Antillaise clearly identified the person in the label. For many products, however, the specific origin of the "Noir" or "Nègre" could not be determined by clothing, surroundings, or product name. Moreover, trademark drawings of blacks in traditional Caribbean-style dress were also used for products associated with Africa. A clear example of this is seen in Henri-Louis Saver's 1895 soap

25

trademark called Le Volof. While the name of the trademark referred to the Wolof people of Senegal, the drawing on the label was a depiction of a black man wearing a wide-brimmed straw hat more often pictured in scenes from the West Indies. This depiction misleadingly portrayed a Caribbean black as a member of the Wolof ethnic group, a group that was generally Muslim and wore garments, caps, and turbans influenced by Arab North Africa. Many businesses that registered trademarks in France during this period used a generic image of Africans and people of African descent that was modeled after familiar images of mulatto Antillais, the descendants of Africans who were enslaved to work the Caribbean island plantations.[7] The discussion that follows is based on a survey of 316 French trademark labels that include images of blacks from French sub-Saharan Africa (and Madagascar) and blacks whose regional identity is not specified.

Political events spurred several companies to adopt exotic portrayals of Africans on their trademarks. Two companies used the highly publicized kingdom of Dahomey as the theme for their product labels. In 1889, as tension grew between French officials and Dahomean rulers, Xavier Pène registered his hygiene soaps called Savon des Amazones du Royaume de Dahomey and Savon des Amazones. The labels for Pène's soaps included drawings of male warriors with knives and guns and soldiers in marching formation. In 1908, Felix Fournier illustrated his Bougie du Dahomey candle with a drawing of a group of Dahomeans with spears. These labels evoked the same images of black savagery and primitiveness that were publicized in the French popular press during this period.[8]

But the most common image of blacks in trademarks during the period 1886 to 1913 was the black head (*la tête noire, la tête de nègre*), which was used as an exotic emblem and an advertising symbol. Many companies marketed their products by using a drawing of a black head in silhouette, profile, or full view on their trademark label. Designers distinguished the *têtes noires* by stressing physical traits, clothing accessories, and special design motifs. Images of black heads first appeared in the west in heraldry emblems of the Holy Roman Empire in the fourteenth century. These depictions seem linked to the Bible story of the Three Kings (Magi) who went to see the baby Jesus. During the fourteenth century, one of the Magi was depicted as a black Moor. The heraldic Moor was pictured on various European armorial bearings. In Corsica, the regional flag still contains a Moor wearing a headband. Different versions of the black head appeared repeatedly in the trademark registers for each year in this study. Some feature the same characteristics seen in designs that were five centuries old.[9]

The prominent physical characteristics of black heads on French trademarks were the lips, teeth, and hair—traits that whites in Europe and America found very different from their own. Designers consistently accentuated these features, especially in caricatures. Trademark artists particularly emphasized the lips in their drawings of black heads, which stressed the Ne-

groid origins of the subject and caught the attention of the viewer. In 1905, the Société Générale des Huiles et Fournitures Industrielles in Paris registered the name Oléo for its line of automotive and bicycle lubricants and related items. Their trademark was a smiling black male head with large lips. Throughout the 1910s and 1920s the company kept this basic image for new products it registered; it used a hideous caricature from an advertising poster designed by Raoul Vion on its 1922 trademark.

In more-elaborate black head illustrations, designers added jewelry and headgear to the subject. Women in the drawings often wore African- or Caribbean-style head coverings; men wore hats, Islamic caps, and Oriental fezzes. However, both male and female black heads wore large hoop earrings and necklaces, making the gender of the individual in a number of the trademark labels impossible to determine. The toothpaste label for Poudre Dentrifice du Soudan (Paris, 1889) exemplifies the androgynous black head. The oval label simply pictures an African with a band across the forehead. On the trademark for Le Noiro soap (Marseilles, 1894), a dark-skinned person wears earrings and a necklace. It is not certain if the drawing depicts a man or if the masculine article in the name simply refers to the soap—*le savon*. The designer did not need to clarify the gender of the individual in the trademark because this detail was irrelevant to the commercial strategy that was being used. A consumer would have been drawn to the label because of its exotic image or because of its association with the idea that soap cleans away filth; the African figure represented uncleanliness.[10]

As trademark images, *têtes noires* varied from stately images with refined or classical designs to caricatures. Black heads were displayed in several positions, and most were framed in round or oval seals and medallions. Generally, the presentation and detail of the design depended on the nature of the product. For instance, trademark designers often used the simplest drawings for liquor labels. The Conilh Brothers of Marseilles marketed their own Amer Conilh (1888), a bitter made from African plants, with a black head in the center of the label. Their Fine Champagne label (1891) shows a similar black head drawn in a medallion with a more distinctive border of grape clusters and leaves. Several beer companies incorporated the black head image on their labels, notably the Brasserie de la tête noire (Paris, 1886).

Other companies created special motifs with black heads. An 1890 label for Corsican mineral water included a black head in a medallion frame being held up by angels. For his Comica line of film products and publications (Paris, 1910), Henry Danzer registered a trademark showing a black head bursting through a movie screen. The mouth was open, but instead of teeth, the word "Comica" filled his smile.

Business-owners who registered trademarks in France from 1886 to 1913 adopted the *tête noire* image frequently, often not even linking the qualities or origin of the product to the black head itself. Black heads appeared in forty-eight of the seventy-four trademark categories. They were absent

from categories such as artillery, clocks, locks, and ceramics, which generally made up a small percentage of the total trademarks registered annually. The prevalence of black head images reveals the confidence of entrepreneurs in their appeal and their traditional use as a symbol of ownership. There seems to be no other logical explanation for why French companies placed *têtes noires* on their official trademarks for items ranging from safety pins to champagne.

good reasoning for appeal of têtes noires?

Symbolic Blackness

Definitions of "black" in the late nineteenth century suggest how a characterization based on skin pigmentation created a negative framework by which Europeans viewed sub-Saharan Africans. Literally, black meant "dirty" and "obscure." Used figuratively, black referred to anything that was criminal, melancholy, or defamed. The dictionary of the Académie Française gave a concise definition for the word "black" when it was used to describe an individual: "Noir. Nègre. Il se dit par opposition à Blanc" (Black. Negro. Nigger. Used in contrast to White).[11] Blacks, then, were all the things that whites were *not*. Intellectuals communicated these ideas when they used the term "savage" to describe dark-skinned Africans.

By the late nineteenth century, Europeans had been portraying African morals as "black," depraved, and far below the western standard for a long time. Pierre Loti's popular novel *Le roman d'un spahi* (1881) recounts how a French youth in the colonial army is "corrupted" by the entangling charms of an African woman. His black mistress holds an "evil" power over him, so much so that he chooses life with her in Africa over marriage to a virginal French girl awaiting his return in his home village. Writings and drawings from the modern colonial period illustrate how the French, who viewed themselves as exemplary members of the white "race," believed that they represented the qualities that were lacking among Africans. The French often considered sub-Saharan Africans lazy and saw themselves as industrious. White French Catholic morality opposed black African animist immorality. In the view of most French people, blacks had limited intellect, while the French were capable of complex reasoning; expressed differently, blacks were intellectually "dull" while whites were "bright."[12]

Another place color symbolism frequently appeared was in the trademarks registered during the Third Republic. Blackness had both a negative and a positive value in trademark depictions. On trademarks for cleaning products prior to World War I, Africans and blacks often represented the undesired filth or dirt to be washed away. Those who associated black identity with uncleanliness portrayed blacks on their labels for special degreasing soaps. Black men and women were often depicted on labels for personal soap products without the elegance accorded members of other races on

comparable labels, but some Marseillais soap companies used busts of Africans on their soap bars in the same way they used drawings of character types such as "the Provençal," "the Emir," and "the Alsacienne." Companies that named their soap bars after African countries or people from African countries may have intended to evoke exotic themes; their depictions of blacks contained none of the negative imagery that typically appeared on soap labels.

Images of blacks also illustrated the efficiency of cleaning products. Several Parisian companies "humorously" asserted that their product was powerful enough to bleach a Negro white. A laundry bleach called La Négresse that was registered in 1888 presented a before-and-after drawing to suggest that La Négresse was the best laundry whitener (fig. 1). The same theme appeared in the trademark for Lessive Instantanée, Au Nègre Blanchi (1891). Labels for KYR (1906), Savon des Comtes de Provence (1907), and Jeffh, Savon Ponce (1907) pictured black children being cleaned by special soaps. On the KYR label, a white woman towels dry a black child who has been whitened from the neck down in a washbasin of the product. Blackness was washed or bleached away by French products, and black adults and children in the drawings actively cooperated with the process. The soap and bleach trademarks promoted the long-held idea that black people were under the "curse of Ham" and that their dark skin color and inferior status were a punishment from God.[13] Therefore, whitening was a desirable goal for both blacks who wanted to be white and whites who desired a world without blacks. In this commercial use of color symbolism, we see a vivid illustration of what Abdul R. JanMohamed calls the "Manichean allegory," which divides the imperial world into mutually exclusive categories; here opposing moral qualities are linked to race and complexion.[14]

On the other hand, blackness was emphasized as a positive attribute in trademark labels when companies used drawings of Africans on labels for dark-colored products that ranged from motor oil to cocoa powder. These black likenesses confirmed the origin, purity, and strength of the product. Businesses used images of blacks on trademarks for chocolate, coffee, and dark beverages such as chicory and cocoa. Trademarks for these products displayed two relationships between the image and the product: the dark pigmentation of Africans and mulattos represented the color of the beverages, and blacks harvested coffee and cocoa in plantations in America and Africa and prepared and served the beverages as servants in European households.

Blacks appeared more frequently on coffee trademarks than on any other category of registered products. Generally, these were realistic plantation scenes where one or more workers packaged or displayed the coffee beans and domestic scenes where a smiling servant in uniform stood waiting to serve the piping-hot beverage. The names of coffee trademarks reflected

29

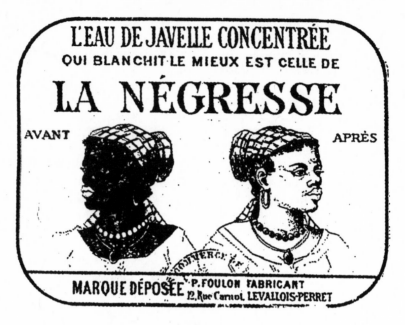

Figure 1. La Négresse (Paris, 1888).

these two images. Café du Colon (Marseilles, 1898), Au Planteur de Koui-
lou (Paris, 1903), Aux Planteurs Français (Paris, 1908), and Au Nègre Ré-
colteur (Paris, 1912) are examples of typical plantation-scene trademarks.
Domestic-scene coffee trademarks were often named after the black servant,
as in the Parisian products Cafés du Joyeux Négrillon (1900) and Au Nègre
de Neuilly (1902). Trademarks for chocolate depicted blacks in the same
two settings. The stance and attire of the blacks in these labels is nearly iden-
tical to illustrations of black dandies, performers, and servants in American
advertisements.[15]

As with coffee and cocoa products, French businesses used images of
Africans and blacks in their trademarks for shoe polish, oil, and ink. De-
signers presented black men as shoe shiners on trademarks for shoe and
boot polish. Blackness was stressed in the names of various polishes such
as La Nigrosine (1887), Beau Noir (1888), and La Soudanaise (1909), all
of which were registered in Paris. The prewar Parisian trademark registers
contained two portrayals of blacks in trademarks for ink: Encre du Congo,
Noire Fixe Inaltérable (1887) and Encre de Javel, Oh! Qu'Elle est Noire
(1898). On the Encre de Javel label, an attractive black woman was depicted
in a cloth wrap dress that left one breast completely exposed, an example
of the pairing of exoticism and eroticism in advertising trademarks. These
labels linked the blackness in the product with the blackness in the image
as a desirable trait.

A Socioeconomic Relationship

French trademarks confirmed the unequal economic relationship that had existed between African peoples and Europeans for several centuries. Commercial images of blacks and Africans in the late 1800s evoked the slave system that had been dismantled only a few decades earlier. Drawings of black domestic servants and black agricultural workers were the familiar images of house slaves and field slaves from the Caribbean. Some of these trademarks showed French planters in tailored white three-piece suits surveying their lands while black workers in loincloths and shifts labored over crops. Trademarks established from 1886 to 1913 made master and servant roles clear, confirming the inferior socioeconomic position of blacks.

When French entrepreneurs wanted to associate blacks with certain foods and household products, they portrayed them as domestic servants—a realistic depiction of black roles in French colonial society. Trademark designs showed servants at work at daily tasks in mundane or comic scenes. Black men and women were pictured in European homes serving or preparing cocoa, coffee, breakfast cereal, cookies, and candy. Women were shown hunched over the laundry basin; men shined shoes and boots. Most images in this category of trademarks imitated older images of black slaves working in white households. For example, in 1897, Gaston Lenglet, a Parisian dealer in coffees, teas, and spices, registered as his trademark a drawing of a white woman being served at a dining-room table by a miniature-sized black servant. Plisson and Company's 1908 Cirage Parisien trademark label for shoe and boot polish evoked the master/servant relationship with a drawing of a black man polishing a boot while his white employer held a leisurely pose at his side.

Black men appeared more frequently than women in the role of domestic servant in the trademark labels. Usually dressed in fancy butler uniforms, these stylish dark men adorned trademarks for coffee, tea, candy, bleach, and metal polish. In 1898, Paris merchant Pierre Laba chose Au Nègre Gourmand, Café du Nègre as the name of his products. Laba's trademark label used a drawing of an immaculately dressed black domestic wearing a long service apron and holding up a cup of coffee. In 1913, another Paris businessman, Adrien Hémery, named his coffee specialties Au Nègre de Madagascar. His trademark pictured an African man dressed in a formal white suit with tails. Regardless of their dignified appearance, there was never a doubt that these black men held the most subordinate position in French society. Their childlike grin or facial expression created a persona that differed from the "civilized" image associated with their western uniforms.

The black domestic in European attire offered a sharp contrast to the modestly clad black plantation worker. Parisian and Marseillais trademarks depicted blacks as agricultural workers in fields and groves, where they gath-

ered cotton and cocoa pods or carried crates and sacks for European merchants. Label designers at the end of the nineteenth century continued to use slave-plantation illustrations with symbols that allowed even illiterate consumers to identify the product's exotic origins. Tall ships, palm trees, and black field workers indicated that the item came from America or Africa. The plantation owner wore a hat, often held a walking cane, and was always relaxed. One or two of his black workers, who held shovels or gathered crops in the fields in the background, appeared opposite the planter. All the symbols in the plantation worker labels are present in the Chocolat du Planteur trademark registered in 1898. The scene on the label was not meant to be a realistic depiction of chocolate production since it showed blacks working in a grain field. This trademark portrays the owner/worker relationship—the white man overseeing the work of the black—and the authenticity of the exotic product illustrated by the presence of symbols such as palm trees. The Chocolat du Planteur label and others like it invoked the past slave system and suggested that at least in this commercial realm, little had changed in the way the French viewed or portrayed blacks. Businesses continued to use plantation images until events after the turn of the century created new black types.

The value of black images before World War I lay in their ability to allure the consumer by stressing exotic themes, serve as signifiers of product traits or effectiveness, and reaffirm a socioeconomic relationship of French supremacy over nonwhite groups. In all three functions, blacks were objects—whether objects of scorn, as in the plantation and cleaning product labels, or "colorful" objects, as in the chocolate trademarks. In nearly every case, the French represented blacks as exotic uncivilized types who in their role and attire might emulate civilization but who were maligned and subjected to the power and needs of the French.

Sub-Saharan Africans at the
1900 Exposition universelle in Paris

The colonial sections at the 1900 Exposition universelle reinforced an image of sub-Saharan African primitiveness versus French power, technology, and culture. Government organizers prepared a vision of the African empire that was meant to be both educational and entertaining. Exhibits for the French sub-Saharan African colonies at the 1900 exposition featured "authentic" miniature villages with African artisans, musicians, and military units. Colonial administrators in Dahomey, Senegal, and Madagascar provided the transportation, food, lodging, and compensation for workers and their family members who agreed to participate in the event. Madagascar sent over the largest African contingent, a total of 124 individuals; an additional twenty-six Dahomeans and twenty-one Senegalese added "local color" to village buildings and huts. Other colonies such as the Congo,

32

Ivory Coast, and French Guinea decided not to send Africans to the exposition but sponsored standard exhibits with product samples, artifacts, and economic and geographic documentation displayed in exotic pavilions. In addition, a concessionary company, the Société Anonyme du Panorama de la Mission Marchand, celebrated French expansion with twelve dioramas depicting Commander Jean-Baptiste Marchand setting out on the Ubangi River in the Congo in 1899, various nature scenes, a settlement with women cooking, and the burning of a village that had revolted.[16] The collection of dioramas, imitation villages, documents, and living displays of sub-Saharan Africans presented blacks of the continent as primitive but capable of advancement.

Featured Exhibits

Madagascar. The Madagascar exposition boasted a cylindrical three-story Malagasy-themed pavilion, indigenous huts, and dozens of Malagasy workers who represented "specimens of the principal groups of peoples" inhabiting France's new possession.[17] In selecting the individuals who were to be displayed in Paris, officials in the territory referred to two main criteria—ethnicity and profession. Officials made a genuine attempt to show the diversity of the island's population in the composition of the group and to demonstrate various Malagasy artisanal skills. At least ten ethnic groups were represented at the exposition.

The Madagascar exhibit contained three parts. First came what Jules Charles-Roux, the exposition commissioner's delegate for the French colonial section, called a "spectacle mouvementé," an outdoor scene of a Malagasy forest region complete with vegetation and native animal life. Designers built an artificial island in the center of the Trocadéro basin (which was specially heated for the occasion) and imported crocodiles, birds, and snakes. In another area, near the Malagasy huts, stood a small park where domestic animals grazed. The colony displayed economic information about and agricultural samples of coffee, cocoa, rubber, tobacco, and other products on the first floor of the main pavilion. The second part of the Madagascar exhibit featured an ethnographic section and maps and charts of the island's terrain, cities, and infrastructures. The third part presented historical and geographic information, artwork, precious objects from the former queen's palace, *lambas*,[18] and a concessionaire's panorama of the seizure of Tananarive by the French.[19] Outside the pavilion, the public watched as Malagasy in the straw huts made cloth and lace, wove baskets, and worked gold.[20] Uniformed *tirailleurs malgaches* and militiamen plus thirty-five musicians added spark to the "living" section of the government exhibit.

The Malagasy "specimens" participated in numerous colonial fêtes organized during the fair. Charles-Roux coordinated these celebrations during a series of meetings with the commissioners who had imported colonial

33

workers. Their first organizational session was held in June after all the pavilions were completed and the exhibits were installed. The immediate goal of the evening festivals the commissioners planned was to draw crowds and increase the number of customers for concessionaires in the colonial section.[21] Additionally, the administration wanted these celebrations to show off the well-groomed troops and the diversity of the indigenous groups and their exotic cultural traditions. The commissioners decided to "stimulate the zeal of the natives" by paying them one franc for each event.[22] Because of their numbers, the Malagasy played an important part in the festivals. At the first program, the contingent from Madagascar appeared second in line after a platoon of Algerian *spahis*. A group of *tirailleurs malgaches* carrying animal-shaped lanterns led their compatriots. They were followed by musicians playing "turbulent" refrains, a group of men carrying a platform holding an enormous stuffed crocodile, and a Sakalava woman with a "strange" hairstyle carried on a *filanzane* chair. Another group of *tirailleurs* carrying lanterns marked the end of the Malagasy section.[23]

Exposition organizers found other ways to display Africans. The Alliance française and the Berlitz School of Languages both gained permission to construct small pavilions to use as classrooms for language instruction. After all, a Berlitz director reasoned, "At the Exposition we're having the natives dance, sing, and do manual work before the public. Why not try to teach them?"[24] Visitors to the exposition could observe firsthand this vital aspect of the civilizing mission in the two pavilions. The Alliance française had the first choice of which groups to instruct; they chose the Malagasy. The Dahomeans and the Senegalese were divided between the two organizations.

The individuals sent to the Paris exposition from Madagascar provided colonial enthusiasts with a sample population through which to investigate anthropological and cultural questions in an environment entirely controlled by the French.[25] Malagasy were studied and observed during their stay in Paris by anthropologists and others. Members of the Anthropological Laboratory of the Ecole Pratique des Hautes Etudes took detailed measurements of individuals from each ethnic group with the ultimate goal, they claimed, of clarifying Malagasy origins. Anton Jully, the colonial delegate responsible for technical concerns who was an architect and engineer, compiled a Franco-Malagasy lexicon during the exposition that included eight dialects. Charles-Roux reported that after observing the musical aptitudes of the Malagasy musicians, the exposition administration provided the group with three months of music study in Paris. French musical training purportedly transformed the group into "a good ensemble" and secured them a prize in a sight-reading contest.[26] In this situation, the civilizing mission included changing traditional Malagasy music forms to meet a French standard.

Organizers of the Madagascan exposition created their pavilion exhibit and village display areas to familiarize the public with the new colony and underline its economic value to France. The workers, soldiers, and per-

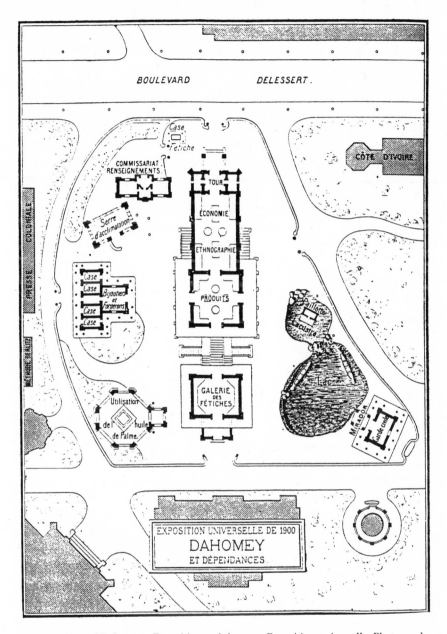

Figure 2. Map of Dahomean Exposition and the 1900 Exposition universelle. Photograph
from L. Brunet, *Dahomey et dependences.*
Courtesy of the Bibliothèque Nationale de France.

formers they brought to Paris were an exotic attraction for the public and for academics who were eager to document their physical traits and define their racial origin. The presence of the Malagasy gave the organizers an opportunity to "civilize" the group through language and music lessons. Through the various documentary exhibits and "living displays," the French showcased the foreign qualities of the Madagascan group and reinforced their own superiority.

Dahomey. The Dahomean exhibit at the exposition attracted public attention because of the highly publicized French campaign in the 1890s against King Behanzin. French images of African savagery at the end of the nineteenth century developed in part from portrayals of Behanzin and his Dahomean entourage as bloodthirsty and ruthless.[27] The Dahomean section at the exposition contained a 20-meter-tall military post tower; a pavilion and annex that housed maps and charts, products, and ethnographic objects; and a small native village next to a manmade lake (fig. 2). A short wall made of bamboo and reddish plaster surrounded the entire village. In the pavilion, organizers displayed samples of the finest products the colony offered—palm oil, wood, nuts, cotton, and coffee—plus European products sold in the colony. Several of the featured items in the pavilion were royal seats from the kingdom of Abomey. Administrators claimed that one of these seats, which belonged to a ruler named Guézo, rested on top of "the skulls of his four ministers." The pavilion annex contained the "Table of Sacrifices," further evidence of the savage ways of Behanzin and the defunct Dahomean leaders.[28]

The Dahomeans who were on display in the village included ten men from the civilian guard, seven artisans, four "boys" (young servants), and five wives (fig. 3). These were "true" Dahomeans, according to an official publication, in contrast to the "so-called Dahomeans" who had been brought to France in the past who actually came from Togo or Lagos. Here, the writers surely referred to the "Dahomeans" who had been exhibited at the Jardin d'acclimatation in 1891 or the group presented on the Champs de Mars in 1893.[29] For the first time, the French public would observe inhabitants of Lower Dahomey, members of the Nago and Djedji races, who did not resemble the black troupes that traveled the continent in ethnographic shows and begged audiences for money. The artisans in the group—jewelers, cloth weavers, and basket weavers—worked in a large hut and were permitted to sell their products to the public. Their wives occupied themselves in the village while their husbands worked or kept guard.[30]

At the first colonial evening festival, the Dahomeans distinguished themselves with their music and costumes. Their section of the parade, as described in the official report, consisted of several people beating on gongs and drums, Dahomeans in "bizarre" ceremonial dress carrying "fantastic" lanterns, and the simulation of a royal cortège. The Dahomean "queen,"

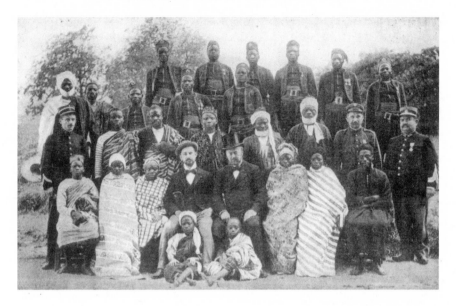

Figure 3. Dahomeans at the 1900 Exposition universelle. From L. Brunet,
Dahomey et dependences.
Courtesy of the Bibliothèque Nationale de France.

dressed in a long red velour robe with a tall silver-fringed hat, sat in a ham-
mock suspended between two porters.[31]

Unlike the Malagasy, Dahomeans refused to participate in any "scien-
tific" examination—especially efforts by anthropologists to measure their
physical features—but they did submit to being displayed in the language
classroom.[32] The results of this experiment were reportedly mixed. At the
end of the exposition, Monsieur Collonge from the Berlitz program ex-
pressed disappointment in the fact that the Dahomeans could attend classes
only three times a week due to the large number of celebrations in which
they participated. He considered the Dahomeans to be "less cultivated" than
the Senegalese and felt that this explained why they had difficulties grasp-
ing the language in the beginning. The Dahomeans left the exposition with
enough French skills to handle everyday matters, but he noted that it would
require a more stable setting to train them effectively.[33]

The Dahomean section presented the public with two images of the
colony. Visitors saw the old "savage" nation in the objects, descriptions, and
processions associated with Behanzin's rule. Through other displays in the
pavilion and village they discovered the wealth produced in the region and
the economic development and political stability in Dahomey since its incor-
poration in the empire. Exposition scenes of talented Dahomean artisans,

disciplined guards, and men learning French supported the theme of progress the colonial officials stressed. By using opposing images of a "dark" and "savage" African-ruled Dahomey and a productive and civilized French Dahomey, officials buttressed their case for developing colonial rule.[34]

Senegal. The Senegalese exhibit was housed in a striking pavilion 917 square meters large that was accompanied by a miniature West African village with soldiers and artisans. After being "inspired by documents brought from Djenné and Timbuktu," the resident architect of the colonial exposition designed this structure with an Islamic motif representative of regional mosques.[35] A straw-covered wooden hut stood on each side of the pavilion. Here Senegalese artisans, filigree jewelers, leather workers, woodcarvers, and a cloth weaver demonstrated their skill. The pavilion housed over 200 exhibits that stressed the main Senegalese exports of peanuts, gum, and rubber.

The French local committees of Senegal sent only a small contingent of Africans to Paris in 1900. This is perhaps because the French public was already familiar with Senegal, the oldest of the sub-Saharan African colonies. Charles-Roux presented the Senegalese as an example of the promising effects of the civilizing mission.

> These blacks are tall, agile, well built; frequent and long-term contact with the Europeans has removed every type of savagery from them. And while they are still completely Muslims, a bit too fond of fetishes, they understand our civilization well and willingly seek to assimilate.[36]

The all-male group sent to the exposition was composed of nineteen Wolof and three Bambara. Among them were two *cora*[37] players who were important participants in colonial processions and celebrations. At the first fête, held on July 4, the *cora* players strummed tunes while their compatriots carried a series of lanterns. Charles-Roux recounts how the rest of the Senegalese group "promenaded majestically" in their "long white *boubous*." The organizers of the colonial exposition did not attribute to this group the "uncivilized" or "savage" qualities it saw in other Africans.

The Alliance française and Berlitz language programs exhibited the Senegalese group in their pavilion classrooms, as they did the Malagasy and the Dahomeans. Berlitz's instructor Collonge reported at the end of the exposition that the Senegalese attended classes every day and made good progress. They were able to communicate in French for their "petites affaires," and several became fluent. Collonge was convinced that the Senegalese would "carry back to their country the taste for the French language which they all enjoyed speaking." Nevertheless, he noted that "they have enormous difficulty conjugating, and those who knew a few words couldn't keep from addressing us in the familiar 'tu' form," a certain insult to the instructors.[38] The students may have continued in this error precisely to irritate their teachers, since such repeated linguistic faults did not result in punishment at the

exposition where they might have in an African setting. Despite these problems, Africans were learning the French language. This was an essential victory for colonial enthusiasts who believed that "the native who speaks French is won over to France."[39]

In many ways, the Senegalese group at the exposition served as the "model" African population; it was successfully transformed because of extended contact with French civilization. Yet no colonial official ever suggested that the Senegalese were close to being "civilized" or that their complete assimilation of French social traits was a tenable goal. Exposition exhibits and displays maintained the underlying premise of African racial inferiority while emphasizing the idea of progress toward the French definition of civilization. Officials had to show the exotic musicians, dancers, and village dwellers next to assimilating groups to prove that the civilizing mission was successful. In the context of the 1900 Exposition universelle, the showcase of modern European progress, the French used the colonial exhibits to express confidence in their own "race" and in "La Plus Grande France."

[handwritten margin note: Senegalese as closest to being civilized (most contact w/ Fr)]

Ethnographic Descriptions

In their general effort to educate the public and convince it of the necessity of the civilizing mission, French officials supplemented the colorful visual exposition of colonized peoples at the 1900 exposition with a series of informative texts. The commission charged with the preparation of the Colonial Ministry's exhibit and the colonial administrations overseas offered a number of publications that addressed, among other topics, the ethnographic composition of their territories. These texts and notes (*notices*) provided a detailed picture of the physical and moral characteristics of the populations in the sub-Saharan African colonies. The authors' accounts reveal the views of French officials about their indigenous subjects, views they hoped to pass on to the general public. A series of eighteen illustrated volumes, published by the commission in charge of organizing the Colonial Ministry's participation at the fair, sold for 15 francs. Individual texts were sold in the various pavilions. Six publications within the Colonial Ministry series discussed the sub-Saharan African colonies. The *notices* may have been the most influential source of information available about the territories that did not send Africans to Paris. Administrators serving in Africa and Paris-based exposition commissioners wrote or edited most of the texts, but some were written by French academics.

The various writers painted a mixed but largely negative picture of the African groups they described. Their comments fell into three general categories: 1) ethnic/racial groups and phenotypic descriptions; 2) the livelihoods they pursued and their potential as a labor force; and 3) temperament, intelligence, and morality. Quite often, the descriptive categories were intertwined and "races" were categorically condemned. For example, groups

that were opposed to French rule were portrayed as morally degenerate, useless as laborers, and even physically unattractive. With vivid language, the ethnographic descriptions published for the 1900 Exposition universelle defined sub-Saharan Africans, outlined their usefulness as workers, and reaffirmed French moral superiority.

Races and Phenotypes. The authors of the ethnographic *notices* described each significant ethnic group in France's African colonies with varying degrees of detail. A typical publication is *Notice sur la Guinée Française,* prepared by Lucien-Marie Famechon, the chief of the customs office at Conakry. His text contained a short ethnographic section on the colony, including physical descriptions of the Guinean populations and commentary on their intelligence level and character. For example, Famechon described the complexion, facial characteristics, physical build, and languages of the Mandingo and Baga peoples. After discussing the nose, cheeks, jaw, and teeth of the Mandingo, Famechon pointed out that "in spite of these characteristics, the type isn't disagreeable, and the individuals are gentle, docile and intelligent." Famechon called the Baga "robust men, stocky, with an almost flat face, wide nose, thick lips—in a word, possessing all the characteristics one attributes to the Negro race." He also pointed out that "the characteristic sign of the Bagas is extraordinarily small ears located near the top of the head."[40] Famechon's detailed description of the Guineans shows that he considered the physical appearance of the peoples in his jurisdiction unusual (in comparison to Europeans) and worthy of mention. At least for the Mandingo and Baga, he gave the impression that "race" did not necessarily determine character or intellectual ability. However, the fact that Famechon emphasized physical traits more than any other aspect of Guinean identity communicated the idea that phenotype was a crucial dividing trait among humans.

Dahomey et Dépendances, written by Jules-Louis Brunet, the delegate to the exposition from the colonial government in Dahomey, included a section that described and linked the "physical and moral characteristics" of the people. Brunet divided the population into "three distinct types"—Mina, Dahomeans, and Nago. He called Mina beautiful—"[their] open physiognomy expresses intelligence and goodness." Gentle and faithful, Mina were also perceived as more sly and argumentative than other blacks. Brunet attacked the Dahomean "type" and linked their physical traits with moral values. "Morally, he's the worst of the Guinean Negroes," he claimed. "His stupid and hypocritical physiognomy is hardly friendly; he is a liar, a thief, a fake, lazy and puffed up with pride for his race and his country." Brunet reserved the kindest words for Nago. Compared to Dahomeans, their "more open physiognomy is less disagreeable. The Nago is good, kind, conscientious, sincere, and very obliging." Not surprisingly, Brunet felt that "it's with him that we have the easiest and most reliable relationship."[41] These comments illustrate how French officials emphasized pleasant character traits in

the peoples with whom they had the least conflict. Enemy races were generally viewed as unattractive and corrupt.

Labor Potential. A second concern administrators addressed in their ethnographic descriptions was the livelihood of African peoples and how they might be employed to serve the French. In the publication on French Guinea, Famechon stated that in spite of "several moral deficiencies," Guineans had served well as soldiers, subordinate employees, and artisans.[42] The author of a second exposition publication on Dahomey had a positive outlook about the use of Dahomean labor. Jean Fonssagrives claimed in one chapter that "it is easy to recruit from the mild and submissive Dahomean population the number of workers needed even for important long-term enterprises." He anticipated no problem in finding the more than 2,000 men needed to prepare the embankments of the Dahomean railway. Then, for readers who might be potential investors in the colony, Fonssagrives explained the usual salary ranges for typical manual labor and construction workers. French employers could hire Dahomeans for two-thirds the cost of European labor. Better yet, they could employ Krumen, Africans from the coast of Kru who worked as contract laborers for a one-year period at a minimal cost of 1.30 francs per day, food included.[43] In his comments, Fonssagrives hoped to convince readers that despite its turbulent past, Dahomey had great economic potential and an available labor pool.

Notice sur le Congo français, edited by Marcel Guillemot, highlighted some of the prominent skills and occupations of the native populations. The author described seven main Congolese ethnic groups. Guillemot called the Pahouin a "violent" and "belligerent" people whose only industry was blacksmithing. He described several of the Chaké peoples as "excellent canoers" and recognized one group, the Adouma, for their skill as cloth weavers. The text portrayed the Bateke as mainly agricultural people who, like their neighbors, "practice cannibalism during times of war." But, according to the authors, they had positive qualities as well. They were traders, "hire themselves out as porters, and are excellent servants to French authority." Finally, the *notice* described the Loango. While seen as prideful and haughty, the Loango were recognized as sailors, porters, and talented cooks and tailors.[44] The authors described all but one of the peoples of the Congo as capable of providing the labor required for the development of the French colony. The "savage" nature of some of the inhabitants notwithstanding, the administrators responsible for the *Notice sur le Congo français* emphasized the untapped potential for new African workers for France.

Character, Intelligence, and Morality. Although most ethnographic descriptions began with sketches of African racial "types" and categories, the greatest concern of the authors seems to have been about defining differences in group character and morality. No matter how positively an author might describe a characteristic of an African race, he never compared the Africans to the colonizers. Conversely, French officials harshly condemned Africans

for moral or character weaknesses that were also present in French society. In the exposition texts, French hypocrisy looms large.

One vivid example of this hypocrisy appears in the *notice* on French Guinea. The customs official who wrote the text labeled Fulani women and their husbands as "extremely lazy." He explained that the husband "non-chalantly watches over the crops cultivated by his slaves but does not work himself." The writer was unable to recognize the double standard the French applied to colonial societies. An African landholder whose slaves worked the fields was "lazy," while a French landholder whose laborers (or slaves) worked the fields for him was considered to be a respectable planter.[45]

The publication on Senegal also judged Africans harshly. *Une Mission au Sénégal*, written by government physician Alexandre-Bernard Lasnet and three other academics, contains a detailed ethnographic description of twelve populations. The presentation focused on the religious temperament of the groups, their work habits, their morals, their conflicts with neighboring groups, and their reaction to white influences.

Lasnet and his colleagues began by describing the morals and customs of Moors. In rather strong language, they depicted Moors as Islamic zealots who had "little sympathy for whites" (or blacks) and were beggars, thieves, and sluggards. The writers said that Moors were particularly cruel in times of warfare, given to murdering and mutilating their prisoners.[46] A rival group, the Tukulor (Toucouleur), fared no better in the eyes of the French authors: "More intelligent than the other blacks, their superiority makes them arrogant and insolent." The Tukulor were also described as fanatic Muslims who lacked enlightenment, advocates of holy wars against the infidel. In the eyes of Lasnet and colleagues, the character strengths of this group only served ignoble purposes:

> Very energetic and enterprising, the Tukulors subject themselves to all hardships to achieve their ends; scruples do not overburden them—they are great liars, conceal perfectly, and are capable of every misdeed to gain fortune and power.[47]

As this passage suggests, characteristics that were viewed in a positive light in the west—enterprise and financial gain—were interpreted as a reflection of greed inherent in Africans. In making a subjective assessment of Africans that avoided comparisons with "whites," the French maintained their posture of moral superiority over colonial peoples. The authors downplayed positive or moderate traits observed in Africans and emphasized excessive behavior. Weaknesses that appeared in both Africa and Europe were presented as signs of "evil" in the African context. For example, African drunkenness, theft, pillaging, and lying were pinpointed and condemned. The French strongly criticized the lack of openness of certain ethnic groups to outsiders, especially where Europeans were concerned.

The authors' depiction of the Wolof contrasted strikingly with their por-

trayal of the Moors and Tukulor. Although the Wolof had their character flaws, the writer believed that these worked to the advantage of the French:

> The Wolofs are mild-mannered, used to Europeans for centuries, and completely without the fanaticism that distances us from the Moors and often the Tukulors. They are big children who only live for pleasure and ostentation, incapable of thinking of tomorrow; they expose themselves to misery or famine in order to stand out with a rich *boubou* or a handsome get-up, spending all their money to acquire a pretty wife. Very arrogant, there is no work they will not joyfully accomplish when you appeal to their pride—they cannot resist the most superficial praises and let themselves be stripped clean by those who flatter them.[48]

The passage cited the lack of commitment of Wolof to Islam and their openness to any type of religious practice or celebration they found attractive. It described their love for amusement, dance, and the attention of others. In *Une Mission au Sénégal,* Lasnet and his colleagues ridiculed the Wolof as a childlike, pliable, and controllable race—available and faithful workers who posed no threat to the French. They presented them as perfect subjects, amenable for adoption into the French colonial family.

The *Notice sur le Congo* presented the moral qualities of the territory's major ethnic groups. In the "Populations indigènes" section, the authors referred to the explorer Savorgnan de Brazza's classification of the Congolese into people of the bush and people of the forest. The authors described the people of the forest as "in general belligerent, savage, mistrustful, cruel, difficult to tame and bend." On the other hand, "the bush people are a little spineless (*mou*) but more diligent and less bloodthirsty." The writers followed this blunt description with a section that highlighted some of the positive skills and occupations of the Congolese.[49]

Likewise, the local committee for the Madagascar exposition prepared a volume that addressed the character of the Malagasy. Of the ten principle ethnicities, the authors described the Hova (Merina) as the most intelligent and civilized of the Malagasy peoples and the Sakalava as the most degenerate. In between these two extremes are the Betsileo, Betsimisaraka, Antaimoro, Antanosy, Sihanaka, Bezanozano, Tanala, and Bara. The authors depicted the Betsiléo as "docile and indolent and therefore easy to govern. They rarely develop their intellectuals faculties." They criticized the lack of "marriage" in Betsiléoan society and explained that couples lived in a state of concubinage and "never pride themselves in faithfulness." The *notice* depicted the Betsimisaraka as "gentle, fearful and naïve" animists known for their drunkenness and debauchery. Other groups were criticized for their laziness or lack of submission.[50]

For the description of the Sakalava, the *notice* relied on the findings of Monsieur Gautier, the director of instruction in Madagascar, who spent two years among the people:

> As far as civilization goes, they have only borrowed the gun and rhum; they are bellicose without courage and plunderers by nature. Mixed with renegade Hova, they have provided the bands of *fahavalos* that the French authorities are having difficulty eradicating.
>
> They are incapable of improvement and hold firmly to the customs of their ancestors.[51]

If little hope existed for the rebel Sakalave to become civilized, the opposite could be said of the Hova. First of all, they were the dominant power in Madagascar before the French takeover and the only non-Negroid group. The most frequently mentioned Hova quality was intelligence. Not only were the Hova viewed as more intelligent than the other Malagasy people, they "had been taken by a great desire to copy our [European] institutions."[52] The ethnographic section of the Madagascar text concluded that they were the only Malagasy people open to French civilization. It claimed, "In summary, with the exception of the Hova, for whom multiple aptitudes fortunately make up for no fewer various vices, the Malagasy population is generally opposed to civilization with an apathy that we will only get the better of with time."[53] The authors of the Madagascar *notice* assigned intelligence and positive traits to cooperative and assimilating groups and labeled groups that were less open to French rule and the civilizing mission as stubborn, lazy, and backward. This pattern appears in all the ethnographic and character descriptions of sub-Saharan Africans by the French.

Finally, in the Brunet text on Dahomey, we find a comprehensive assessment of the character of "the Negro." As always, the solution for saving him from his savage ways was further contact with French civilization:

> The dominant defect of the Negro is curiosity; he is very observant and follows the white in every detail of his conduct.
>
> Drunkenness is his favorite passion.
>
> The Negro's intelligence is very developed, and it is even more advanced than the White's; it would develop more rapidly if puberty did not stop the blossoming of the Black's mental faculties.
>
> He understands and reasons very well; what he is missing is the will, the energy, the continuation in ideas that the European possesses.
>
> As Abbot Bouche said, the Black has *more intuition* and *less reflection.* When it comes to his will, there is more spontaneity than steadfastness. Energy is lacking in the Negro if he has to maintain it, and if he has some at first it immediately disappears.
>
> Because of their intelligence, we can hope that through contact with our civilization—and after having acquired a bit of instruction—that the natives will quickly lose the bad instincts that are inherent in their savage character.[54]

The opinions and observations about sub-Saharan Africans expressed in the colonial *notices* reinforced the general image of blacks on the continent as savage and backward yet moldable into workers who would serve their

French masters adequately. The publications asserted that French conquest and colonization of Africa was necessary, orderly, and effective and that as colonizers they had acquired an intimate knowledge and understanding of the populations who were under their charge. The propaganda was far from the reality. Ethnographic descriptions prepared for the colonial exposition gave a slanted French version of African customs. Colonial administrators, who had varying degrees of contact with African populations, spoke as experts on "*la race noire*" or recycled the accounts of one or two explorers as the unbiased truth. The texts affirm the dual perspective of Africa that William H. Schneider found in the French popular press of the same period.[55] To justify the colonial system, the authors reinforced the image of African savagery and moral decadence on the one hand and economic potential on the other. Each perspective supported the argument for continued French intervention. Through long-term contact with their French tutors, Africans were expected gradually to reach a material form of civilization but never "Civilization" itself.

The portrayal of black Africans at the Paris 1900 exposition and of blacks in trademark images registered from 1886 to 1913 demonstrates an official and commercial view of the "uncivilized type"—a colonial Other. During this period, the French used scientific taxonomy to emphasize the physical and moral "differences" between blacks and whites. French colonial officials and business-owners presented blacks as a race that had qualities that were the opposite of their own. They condemned ignoble "black" qualities such as laziness and portrayed "white" qualities such as commitment as positive attributes. Although the authors of some ethnographic descriptions assigned favorable traits to African groups, they never drew parallels between black character strengths and white ones. And they never pointed out that white weaknesses were the same as the black ones they portrayed.

The French recognized and defined differences among African ethnic groups. The goal of the defining process, however, was primarily to classify enemies and allies in the political, cultural, and economic conquest of Africa. In trademark illustrations, the "Manichean allegory" functioned in a similar way. Labels for soap and cleaning products demonstrate the associations of whites with cleanliness and goodness and blacks with filth and evil. Paradoxically, blacks and Africans also represented the potency and positive traits of some dark-colored products. Yet even these portrayals ultimately focused on the subordinate roles of blacks as laborers, servants, and exotic Others. The representation of "*le noir*" in the 1900 Exposition universelle's colonial section mirrored the idea of black subordination to whites found in French product trademarks before World War I.

3
North Africans:
Mysterious Peoples

The territories in North Africa had a special place in the empire be-
cause of a number of factors that included the proximity of the Maghreb
to France's southern shores, a history of settlement by French emigrants in
Algeria, and lengthy commercial ties. Before World War I, French exposi-
tion organizers and entrepreneurs presented the Arab, Berber, and Moor-
ish populations of North Africa as mysterious peoples with customs consid-
erably different from their own. At the same time, supporters of colonialism
wanted to instill in the minds of the public the idea that Algeria was be-
coming an integral part of metropolitan France.

In their definitions of Arab and Berber peoples, the French had to look
beyond the phenotypic definition of "race," since both were "white" in the fa-
miliar classification systems of the day. These systems ranked peoples within
each broad racial group. Arthur de Gobineau placed Europeans at the apex
of all white races based on their beauty and their ability to produce "civi-
lization." Racial mixing, he believed, created weakened types, and efforts
to civilize these non-European groups produced mixed results.[1] He argued
that Semitic Arabs constituted a less-developed white group. Dr. Gustave
Le Bon, writing in *Les Lois psychologiques de l'evolution des peoples* (1894),
agreed with this assessment of Arab capabilities based on his study of their
psychology and lower level of "civilization." He ranked Arabs, Chinese, and

other Asians as *moyenne* (average), just behind the *supérieur* Indo-Europeans and ahead of *inferieur* Africans and *primitive* groups. This popular conception of the relatively positive racial standing of North Africans helped the French accept the inclusion of the Maghreb in the political *métropole*.[2] Yet the French linked an inferior ranking of this group vis-à-vis Europeans to what they viewed as unusual traits of Islamic culture.

The exhibits at the government-sponsored Algerian section of the 1900 Exposition universelle stressed the economic development and modernization of the colony. When they defined the section's appearance, however, the organizers relied on traditional symbols of an exotic and mysterious North Africa that remained outside the reach of French influence. Product trademarks registered during this period reflected these portrayals, presenting North Africans as members of a vast Oriental Muslim culture, as residents of a land of abundance, and as Muslim zealots and Maghrebian warriors.[3] French representations of North Africans during this period show the interplay between the image of a prosperous modernizing French Maghreb and an exotic traditional Islamic society. This chapter focuses on the relationship between these two themes in trademark illustrations, especially in exposition propaganda, and what the themes reveal about France's identity as an imperialist nation.

Trademark Images, 1886–1913

French designers used stereotypical Oriental scenes as the backdrop for many product labels. Turbaned men seated in Moorish courtyards smoked from long Turkish water pipes, alluring women lounged in palace salons, and Arabs on camelback led caravans across endless deserts. Images of the Orient and Arab North Africa meshed, making it impossible to pinpoint the specific location of each scene from the collection of trademarks in this category. The individuals, dwellings, and decor portrayed in these labels describe an exotic Oriental world utterly unlike that of continental Europe. Merchants also depicted North Africans as producers of a range of agricultural products common to their region. Business-owners also emphasized Islam to characterize the North Africans depicted on their product labels. Muslim religious figures, devotees, political leaders, and warriors appeared on numerous trademarks.

North Africa and the Exotic Orient

During the period 1886 to 1913, entrepreneurs displayed North Africans or Orientals on trademark labels for various products, presumably relying on exotic presentations of these cultures to distinguish their label from the hundreds that entered the market each year. The use of these images appar-

ently served two commercial purposes: to attract the French consumer by allusions to mysterious and distant cultures and to expand an Arabic-speaking market by offering products with familiar Arab images. The Marseillais soap industry, for instance, appealed to an Arab North African market with a variety of soap bars stamped with Arabic captions. However, most products with registered trademarks that included North African images were ultimately destined for a French or European market.

An exotic view of North African populations dominated the trademarks registered during this period. One example of this was a scene in the Witz et Colas soap label Savon des Princes Marocains (Paris, 1902). In the center of the label drawing, a European woman lay on a hammock strung between palm trees along a lake. Two stately Moroccan princes, followed by their servant holding an umbrella, approached the woman. One of the men gestured toward her, as if to say to his friend, "Here she is." In his Café des Caïds trademark label (Paris, 1906), Gaston Manzoni pictured a Caïd sitting on a stool and smoking from a hookah. The Société Anonyme des Rôtisseries de Café in Marseilles registered a trademark in 1907 for Chocolat de la Mauresque that showed a coquette woman with dark hair and dark eyes holding a fan in one hand and a chocolate bar in the other. Several soap and perfume companies used similar images of beautiful mysterious North African women. A few examples are La Mauresque (Marseilles, 1886), Savon Aïcha (Marseilles, 1902), Fatiha (1904), La Belle Algérienne (Marseilles, 1905), and Fatma (Marseilles, 1912). In all these trademarks, the women were completely veiled with only their eyes exposed, as required by conservative Islamic tradition. For westerners, the veil on these labels symbolized one of the distinct aspects of Near Eastern culture and the Islamic faith—the sequestering of women.[4] Other images such as the crescent moon, the turban, and the fez hat linked products with the Ottoman Empire or exotic Muslim dignitaries. These objects were recognizable symbols of western stereotypes of the Near East and Orientalism.

French companies frequently included drawings of camels, desert caravans, and oases on their trademarks to create an exotic image of the Arab nomad of the Sahara desert. These desert image trademarks often did not correspond to the products they represented. Consider, for instance, the Au Chameau label for "silks, fancy fabrics and wools of all kinds" (Paris, 1888). The company Vaquez-Fessart et fils, owner of the trademark, designated their fabrics with a drawing of a desert terrain featuring a turbaned man on camelback. The Société des Matières Colorantes et Produits chimiques de Saint Denis put a label with an Arab on horseback riding across the desert on the chemical products they marketed (1911). Other trademark labels with desert scenes were used to market native North African products. The label for Dattes Muscades (Marseilles, 1901) included typical desert symbols—a camel, people in long white *burnous*,[5] a date palm tree, and a cactus—that realistically connected the product and the illustration.

Merchants who sold coffee and coffee substitutes used a range of exotic North African symbols on their trademarks. Since the period of Turkish rule in the region, coffee-drinking had been associated with Oriental or Arab culture. Twenty-one coffee trademark labels in this survey contained images of North African people. Imported coffee made up the third highest number of trademarks after the categories of grains and fruit (particularly dates) grown in the Maghreb.

A number of merchants incorporated the titles of Muslim or North African leaders into their coffee labels. These trademarks included Café du Khalifat (Paris, 1903), Café des Caïds (Paris, 1906), Café le Caïd (Paris, 1909), and Mélange du Kroumir (Marseilles, 1911). Two businessmen chose classic *têtes d'Arabes* (Arab heads or busts) for their Le Touareg (Paris, 1905) and Café Marocain labels (Marseilles, 1906). Gaston Edé's Touareg was a mysterious-looking man wearing a turban and a scarf that covered his nose and mouth. Justinien Fontenille's bearded Marocain wore a cape and the characteristic turban. Another interesting coffee trademark was Gouret and Allouche's Au Colon Africain (Paris, 1904). Their label stood out because it was the only registered trademark in this period that pictured North Africans alongside a European colonist—a more common composition for trademarks with blacks. When blacks or sub-Saharan Africans appeared with colonists, however, designers portrayed them as servants or plantation workers. In this label, the European colonist stood in the center and the North African man and woman stood on either side of him, each one holding up a cup of coffee. The scene evokes a partnership between the colonizer and the colonized rather than a relationship of authority and submission. Gouret and Allouche's label symbolized the privileged economic ties between France and its North African colonies and the political incorporation of Algeria into the French system.[6]

Peoples and Products of North Africa

A second category of trademarks emphasized the agricultural abundance of North Africa. The Mediterranean coast of North Africa flourished in the production of fruits and grains, and French merchants who sold these products frequently used images of people from the region on their trademark labels. Trademarks for grain products such as wheat flour and semolina made up more than half of the 130 labels for regional products, followed by dates, wines, and liquors. Some of the trademark designs registered in Paris and Marseilles before World War I depicted people with bags, crates, or bottles of the product, while others used drawings of North African busts or heads as emblems.

French merchants, most often based in the Marseilles region, used drawings of North Africans on trademark labels for the grains that they sold. An image of an Arab, Tuareg, or Moor on a trademark for a grain-based prod-

uct highlighted its regional origin. All but four of the more than seventy trademarks for flours and semolina registered in Paris and Marseilles during this period were submitted by milling companies based in Marseilles, and Provençal companies played a major role in the flour and semolina market in France. These businesses often chose a drawing of a turbaned head, a *tête d'Arabe*, or of men with historical significance or exotic Arabic names. Valentin, a Marseillais miller, registered three trademarks for flours and semolina products in 1912 with depictions of North African men in traditional clothing. The men were labeled El Cherkessia, El Moufti, and Amir Farablous.[7] In 1888 and 1903, Joseph Maurel chose Tête d'Arabe to mark his bails of flour and semolina. Another Marseillais businessman, Coundouris, named his grains after the twelfth-century Egyptian sultan Saladin, who was victorious over Christian crusaders. The famous sultan was pictured wearing a black robe and black cap with a white turban around his forehead. Companies also represented their grain products with drawings of North African women. George Pascal Bottazzo's label for La Tunisienne showed a fully veiled woman seated on a carpet (1892), and Régis-Marius-Germain Remusat's La Bédouine label depicted a woman wearing a long dress and veil leaning against an enormous jar (1900).

Images of North Africans appeared on trademarks for a variety of other regional agricultural products. Dates and wine especially were often marketed in this fashion. Entrepreneurs registered twenty-seven different date trademarks in Paris and Marseilles from 1886 to 1913. Primarily, the designers of the trademark labels used two stock images. The first was a desert scene with signs of a small oasis village in the background. In the shadow of Moorish city walls, Arab men in long white robes stood near camels, donkeys, and palm trees. Small groups of men gathered to converse. Others led caravans or packed dates. No single individual was the center of attention on these labels. Two examples of this type of date trademark were Dattes Degla du Djerid Tunisien (Paris, 1902) and Louis Moutte's Dattes Muscades, Surchoix (Marseilles, 1912).

The second type of image on date labels used one or two North Africans as the focal point of the scene against a desert oasis in the background. One of the best examples of this motif was a version of Madame Louis Milan's Dattes Muscades labels that depicted a woman seated on a carpet with a goat at her side (Marseilles, 1900). In the same year, Antoine Ballüco marketed his brand of dates, La Biskarienne, with a drawing of an Arab wearing a cape and riding on a camel. Another trademark, registered by Joseph-Antoine Luxo (Marseilles, 1909), included a village scene on either side of the label and, in the center, a medallion with the drawing of a head of a veiled woman. In 1910, Salomon-Bouillet from Marseilles used a drawing of a young woman carrying a basket of dates on her head as one of his two date trademarks.

In this 28-year period, five individuals registered wine trademarks with North Africans on the label. Two of these trademarks depicted a vineyard scene; the others included stereotypical portrayals of North African nomads. French merchants Savignon and Company used a drawing of a vineyard in the background with a woman carrying a large basket of grapes on her head for Muscat de Bir-Kassaa, Tunis, Vin de Dessert (Paris, 1897). In Auguste Gésing's label for Grand Vin Mousseux, Coteaux du Sahel (Paris, 1890), a desert scene with palm trees, camels, and Moorish architecture was the background for a group of turbaned workers handling wine bottles and barrels. The other wine trademark labels registered in 1893, 1898, and 1906 showed, respectively, a nomad standing in the desert with a goat and a woman, an Arab on horseback with a rifle, and a man riding a camel.

Generally, trademark images that featured North Africans as representatives of products grown in their region were realistic. They reflected the plentiful production of grains, fruits, and wine in the Maghreb. They also illustrated the importance of France's influence in the region, an influence supporters of colonialism hoped to extend as they called for increased commercial and industrial development in Algeria and Tunisia.

Muslim Zealots and North African Warriors

French businesses typically presented North Africans on trademark labels as devout Muslims or Saharan warriors. Although these were more defined roles, the basic dress or appearance of these individuals differed little from other depictions of North Africans or Orientals in the trademark survey. A few entrepreneurs named trademarks after notable Muslims, including Sultan Saladin and the prophet Muhammad's relative Abbas, to sell many types of products.[8] Designers included pious Muslims and warriors on labels for fabrics, soap, flour, semolina, and coffee.

Muslim religious figures in the trademark labels were easily identifiable from the name of the product—often a religious title or the name of a Muslim order. Four trademarks from 1886 to 1913 referred to the Islamic *marabout,* or ascetic: Léon Arnaud's Le Marabout label for semolina, rice, and flour (Marseilles, 1896); Joseph Tardivi's soap label of the same name (Marseilles, 1898); Les Deux Marabouts soaps by F. Cordeil and Company (Marseilles, 1904); and Le Marabout brand of coffee and liquor registered by Maximilien Mériaux (Paris, 1909). Several other trademarks depicted representatives of special religious groups. A Marseillais business owned by Maurin and Bontoux selected Le Senoussi, a Muslim brotherhood, as its grains trademark (1913). The Senoussi pictured on the trademark label was dressed in a white hooded robe and had a sad expression on his face. To market their flour and grain, Mallen Théric and Company chose Le Derviche trademark (Paris, 1910). Although dervishes are commonly known for their

mystical dances, this company's dervish was not dancing; instead, he rode a camel and carried a backpack full of arrows. Two French trademarks depicted ordinary practicing Muslims rather than members of distinct orders. René Marquézy registered Feka as the name of his special food product (Paris, 1902). His label showed a desert scene with a traditionally dressed Arab kneeling in prayer, facing a rising sun. The word "Feka" appeared inside the sun, likely an altered reference to the holy city of Mecca. In 1910, the Charles-Roux family of Marseilles named their retail soap Savon des Fidèles. The drawing on their trademark included a bust of a bearded Muslim wearing a turban and had captions in French and Arabic.[9]

Also prominent was the portrayal of the fierce North African warrior. These labels depicted a military figure (often identified in the name of the trademark) or an individual brandishing a weapon or both. These images included Saharan rulers and fighters, individual Muslim warriors, or units recruited to serve in the French army.

Sheiks, Kroumirs, and caliphs were among the Muslim warrior "types" shown in trademarks around the turn of the twentieth century. These figures were popular among Marseillais businessmen who sold soap, flour, and semolina. Joseph Rougier registered his Le Kalife soap trademark in 1892. His label bore a caption in both French and Arabic and pictured a man with a sword dangling from his wrist. In 1903 and in 1910, André Allatini's soap company used Le Cheik as its trademark. Allatini's *cheik*, who stood next to his horse, wore a turban, vest, and harem pants and held a gun. The Kroumirs, a Tunisian ethnic group that was known for raiding and pillaging, were used as a trademark symbol for a number of products. A Kroumir image was used on soap trademarks in 1896 and 1909, on a flour trademark in 1910, on a bleach trademark in 1908, and on a coffee trademark in 1911. On the flour trademark, which was registered in 1910 by the Delphin Brothers of Marseilles, a Kroumir was pictured barefoot holding a rifle at his side. Other warrior trademarks were untitled or contained names and descriptions in Arabic, indicating that some companies targeted an Arabic-speaking population outside metropolitan France.

The most renowned Muslim warrior depicted in French trademarks was the nineteenth-century Algerian resistance fighter Abd el Kader. His likeness appeared on three trademarks during this period. In 1899, L. Félix Fournier and Company of Marseilles named their candle Bougie du Sidi Abd el Kader. Chambon Brothers and Company of Marseilles registered a trademark with a drawing of Abd-el-Kader as the symbol for their flour business in 1906. The Agence Française Maurice-Maxime Labin, which was headquartered in Vienna, used a photograph of the warrior for the cover of their Papier Kader cigarette papers. All three of these label designs presented the leader of Arab forces against the French in the 1830s and 1840s—who later reconciled with the authorities—as a distinguished figure.[10] Abd el Kader's

image appealed to French and Arab consumers respectively as a symbol of triumph over African resistance or as a Maghrebian hero.

Merchants used the three portrayals of North Africans and Orientals in French trademarks from 1886 to 1913 to appeal to consumers fascinated by nonwestern cultures. In most of these images, French entrepreneurs referred to existing European stereotypes about Arabs and North Africans that depicted them as mysterious and often hostile. These views emanated from older visions of Orientals from literature about the Crusades and the *Book of One Thousand and One Nights*. Trademark illustrations for some regional products, however, gave a neutral or positive view of North Africans and the vast Maghrebian agricultural resources. The commercial vision of a North Africa of abundance coexisted with the symbolic image of an Islamic Maghreb at odds with the west in the French trademarks registered before World War I. The same underlying tension was evident in the representations of North Africans at the 1900 Exposition universelle.

Portrayals at the Exposition universelle de Paris in 1900

The Algerian and Tunisian expositions captured much of the spotlight at the French colonial section of the 1900 Exposition universelle de Paris. Located on the bank of the Seine just across from the Eiffel Tower at Pont d'Iéna, the Algerian exhibition palace stood at the entrance to the Trocadéro grounds and marked the focal point of the section. A group of concessionaires ran the Algerian attractions, a showcase of exotic shops, entertainment, and food that was adjacent to the palace. The government of Tunisia, which had been a protectorate of France for seventeen years, sent more than 100 of its residents to participate in the exposition. It housed its exhibit in a large Tunisian-style palace that measured close to 1,200 square meters. Organizers gave Algerian and Tunisian military units important positions in parades and processions. The organization and funding of the Algerian and Tunisian expositions demonstrated the strong political and economic bonds that linked this region to the French Republic. But the division of the Algerian and Tunisian sections into government exhibit areas and commercial attractions exposed incoherencies in the projection of an official image of France's North African territories. Exposition officials wavered between contrasting portrayals of a modernizing exploitable French North Africa and a mysterious impenetrable Oriental world.

Organization of the North African Exposition

The organization of the Algerian exposition resembled that of other French metropolitan departments participating in the world's fair. Algeria was an

overseas territory of France composed of three departments—Oran, Constantine, and Algiers. A committee of individuals selected by the commissioner general and approved by the minister of commerce, industry, posts, and telegraphs represented each of the departments. In Algeria, the honorary presidency of the departmental committees went to both the prefect and the military commander of the department. A decree from the minister of commerce in 1897 created a central committee to organize the Algerian section under the direction of the governor general of the territory. The presidents of the departmental committees, who were elected by committee members, reported to the central committee that met in Algiers. This committee, in turn, selected a delegate to represent them before the commissioner general of the exposition in Paris. All elected deputies and senators from Algeria had the right to belong to their departmental committees and to the subcommittee located in the capital city of their department. Within this framework, all the major administrative and military powers in the colony had the opportunity to participate in the planning of the exposition.[11] Additionally, the Franco-Algerian business community demonstrated its support for the exposition with the participation of members of the chambers of commerce and by submitting thousands of samples of colonial products for exhibit and competition.

Local and departmental committees responded to the occasion by allotting nearly 200,000 francs from their budgets to the Algerian exposition. The French Parliament voted a sum of 400,000 francs to assure that Algeria would make a brilliant showing in Paris, and the colony received 50,000 francs from the Ministry of Public Instruction and Fine Arts to undertake a reconstruction of the ancient Roman city of Timgad.[12] No other colony received this level of financial support from the republic's coffers. In the eyes of government officials, Algeria was the crown jewel of France's overseas territories, even if recent conquests in Africa or Indochina were drawing attention away from this rapidly developing colony.

The massive Algerian palace symbolized the preeminent political and economic position of the colony. Located at the entrance to the Trocadéro, it welcomed the public to the miniature colonial empire created for the exposition. The French architect who designed the palace imitated the Moorish style of mosques and buildings in North Africa, incorporating domes, patios, and Islamic minarets into the structure. Inside, there were paintings, Algerian tiles, drawings of historical monuments, and other artistic decor. The main agricultural and industrial exhibits completed the government's display of the colony's treasures. Some of the samples exhibited included wheat, grapes, wines and wine production methods, tobacco, olives, mining industries (iron, zinc, copper, etc.), ceramics, and tapestries. Algeria presented the largest exposition of colonial products with 1,955 different exhibitors represented.[13]

The organization of the Tunisian section at the 1900 Exposition uni-

verselle was unique because, due to its status as a protectorate of France, the French encouraged the participation of officials from the reigning government. Diplomats and officials from the French Ministry of Foreign Affairs worked in collaboration with the bey of Tunis and his staff to prepare the exposition. The French included Tunisian dignitaries in planning committees, and these men provided inspiration for some aspects of the section at Trocadéro. Nevertheless, French administrators in Tunis and Paris made all the decisions concerning the exposition's final composition. The beylical government's greatest contribution to the exposition was by far financial. It paid for the artisans and soldiers sent to Paris and for the preliminary purchases and work that was completed in the protectorate. The French administration in Tunisia added 591,000 francs toward the exposition; the Colonial Ministry contributed no financial support for the Tunisian section.[14]

The focal point of the Tunisian section was a beautiful Moorish palace with adjacent traditional *souks*. In keeping with the architectural patterns of the 1889 world's fair, the designer of the Tunisian palace for the 1900 exposition, Roger Saladin, modeled the structure after several mosques in his homeland. The palace featured a crescent design on the ceiling, a series of vaults, a large main exposition room, and smaller exhibit rooms off to the side. These rooms contained a variety of exhibits that focused on ancient artifacts (especially from Carthaginian ruins), artwork, and industrial and agricultural products. A central court from the palace led to the special *souk* area where Tunisian shopkeepers sold their wares and artisans practiced their crafts. *Spahis* and *chaouchs,* native cavalry forces and guards, maintained order in the section.[15]

Exhibits and Events in the Official Sections

Organizers of the Algerian and Tunisian expositions used the exotic image of the North African warrior and the Arab *souk* to attract visitors to Trocadéro. Parades that originated in the park and circled the Champs de Mars featured North African civilians, soldiers, and cavalry units. A unit of Algerian *spahis* riding Arabian horses led the colonial representatives in the first evening colonial celebration on July 4. Not far behind them marched a group of Tunisians carrying large standards, glass lanterns, and musical instruments. Several African and Indochinese groups were followed by one final group of Algerians holding crescent lanterns, accompanied by the music of *derbouka, bendaïr,* and *nouba.*[16] These parades were repeated regularly throughout the summer.

By all reports, the Tunisian marketplace, which was located next to the official palace, charmed many visitors. This part of the exposition received positive comments in the Parisian daily *Le Matin's* guidebook and from the colonial minister's delegate, Jules Charles-Roux. The Tunisian organizing

committee members responsible for the *souk* chose to include a wide variety of shops to depict the typical trades of Tunis. Among the thirty-seven types of professional tradesmen present were jewelers, basket weavers, woodcarvers, potters, and carpet makers. The section even included an Arab barbershop. Merchants sold North African sweets and spices and other delicacies. A restaurant, where traditional dishes such as couscous were served, and a Moorish café completed the ambiance. According to Charles-Roux, the *souks* that the French had carefully recreated were so authentic that the Tunisians could imagine they were back in their country. He called two of the vendors at the *souks* "the kings of the bazaars." Ahmed Djamal and Barbouchi "attracted visitors into their boutiques, where their employees hurried over, unfolded the fabrics, silks, and embroidery and spread out ancient carpets. The visitors accepted a cup of Moorish coffee and quickly became clients."[17]

In official publications on North Africa sold or distributed during the exposition, authors virtually ignored racial and cultural questions about the indigenous population. Instead, the committees that organized the Algerian and Tunisian expositions stressed the economic relationship between their region and France. Their writings almost exclusively addressed the development of infrastructure and agricultural and mineral resources in Algeria. For example, government offices prepared pamphlets on irrigation, tobacco farming, and viticulture. Of the six publications the Government General of Algeria prepared, four were brief *notices* about topics such as mining and ports, land ownership, and indigenous provident societies (*sociétés indigènes de prévoyance*). The absence of ethnographic descriptions suggests that the North African population was a secondary concern for colonial officials. Instead, officials reinforced the idea of Algeria's economic integration into the *métropole* with publications about the territory's developing infrastructure.

Exposition officials hoped to influence North African elites by organizing a series of five Arabic-language conferences during the fair. The conferences were titled "France's Relationships with the Muslim Nations," "France and Its Colonies," "France's Historical Relationship with the Peoples of the Orient," "Paris and Its Monuments," and "World's Fairs and Their Utility." Cheikh Abou-Naddara—a pseudonym for Jewish Egyptian writer James Sanua—organized the conferences, and officials in the Colonial Ministry, representatives from the Algerian and Tunisian sections, and Arab dignitaries chaired the sessions. Delegate Charles-Roux wrote that the conferences initiated the Algerians, Tunisians, Moroccans, and Egyptians who attended to the activities and goals of the world's fair. Some of the sessions included readings of Arab poetry for entertainment. These conferences gave the French organizers an opportunity to demonstrate their hospitality and strengthen bonds with North African elites, always within the framework of France's role as an imperial power.[18]

The Algerian Attractions Section

The exotic image of the North African thrived in the Algerian attractions segment organized by a group of French businessmen who saw a commercial opportunity in exposition entertainment. After receiving initial approval from the Algerian central committee in 1898, Chaudoreille, Palis, fils et Compagnie created a new limited liability company called the Société concessionnaire de la Section Algérienne (Attractions). Algeria's governor general and the commissioner general of the exposition gave the company the right to construct and operate a variety of paid attractions in the lot opposite the Algerian palace and to subcontract certain aspects of the section to other entrepreneurs. Ernest Pourtauborde, Augustin Chaudoreille, and Constant-Edouard Vaucheret were the main partners in the company. In the text of the company's statutes, the stockholders expressed their plans to operate the concession "by all means and procedures which in its view are in the greatest conformity with its goal and the most profitable to company interests" (intérêts sociaux). Over a dozen separate attractions were planned with the option to add others if desired. First on its list was a replica of an Arab street in Algiers that would include a bazaar with numerous indigenous artisans and vendors. The success of the Rue du Caire in 1889, the project of French investor and civil engineer Baron Delort, prompted the company to construct a similar area for the 1900 exposition.[19] Pourtauborde and his partners had huge plans. In addition to the bazaar, they hoped to include a native theater and circus, scenic films and photographs, Arab habitations, Isawiyas,[20] Negro dancers, a Moorish café, a Maghrebian restaurant, a French beer house and restaurant, and donkey and camel rides.[21] The company gained approval from the commissioner general's office for all of these projects except the French restaurant and the Negro dance performances, and it chose not to offer the animal rides.

Visitors to the Algerian Attractions section commented on the mysterious and colorful world they encountered in the shops and restaurants. The author of the Guide bleu du Figaro à l'Exposition de 1900 described the path the visitor followed along the Rue Arabe (or Rue de la Kasbah) in the Attractions section:

> Passing through the Bab-el-Oued gate, we arrive at the Kasbah road. The path mounts, winding, with its low houses, jutting top floors, grilled windows and doors, behind which the shadows of mysterious veiled women pass. . . . It is filled with bazaars where craftsmen work before the public, stages where belly dances, sword and Isawiya dances are performed, [and] with restaurants where Arab cuisine triumphs with falafel and couscous. And in this scene, in the middle of laughs, shouts and songs, are the comings and goings that create the most colorful, animated and lively tableau: gondouras and chabarahs, kaftans and fustanellas, burnous and turbans, sky-blue robes and tight-fitting Persian tuniques. . . . A pêle-mêle of clothing, races, faces and idioms.[22]

Le Matin's guide told readers of the "attraction and fantasy" of the area. They were assured that there was "nothing more curious, more authentically Arab" than the Rue d'Alger.[23]

To create this mysterious Arab world, the company subleased boutique, entertainment, and restaurant space to a number of businessmen and vendors. Most of these individuals came from Algeria. The original list of tenants included a cinematographer, two dance troupes, and shopkeepers who sold lace, embroidered items, and paintings on wood made on site by North African workers. In the company's proposal, food and drink concessionaires would offer Algerian wine, beer, liquor, and regional dishes. These tenant contracts varied in detail, some clearly specifying what was expected of the concessionaire but others leaving room for interpretation. The contract between the Société Concessionnaire and La Société de Vulgarisations et Attractions Algériennes en 1900, which was represented by Monsieur Seigle-Gouyon, listed multiple ways the company planned to present an exotic image of North Africa, including wrestling, "tortures," and female Kabyle performers.[24] The fact that it also envisioned West African elements—Negro performances and dervishes from Timbuktu—shows that the company was more interested in producing a popular exotic sideshow than it was in portraying representative Algerian attractions. Moreover, how each of the attractions should be executed remained open to numerous interpretations. What constituted a presentable "spectacle," "sensation," or "attraction" to Seigle-Gouyon and the concessionary company did not necessarily conform to the exposition administration's version of appropriate entertainment. Indeed, the operation of the entertainment concessions greatly concerned the commissioner general's office. Writing on behalf of his superior several weeks after the opening of the exposition, Grison, the director of finances, cautioned Monteil, who represented the Algerian central committee, about the nature of these concessions. His office would approve the contracts if the shows "keep a character of decency and good taste which certain of them have not had at the beginning [of the exposition]." Grison gave Monteil the responsibility of making this point clear to Pourtauborde and his partners.[25]

The commissioner general's office strove to ensure that the Algerian Attractions section presented an "authentic" view of the colony to visitors. In a letter to Monteil, the director of finances stressed that the concessionary company should offer the public "an interesting and exact reproduction of an Algerian quarter." Therefore, food and drink served in restaurants and cafés had to maintain an Algerian character. Trinkets and crafted items for sale had to be made on site by native artisans; items imported from Algeria that were on special display could be purchased by visitors but could not removed until the end of the exposition. The official regulation that required items to be made on site, "before the eyes of the public," most likely grew out of the scandal that arose when small items and souvenirs sold at the Egyp-

tian bazaar of the 1889 world's fair were found to have been manufactured in Paris.[26] Although these rules were stipulated in the exposition regulations and the agreements signed between the administration and the attractions company, the company and the entrepreneurs who rented shop space from it ignored the terms of the contract throughout much of the exposition.

The actions of the colonial vendors reveal a pattern of commercial interest that stubbornly asserted itself against the state apparatus. From the opening days of the exposition, the commissioner general's office struggled to eliminate unauthorized vendors and unauthorized practices among approved vendors and concessions at the Algeria Attractions section. On May 6, Commander Charles de Férussac submitted an extensive report to the commissioner general that listed eleven violations that he felt needed to be brought to the attention of Ernest Pourtauborde. Three concerned technical issues such as fire regulations and the remainder addressed shops and food and entertainment concessions. For instance, several authorized vendors were not crafting their products in the public's view; others were selling items that were made in front of the visitors but were not distinctly Algerian in character. A beer vendor had set up an illegal stand near the entrance to the Rue d'Alger. In another case, the company had allowed a tenant to hire an entertainment group without the approval of the administration. The group, called Sauvages d'Algérie, was really a troupe of "Basatos" from Basutoland, South Africa. De Férussac wanted their performances to stop immediately.[27]

Delegate Monteil sided with the company's interests on several points. He asked the commissioner general to be flexible in his interpretation of regulations that required items for sale by vendors to be made on site by native artisans: "In effect, it would be impossible for any industrialist to realize a profit in relation to the charges that he has to assume if he was limited to selling objects made in front of visitors." He asked the administration to bend the rules to allow it to "suffice to have one or several workers fabricating items before the public in order that the store owners could sell objects similar to the ones being made in this manner." The commissioner did not accept Monteil's request. As far as the food and drink concessions were concerned, however, he agreed to allow the operation of establishments that sold noncolonial items alongside North African fare.[28]

The administration was also concerned about the presentation of the attractions. Acting against regulations, vendors selling waffles and nougats set up business on sidewalks and common areas, hindering circulation on the narrow Rue d'Alger. One concessionaire, Madame Calvet, former owner of a canteen for Zouave troops in Algeria, blocked the sidewalk with tables and chairs and used a soiled canvas cloth as a tarpaulin. Commander de Férussac's greatest complaint about this concession, however, had to do with the fact that the waitresses who served wine for Madame Calvet were disguised as Zouaves. Calvet's business appears to have been modeled after the *brasseries à*

femmes introduced at the Paris exposition in 1867.[29] De Férussac called the establishment "disgusting" and requested that it be closed. In spite of his pleas and the repeated forced removal of dozens of tables and chairs, Madame Calvet managed to keep her business open until the exposition closed.

The government-sanctioned image of Algeria also prescribed the behavior of Maghrebian employees. Officials insisted that workers sell their wares quietly and submissively and stay inside their boutiques. De Férussac's report cited the inappropriate behavior of some North Africans employed in the Attractions. He saw the need to forbid "all external and misplaced expressions" by indigenous workers. "The natives are going to solicit and apprehend the public," he wrote. "Many people are already complaining."[30]

Commander de Férussac's report suggested that an ultimatum go out to the concessionary company to rectify all these problems—most of which had already been addressed on more than one occasion. At the same time, Férussac saw the situation as "delicate" and recognized that a scandal would result if the company refused to conform to the regulations and the administration decided to withdraw the concession. He anticipated that such a confrontation would result in a lawsuit and make newspaper headlines. Moreover, the public would be left without any entertainment at the Trocadéro. In the end, the administration did not entirely follow Férussac's suggestions but decided to attempt to get the company to comply with regulations by forcefully addressing the most troublesome violations. On June 13, the commissioner general sent an official order to the company via Monteil. It listed four of the infractions Férussac had cited in the May 6 report and gave the company forty-eight hours in which to comply. The commissioner threatened to issue an *arrêté*, a formal order, if the *société* did not deal with the problems within this period. On June 16, an *arrêté* went out to the attractions company. In his reply to the commissioner's letter and the *arrêté*, Pourtauborde yielded to the administration's demands about most issues and pled ignorance or inability to act on others. For instance, he claimed he did not have the power to make Madame Calvet obey the regulations, although he did verbally order her to reduce the number of her tables. As for the beer being sold at the entrance to the Rue d'Alger, he personally had never observed such an activity. Pourtauborde added his own complaints about an administrative process that gave him forty-eight hours to rectify problems that were communicated to him twenty-four hours into the deadline. The order apparently resolved the issues of the African "Basatos" and the demand that merchandise be produced in front of the public. However, some refreshment vendors continued to ignore regulations about where they could place their stands, tables, and chairs. In general, the administration's response showed lack of resolve and lack of resources to properly monitor the activities it sponsored. The situation calmed down after the administration's ultimatum in mid-June, only to be followed by new com-

Figure 4. Cortège of Arabs passing Le Stéréorama Mouvant at the 1900 Exposition
universelle.
Courtesy of the Bibliothèque Nationale de France.

plaints in July concerning activities outside the buildings for the two largest
tenants of the Algerian section.[31]

Adjacent to the Rue d'Alger, three other large concessions occupied the
Algerian Attractions section: Le Stéréorama Mouvant (fig. 4), Le Diorama
Saharien, and La Grotte aux Millions, or Ali Baba's Cave from the Arabian
Nights tale. The concessions for the *stéréorama* and diorama had been the
first to sign leases with the Algerian Attractions company in the early plan-
ning stages of the Attractions area. Compared to the boisterous Rue d'Alger,
they provided a more sedate form of entertainment for the cultured exposi-
tion attendee; they were organized around paintings of the exotic sights of
the North African terrain. In the *stéréorama,* visitors sat in a domed theater
measuring over 800 square meters while a special circular screen with paint-
ings moved to simulate a voyage along the coast of Algeria. The attraction
was operated by Francovich and Gadan, two artists who lived in the colony.
Two other men, Galand and Noiré, ran the Diorama Saharien, a smaller

attraction with seven large paintings of Algerian scenes. The diorama included "a round dome, porticoes with Algerian-shaped arcades, a dome in the shape of a sugar cube—like those in the Sahara—and a minaret like the one in Biskra."[32]

The third major attraction, La Grotte aux Millions (Ali Baba's Cave), was constructed by Perrault de Jotemps, a businessman who subleased space from the owners of the *stéréorama*. It consisted of an elaborate cavern adorned with Oriental carpets and armory. Special lights and colored mirrors, moved by a hidden mechanism, changed the color of the cavern from one minute to the next. The builders installed a simulated waterfall created by coin-sized disks and a safe filled with 1 million fake francs. In a report to the secretariat general of the exposition before the *grotte*'s official opening, Férussac wrote that La Grotte aux Millions posed no moral danger to the public and was "more interesting than other Algerian attractions—except for the Stéréorama."[33] The *grotte* represented the pure exoticism and fantasy that helped propagate the image of a mysterious Arabian culture in North Africa.

Although Ali Baba's Cave posed no problem for the administration, the same could not be said of activities organized by the sponsor of the Saharan diorama—the Société du Diorama du comité d'hivernage Algérien. This group of Algerian investors added a sideshow to their regular concession that ostensibly demonstrated "an Arab custom." Dressed in Moorish clothes, a woman stood just outside the doors of the diorama, head and wrists locked in a Chinese stock. A man led her around the Algerian section as she let out loud cries, apparently drawing much attention from passing visitors. The individuals enacting this "custom" were English employees of the diorama company.[34] After Commander de Férussac attempted to stop the scene and ordered the group inside the diorama on several occasions, the representative of the diorama company, Monsieur Rabarot, wrote to the commissioner general to complain. He defended the rights of the investors, a group of Algerian colonists:

> Mr. Commissioner General, we are a company of French citizens who have made Algeria fertile with our sweat and money—166 subscribers who have spent 150,000 francs to make our beautiful colony familiar to the wider public. The Governor General has given us his full support, as well as all the authorities; the subscribers are Bankers, Industrials, Businessmen and Colonists. All wanted to make their small contribution to this Algerian *oeuvre* that the Government should have created itself.[35]

During one of Férussac's interventions, the diorama administrator declared, "No one will stop me from making money however it pleases me." Rabarot's determination to make good on his investment is evident from the conflict that ensued in the following weeks.[36]

Several days after the commissioner received Rabarot's letter, Francovich,

one of the owners of the adjacent Stéréorama Mouvant, expressed his dismay about the chained woman who was causing such a scene outside his doors. Appalled by the "grotesque exhibition," Francovich argued that the diorama concessionaires did not have the right to "transform the premises that had been given to them for a Diorama into a grotesque fairground which greatly damages our business—we who are first and foremost an Artistic attraction." There is no evidence on file that the administration addressed Francovich's first complaint. Rabarot bargained that more of the public would be drawn to the concession by the shocking "cultural" exhibition than by promises of a tranquil visit to the Sahara Desert, so he continued with his sideshow.

Francovich and his partner wrote two more letters to the commissioner concerning the diorama show in July and a third letter to the director general of finances in early August. The tone of the letters showed that the artists were fed up with "the daily scandals" taking place outside of their *stéréorama*. Screams from the woman in the stock persisted, and monkeys had been added to the diorama show. The men could not understand the inaction of the exposition authorities. After nearly a month of frustration over the situation, Francovich and Gadan threatened to close their popular concession. They declared:

> We are the spokesmen for an irritated public that does not understand
> the tolerance of the Administration before a Diorama [company] that has
> changed its Concession and has given way to a disorderliness that, in comparison, makes "belly dancing" look like child's play.

Finally, four days later, the director of finances made an official request that the police intervene in the affair. But not until the middle of September, after Delegate Monteil had been asked to intervene, did the diorama operators cease all inappropriate activities outside their official concession.[37]

The Saharan diorama affair demonstrates the conflicting goals and values of the organizers and concessionaires in the private-run attraction sections of the exposition. In their rhetoric, government organizers of the colonial section proclaimed the importance of familiarizing the public with the new empire constructed in the last decades of the nineteenth century. Many efforts were made to replicate the architectural styles of the indigenous cultures, and organizers considered it a priority to construct "authentic" dwellings and villages populated with "natives" living out everyday tasks. At the same time, private concessionaires wanted to capitalize on the exotic and unusual aspects of the colonial regions, not on the social and cultural realities. Businessmen and government officials were naturally concerned about making a profit. The French colonial section as a whole especially could not afford to repeat the financial losses of the 1889 Exposition universelle, when it had finished 280,000 francs in debt and had been bailed out by the Ministry of Commerce with funds from the exposition's general treasury. In view

of these concerns, it was unlikely that the government and its contracted concessionaires would place ethical issues over financial considerations. The diorama owners believed that the public wanted the sideshow atmosphere they were providing, one that presented North African customs as cruel and bizarre. Moreover, the administration did not find it necessary to stop the displays immediately because eliminating them might curtail the colonist stockholders' means for making a profit. In the end, it was a different financial threat—the possible closing of the admired Stéréorama Mouvant—that persuaded the administration to take action against the diorama activities.

The roots of these conflicts lie in the initial conception of the Attractions section by the central committee in Algiers. When the committee awarded Chaudoreille, Palis, fils et Compagnie the Algerian Attractions concession, they entrusted it with the task of constructing an Algerian quarter and providing interesting entertainment that would complement the official exposition in the Algerian palace. But the concessionary company did not necessarily share the image of Algeria and the propagandistic goals advocated by the government organizers. The exposition records suggest that this group of Franco-Algerian investors saw the Algerian Attractions first and foremost as a lucrative business venture. The original list of attractions cited in their official statutes reveal the sensational nature of the entertainment they envisioned. The company's statutes stated that it planned to present exotic subjects in a type of "ethnographic" show similar to those staged at the Jardin zoologique d'acclimatation in Paris and at many European and American fairs. These shows had been proven to draw large crowds and generate sizable revenues. Exposition organizers in Algeria, the attractions company, and their tenants hoped to benefit from the public's interest in and curiosity about colonial peoples. Metropolitan officials agreed to use exotic attractions to entertain crowds and draw the public's attention to French North Africa but hesitated to condone exaggerated spectacles. It is significant that government officials in Algeria accepted these proposals nearly two years before the exposition began. Presumably, the Algerian government organizers did not anticipate the lack of "good taste" and judgment that the private concessionaires would display in this affair by their choice of "attractions."[38]

The commissioner general staff's inconsistent response to the activities of the concessionaires in the Algerian Attractions section reveals other problems with the structure of the private concession arrangements at the 1900 Exposition universelle. First, the failure of Algerian organizers and the commissioner general in Paris to coordinate their plans adequately reflects administrative lapses and a traditional tension between central and regional state authority. When the Algiers committee initially hired Chaudoreille, Palis, Fils et Compagnie, it did not transmit the company's defining statues to Paris until over a year later, after a conflict arose over several of the concessions. To address these concerns, the commissioner general corresponded

with the company via Monteil, the delegate for the Algerian exposition. This process followed proper channels of authority, but this meant that the transmission and execution of the requests made to the company did not happen quickly. In addition, Monteil and the commissioner general's staff in Paris disagreed about the interpretation of different regulations. Monteil, in fact, may have deliberately delayed the execution of some of the commissioner's orders. Moreover, since the Paris administration was unwilling or unable to control the concessions on a consistent basis, it sent a confusing message about what could be presented as an officially sanctioned view of indigenous Algerian culture.[39]

Second, the structure of the concessionaire system and the size of the Attractions area made it difficult to control all the activities at the site. The Algerian Attractions area measured over 2,300 square meters and contained various small shops and performance areas on the curved Rue d'Alger that were hidden from the main walkways of the Trocadéro. Once the tenants had moved in, the administration had to verify that the concessionary company required them to follow the Réglementation Générale concerning the manufacture and sale of colonial products. This could be a time-consuming process. Only one administration inspector is on record as making regular visits to the Attractions to verify that the concessionaires were complying with regulations. Shrewd shop-owners who were confronted for certain violations returned to ignoring the rules as soon as the inspector was out of sight.[40] Given the size and nature of the area, the lack of personnel, and the length of the exposition, it was obviously impossible for the administration to observe every performance for decency, assure that every shopkeeper sold items exclusively made before the public, keep vendors confined to the space assigned to them, and verify that every form of attraction was authorized by the commissioner general's office.

Third, the idea of reconstituting a section of Algiers in Paris, placing the project in the hands of private businessmen, and maintaining an "authentic" and official image was flawed from the start. Businessmen, who made large investments in the Attractions section, concerned themselves first with turning a profit and not necessarily with presenting an authentic or realistic image of Algeria and the Algerian population. Delegate Monteil was not exaggerating when he said that it would be nearly impossible for an entrepreneur to make money if he followed the regulations for the sale of colonial items. Merchants tried to dodge the strict definition of authenticity— on-site manufacture by "natives" in public view—the administration had established, resenting the ban on items made in Algeria or prefabricated with Algerian materials. Nor could government officials depend on concessionaires to assure an "authentic" environment when these businessmen and women could save money by hiring Europeans to play the roles of Moors or Arabs instead of transporting North Africans. For these reasons, visitors to

the Algerian Attractions section saw an Algeria created by colonial entre-
preneurs to entice a popular clientele and not the official "authentic" view
of the colony that the colonial administration hoped to propagate.

The Algerian and Tunisian expositions at the 1900 Exposition universelle
presented an exotic vision of the lands just across the Mediterranean while
emphasizing that these countries' destinies were intertwined with that of
France. Officials saw great potential for growing trade between the *métro-
pole* and its North African territories. In his official report, Commissioner
General Picard focused on this aspect of the value of the region. The offi-
cial exposition of Algeria presented the colony's resources and the grow-
ing modern infrastructures that worked to integrate this colony-province of
France. However, the original division of the Algerian section into an official
government-sponsored area and an unofficial but government-sanctioned
"Attractions" area reflected a dual vision of the colony. French officials saw
Algeria first as an economically viable region and second as a land of myste-
rious peoples with a foreign religion and an exotic culture.

The same two aspects of North Africa stood out in French trademark im-
ages from 1886 to 1913. Businesses used North Africans on labels to pres-
ent the agricultural products that represented an Algeria of abundance—
semolina, grains, dates, and wine. On other products that were not necessarily
produced in the region, images of veiled and turbaned people stressed a
mysterious culture, exotic and alluring, and an Islamic faith that was hos-
tile to the Christian west.

French organizers of the 1900 Exposition universelle relied on Oriental-
ist visions of North Africa to build the public's interest in the region and
ultimately convince it that commercial ties with the territories were vital to
France. The contradictory images—the precolonial Oriental North Africa
versus the commercial, developing, civilized French North Africa—served
the same propaganda purpose: encouraging the public to support colonial
development through increased trade and investment. Nevertheless, by re-
inforcing stereotypes of exotic Muslims to get the public to recognize com-
mercial interests, officials implied that a gulf existed between the two cul-
tures that made civilizing efforts futile and challenged future development.
Administrators offered Algeria as the model of a viable colony and dis-
regarded political and cultural differences that proved that more than just
the Mediterranean separated North Africa from France.

4
Indochinese:
Gentle Subjects

From the 1880s until World War I, French government officials and merchants typically portrayed the peoples of France's Asian colonial territories as diligent gentle subjects. Advocates of colonialism did not consider the Indochinese to be in need of civilizing efforts, as were black Africans, nor did they portray their culture as mysterious, as they did the Arab culture of the Maghreb. Instead, French imperialists emphasized the untapped potential of a skilled and compliant Asian population with a history of worthy achievements. For colonial officials, this image served both a political and an economic purpose. The military takeover of Vietnam near the end of the nineteenth century had drawn public disapproval in France, particularly during the Tonkin affair in the early 1880s. Government officials needed to justify France's presence in distant Indochina by assuring the public that commercial exchanges would develop and French control would stabilize the region. This chapter explores how French officials used common stereotypes of East Asians to publicly validate their increased political and economic control of Indochina. The French image of Asian people could be complex, simultaneously complimentary and demeaning. During the early decades of the Third Republic, officials and entrepreneurs emphasized the facet of the image that favored French hegemony.

A featured element of the French popular view of East Asians, particularly

of Chinese, developed from tales of European missionaries brutally mar-
tyred by faithless "natives." Western attempts to open China for markets in
the mid-nineteenth century produced new stories of Chinese political and
social backwardness and resistance to progress.[1] Even though scholar Ernest
Renan lauded the Chinese for manual dexterity that he said was God-given,
a racial trait that he believed made them ideal workers for European mas-
ters, the image of China that political commentators and the press offered
was invariably determined by the political tensions of the fin de siècle.[2]

About a year before the start of the 1900 Paris world's fair, imperialist
Paul Leroy-Beaulieu sought to outline the failings of Chinese civilization
in a *Revue des deux Mondes* article entitled "Le Problème chinois." Leroy-
Beaulieu's remarks centered on problems in China such as the love of gam-
bling ("the national vice") and a commitment to political, social, and cul-
tural traditions that held back the European version of "progress."[3] When
the article appeared, the Chinese resistance movement was already plotting
the action against foreigners that would erupt into the Boxer Rebellion in
the summer of 1900.[4] Partly because of tensions with China in the late nine-
teenth century, the French characterized the Chinese as troublesome Asians.
In comparison, they depicted the populations of their Southeast Asian terri-
tories as model subjects. At the 1900 Exposition universelle, the image of the
gentle or deferential Southeast Asian masked the reality of widespread Indo-
chinese resistance to French colonial rule and Asian resistance to western
imperialism in general. The official portrayal of the peoples of the region
as diligent workers also supported arguments about the potential of the re-
gion as an exporter of raw materials and finished goods. France's civilizing
mission in Indochina took a secondary position to these political and eco-
nomic issues in colonial propaganda at the beginning of the century.

Colonial rhetoric during the world's fair did not emphasize the backward-
ness of the Indochinese; only mountain-dwelling or isolated rural groups
were considered to be in serious need of civilizing efforts. French officials
acknowledged the rich cultures and traditions that had developed in Cam-
bodia, Laos, and Vietnam. To highlight these traditions, the architects of the
Indochinese exposition at the world's fair constructed temples and palaces
in Paris that were patterned after famous structures in Vietnam and Cam-
bodia. Additionally, the governor general of Indochina, Paul Doumer, hired
a colonist to run a theater that showcased the artistic talent of Indochinese
actors, dancers, and musicians.

The images of Asians French merchants used in the decades before World
War I contrasted with the somewhat more respectful portrayal of this popu-
lation at the 1900 fair. Trademark images evoked stereotypes of the Japanese
and Chinese. Often merchants selected illustrations that portrayed people in
domestic settings, surrounded by flowers, or with exotic animals and plants
that carried different meaning for Asians than they did for Europeans. Some
illustrations did not conform to these traditional scenes but emphasized

the labor and artistic potential of the Indochinese. The number and types of trademarks grew over time as more businessmen marketed Indochinese products in the *métropole* and their own French products overseas.

Trademark Images, 1886–1913

Trademarks registered in France before World War I contained drawings that presented an exotic view of Indochina as part of a generic Far Eastern culture. Entrepreneurs depicted people from the Far East as members of a single race with Chinese or Japanese cultural traits. Merchants accentuated the race's manual skills and mild disposition in their illustrations. The survey that follows includes trademark labels that represent a product specified as Indochinese and all those that depict Asian people but have no clear link to a particular country.

The Indochinese labels displayed three distinguishing aspects: they used traditional Asian symbols to help define the exotic nature of the product, they usually marketed a limited variety of regional products, and, with some exceptions, they included stereotypical portrayals of diligent Asian workers and servants. These three elements combined to reinforce the representation of Indochinese as gentle people who made humble French subjects.

Symbols of Exotic Asia

Images of Asians and Indochinese in French commerce near the beginning of the twentieth century were associated with special symbols common to art forms in the Far East. Emanating from religious beliefs, myths, or design traditions, these symbols made up one dimension of the exotic portrayal of the "race." Companies that registered trademarks with Asian themes generally used drawings with elements that evoked beauty and nature. In many cases it is clear that French entrepreneurs acquired traditional Chinese or Japanese drawings, perhaps commissioning them from artists, to create their product labels. Trees, flowers, plants, and gardens were the most common natural symbols used. Some labels included birds, such as the crane, a Chinese symbol for longevity, or the phoenix, which represented peace and prosperity; others included mythical creatures such as dragons. For Asian consumers, the dragon had cultural significance as a symbol of transformation, spring, and life-giving waters, but for Europeans it was simply a frightful fantasy creature associated with medieval imagery.[5]

Most of the "exotic Asia" trademarks communicated serenity in common situations and natural settings. They presented people in a variety of poses, standing outdoors with hats and parasols for protection, seated in homes and on terraces, drinking or serving tea, and meditating. Attractively dressed women with fans and parasols were pictured along with flowers or plants. For example, Mademoiselle Marie Caussemille's Tea Paper cigarette

papers trademark (Marseilles, 1908) pictured a woman holding a bouquet of flowers and three Asian men making cigarette paper in the background. A fabric manufacturer named Seydoux, Sieber et Compagnie (Paris) registered a label in 1891 that featured an Asian man seated on a cushion with mice at his feet and a large vase filled with flowers in the background. In 1892, the Maumy Brothers of Paris, who were fabric merchants, registered a trademark with a woman in a kimono standing on a porch holding a fan. Plants and birds adorned the background and the scene was framed with bamboo (a symbol of longevity). In 1895, Edmond Saxel presented a drawing of an Asian woman standing in a rice field with a parasol as the trademark for his perfume and soap (Paris). Two designers used religion or meditation as a theme in their labels—the Manufacture des Tabacs de l'Indo-Chine (Paris) and the Société anonyme des Rizeries Indo-Chinoise (Marseilles), both in 1911. A Marseillais merchant selected a drawing of a "Saigonnais" wearing the wide straw hat (*nón lá*) often seen on peasants for his condiment label in 1909. In all but one of the labels mentioned above, the illustrations had no direct connection to the products being marketed; instead, they used exotic scenes to draw the attention of the customer.

A small group of trademarks differed from this main group by presenting a variety of elements in their drawings of Indochinese that did not appear in traditional domestic settings. Some businesses used mythical animals or atypical people as the centerpiece or as decoration for their labels. The Anglo-French Textile Company, Ltd. (Paris) chose several of these unusual images for its cotton products in 1904. In one drawing, two women rode a horned four-legged beast. A second scene showed a man riding on a giant bird, perhaps a crane. A third label pictured two plump figures squatting on the ground. These were perhaps Bodhisattvas or Buddhist teachers. Two companies used a warrior or a military theme on their labels. In 1895, the Brulh frères et Compagnie (Paris) marketed cutlery and assorted products with a series of labels that pictured Asian men bearing weapons. One label showed a man in military dress riding a horse and carrying a sword. A second pictured a masked man in a special costume killing a tiger, a Chinese animal symbol of power. The third label also pictured a man in costume, seated on the ground with swords and arrows placed at his side. A trade company owned by the Derode frères of Paris presented an Asian in warrior dress for one of its Thé du Phénix labels in 1887. Another exception to the bucolic depiction of Asian life appeared in a liquor trademark for the Société de l'Union commerciale Indo-Chinoise (Paris). In 1911, the company registered an Eau de vie Anisée label that pictured a bare-chested gleeful Indochinese youth holding up a glass of the liqueur. Indeed, the diverse labels described above contrasted with the common domestic scenes where people relaxed over a cup of tea or stood in their gardens and fields. These depictions vividly illustrate some of the alternatives to the dominant commercial image of the passive hard-working Asian.

Made in Indochina

Depictions of Indochinese also appeared in trademark illustrations for products that were typically grown and exported from the region. The two most common items in this category were tea and natural fibers in the form of thread or cloth. Furniture lacquers, alcoholic beverages, rice, and tobacco were the next most common. Trademarks for Indochinese products relied on exotic themes as often as they actually depicted the goods being sold. Drawings with Asian men and women decorated each of the twenty-nine tea trademarks for the period from 1886 to 1913. In the early years of the survey, new tea trademarks were rare, and there was a six-year lapse in registrations between 1887 and 1894. After that, new tea trademark registrations occurred almost annually, likely a reflection of renewed commercial activity as a 20-year European depression drew to a close.

The artistic motif of scenes on tea trademarks remained fairly constant from label to label; tea consumption was usually depicted as an important Asian custom. The most common elements in drawings for tea trademarks were simply furnished and decorated terraces or sitting rooms and Asian women with chignons dressed in kimonos or robes. Groups of women, couples, or families sat down to enjoy the beverage. Servants waited on their masters, serving tea in small china cups. An 1887 trademark for Thé de la Compagnie Orientale, registered by Joseph-René Miraud et August Courtine (Paris), pictured two groups of Asian men and women with their servants. One group was drinking tea, another playing cards.

Fifteen of the tea labels featured women. The bamboo-framed illustration for Fleurs de Souchong d'Annam (Marseille, 1904) pictured a woman in a garden holding up a branch of tea leaves. Another label for tea from Annam, Fleur de Thé Imperiale d'Annam (Paris, 1912), contained panels with a Chinese dragon and a woman wearing a Japanese kimono and hairstyle (fig. 5), a demonstration of how the French mixed images and symbols from different Asian countries to create a label for a Vietnamese product. In 1907, Jean-Baptiste Vincent registered La Tonkinoise teas in Paris. His trademark was a photo of a Tonkinese (northern Vietnamese) woman in the center of the label with Chinese writing on the sides. A number of businessmen marketed their products to Indochinese as well as European consumers using bilingual labels. On a few labels, however, designers who were confident that metropolitan consumers could not tell the difference decorated trademarks with pseudo-Chinese characters, hoping to lend an "authentic" look to the image.

Fabric was the next most popular product associated with images of Asian people in the survey. Cotton, silk, jute, and ramie, in particular, were cultivated in French Indochina. Merchants depicted Asians on trademarks for their cotton cloth, sewing thread, and fabric made of mixed fibers. The first fabric trademarks in this series were registered in 1891 by Seydoux, Sieber

FLEUR DE THÉ IMPÉRIALE D'ANNAM
Marque '' AU DRAGON ''

139475. — M. p. désigner du thé et de la fleur de thé, déposée le 23 aoû 1912, à 1 h., au greffe du tribunal de commerce de la Seine, par M. *Séche* (*Charles*), 386, rue de Vaugirard, à Paris.
Cette marque est de couleurs variables.

Figure 5. Fleur de Thé Impériale D'Annam (Paris, 1912).

et Compagnie of Paris. It submitted four label designs for its cloth, each picturing an Asian man or a boy in a symbolic composition. One showed a man carrying the globe on his back. In 1898, a Marseillais fabric enterprise, Besson et Compagnie, registered a label that pictured an Asian man with a long beard (a symbol of health and longevity) holding up one finger. Only one fabric company depicted weavers making cloth on its trademark, and only one label pictured someone holding a spool of thread.[6]

Other products that appeared in the series of trademarks with Asian images were rice, tobacco, and furniture lacquer. Although rice was an important staple crop in Indochina, only two companies registered trademarks for it in Paris or Marseilles in the decades before World War I. For its three trademark labels, the Société anonyme des Rizeries Indo-Chinoises chose two prayer scenes and one drawing of a worker wearing a *nón lá* and carrying sacks on a pole balance (Marseilles, 1911). Jean Savoye's 1913 trademark for Produits Coloniaux à la Congaï featured a drawing of a young woman. In colonial Indochina, the French used the Viet term *congai* (meaning "little girl" or "young woman") to refer to Asian concubines and mistresses. The term evoked the mystique, desirability, and availability of Asian women, a stereotype perpetuated in colonial writings.[7]

Three companies in the survey registered tobacco trademarks. Brunon and Rothe of Marseilles marketed Cigarettes Annamites beginning in 1895. The label showed a Vietnamese man in a wide straw hat, vest, and pants, holding a pack of cigarettes. For one of their 1906 trademarks registered

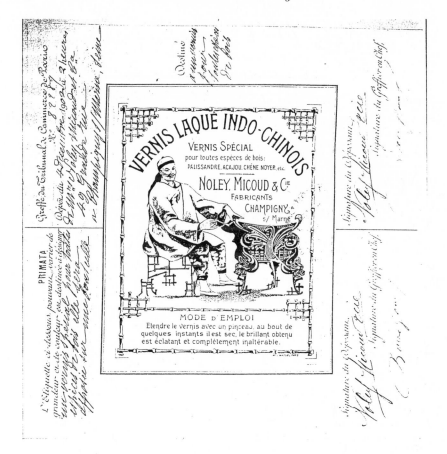

Figure 6. Vernis Laque Indo-Chinois (Paris, 1902).

in Paris, the Manufacture des Tabacs de l'Indo-Chine, Hanoï portrayed a group of Asian workers squatting down on a carpet with cigarette and cigar boxes. The same company's 1911 Chinese-language label pictured a man seated inside an Asian temple.

Four businesses registered trademarks in the furniture lacquer category. La Laketine (Paris, 1900) and Vernis Laque Indo-Chinois (Paris, 1903) pictured Chinese men with long braids (fig. 6). In 1907, Marseillais businessman Charles Dubois named his special paints Laque Dubois. His label featured three Asian women painting vases and showed the name of the product in bamboo lettering. A Dutch company, Ivormica, registered varnishes and lacquers in France in 1912. Its creative international trademark label was an illustration of five men, each of whom represented his respective continent and was varnishing his section of the world. Asia appeared as a man wear-

ing a black cap, dark shirt, and light-colored smock or vest. The artist pictured America at the center of the top of the globe, Europe standing at the left, Asia slightly lower on the right, Africa kneeling near Europe (and lower than Asia), and Australia squatting at the underside of the globe. Surely the artist's rendering of the world's continents and races sent a message to the consumer about the superiority of the west.

Indochinese Workers

From the trademark illustrations in this survey, we can evaluate certain traits that define the French commercial image of the Indochinese worker during the pre–World War I era. The labels that depict Indochinese or Asians doing specific tasks coincide with the general image of them as a mild-mannered and diligent people. Women were depicted as gracious and submissive, men as laboring Chinese "coolies." Drawings on several trademarks showed distinctions between upper-class Asians and workers. A few labels even pictured Indochinese serving European clients.

The trademarks that include worker scenes fall into two categories— group work scenes and individuals doing specific tasks. The best examples of groups depicted at work are Thé Noir, Thé pour Déjeuner (Paris, 1913), Tea Paper (Marseilles, 1908), and Les Lolos (Paris, 1910, 1912). On the Thé Noir label, the illustration contained two parts: one section pictured Asian peasants cultivating tea leaves and the second showed servants carrying an Asian dignitary in a palanquin. The three Asian workers in the Tea Paper illustration were absorbed in the preparation of the cigarette papers. One of the men wore a long braid down his back. The Lolos labels used the same image of workers with braids, although this time they were weaving fabric at a loom.[8]

Four labels pictured individual Asians or Indochinese in work scenes. Three of these showed rickshaw, or *pousse-pousse*, drivers pulling along European passengers. This scene appeared in a trademark registered by the Anglo-French Textile Company in 1904 and by the Société anonyme des Rôtisseries de Café in Marseille in 1907 and in a label by Marseillais businessman Paul Vian in 1909. Vian's coffee company sold chocolate under the name of Chocolat du Pousse-Pousse. He also marketed Le Pousse Pousse brand flour and semolina. The *pousse-pousse* driver in both these labels transported a woman passenger. Since neither of these products is of Asian origin, Vian apparently offered the *pousse-pousse* image, with its subservient Asian laborer, for its exotic appeal.[9] The last work scene in this group, registered by the American-based Singer Manufacturing Company, pictured an Asian woman seated at a sewing machine and contained a Chinese caption. This product trademark, with a drawing depicting a familiar stereotype of an Asian at work, likely targeted the local market for sewing machines in French Indochina.

The trademarks registered in Paris and Marseilles from 1886 to 1913 illustrate that merchants selected images that reflected and perhaps reinforced a stereotype of the people of the Far East as docile and hardworking. When trademark designs portrayed Asian and Indochinese people at work, they appeared disciplined, skilled, and submissive and were rarely shown under the supervision of Europeans, as were Africans. Designers created a peaceful atmosphere on some trademarks by including tranquil scenes of nature and domesticity. Other labels had Chinese motifs with symbolic flowers and animals that would hold meaning for Asian consumers in the colonies. For consumers in France, however, the symbolic drawings were eye-catching exotic emblems. These trademarks appear to have been created in Asia or by Asian artists engaged by French companies. Unfortunately, the early trademark records—and the labels themselves—do not include the names of the artists, so we cannot determine the origin of the designs. The fact that entrepreneurs registered these trademarks in France instead of with the commerce tribunals in the colonies strongly suggests that France was the focus of their business.

The commercial depiction of Indochinese and Asian character in trademarks registered from 1886 to 1913 reflected the official view of France's newly established overseas territories. The stereotypes of diligence and gentle disposition reinforced the idea that the government could intensify political control over the region and develop it to the economic benefit of the *métropole*. This was the focus of Paul Doumer's administration when he assumed the post of governor general of Indochina in 1897. Since Doumer had ultimate responsibility for the success of the Indochinese section at the 1900 Exposition universelle, he and his collaborators designed the exposition to emphasize the economic potential of the population based on stereotypical images of their skills and character.

"Gentle Subjects" at the 1900 Exposition universelle

The presentation of the peoples of Indochina by the organizers of the colonial section stressed the artistic talents and deferential nature the French believed—and wanted—Asians to possess. Able and willing to make a large investment in the exposition, the Government General of Indochina spent 1.67 million francs to recreate the lands of the Far East in the Trocadéro gardens of Paris.[10] The Indochinese exposition impressed the public with its five decorated pavilions and a village inhabited by over 100 "natives." It covered over 10,000 square meters—nearly one-fourth of the space reserved for the colonial sections. Each of the main regional governments of the Union Indochinoise funded its separate pavilion. To entertain the public, Indochinese soldiers and artisans paraded in colonial festivals with Chinese lanterns and mythical monsters. These parades featured the famous giant dragon, a favorite with the French crowds. In order to provide a full range of

75

entertainment options, the central organizing committee awarded a special concession to a French colonist from Saigon to operate an Annamite theater, where traditional plays and Cambodian dancers wowed the public.

At the local level of organization, the Indochinese exposition involved a sizable group of colonial officials and native dignitaries. Local committees from administrative territories in Indochina—Vietnam (Annam, Cochinchina, and Tonkin), Laos, and Cambodia presented plans to the governor general.[11] These committees included a variety of colonial figures from every important public and private institution in the region. Doctors, teachers, pharmacists, professors, and judges participated. Several ecclesiastics also helped define the expositions from their regions. Businessmen, especially members of the colonial chambers of commerce, participated in the local committees. Government employees and officials who were tapped for the committees had a wide range of responsibilities. Committee lists from the four main provinces included mayors; a civil servant from the posts and telegraph service; customs officials; representatives from the ministries of the interior, war, and finance; military commanders; health officials; engineers; and employees from public works departments. Thus, individuals from a wide segment of French colonial society determined the character of the exposition. In the protectorate territories, French authorities included Asian dignitaries on the committees as a matter of protocol.[12]

Governor General Doumer and the Permanent Centralization Committee determined the final composition of the Indochinese exposition. Six businessmen and administrators sat on this special committee, which was led by Monsieur Rolland, president of the Chamber of Commerce of Saigon. The Centralization Committee coordinated the plans from the local committees with the goal of creating a unified Indochinese exposition that represented the regional characteristics of each territory. In Paris, Pierre Nicolas, commissioner of the Indochinese section, directed the construction and presentation of the exposition.[13]

Featured Exhibits

The Indochinese exposition consisted of five structures that housed exhibits that presented the products, arts, cultures, and religions of the Asian colonies. A group of French architects, headed by du Houx de Brossard, designed the Indochinese palaces and temples. Each of the principal buildings was patterned after existing structures in Indochina. Architect Decron reproduced the great pagoda of Cholon, Cochinchina, in the Palais des Produits de l'Indo-Chine. Du Houx de Brossard's Palais des Beaux-arts de l'Indo-Chine imitated the Palace of Co-loa in Tonkin. His design for the Pavillon des Forêts (Forests Pavilion) came from the house of a wealthy Vietnamese, and his Théâtre Indochinois, also known as the Théâtre Cambodgien, reflected Cambodian building styles. Architect Marcel reconstituted

the Pagode de Phnom Penh of Cambodia, which included a decorated underground crypt modeled after Khmer temples. The pagoda, a centerpiece of the Indochinese section, evoked the glory of the ancient Cambodian kingdom, demonstrating that the people of the region had great potential to advance toward western civilization.

The Indochinese collections were arranged by theme rather than by colony. This arrangement emphasized the productive capacities of the region. Organizers displayed samples of agricultural and industrial products in the Palais des Produits that included rice, tea, coffee, indigo, nut oil, bamboo, wood, opium, copper, and coal. In addition, organizers highlighted government projects and the development of trade in Indochina with models of bridges and charts that showed agricultural and industrial production. The Palais des Arts and the Pavillon des Forêts housed the remainder of the Indochinese exhibits. The industrial and traditional arts of Indochina displayed in the arts palace included paintings, fans, parasols, finished silk, furniture, decorated porcelain, lacquered objects, woven baskets, ivory, and weapons. The Pavillon des Forêts was dedicated to the Indochinese wood and bamboo used in cabinet and furniture-making. It also held displays of fishing and hunting paraphernalia.[14]

French organizers displayed the art and culture of Cambodia in the special Pagode des Bouddhas on the impressive Cambodian *phnom* (hill). Accessible from the ground level by several long staircases, the *pagode* was decorated with numerous statues of the philosopher and other Buddhist ornamentation. A magnificent underground section displayed stone statues, columns covered with bas-reliefs, and detailed engravings beneath the pagoda. In the vestibules to the back entrance of the pagoda, the organizers allotted space to a display of the Pavie Mission. This mission, sent by the French government to explore Siam and the Mékong River up to Tonkin, studied the culture of the region's ethnic groups. Documents and objects from the Pavie collection displayed in the cavern included ethnographic information, watercolors, photographs, jewelry, and wax figures of racial "types" the all-male mission had studied. Most of the wax figures were of young Indochinese women.[15]

Artisans and Performers at the Indochinese Village

Near the *phnom,* architects completed the exotic reconstitution of French Indochina with a small area of "native-style" huts. These Vietnamese, Laotian, and Cambodian dwellings served as the workshops for artisans. Jules Charles-Roux, commissioner of the colonial sections, labeled this area the Tea Village. The huts also doubled as stores for the Indochinese merchants at the exposition; they sold tea, fans, and other regional items to visitors from their living quarters (fig. 7). On the opposite side of the village stood a bamboo hut that was the home of "Chéri," a small white elephant that the

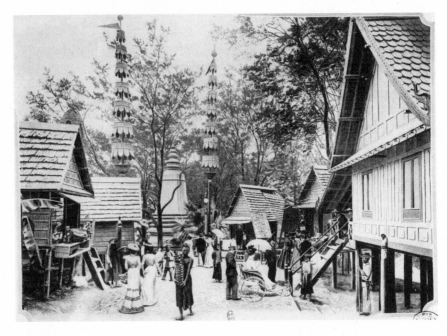

Figure 7. The Laotian Village at the 1900 Exposition universelle.
Courtesy of the Bibliothèque Nationale de France.

king of Cambodia had given to Governor General Doumer and shipped to Paris for the exposition.[16]

To assure the Asian character of the pavilions and palaces, Doumer's Indochina centralization committee sent a diverse group of artisans and design workers to France before the start of the exposition. These men shared in some of the construction work for the section but primarily provided the artistic finishes to the various buildings. Fifty-three Chinese, Vietnamese, Cambodians, and Laotians arrived in Paris in early October 1899 and spent the winter months doing masonry, painting, and sculpting and decorating the Indochinese section. The workers and artisans lived in a residence especially constructed for them on rue du Docteur-Blanche in Passy, not far from the exposition grounds. Most of these workers, who were employed and sent to Paris with funds from the budget of the Government General of Indochina, returned to Asia during the spring of 1900.[17]

In his official report, Charles-Roux praised the handiwork of the Indochinese and their "gentle and submissive character." Yet, he found the ethnic Chinese workers less compliant than the other Indochinese groups. Charles-Roux reported that during the preparation of the exposition, they protested against their French employers because their salaries were too low and they had to work too many hours. None of the other workers argued with the

French authorities or participated in these "mutinies," as the delegate called them. Initially, the Chinese workers disputed the exchange value of 2.50 francs to the piastre—a rate set in Indochina before their departure—and declared that each piastre was equivalent to 5.00 francs, effectively doubling their salaries. Charles-Roux attributed this error to a misunderstanding of the piastre, which was subdivided into five parts of 20 percent each. Officials resolved this conflict after a two-day work stoppage. The second dispute involved the French organizers' desire for the workers to extend their workday as spring brought additional hours of daylight. Accustomed to the winter schedule, the Chinese group resisted the new schedule that meant beginning at 6:00 AM and remaining on the worksite until 6:00 PM. They wanted to end the day at 4:00 PM and receive supplementary pay for any work completed after that hour. This second conflict was resolved after a week of negotiations. In spite of the lost work time, the exposition was not seriously affected because French workers were brought in to do some of the tasks.

The delays caused by the demands of the Chinese workers did not endear the group to Charles-Roux. Although he admitted that they were extremely skilled, he criticized their "nonchalance" and "placidity," which he found incompatible with the fast-paced construction schedule at the exposition.[18] In April 1900, the popular newspaper *Le Petit Journal* also characterized a labor disturbance among the Chinese at the exposition as a mutiny. According to its report, angry laborers tied a manager to a pole so they could beat him. The police arrived and arrested seventeen "extraordinarily lazy" workers, who were later repatriated.[19] In both cases French observers described the willingness of the Chinese to contest working conditions as an aversion to work instead of acknowledging that they refused to acquiesce to European authorities. Negative sentiment toward the Chinese was high as reports on the Boxer movement reached Europe, but French distrust of them was not new. Among the "races" of Indochina, according to Michael Vann, the French colonists reserved the greatest animosity for the Chinese because of their impenetrable entrepreneurial networks and their political activities. The Chinese seemed to pose "a chaotic threat to their [colonial] social order."[20] They could certainly not be allowed to disrupt the success of the featured colonial section in the *métropole*.

With the labor disputes resolved and construction of the pavilions complete, exposition officials turned their attention to the Indochinese artists and artisans who had been sent to Paris to perform and demonstrate their trades before the public. Thirty-five arrived in Paris on April 14 after a month-long journey from Hanoi. The talented group included several sculptors, embroiderers, cloth weavers, fan makers, female cooks, jewelers, nielloers, interpreters, and one lacquerer.[21] During the exposition, these skilled workers exercised their crafts in the Laotian huts built by their compatriots. They were joined by twenty-nine militiamen sent by the Government Gen-

eral of Indochina. These contingents of fifteen Tonkinese and fourteen Laotians served as guards for the Indochinese pavilions. A third group of Indochinese sent to Paris consisted of musicians, singers, and dancers employed by the manager of the theater concession.

Special Events and Concessions

The Indochinese group at the exposition gave a proud showing at the weekly evening colonial festivals that began in July. About 100 people, the largest of the colonial contingencies, participated in the first festival. In his final report, Charles-Roux credited Viterbo, the government delegate from Indochina, with the careful organization of the artistic presentations. He was struck by the color and detail of their costumes, banners, and lanterns.

> Men, women, even children were adorned in ceremonial dress, in red robes ornate with curious arabesques, and wearing strange helmets. They carried large jagged standards covered with black Chinese characters fixed on bright colors, and halberds and *fauchards* in the most bizarre and twisted forms. But the highlight of this group was a 17-meter-long dragon, whose enormous head moved in all directions—horrible and grotesque—followed by a long scaly body that snaked in cadence to the rhythmic sound of deafening gongs and tambourines. Twelve natives maneuvered this monster. . . .
>
> Above this group, from a curved reed frame, floated a throng of paper lanterns, of rare elegance and perfectly picturesque, but above all maintaining a supreme lightness and artistic character that struck all who were spectators.[22]

The procession of "natives" carrying the mythical beast, the lanterns, and the musical instruments covered 80 meters of a parade that was 270 meters long. Placed near the end of the procession, the Indochinese group stood out because of its uniqueness and size.[23]

The major entertainment attraction in the Indochinese section of the Trocadéro was the Théâtre Indochinois directed by Paul Beer, a colonial distiller in Cochinchina. Governor General Doumer and Capus, director of agriculture and commerce in Indochina, gave Beer the theater concession and an Indochinese bazaar of trinkets and souvenirs in Saigon in June 1898. The colonist planned to show plays from the Vietnamese court in Hué and plays and dances performed at King Norodom's court in Cambodia. Beer's theater was the only source of daily entertainment in the section and symbolized the more advanced civilization of the Indochinese people. Parisians and Asians were said to share a passion for the theater arts.[24] Indeed, advocates of colonialism often alluded to general similarities in the nature of scholastic and artistic culture in Asia and France.

In 1899, Beer and his partners created the Société anonyme du Théâtre Indo-Chinois. Among the administrators of this company were banker Fernandez Diaz and businessman Ernest Pourtauborde, who was also a key

figure in the Algerian Attractions company. J. de Lamothe presided over the ruling council of the theater company. In the original contract with Doumer and Capus, Beer agreed to pay for the construction of the theater, to ensure that certain types of theatrical performances would take place there, and to provide room and board for the personnel, all of whom would be Indochinese. The government agreed to pay for the transportation of the personnel. A convention that Paris officials signed in July 1899 specified regulations concerning the performances and personnel. It included a clause that gave the commissioner general the right to determine or modify all aspects of the performances in the interest of "decency" and "good order."[25] These stipulations were important to the French authorities, who wanted complete control over the presentation of Indochinese culture in order to monitor its impact on the public.

In spite of the regulations and signed agreements, the exposition's administration had difficulty controlling the artistic nature of the performances and the treatment of Asian personnel by concessionaires. In addition, the concessionaires made additions to or changes in their programs without consulting the administration. For example, in August the commissioner's representative, Commander de Férussac, reported that the Indochinese theater had added a five-man brass ensemble that he found "not worthy" of the exposition. He also noted several serious complaints from the Vietnamese musicians working in the theater. They claimed that they had not received back pay, that their meals were not adequate, and that sick members among them were not getting proper medical care. In August, Férussac wrote his superiors that the workers were spending their own money on food and treatment for their illnesses despite the fact that the French concessionaires had agreed to provide for these needs. Even with the evidence of breach of contract, Férussac's reports did not instigate any formal action from the commissioner general's office. The Paris officials seemed either unwilling to confront the concessionaires or only mildly concerned about the complaints. There is no further mention of these problems and there is no evidence that the Indochinese employees' situation ever improved.[26]

Conflicts also arose between government officials at the Indochinese section because of the exposition's dual role as a state forum for colonial propaganda and as a commercial entertainment fair that provided opportunities for worthy French colonists. Paris-based organizers and colonial delegates did not always share the same priorities. On one occasion, the commissioner representing the central committee in Indochina authorized an activity that the Paris inspector found unacceptable. In mid-June, Commander de Férussac reported that Gabriel Gosset, the man responsible for keeping Chéri, the white elephant from Cambodia, was selling small rolls to the public from a table near his guard post. Gosset told Férussac that Commissioner Nicolas of the Indochinese section had given him permission to sell the rolls. Several weeks later, a perturbed Férussac wrote his supervisors again to com-

81

plain that Gosset was more concerned about the rolls than about caring for the elephant and to ask whether his concession was authorized.[27] In the end, Férussac could not control Gosset's activities. Commissioner Nicolas and his colonial staff were responsible for encouraging the success of the Indochinese concessionaires and the exhibits. Since concessionaires, French employees, and Asian workers were recruited and employed by administrators in the colonial territories, they were not necessarily compelled to take instructions from exposition officials in Paris.

Despite these disagreements among the French participants in the Indochinese section, the exposition succeeded in promoting the stereotype of the mild-natured, talented, and skilled Indochinese colonial subject in order to reinforce the idea of firmly established French rule. Officials managed to contain workers' disputes throughout the exposition so that visitors saw the "gentle" Asian subject and absorbed the most important lessons about race, commerce, and empire. The colonial organizers used exotic artisans, soldiers, a theater company, dragons, and an elephant to draw in visitors and instruct the public about the advanced culture and economic vitality of the Southeast Asian territories.

Race in Exposition Publications

Individuals with a serious interest in the peoples of colonial Indochina could purchase an official publication, *Notices sur l'Indochine,* to supplement their knowledge. Although these publications were not sold widely, the *notices* are significant because they provide us with a description of the people of Indochina that was written by French government officials and distributed to agencies and citizens as an authoritative text. A brief set of ethnographic descriptions, edited by Indochina commissioner Pierre Nicolas, emphasized the labor potential of Cambodian, Laotian, and Vietnamese populations. The *notices* discussed the physical characteristics, commercial activities, and general character of each ethnic group, sometimes comparing them to the large "Annamite," Chinese, and Cochinchinese populations. The authors designed the short population section of the *notices* to "give the European who wished to establish him or herself in Indochina a few summary descriptions of the populations that will be introduced to his or her products, and the available forms of action for agricultural, commercial, or industrial activity." The information in the *notices* about the Indochinese people was geared toward the needs of business owners. Officials hoped to educate entrepreneurs about the potential market and the available labor force.[28]

The text defines two types of Indochinese: "robust" businesspeople and indolent groups. Tonkinese, Pou-Thaï, Pou-Eun, and Annamites constituted the first group; Cambodians, Laotians, and Moïs (Muong) belonged to the second.[29] Two other ethnic groups, the Nong and Thô, were mentioned, but no specific comments were made about their traits. In height and strength,

82

the authors ranked the Tonkinese over the Cochinchinese and noted that they showed "more initiative and a greater activity" in business ventures. The authors referred to the homeland of the Pou-Thaï and Pou-Eun peoples in the Black River basin and Sông-Ma region and suggested that they were "representatives of the autochthonous race." Their distinguishing physical qualities were their vigor and beauty, which surpassed that of the Annamites, the authors claimed. The *notices* characterized Cambodians as "naturally apathetic." Laotians and Moïs, groups cited as often oppressed by their neighbors, "have the reputation of being not very active, [and of being] fearful, and distrustful. They farm only to avoid dying of hunger."[30]

In its treatment of the Annamites, the majority population, the text included a thorough description of physical qualities and emphasized several main character traits:

> The Annamites belong to the Mongolian race. They have, moreover, all its physical characteristics: medium height, sound lower limbs, long thin torso, well proportioned head, narrow and long hands.
> The Annamites' complexion is bronzed but very differently nuanced according to their [social] level and the nature of their work. The forehead is round, the cheeks prominent, the dark eyes slightly slanted. The countenance is mild and despondent; their manner is distrustful and respectful, then polite and affable.[31]

The author also wrote that the Annamites possessed a sober character and other good qualities that made up for "the flaws that always develop among a people with an autocratic government." (The author did not say exactly what these flaws were.) He concluded the description with positive comments about Annamite hospitality and charity.

The brief ethnographic descriptions in Nicolas's publication gave a mixed view of the Indochinese peoples. All groups except Cambodians, Laotians, and Moïs possessed some valued quality that made them a potential source of workers. Most significant, the majority Annamite population fit the stereotype of the gentle and diligent Asian who would make a submissive worker. The information presented in the *Notices sur l'Indochine* indicated no serious obstacles to further commercial development in the region and sought to reassure entrepreneurs that success awaited them in French Indochina.[32]

The Indochinese section of the 1900 Exposition universelle in Paris presented the peoples of the French territories in Asia as skilled workers and gentle-natured subjects. On the initiative of Governor General Doumer, the central organizing committee in Saigon prepared a collective Indochinese exposition that showcased the special features of the administrative regions of Annam, Tonkin, Laos, Cambodia, and Cochinchina. Organizers used Asian militia, performers, and artisans working within an architecturally recreated environment to perpetuate the view of the Far East as exotic. In partner-

ship with colonial businessmen, the Government General of Indochina presented the French public with a glimpse of its image of "Indochina," an alluring territory with a glorious past, a relatively advanced culture, and a docile population—a region worthy of increased French commercial investment. In their rhetoric, government officials marginalized individuals and groups who did not conform to the French vision of the "Indochinese" in favor of those who seemed to embody the ideal image. The exposition defined Indochinese peoples primarily in terms of the economic potential they could offer France rather than as recipients of French civilization.

Representations of Asians and Indochinese in commercial trademarks before World War I matched the government's portrayal of the race as gentle and adroit. French companies depicted Asians surrounded by tranquil images or exotic compositions to sell regional products. Unsupervised workers were pictured as humbly and diligently completing their tasks. These depictions by entrepreneurs promoted the idea of Asian submission and, indirectly, acquiescence before the west. In practical terms, this image corresponded to the political aims of French supporters of colonialism and officials such as Governor General Doumer for increased control over the population and the economic development of Indochina.

Part II

CHILDREN OF FRANCE, 1914–1940

World War I had a significant effect on the French outlook on the empire because of the material aid sent to France from the colonies, the visible numbers of non-French soldiers on the continent, and the impact these soldiers had on the military situation during and after the conflict. No one could deny that the empire helped France survive the destructive war. North African, Malagasy, and Indochinese laborers replaced mobilized French factory workers and ensured industrial output. Close to 200,000 of these men filled jobs while the French fought on the front. About 1 million tons of food and material from sub-Saharan Africa, Madagascar, and Indochina reached France.[1]

The French military conducted a major recruitment effort in Africa and Indochina for workers and soldiers and forced thousands into service of the colonial state.[2] About 172,000 Algerians fought on the side of the French.

Tunisia mobilized 60,000 men, West Africa 134,210, Madagascar 34,386, and Indochina 43,430.[3] Thousands more were recruited but were not mobilized. Roughly 800,000 men from the French empire played a part in the war effort. The large number of workers who served in France made an impact on the communities adjacent to the military bases where many were posted after the war. Writings, posters, and advertisements praised and poked fun at the many African soldiers gathered at military bases or recovering in hospitals.[4] The German press, however, attacked the French for using "savage" black African troops, especially for posting them in the Rhineland.[5]

French trademark registrations from Paris and Marseilles also reflect the impact of the Great War on business activity. The number of trademark registrations with images of Africans and Indochinese decreased from 1915 to 1918 but had returned to prewar levels by 1920.[6] In the fall of 1920, the Ministry of Commerce reorganized its system for registering new trademarks. The new system updated the classification system created in the mid-nineteenth century by grouping and numbering trademark classes according to similar types of products.[7] New trademarks were now valid for twenty-five years instead of fifteen. The wartime environment produced a whole new set of French commercial trademarks that represented products used by soldiers or illustrated with drawings of soldiers. Exotic black African troops, portrayed as a crucial factor in the war, became the emblem for several new products and represented the "loyalty" of colonial peoples to France.

Background and Organization of the Interwar Colonial Expositions

Enthusiasm for the French colonies and disappointment over the financial arrangements, inadequate displays of "natives," and space limitations at the 1900 colonial exposition spurred Jules Charles-Roux and a group of Provençal colonial supporters to formulate plans for a new exposition entirely devoted to France's overseas territories. The idea of a special exposition in Marseilles with colonial elements was first proposed to the leadership of the Marseilles Chamber of Commerce and Industry in 1894 by L. Mirinny, an engineer residing in the Paris region.[8] Mirinny suggested that Marseilles organize an annex to the 1900 world's fair that would showcase the city's role as a maritime and colonial center. His suggestions included presenting aquatic races, a giant aquarium, exotic dwellings, and an underwater palace. This event would celebrate the 2,500th anniversary of the city's founding and help revive Marseilles' economy. Mirinny emphasized that Marseilles was the only logical place to hold this type of exposition because Paris did not have the aquatic facilities. He proposed that special arrangements be made to encourage world's fair visitors to pass through Marseilles on their

way to or from Paris to experience the annex and anticipated that the state would provide a sizable subsidy. Although Mirinny's ideas were not accepted in 1900, organizers of the 1906 Exposition coloniale incorporated several of his suggestions.[9]

In 1902, Dr. Edouard Heckel of the Institut colonial, who had been a member of Charles-Roux's staff in 1900, proposed the idea of a national colonial exposition in a speech to the Marseilles Geographical Society. With the support of the Marseilles Chamber of Commerce and other important regional and governmental organizations, the city of Marseilles brought the plan before the ministries concerned in Paris. They approved of the plan and named Charles-Roux as their representative and de facto commissioner general. Parliament, however, offered no special funding for the project. Not dissuaded from their plans, the city of Marseilles, the Syndicat d'Initiative, and the Chamber of Commerce financed most of the exposition with contributions from each colonial administrative region.

Serving at the helm of the 1906 Exposition coloniale, Charles-Roux was able to realize his desire to transplant an authentic portion of the colonial empire in France. The new exposition reflected the commissioner general's conception of the relationship between France and its colonies and protectorates. Buildings and exhibits represented both the colonial goods provided to the *métropole* and the manufactures that France exported to its territories. "Natives" from each colonial region were present to do craftwork or perform before the public, and some of them lived at the exposition site in traditional dwellings. The Marseilles exposition covered thirty-six hectares (eighty-nine acres) of level terrain between two major boulevards at the Rond Point de Prado. Indochina presented the largest section, encompassing over 6,800 square meters, followed by West Africa (AOF) with 3,400 square meters and Tunisia with slightly over 2,900 square meters. For the first time, the exposition included a special cinema house where documentary films with scenes from sub-Saharan Africa were projected.

The success of the 1906 exposition in attendance and presentation encouraged the city to plan another colonial show in 1916 and every ten years thereafter. This time the Marseilles organizers received the full support of the state. The Ministère des Affaires étrangères et des Colonies again named Charles-Roux commissioner general. The president of France traveled to Marseilles to initiate the groundbreaking ceremony for the exposition in 1913, and Charles-Roux's staff and government representatives in the colonies proceeded with their organizational work until the war put the plans on hold in August 1914.

The European conflict interrupted the construction of the pavilions but did not dampen the zeal of Marseilles' colonial supporters for the new exposition. Just days after the armistice, the mayor of Marseilles and the head committee for the exposition resumed the preparations, moving the starting

date to April 1922. Adrien Artaud, president of the Chamber of Commerce and adjunct commissioner, was named commissioner general after Charles-Roux's death in September 1918. At the start of this new planning stage, the Marseilles organizers faced a serious challenge from Paris. They learned that the Paris Municipal Council had approved a proposal for a colonial exposition by France and its allies in 1921 or 1922. Moreover, Ernest Outrey, who represented Cochinchina at the French parliament, had introduced a petition for a law proclaiming a similar event for Paris in the early 1920s.[10]

Several months passed and a heated debate raised tensions before the two cities came to an agreement over who would hold the exposition. The editor of the *Journal officiel de l'Exposition coloniale* remarked that the Provençal press saw the situation as a perfect example of the central government usurping a regional initiative. He reprinted letters of protest from the mayor of Marseilles and the president of the Chamber of Commerce. One newspaper, in an article entitled "Paris Contre Marseille: Une Belle Occasion de Solidarité Provinciale," argued that a second Marseilles exposition would increase business for colonists overseas and merchants in France. The author insinuated that the exotic features at a new Paris exposition "would especially attract . . . the idle off the boulevards and gawkers from pleasure trains" and not necessarily encourage commerce. He admitted that Marseilles would attract fewer people than Paris but believed that it provided a better environment for promoting new trade deals to build the economy.[11]

The two parties reached a compromise in the spring of 1919. It was decided that Marseilles would go ahead with its exposition in 1922 and Paris would sponsor a colonial exposition with its allies in 1925. Maréchal Hubert Lyautey, a friend of Charles-Roux, apparently persuaded the government to let Marseilles proceed with its own event in memory of the deceased commissioner. Interestingly, Lyautey was named the commissioner general of the Paris event, the 1931 Exposition coloniale internationale.[12]

The 1922 colonial exposition expanded the image of the colonial empire that had been displayed so successfully in 1906. Organizers emphasized the theme of the native soldier and his indispensability to France. In their eyes, the noteworthy performance of overseas troops during the war proved that the colonies were vital to France's existence. Displays and monuments and the presence of African and Indochinese regiments at the exposition reflected the officials' convictions. The event showcased the economic and human potential of France and its overseas empire, following the pattern of the 1906 exposition.

After two successful colonial expositions in Marseilles, the organizers of the Paris Exposition coloniale internationale worked to create a showcase that would surpass the impact of the provincial events. In 1931, following years of administrative problems and several postponements, Lyautey and the organizers of the Paris exposition transformed the Bois de Vincennes,

a wooded park on the eastern edge of Paris, into an exotic world of foreign lands and cultures controlled by the powers of the west. The exposition was advertised internationally as "Le Tour du Monde en Un Jour" (Around the World in One Day). Chapters 5 through 8 will continue the examination of the communication of French racial and cultural superiority through expositions and trademark images in the period 1914–1940.

5
Sub-Saharan Africans:
La Force Noire

The world war demonstrates that these people of all colors, these 70 million Africans and Asians, France has made not subjects but citizens, and more than citizens: patriots.[1]

The participation of sub-Saharan colonial troops in France's struggle against Germany from 1914 to 1918 transformed the primary image of black Africans that government officials and entrepreneurs presented to the public in the postwar period. Instead of stressing the negative or "primitive" qualities of Africans and African society, many officials began to focus on the participation and performance of African troops in the conflict. The colonial *force noire*, a source of pride for the French army, provided a vital reinforcement for the continental troops. Over 160,000 black Africans fought and died for France in the trenches of Europe.[2] Advocates of colonialism praised the commitment and bravery of the black troops and argued that their presence on the side of France was a deciding factor in the final outcome of the war.[3] After the conflict, African soldiers stayed in the public eye. Some African troops remained on French soil in military bases and others were posted to the occupied Rhineland. Commercial images of the *tirailleurs sénégalais*, such as the one made famous in advertisements for the breakfast drink Banania, came into vogue during the war years.[4]

French supporters of colonialism expressed gratitude to black soldiers in a variety of ways. Organizers of colonial expositions in Marseilles and Paris praised black African soldiers in public and private forums for the help they provided to their white colonizers. In their speeches they claimed that since

the native troops had offered their physical strength to the French, France had the responsibility (*le devoir*) of training and providing for their societies. It seemed evident to French imperialists that the *mère patrie* should raise her colonial children to maturity.

The men who prepared the Exposition nationale coloniale in Marseilles in 1922 and the French sections of the Paris Exposition coloniale internationale in 1931 used creative methods to instill the utility of the African colonies in the mind of the metropolitan public and demonstrate that France had a parental role to fulfill. Organizers added new types of performances and exhibits alongside displays patterned from past fairs. Product trademark designers also responded to contemporary developments by placing pictures of West African soldiers and black performers on new trademarks.

The image of blacks as a *force noire* brought about new ways of interpreting the colonial relationship. During the interwar colonial expositions, French officials began to stress fraternal partnership and union with African peoples while maintaining an ideological framework of white racial and cultural superiority. The idea of partnership suggested a future of close collaboration where African economic and cultural contributions would be valued but where the French would continue to exert their "superior" position as a modern and civilizing nation.

This chapter explores the changing French depiction of sub-Saharan Africans during the period 1914 to 1940. It begins by focusing on the evolution of trademark images and moves to portrayals of Africans at the two major French colonial expositions of the interwar years. Finally, it considers the last major government attempt to highlight sub-Saharan Africa to the metropolitan public—the 1937 Exposition internationale des Arts et Techniques dans la Vie moderne. In the last years of the Third Republic, colonial officials hoped to keep the promise of the African colonies alive before the public, but the economic downturn and tensions in France and abroad limited the scope of attention the 1937 exposition devoted to overseas possessions.

Trademark Images, 1914–1940

Although French commercial images of American and African blacks changed after the Great War, the concepts of many trademark designs did not change. Blacks remained important symbols on trademarks for dark-colored products such as coffee, tea, cocoa, and industrial oils. Merchants continued to picture them as exotic subjects to draw attention to a variety of products that seemed to have no symbolic or geographical connection to black peoples. And entrepreneurs continued to show blacks as servants and laborers, just as they had in earlier years. These three uses of black subjects, which often coincided, characterized trademarks after the war.

In the trademarks registered in Paris and Marseilles from 1914 to 1940,

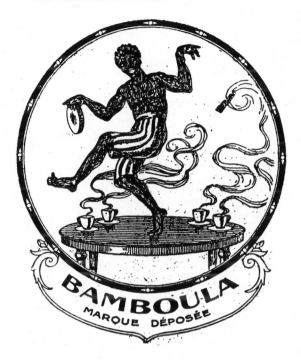

99334. — M. p. désigner des cafés verts et torréfiés, déposée le 4 juin 1926, à 15 h. 40, au greffe du tribunal de commerce de Marseille (n° 24530), par les *Etablissements V. et M. Carretier,* 63, rue d'Aubagne, Marseille.

Figure 8. Bamboula (Marseilles, 1926).

blacks remained important exotic subjects for attracting the attention of consumers. For example, the JAM spark plug company placed a black girl on its label with five spark plug "braids" extending out from her head and spark plugs as part of her dress (Paris, 1922). The 1931 trademark for Chocolat du Nègre (Paris) made no visual reference to the chocolate product but pictured instead a young African man guiding a log down a river. Other companies such as Papiers Abadie and L'Oléo (Société Générale des Huiles et Fournitures Industrielles) kept black heads on their trademarks through the 1920s.

After the war, coffee and chocolate remained among the top "black" or dark-colored products associated with Africans and blacks. The Bamboula label registered by the Carretier Etablissement in 1926 (Marseilles) depicted a dancing man wearing only striped shorts who was standing in the center of a table decorated with cups of steaming coffee, playing a tambourine (fig. 8). A 1928 label for Yacao cocoa (Marseilles) showed a large-lipped

black man sipping from a cup with the caption "Si Yacao, Y a Moyen" (If there's Yacao, there's a way). Also, shoe polish labels such as Vite et Beau Noir and Oeil Noir (Paris, 1919) continued the tradition of associating black images with positive qualities of products. Only one soap and bleach trademark, Eau de Javel Nègre blanc (Paris, 1922), mocked blackness as an undesirable quality; it featured a drawing of a black man scrubbing one side of his face white.

After World War I, there were fewer scenes of blacks in the plantation setting on French trademarks, but blacks continued to be depicted as servants and laborers. An example is the Compagnie Française de l'Afrique Occidentale's 1927 trademark for Carriers' Brand, Les Porteurs cotton thread and cloth. Using a wheel design, the drawing depicted an African porter at the end of each spoke balancing a load of cotton on his head. One businessowner pictured a black servant in the label for Moka-Bon coffee in 1928. The trademark showed a servant dressed in a tuxedo carrying a cup of coffee in one hand and holding a sack of coffee beans in his other arm. Beans were spilling from the sack, but the man did not realize it. Although the servant had a spiffy outward appearance, he played a buffoon. Such images conveyed the idea that blacks were simple-minded, incapable of completing menial tasks. Though they had "progressed" in trademark depictions from the fields to the "plantation house," they remained objects of ridicule to white masters.

A New Noir

Three new or expanded images of blacks stood out in commercial trademarks from 1914 to 1940. First, depictions of black African soldiers as protectors of France began to appear on a variety of product labels. Second, companies increasingly began to picture black children and childlike adults in comic scenes. Before the war, French trademarks had rarely been the source of such blatantly derogatory images. This development may have reflected a change in advertising design, a shift in perceptions of blacks, or a combination of both.[5] The trend began to appear in label drawings around 1910, after the colonial wars had ended and many African societies had submitted to French rule. Third, companies began to register trademarks with images of blacks or Africans as entertainers. French portrayals of black entertainers primarily focused on the urban nightclub scene, and entrepreneurs began to choose black nightclub performers and African drummers for trademark designs on various products. The use of these three images of blacks reinforced stereotypes of black "racial" qualities—namely, a unique physical prowess, limited intelligence, and a special talent for music and dance.[6] Brett Berliner and Petrine Archer-Straw point out that the attraction of the French to black culture in the interwar years was tied to a vital force they perceived to be present in the black exotic that they lacked. Negrophilia

coexisted with fear and disdain of black "primitive" traits in the minds of many French, and both attitudes were expressed in commercial images.[7]

The Soldier. French trademarks during the Third Republic portrayed black men in two different military roles: the ancient African warrior and the *tirailleur sénégalais*, the West African infantryman created during the Second Empire.[8] On the warrior labels, designers drew violent or threatening depictions of African men (and sometimes women). By the 1910s, with West Africa firmly under French control, trademark labels had stopped depicting Africans as a threat to their colonizers. The *tirailleur sénégalais* was a friendly and harmless character. Except for his uniform, little in his appearance or disposition communicated strength or military preparedness. The *tirailleur* images on trademarks presented blacks as carefree and childlike, quite unlike the depictions of the proud fierce African warrior. On one level, this visual depiction contradicted the government's rhetoric and praise of the *force noire* as disciplined and courageous. In publications, however, government officials in the colonial administration expressed views about the character of black Africans that were nearly identical to those in the trademarks. Instead of honoring the black troops, the image of the African soldier on trademarks mocked and belittled them.

The earliest trademark in this study's survey that included a French African soldier was Henry Charleville's Le Turco Noir, which was registered in Paris in 1904. Charleville's hosiery product label showed a bust of a *tirailleur sénégalais* wearing a cap and vest with a gun strapped over his shoulders. In 1912, Madame Josette Genet of Marseilles registered Kola-Soudan, an invigorating cola beverage. The label pictured an African soldier offering a Kola-Soudan to an exhausted French soldier who was resting against a boulder. Its motto read: "The Sudan offers its strength to France. Take it, Frenchmen!" Genet's label became a prophetic statement when West African troops fought for France on the western front a few years later.

During the period 1915 to 1925, ten businesses incorporated the *tirailleur sénégalais* image into their trademarks for products ranging from chocolate to water purification tablets. Half of these trademarks were registered in 1915, the year advertising posters for the French beverage Banania began to picture a *tirailleur sénégalais* tasting the banana and chocolate drink and declaring "Y'a Bon!" ("Dis be good!")[9] The expression stuck, and other businesses rushed to imitate and register versions of the Banania image formula. "Chocolat! Ya Bon!" combined the soldier image with the "black" advertising scheme traditionally used for the chocolate bar (fig. 9). Leon Goube registered his trademark, Ki-re-gal, Y a bon!, for a line of canned foods. The Ki-re-gal soldier held up a can in one hand and, with wide eyes and a big smile, tried to persuade the consumer to purchase the delicacy. His expression was jovial and carefree. The Kir-re-gal soldier depicted the stereotype of the *bon noir* or *bon nègre*—a harmless, infantile black figure who was devoid of power despite his military role. These imitators had some short-lived success, but

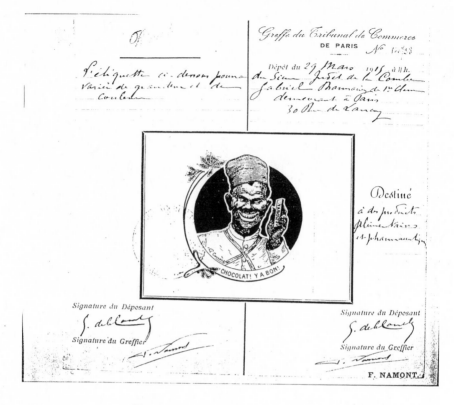

Figure 9. Chocolat! Y A Bon! (Paris, 1915).

more than ninety years after its creation, the Banania soldier's grin remains one of the most recognized and popular trademarks in France.[10]

The Child. Advertisers used humorous drawings of black children and childish adults on trademarks for a wide range of products. Most of these portrayals characterized young blacks as mischievous, simple-minded, ignorant, and unruly. Only one nineteenth-century trademark featured a black child—Chocolat du Négrillon (Paris, 1896). By the 1920s, French businesses had produced several of these images. For example, a mischievous child decorated the label for Café des Gourmets (Paris, 1922). Naked except for his white socks, the child drank from the spout of a coffee pot. As he sipped his beverage, most of the coffee spilled from the top of the pot onto the ground. In 1931, a Parisian hosiery and undergarment company established Petit Négro as its trademark. The label pictured a smiling black boy with two bulldogs pulling at the sides of his underpants.

With the growing popularity of the banana in Europe and the success

of Banania, a number of banana-based foods were registered in France in the 1920s. Two of these included children on their labels. The owner of Banavivic, l'Aliment complet (Paris, 1923) used a drawing of a black infant in a diaper drinking the beverage from a large cup. His hands were covered with oversized mitts to protect him from the heat. On the label for Super-banane (Marseilles, 1929), three excited black girls waited for their mother to offer them banana jam. They leaped in expectation, tossing bananas behind them while the mother sampled the product.

In the 1920s, entrepreneurs began to increase their use of comic portrayals of blacks that emphasized stereotypical qualities associated with the "race." These trademarks evoked the idea that blacks were ignorant and childlike—*grands enfants*. Alexandre Rannou et Companie of Marseilles selected a drawing of a black man climbing a date palm tree for their Honey Brand (1922) and Nigger Brand (1922, 1937) date products. The comic figure clung to the trunk of the palm, trying to munch on dates as his long legs and big feet dangled in the air. In 1930, the Compagnie Française des Boissons Hygiéniques (Marseilles) adopted a hideous drawing of a black dunce for its Yoyo Soda trademark. The character, who was drawn with a black cap, huge ears, and protruding eyes, contorted his face as he sipped from a straw placed in a dish. Paul Jachiet et Companie (Paris) used a comic drawing of a black man to sell black cotton thread in 1923 and 1938. Seated cross-legged and wearing only shoes and bracelets, the man's torso was represented by a spool of thread and his hair was pulled up by a magnet (fig. 10). The growing presence of trademarks such as these indicates that French commercial images of blacks actually became more demeaning in the early twentieth century. The most likely source for these caricatures is American images of blacks in publications, posters, and trademarks for items sold in France.[11]

The Entertainer. Images of blacks as entertainers began to appear on Parisian and Marseillais trademarks after the turn of the century. Prior to 1907 only one trademark illustration, the 1890 label for Les Soudanais cigarette papers (Paris), adopted this theme. In the 1920s, however, a series of trademarks began to picture blacks as musicians and dancers. This new image reflected changes in postwar French society, including the government's praise of black soldiers and a growing interest in black American entertainers in Paris.[12] This period marked the beginning of the Jazz Age, which was symbolized by its most famous figure in France, Josephine Baker. Some French businessmen used the black nightclub entertainer image to advertise their products, while others depicted traditional musicians in Africa on their trademark labels.

Several of the labels with black entertainers used unique designs. The Cafés Négrita label (Paris, 1923) showed a black showgirl seated on a crescent moon holding out a cup of steaming coffee. A dejected Pierrot the

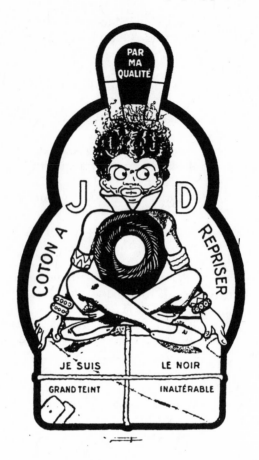

PAR MA QUALITÉ

COTON A

J D

REPRISER

JE SUIS LE NOIR

GRAND TEINT INALTÉRABLE

294458. — M. p. désigner des fils de coton, déposée le 24 octobre 1938, à 16 heures, au greffe du tribunal de commerce de la Seine (n° 325394), par la *Société à responsabilité limitée · P Jachiet et C₀ 243 b. rue Cadnette, Pa...*

Figure 10. Coton à Repriser (Paris, 1938).

clown climbed up a ladder to reach her. French entrepreneurs Jeanne and Marie Le Blanc registered their new cookies with the name Biscuits Black-Bottom and used a black saxophone player to illustrate the label (Paris, 1927). Cookies escaped out of the end of his instrument as the large-lipped man played his saxophone. In the same year, a Marseillais company pictured a black male dancer on its Charleston label for household and industrial

soaps. The man was dressed in tight white shorts and struck a dance pose. In addition to the nightclub scenes, ten other entertainer labels pictured African drummers and percussionists.

In these newer trademark depictions of sub-Saharan Africans and blacks, entrepreneurs tempered black strengths with comic, infantile images. The black African soldier never had a serious expression on his face, and black men and children were portrayed as buffoons. Images of nightclub entertainers portrayed blacks in a more realistic but stereotypical role. Even the positive portrayal of a *force noire* of musicians reflected the paternalistic views of Europeans toward blacks. Through their trademark labels, entrepreneurs showed French consumers that blacks were childlike beings whose role was to amuse and entertain them.

The Interwar Colonial Expositions

Where are we? Who are we? Is this star-covered sky the sky of Africa or of Provence? These shadows that pass, are they European or Senegalese? What does it matter? [I]t's everywhere and always la France. [T]hese primitive people live and suffer with us; they were soldiers; tomorrow they will be farmers, but they have lost the memory of their ancestors to adopt ours. By her genius, goodness and justice, France shines on the boundless bush, forest and desert.[13]

Government officials and imperialists rallied to focus the attention of the nation on its colonies in two major colonial expositions staged in the 1920s and 1930s: the Exposition nationale coloniale in Marseilles (1922) and the Exposition coloniale internationale in Paris (1931). From April to October 1922, the Marseilles exposition distinguished itself as the most extensive showcase yet of the peoples and resources of France's overseas empire. During the exposition's African Week, Governor General Martial Merlin of French West Africa lectured a group of African chiefs who had been invited to the exposition about their obligations to France and their need to inspire their peoples to act "in their mother's service" (*au service de leur mère*) as peaceful laborers for the French. Merlin's words reflected the exposition's focus on Africans' service to their French colonizers, mostly in the form of military assistance and physical labor to expand the region's economic contribution to France.

Through an examination of speeches, exhibits, and celebrations, this section will consider how colonial officials and organizers of the 1922 Exposition nationale coloniale propagated the image of service from Africans. It will also address how the French perceived themselves as fulfilling a maternal guiding role vis-à-vis their African colonies even as they claimed to act as their brother. The ambiguous images presented to the public at the Mar-

seilles exposition perpetuated the idea of black inferiority at the same time that organizers' discourse expressed republican values such as brotherhood and equality. By considering different aspects of the exposition, we will get a glimpse into the use of racial stereotypes and contradictory representations in defining the colonial relationship.

During the 1922 Marseilles exposition, organizing committees and colonial officials responsible for the exhibits and shows worked to emphasize the idea of the sub-Saharan African soldier as a *force noire* in service to the *métropole*. Lieutenant Colonel Charles Mangin used *La Force Noire* as the title of his 1910 book that praised the character and military skills of the West African soldier and outlined a scheme for increased recruitment.[14] At the Marseilles exposition, the army proudly presented African soldiers to the public in various settings. Sharply dressed *tirailleurs sénégalais* stood guard in and around the West African pavilion or performed in exposition festivals that highlighted their exoticism and physical abilities. But exposition displays or expressions of appreciation for the West African troops relied on western stereotypes of African primitiveness, childlike innocence, and teachability; Mangin felt that these were the qualities that made black soldiers so effective.

The featured exhibits at the 1931 Exposition coloniale internationale in Paris combined commercial exoticism with government propaganda to educate the public about the colonial empire in sub-Saharan Africa. Regional pavilions that incorporated African design schemes presented the history and economic development of each colony. West Africa, Equatorial Africa, Togo, Cameroon, and Madagascar each displayed its own economic *force noire* in native villages where artisans performed their trades before the public. Colonial officials used these traditional villages and their temporary inhabitants to depict "primitive" Africa in contrast to the manufactured goods and modern technology shown in the metropolitan section of the exposition. This juxtaposition of cultures was meant to prove the need for France's parental civilizing role in its African territories.

Featured Exhibits

French West Africa. In 1922, a different kind of "black force" that could serve France was on display in the West African exhibit, where organizers displayed the labor potential of African farmers and craftsmen. A West Sudanese-style pavilion, inspired by the architecture of Djenné and Timbuktu, was the centerpiece of the African section. To this African structure, the designer added a 50-meter tower with an elevator that provided a view of the entire exposition site. Within the pavilion, committees of businessmen and colonial officials from Africa displayed samples of the best export goods the continent had to offer, including nuts, textiles, palm oil, and woods. Colonial officials placed a large monument inside the main hall to represent Franco-

Figure 11. West African dancers performing at the 1922 Exposition nationale coloniale du Marseille.

African cooperation during the war entitled "A la gloire des créateurs disparus et de l'Armée de l'A.O.F" (In Praise of the Departed Creators of the Army of French West Africa). The base of the monument was a five-sided pedestal honoring the colonizing work of Faidherbe, Ballay, Ponty, Clozel, and Van Vollenhoven. Topping the pedestal were statues of a French colonial soldier and a *tirailleur sénégalais* "marching together towards victory."[15]

Opposite the pavilion, a West African village surrounded a manmade lake and a small stream separated different "authentic" exhibits. One area included a cluster of huts, a small animist temple, an aviary with exotic birds, and an infirmary. Another section contained a small farm with domestic animals, a granary, a mosque, a military post, and a set of artisan workshops and boutiques. Nearly 100 Africans inhabited the village—men, women, and children who engaged in daily activities on the farm, in the shops, or by the lake. This was more than twice the number of participants at the West African colonial section of the 1900 Exposition universelle. The workshop area featured cloth weavers, smiths, tanners, and jewelry makers from Senegal, Mauritania, and Dahomey who sold finished products to the public. Dancers from the Ivory Coast and Moors from the Trarza region of Mauritania entertained European crowds in the village square (see fig. 11).[16]

At the 1931 Exposition coloniale internationale, the Government General of West Africa showcased the people and products of its region in four

dwelling areas. The artisans present from Senegal, Ivory Coast, Niger, Mauritania, French Sudan (Mali), Guinea, Upper Volta (Burkina Faso), and Dahomey (Benin) greatly surpassed the number who attended in 1922. Furthermore, the French army had selected and trained hundreds of *tirailleurs* to take part in parades and special theatrical performances. In addition to these presentations, exposition organizers showed films and sold monographs that described the colonies to visitors. The impressive number of sub-Saharan Africans and the villages, festivals, and performances created a grandiose exotic spectacle and illustrated the success of the French nation in its tutoring of colonized Africans and its economic development of its colonial holdings.

The West Africa section in 1931 covered 3.5 hectares (8.65 acres) and was located south of Lake Daumesnil on the edge of a major exposition walkway. For the main pavilion, the architects followed the same basic design used for the two Marseilles colonial expositions; they constructed a clay-walled western Sudanese palace, or *tata,* 5,000 square meters in dimension, that featured three towers, one of which had an elevator. Inside the palace, the seventy-two European and African exhibitors displayed their agricultural products, industrial goods, and art.[17]

The remaining buildings for the section were arranged around the palace. On the right stood a "reconstituted" Sudanese village, complete with its own commercial street—the Rue de Djenné. The Government General also constructed a trading depot and a small-scale version of the famous Djenné mosque where visitors could view films prepared for the exposition. To the left of the palace were an African forest settlement and a lakeside village, similar to the one presented in Marseilles, with several huts elevated above a manmade lake. As they had in Marseilles in 1922, organizers included a menagerie of small African animals and an aviary. They presented the French Sudanese village as a demonstration of the lifestyle of Islamic groups, while the lakeside village presented the customs of the animist populations.[18]

Both villages functioned as worksites for the dozens of Africans on display during exposition hours: cloth weavers, jewelers, coppersmiths, sculptors, potters, fishermen, canoers, and camelkeepers who sold rides. Most of the 200 participants actually resided in a protected casern furnished with electricity and heat, to which they returned at the end of each day. This arrangement, according to the official report, protected the private lives of the "natives" from the public's curiosity and immoral influences.[19] As at the Marseilles exposition, the commissioner general established an infirmary on site to ensure that any illnesses among the African contingent would be treated promptly. These two measures protected the government from accusations about inadequate health care and poor treatment of the African workers—concerns that were the result of problems at earlier expositions.[20]

The Government General of West Africa provided the public with regular entertainment outside the villages and pavilions of the African exposition.

Official exposition programs announced the "Exotic Dances, Songs, and Customs" that occurred daily at 3:00 PM. Other entertainment features of the section were outdoor films, camel and donkey rides, and dining and African dancers at the Restaurant de l'Afrique Occidentale Française. According to the commissioner general's report, "Our great West African possession offered a real vision of a corner of black Africa, transported from the banks of the Niger River to those of the Seine, with a note of respectable exoticism that drew and retained the crowd."[21]

Visitors interested in a deeper look at West Africa could purchase colonial *notices* in the offices of the Cité des Informations (a clearinghouse for colonial trade statistics and information), in the colonial pavilions, or at the bureau of the commissioner general. The Government General of French West Africa, in conjunction with the Commissariat General, prepared nine publications for the exposition of 1931—one general volume edited by Roger Delavignette, a colonial administrator; seven treating each of the West African colonies; and one on the city of Dakar, Senegal. Texts were also written for the mandated territories of Togo and Cameroon. The texts explored the themes of African racial, physical, and moral traits; the degree to which Africans were a potential labor force; and African responses to French influence in the territories.

The concept of "race" varied from author to author in the *notices* on West Africa. For example, in the publication on Senegal, race was defined not only by pigmentation but also by cultural and character traits. The authors began with the Moors, the "white" race, then presented the Peuls, the "brown" or Semitic race, followed by different "black" racial groups. Within the black groups, they classified races according to intelligence and religion. The less the culture of the African group resembled that of the Europeans, the more the authors disdained it. They made the same assessment for differences in physical features such as lip shape and size. We might then expect that the Muslim Wolof, whom the French considered to be handsome and very intelligent, would be among the Senegalese races the authors praised.

Some *notices* emphasized both the physical traits and moral shortcomings of West Africans. *La Mauritanie* included a poetic description of the frame, skin, hair, and facial features of "the great nomad of the desert."[22] It praised Moorish women for their beauty, but the authors felt that their physical attractiveness was often ruined by their plumpness, which Moorish men preferred. The authors wrote that "nothing speaks more strongly to [the] heart [of a Moorish man] than a young woman rendered misshapen, impotent, beneath successive layers of intrusive fat."[23] But the Moor's greatest flaw, in the view of the French authors, was his independence, pride, and violence.

> Pride, the desire to be noticed and to play the great lord, dominates his thoughts. To satisfy his likings, he excuses theft, allows plundering, and tolerates assassination. This is why every chief feels surrounded by diffuse

hostility and discreetly keeps a constant eye on those he suspects want to succeed him.

Only since French occupation have the Emirs of Mauretania, restored by our authority, been able to hope to leave this world other than by a discreet bullet or a skillfully handled dagger.[24]

For these authors, only France's civilizing influence enabled the Moors of Mauritania to establish a stable political system. The French prided themselves on bringing the violent political leadership under control and saving Mauritanians from their own iniquity.

The ethnographic descriptions also focused on the occupations and labor potential of each African population. *Le Soudan* highlighted the labor and service the five "black race" groups—the Tukulor, Songhai, Mandingo, Senufo, and Voltaic—provided to France and the potential they held for filling future labor force needs. According to the authors, Islamic Tukulor served honorably as soldiers and as laborers for the French on public works projects in spite of their independence and pride.[25] The authors felt that the Mandingo groups from central Sudan could also be of use to their colonizers, especially the Bambara, who were distinguished for their energy, hard work, and performance as *tirailleurs* in the French army. *Le Soudan* called the Senufo hard workers and "patient and methodical" farmers who were "very backward when it comes to exterior civilization but adroit with their hands. . . . They are a people imminently suitable to provide the workforce—without initiative but easily dirigible—especially needed for the development of a new country."[26]

The other groups, the Muslim Songhai and the animist Voltaic, worked as farmers, herders, fishermen, and merchants. None were praised for exceptional skills that were useful to the French. These ethnographic descriptions indicate that by 1930, French administrators were familiar with the cultures and livelihood of the people they ruled over and had classified and labeled qualities they identified as their particular strengths and weaknesses. Officials seem to assert in these texts that all African peoples could serve them in their mission to develop the colonies as long as the capabilities of each race remained under the control of the colonizer.

French Equatorial Africa. In sharp contrast to the West African exposition, the 1922 exposition for French Equatorial Africa highlighted the practical economic value of France's territories in the postwar period. European-style buildings with Cameroonian wood housed the exhibits. These held product samples, documents, a panorama of Captain Jean-Baptiste Marchand's travels in the Congo in the 1890s, and informative displays on the colonies of Gabon, the Congo, and Cameroon. In a symbolic gesture, the Government General of Equatorial Africa offered the buildings to a village in the Pas-de-Calais that was heavily damaged during the war. This act demonstrated in a practical way that colonial exports could help rebuild postwar France.[27]

The 1931 colonial exposition emphasized exotic and representative displays, and administrators from French Equatorial Africa sought to create an authentic African environment. Equatorial Africa's official pavilion, which was painted with colorful traditional designs, was an impressive circular wood building with a 20-meter narrow dome in the center of the roof. The architect claimed that its design and decoration were modeled after habitations he had seen along the shores of the Congo River.[28] Inside the pavilion, the government presented economic, cultural, ethno-demographic, and historical displays concerning the colonies of Gabon, Moyen-Congo, Ubangui-Chari, and Chad. These included dioramas; an gallery of indigenous art that included fetishes, masks, musical instruments, and arms; a gallery that presented the exploration and conquest of the Congo; and exhibits by thirty-three individuals and companies. Nine other exhibitors organized separate stands outside the main pavilion.[29]

Whereas the lack of funds made it impossible to send artisans to Marseilles in 1922, Equatorial Africa employed twenty-two Africans to demonstrate their trades at the 1931 Paris exposition. Two dozen family members accompanied the craftsmen. The French army also sent a detachment of thirty-three *tirailleurs* to guard the section and serve as honor guards. Like the West African contingent, the participants from central Africa worked in the village huts during the day but retired to modern buildings next to the village each evening.[30]

Although the final exposition report on the Equatorial Africa village emphasized the resources and talents of the region, the preliminary press release about the section (which was released eight months before the event) provides a lucid example of how officials appealed to common myths and stereotypes of a dark savage Africa to attract audiences to the exposition. In October 1930, the Commissariat General urged its readers not to miss the Pahouin that would be displayed in the Afrique Equatoriale Française (AEF) section because they "were not ordinary Negroes" due to their Nilotic origin and lack of the usual negro physiognomic traits. These "natives," according to the release, were the descendants of cannibals civilized by French control. The article concluded by assuring the reader that exposition visitors "will be able to approach them without fear—they will not eat anyone!"[31]

French Mandates in Africa. The League of Nations French mandates of Togo and Cameroon also had a place in the exhibits in the Bois de Vincennes where the 1931 exposition was held. A small pavilion housed documents and displays concerning economic, medical, and cultural progress the French administration had brought to both territories. Only eighteen exhibitors sent samples of their products or industries to Paris. They included mining companies, construction firms, and coffee, cocoa, and palm oil plantations. According to the official report, the number of exhibitors was low because of the economic crisis.[32]

The Depression notwithstanding, government organizers designated funds to transport thirty-one Africans from the mandate territories to Paris. Tanners, jewelers, and cloth-weavers crafted and sold their goods to visitors from the village's huts. Several canoers also demonstrated their skills on the lakes near the exhibit. A police station built to resemble a Bamiléké hut housed a group of Cameroonian and Togolese militiamen who guarded the section around the clock. The contingency from these French protectorates lived in a modern barrack near the site with the other African participants.[33]

Madagascar. The island colony of Madagascar, which had been one of the featured colonial sections in the 1900 Exposition universelle, played a much smaller role in the interwar expositions. In 1900, the island had just been acquired as a French territory, which probably accounts for all the attention it received at that year's fair.[34] French officials claimed there was no "Malagasy" style to replicate, therefore architects for the 1922 event constructed a European pavilion as the Madagascan palace. The exhibit inside the building contained the usual economic statistics and product samples, along with an ethnographic display that included photographs of characteristic racial types. However, in 1922, the colonial government in Madagascar did not send over any Malagasy to be displayed as workers or performers, and the Indian Ocean colony was no longer associated with the sub-Saharan African colonies in the layout of the exposition grounds. By a combination of circumstances, the committee in charge of the locations of the regional expositions assigned Madagascar a terrain just north of the Indochinese section. Literally and figuratively, the island had drifted away from Africa. It is unclear from official reports whether the diminished presence of the colony was due to budgetary constraints or to a decision to eliminate the fanfare with which Madagascar was presented to the public at the turn of the century.

Madagascar regained its splendor at the 1931 exposition. The architects of the Madagascan palace in 1931 adopted basic elements of Malagasy design that officials had claimed did not exist ten years earlier. As a purely aesthetic move to offset the horizontal lines of the palace, they added a 50-meter tower with sculptured zebus heads crowning the top. This tower, the Tour des Bucrânes, became a special attraction at the exposition.[35]

More than 1,000 government services, private individuals, and groups exhibited at the Madagascan exposition, a sign that organizers in the colony had succeeded in encouraging agricultural producers to participate. Seven hundred of the exhibitors who sent product samples were Malagasy rather than European colonists. The impressive economic exhibit included samples of coffee, sugar, textiles, forestry products, minerals, and pottery.[36]

Over sixty Malagasy worked at the exposition in various capacities. Nearly half were entertainers in a theatrical troupe. The remainder were artisans, canoers, children, and civil servants. The Malagasy group—with the exception of the performers, who had special lodging in the theater—were

housed in fifteen thatched-roof clay huts on the exposition site.[37] No officials expressed any misgivings about the Madagascans' housing arrangements or possible risks to their health, in contrast to the concern some voiced for other African groups. In fact, this different standard of treatment reflects the tendency of French administrators not to view Madagascans as "African."

The Government General of Madagascar presented its views on the unique ethnic makeup of the Malagasy in a publication prepared by a chief colonial administrator named Jules Gaston Delelée-Desloges. In his section on "Les Peuplades" of the island, Delelée-Desloges explained the complex ethnic composition of the colony according to geographical region. He referred to the Asian Bara as "the colony's most vigorous human branch: tall, slender, well-proportioned, solidly built; they show a profound resemblance to [*ils accusent profondément*] the Negroid type." He described the Negroid Sakalava as a "tall, vigorous," warrior people, and the Antaisaka of Indonesian origin as "very intelligent people, hard-working, robust, tough, very thrifty." Delelée-Desloges often viewed Asian populations as intelligent and reserved his greatest disdain for the African Sakalava. As in the other sub-Saharan texts, the Madagascar *notice* assigned "black" groups the least desirable traits.[38]

Special Events, Festivals, and Entertainment at the Expositions

Exposition organizers designed the featured exhibits in the pavilions primarily to educate visitors, but they believed that formal appearances and entertainment by African performers and soldiers were the key to rousing public interest in the empire. At the 1922 Marseilles exposition organizers had given their full support to a plan by a group of French colonists to honor the efforts of African soldiers in the European war. The Committee for the Heroes of the Black Army sponsored a fund-raiser at the exposition in the hope of erecting a special monument to the soldiers in Bamako (Mali). With the assistance of several military figures and West Africa's exposition commissioner, Camille Guy, the committee organized a military festival. General Mangin presided over the festival, which took place on the Grande Esplanade of the exposition grounds. It included a variety of events involving soldiers and civilian performers from Africa and Indochina. The most noteworthy segment of the festival was a procession that began at the West African palace. A long cortège of African "kings," members of their court, and dancers and musicians from the colonies was followed by a group of African military athletes. An article in the exposition's *Journal officiel* described the physical prowess of these athletes, who had been brought together from colonial regiments stationed in Marseilles and nearby Toulon. Referring to the "superb, strapping fellows whose muscles pressed against their white t-shirts," the author marveled at the quality of the group exercises the men

performed. The soldiers demonstrated a variety of sporting activities such as the javelin throw, foot races, and tug-of-war.[39] The athletic portion of the festival ended late in the day with presentations of Madagascan dances, "fantastic evolutions by Negro griots," and the performance of two songs, "La Madelon" and "La Marseillaise," by a Senegalese choir. At nine in the evening, the fund-raiser concluded with the illumination of fountains and alleys in the exposition's park and a complete colonial parade in the presence of "a considerable number of satisfied spectators."[40]

The Colonial Ministry and French organizers increased the number of sub-Saharan Africans in exotic roles at the 1931 Exposition coloniale internationale and continued to emphasize their physical strength and prowess as part of their primitive nature. Exposition officials could rely on Parisian audiences to attend these programs because by the 1930s the French had been paying for decades to see blacks perform in theaters, clubs, and cabarets.[41] Indigenous people from the French territories participated in the dozens of shows, festivals, and presentations organized by the Commission des Fêtes et Spectacles (established by the Commissariat des Fêtes), an 83-member planning body. These events generally took place in the theater of the Cité des Informations or at the adjacent stadium.

Essentially, the events fit into four categories: special ceremonies, theme festivals and parades, theatrical performances and reviews, and "conference-spectacles." The exposition events the commissariat sponsored involved several French professional groups and about 1,000 entertainers and soldiers from the colonies, including nearly 400 from sub-Saharan Africa. With exotic scenery, music, and numerous participants, these performances evoked African traditions and rulers. Yet they often emphasized the physical abilities of Africans more than their other qualities or talents. In the *Bulletin d'Informations* in 1930, the Commissariat General proclaimed that the participation of native troops in festivals and planned sporting events would show their "physical and moral value" and "demonstrate the excellence of our methods in hygiene and the physical perfecting of the races."[42] As Alice Conklin and others have shown, the French conceived of their mission to civilize Africa in a way that included improving the bodies of the colonized peoples, and the exposition provided a forum for demonstrating the supposed success of that endeavor.

The most widely viewed ceremonies involving African participants were the inauguration of the exposition and the Bastille Day parade. For both of these events, the Commissariat des Fêtes relied on a special detachment of indigenous and French colonial troops that had been recruited to serve at the exposition. The army selected 419 African and Indochinese soldiers and trained them at a military camp at Fréjus, near the port of Toulon. In this group were 169 West African and 90 Malagasy troops. From January to April 1931, these soldiers spent their mornings preparing for military pa-

rades and their afternoons coordinating processions that included African drummers and dancers and parade floats. The inauguration of the exposition featured native colonial troops lining the entranceway to the exposition site in honor of the president of the republic, Commissioner Lyautey, the colonial minister, and other French and foreign dignitaries.[43]

The colonial army units serving the Commissariat des Fêtes took part in a regular series of parades and festivals with special themes. While at Camp Fréjus, each regional group prepared a cortège that evoked the precolonial past in Africa. The men made their own costumes and floats.[44] In the Dahomean cortège, the "savage" King Behanzin was carried in his royal hammock and accompanied by his ministers, guards, warriors, and amazons. The Madagascan cortège presented the former Queen Ranavalo carried in a *filanzane* chair. Similar Malagasy and West African cortèges were incorporated into a biweekly children's gala cleverly called "Le Tour du Petit Monde en Quatre-Vin . . . cennes" (or *quatre-vingts scènes*; eighty scenes).[45] In addition, beginning in mid-July, a colonial cortège proceeded down the streets of the fair every Sunday. These parades ended with acrobatic demonstrations by the "athlètes noirs de l'Ecole de Joinville," also known as the "Bloc Noir," a group of 200 colonial soldiers trained for the exposition by gymnastic instructors at the specialized military school.[46]

Exotic musical and dance performances sponsored by the Commissariat des Fêtes that were held in the Cité des Informations were one of the highlights of the Exposition coloniale internationale. The commissariat's staff prepared four alternating shows of short performances by colonial and metropolitan entertainers. With tickets selling for 15, 20, or 30 francs, the programs attracted middle-class and elite audiences.[47] Two of the four alternating "spectacle" formulas featured performances by sub-Saharan Africans. The "Nuits coloniales" program included segments with Malagasy and West African performers such as *tam-tam* drum groups from the Ivory Coast. "La Féerie africaine" show offered an imaginary voyage to the lands of French Africa, beginning with Algeria and ending with Madagascar.

"La Féerie," which featured well-known European performers, was an artistic version of cooperation between the *métropole* and Africa. Two European troupes of showgirls familiar to Paris and London theaters—the Mangan Tillerettes and the Carlton Girls—performed with a Malagasy singer during the premier show. On a different program, twenty dancers from the Théâtre National de l'Opéra and Saras from the Ecole de Joinville collaborated on a dance called "le Ballet blanc et noir," in which 100 African athletes, barefoot and dressed only in black shorts, took the stage with French ballerinas in white tutus. When the athletes lifted the dancers overhead, Africa was symbolically raising up the fragile *métropole*. The program organizers probably hoped audiences would interpret this bicultural performance as a symbol of cooperation or simply as an entertaining exotic display of French-trained

African athletes and classical dancers. By pairing the petite ballerinas with the strong African soldiers, however, the performance also suggested that France was inadequate without its colonies and was in a position of weakness. Although reviews of the show the raved about its contrasting colors and forms, they took particular note of the talent of the Sara soldiers.[48]

The Commissariat des Fêtes also organized paid conferences that concluded with entertaining displays of sub-Saharan Africans. The conference hosts were known personalities in bourgeois literary circles. In September, Pierre Bonardi, author of *Le visage de la brousse,* gave a lecture entitled "L'Ame noire" (The Black Soul). His talk concluded with performances by the "Bloc Noir" Sara soldiers and others trained at Joinville. The commissariat added this type of exotic performance to the academic conferences to increase attendance because, apparently, even celebrated authors were not enough to ensure a full auditorium.[49]

Each of the festivals and events that included black Africans at the Exposition coloniale internationale contributed to Commissioner General Lyautey's plan to "charm the eye of the visitor by a variety of shows able to create an exotic atmosphere and familiarize him with the mores, customs and numerous aspects of the lives of our native populations."[50] Fernand Rouvray[51] and his collaborators from the Commission des Fêtes et Spectacles, including army officers, publishers, cinematographers, theater directors, and sports advocates such as Pierre (le Baron) de Coubertin of the Olympic games, supported the programs that presented black African soldiers as a *force noire*—men whose sole identity rested on the notion of their primitive strength. Exposition officials mocked what they viewed as a backward and barbarian precolonial Africa when they repeated parades of defeated leaders such as King Behanzin and his warrior court. The panoply of exotic programs and festivals implied French superiority over sub-Saharan subjects, even if government officials claimed that the exposition's goal was to illustrate the *union* between France and the exotic—but not inferior—races of the empire.[52]

The major colonial expositions held in Marseilles (1922) and Paris (1931) strove to convince the French public that its colonies in sub-Saharan Africa offered the *métropole* valuable human and material resources. After World War I, colonial officials began to frame colonial propaganda in terms of a cooperative relationship or exchange between two partners. Gone was the idea that the colonies had to be administered by a policy of assimilation to French culture and values. In the new cooperative view, the *mise en valeur* (economic development) and the future of the empire depended on a union or association between France and its African brothers, its *frères de couleur*. Some of the bicultural spectacles evoked the theme of Franco-African brotherhood that exposition officials promulgated. Speeches about brotherhood and equality with black Africans by Marshall Lyautey and Colo-

110

nial Minister Paul Reynaud meant little, however, because the premise of exposition exhibits and displays was that Africans were exotic and less evolved than Europeans. Exhibits and performances posited their physical strength and cultural traits as primitive qualities and emphasized the labor force they represented for the French.

Colonial officials seem to have adopted the metaphor of the fraternal relationship for two reasons: to exploit and maximize the public's perception that sub-Saharan troops were crucial in winning the Great War and that Africa's human resources were essential to France and to dispel the growing claims of anticolonialists about the racism and cruelty of the colonial enterprise.[53] In 1931, for the first time, opponents of colonialism organized an exposition to present the real situation in the colonies to the public; they also tried to disrupt events at the exposition. Their efforts failed under pressure from the authorities.[54] Imperialists had the force of the state behind them and they were able to control the representation of "race" in France throughout the months of the exposition.

Sub-Saharan Africans at the 1937 World's Fair

In the last years of the republic, officials continued to emphasize the vital role of the colonial labor force for the prosperity of France. The 1937 world's fair, the Exposition internationale des Arts et Techniques dans la Vie moderne, promoted the ideas of progress and tradition in the production of consumer goods in France and in the empire. When the Popular Front government came to power in 1936, it inherited an exposition project conceived and molded by previous republican governments from as early as 1929.[55] The real highlight of this exposition was metropolitan France and its people. Each region of France, the French overseas empire, and each foreign power that participated in the world's fair had a "regional center" with exhibit halls and displays that featured artistic and technical achievements and traditional culture. The organizing commission responsible for the French overseas territories, or France d'Outre-Mer, focused on the theme of artistic forms in the colonies. Neither the civilizing mission nor the development of the overall economy took center stage in 1937; instead, the exposition focused on the productive capacities of colonial workers in traditional crafts. In a June 1936 speech, Henry Bérenger, president of the commission who was also a senator from Guadeloupe, emphasized that the upcoming exposition would not repeat the scale or the rampant exoticism of the 1931 exposition.[56]

Organizers agreed that the colonies had to be represented in an honorable fashion, but little space was available at the site along the banks of the Seine. Exposition officials came up with the inadequate solution of placing the entire colonial exposition on the Ile des Cygnes, which was located be-

tween two major bridges—the Pont de Passy and the Pont de Grenelle. A construction company managed to quadruple the 8,000-square-meter capacity of the island by building large platforms along its outer edge.

The confining location and the need for extensive construction before pavilions could be erected displeased a number of colonial officials. Gaston Pelletier, the director of the Economic Agency of Madagascar, resigned his position as commissioner of the Madagascar exposition because of the limitations of the Ile des Cygnes site. He based his objections on issues such as the risk of fire, possible delays in installing the exhibits, and the health of the Africans who would be housed on the island.[57] Likewise, the commissioner of Equatorial Africa objected to the housing of African artists for months on the "unhealthy" Seine River.[58] Despite these complaints, construction plans for the overseas exposition went forward in the spring of 1936.

Featured Exhibits in 1937

French West Africa (AOF). The exhibit of French West Africa was located near the center of the Ile des Cygnes at the 1937 world's fair. The Government General of the territory continued the pattern of previous expositions by emphasizing "faithful reproductions" of African structures to house the product exhibits and artist workshops. French architects designed the main pavilion, which boasted a tower thirty meters high, to be a reproduction of the Djingareber mosque in Timbuktu. Other structures included a Sudanese village with shops (as in 1931, modeled after Djenné), a store where visitors could purchase items crafted by Africans, a cinema, and a tasting booth where hosts offered samples of chocolate, fruit, and coffee from the Ivory Coast. Exposition designers made use of their water-bound location to create a Dahomean lakeside village with houses on stilts and canoes for transportation. They also reserved a small area for traditional Saharan tents occupied by Moorish and Tuareg artisans.[59]

For the colonial sections, the exposition title of "arts and techniques in modern life" referred to traditional artistry and crafts, especially those that could be produced for consumption by Europeans. In the West African section, visitors observed metal craftsmen, jewelers, sculptors, and cloth-weavers, as they did at previous expositions. The army sent a detachment of ten *tirailleurs sénégalais* and two officers for duty in the section. Entertainment was provided by a drum group; three puppet theater groups merged into one, called the "Guignol soundanais"; and a group of young actors from l'Ecole William Ponty that performed plays about African history and folklore.[60]

French Equatorial Africa (AEF). The plans for highlighting the traditional crafts of Equatorial Africa did not proceed with as much enthusiasm as the plans for the French West Africa region. The Paris-based official of the Economic Agency of French Equatorial Africa seemed perplexed when first contacted by the Colonial Ministry about presenting Equatorial Africa in an up-

coming exposition of "arts and techniques in modern life." Monsieur Cottret felt that the work of artisans in AEF could not compare to that of other colonies. Instead, he proposed that the AEF exhibit highlight France's success in saving central African societies from cannibalism, disease, and famine— contributions previous exhibitions had stressed.[61] Eventually officials from AEF, under the direction of the organizing commission in Paris, put together a demonstration of artisanry that featured workers and samples of a variety of crafts that were displayed in an exhibit hall.

The Equatorial Africa section stood near the center of the Ile des Cygnes, framed by the West African and Algerian sections—or, as Albert Prévaudeau, commissioner of the AEF section wrote, between "her two big [colonial] sisters."[62] It was composed of Congolese- and Gabonese-style huts, a gallery divided into eight workshops, a small art store, and a main European-style pavilion. A 13-meter-tall totem greeted visitors as they approached the section. The main pavilion, which was also referred to as the museum, was decorated by French artists with murals, a map, friezes, and a bust honoring Pierre Savorgnan de Brazza, explorer of the Congo. Inside were eight displays of a variety of objects that included weapons, carvings, paintings, and ivory sculptures.[63]

Fourteen Africans were sent to Paris to participate in the exposition—six ivory and leather workers, three soldiers and their wives, a young boy, and a nurse. Officials began recruiting them in February 1937, several months before the scheduled opening of the exposition. Initially, the colonial government in Brazzaville sent out a series of telegrams to regional outposts asking them to select artisans with specific skills based on a list Commissioner Prévaudeau had sent. But the governor general in Africa modified the list. Unable to resist the opportunity to display another exotic race, he explained, "It seemed interesting to me to add to your list a pygmy artisan from the deep forest and his wife. This Babinga couple and the primitive techniques of pygmy artisanry will be a great attraction."[64] The AEF commissariat's original plan was to send a group of forty Africans, but in the end the budget could only support half that number. After recruiting problems in Africa and construction delays in Paris, the African contingent arrived for the exposition in mid-June 1937. The section was opened to the public on July 9.

The lives of the African artisans, soldiers, and their families were completely organized by the commissariat of the section. Ivory carvers and leather craftsmen worked from 10 AM to 6:30 PM. They were paid 200 francs per month plus half the profits from their crafts sold in the official shop. French meals, cafeteria style, were provided by the contractor who ran the Restaurant de l'Algérie in the nearby Algerian section. The commissariat also provided warm clothing and shoes in the fall. While the artisans labored in their workshops and the soldiers kept guard over the pavilions and the grounds, the public discovered the artistic creations of Equatorial Africa.

The Economic Agency of the AEF distributed informational brochures and displayed a new magazine by Afro-Caribbean author René Maran, *Afrique Equatoriale Française, terres et races d'avenir.*[65]

French Mandates in Africa. Several totem poles and a large mask above the main pavilion's entrance greeted visitors to the Cameroon exhibits. The pavilion architects imitated the style of a Peul home from the Adamaou (or Saré) Plateau, creating an eleven-meter dome in the center of the roof. Spacious rectangular wings extended from the center of the building. Instead of continuing with the Peuhl motif, the interior decoration featured Bamun art. It included furniture, paintings, wooden vases, statuettes, and drums. There was no pavilion for the other territory under French mandate, Togo, because its administration lacked funds. A few items from Togo were displayed in the AOF section.[66]

Cameroon dispatched seven artisans to Paris in 1937—embroiderers, wood and ivory carvers, and a cabinetmaker. Officials from the mandate territory decided to house the men in a basement area of the pavilion. Just as Gaston Pelletier, head of the Economic Agency of Madagascar had feared, this housing arrangement led to a dangerous situation in October, when two of the men suffered carbon monoxide poisoning from an illegal stove they placed in their living area so they could keep warm. When the fire department informed exposition officials about the incident, a French official from the Cameroonian section hurried some of the men to La Samaritaine department store to purchase sweaters, socks, raincoats, and other items to protect them from the blustery fall weather.[67]

The artisans drew considerable attention as they worked behind a railing around the pavilion. An article in the exposition's daily program called the Cameroonian area more "vibrant" than the other sections. Writer Estelle Pascal interviewed the men and discovered that only two had learned their crafts the traditional way, from their relatives. The remainder had been trained in France's Ecole professionale.[68] This leads to the question of how authentic the skills African artisans at the exposition displayed really were. French trade schools, such as the one these Cameroonians attended, could introduce new techniques or shift the emphasis in indigenous artisanry to more readily serve the needs and tastes of the colonizer. The French-trained craftsmen on display in the colonial section are examples of France's effort to reformulate a local tradition, possibly in aesthetic form, through western instruction.

Madagascar. The "Grand Island" made a noteworthy but limited showing in 1937 with a decorated pavilion designed as a wealthy Madagascan home. Pieces of art and traditional crafts—wooden sculptures, woven straw mats, fine jewelry, and other crafted objects—adorned the Maison Malgache.[69] Just outside the *maison* were simple huts where the four Malagasy artisans at the exposition plied their trade. The official report of the exposition em-

phasizes the fact that Madagascar lacked a strong artisanal tradition until two administrators—Governor General Galliéni (1901) and Marcel Olivier (1929)—opened institutions to promote traditional art. Instructors in the Atelier d'Art, which Olivier founded, forbade students to imitate western styles and encouraged them to use their own imagination. Had it not been for this policy, the French claimed, traditional art in Madagascar would have completely died out.[70] Even in the realm of art, the civilizing mission could function to "rescue" or "uplift" an element of African culture.

The Malagasy received special treatment in comparison to other African workers in the French colonial section. At the end of each week, the Madagascan French officials at the exposition paid the artisans 50 francs a day (much more than 200 francs per month paid to the men from AEF), but they were responsible for providing their own meals and lodging.[71] Instead of being housed on the island, they retired to a private pension an exposition official had secured for them. A battalion of Malagasy soldiers (eleven men at the height of the exposition) served at the Madagascan section and around the island. As did the other sections on the Ile des Cygnes, Madagascar opened more than a month late, on July 22.[72]

Special Events and Entertainment

The sub-Saharan African sections in 1937 offered visitors other amusement beyond the craft workshops on the Ile des Cygnes. Music was always in the air at the West African section, where the five-member *tam-tam* drum group from the Sudan performed regularly. The Guignol Soudanais began performing puppet shows with songs and dances daily in early July. And young actors from the Ecole William Ponty graced exposition stages with French versions of African stories such as the "Légende de Soundiata" of Mali.[73] In addition to these live performances, the AOF cinema presented six and a half hours of documentary films each day on geographic and social themes.[74]

On several occasions, organizers asked Africans to participate in special programs. Tam-Tam Soudanais entertained an audience of 10,000 as the opening act for the Radio City Music Hall Rockettes at a gala in July at the Grand Palais. Twice in September, water and light shows that featured eighty boats and floating stages carrying Africans and Asians in costume delighted the crowds. These shows recalled similar extravaganzas held on Lake Daumesnil in 1931. African performers also participated in a program to honor Victor Schoelcher, the politician who secured the abolition of French slavery in 1848, and in a private reception held for the Association des Français à l'Etranger and the veteran group Anciens Combattants on October 9.[75] Although there was some variety to the entertainment program in the African sections, the island location generally restricted the size of the au-

dience. Organizers of the exposition viewed the entertainment as a complement to the featured exhibits rather than the focal point; space and financial constraints made the parades and extravaganzas of past expositions impossible in 1937.

After the Great War and the consolidation of French territories in Africa in the 1920s, the relationship between the colonial administration and its subject peoples entered a new period. The colonial expositions in Marseilles in 1922 and Paris in 1931 gave government officials the opportunity to proudly display France's territories to the public and to demonstrate the military and economic *force noire* that was being developed overseas. By the 1937 world's fair, even though officials no longer presented the colonies as central to French prosperity, they still made the point that they were valuable to the economic health of the *métropole*. The populations of sub-Saharan Africa offered an unprecedented potential labor force in the agricultural, mineral, and artisanal sectors and a large consumer group for French products—if France could train the African "races" so it could exploit their wealth properly. This training included improving Africans' military abilities, channeling the production of craftsmen, and transforming disparate ethnic groups into manual laborers and farmers. Exposition organizers sought to illustrate the colonial relationship through documentary exhibits, product samples, reconstituted native villages, parades, films, festivals, and musical performances. These demonstrated that the *force noire*, powerful yet primitive, needed the civilizing influence of its *mère patrie*. A new propaganda emerged that presented the relationship between France and its African colonies as a partnership and a fraternal union. The maternal and fraternal roles used to capture the intimacy of the relationship drew upon a long French tradition of describing political relationships in terms of kinship. The coexistence of these identities, however, illustrates the incoherence of French colonial propaganda and how difficult it was for imperialists to define what they perceived as positive ties that benefited both cultures. As anti-imperial groups began to openly oppose the image of a happy colonial family in the 1930s, supporters of colonialism responded by emphasizing "fraternal" ties and the material benefits they believed colonization brought to sub-Saharan Africa.

French entrepreneurs in the period 1914 to 1940 offered their own vision of sub-Saharan Africans and blacks to the metropolitan public in the illustrations for registered trademarks. The image of Africans in commercial illustrations did not differ from the image the government portrayed at the colonial expositions during the interwar years—they emphasized the service and labor Africans could provide. Entrepreneurs presented Africans and blacks as exotic peoples who lacked intelligence but who could nevertheless serve Europeans as workers, soldiers, and entertainers. In the 1910s, Parisian and Marseillais trademark illustrations began to include demeaning stereo-

typical images of a generic black. The increase in the number of deroga-
tory caricatures of blacks on trademark labels suggests that owners believed
that consumers accepted these images and would buy the products associ-
ated with the trademark. Exaggerated caricatures were used almost exclu-
sively with black subjects, a treatment businessmen did not use in their por-
trayals of other social groups. A similar development in the representation
of sub-Saharan Africans can be seen in the increased focus on the display
of the "primitive" elements of black strength at the colonial expositions of
the interwar years. The *force noire* image thrived while new rhetoric touting
fraternal ties and partnerships grew. The civilizing mission had changed; it
now included a new kinship role for the French but provided no real change
in the status of the peoples of the sub-Saharan African territories.

6

North Africans: *Fils Aîné*

*In spite of the diversity of races that reside there, more
and more each day Algeria is becoming a real province
of France with the same ideals and the same future as
the* métropole *(1924).*[1]

North Africa maintained a rapport with metropolitan France that was
unique among France's overseas possessions. As the oldest of the modern
colonies, it could be referred to as the first son in the colonial family—the
fils aîné. This kinship metaphor was an especially apt description of France's
relationship with Algeria. Administrators who prepared the interwar colo-
nial expositions accentuated the idea that Algeria was modernizing and so
infused with French (and European) blood and values that the aspirations
of indigenous people seemed insignificant to its future. This chapter ex-
plores how French portrayals of the Maghreb perpetuated stereotypes of
its Arab and Berber inhabitants while reinforcing the idea that the colonial
region was French.

After World War I, those responsible for planning French colonial expo-
sitions and designing commercial trademarks continued to rely on exotic
images of Algeria, Tunisia, and Morocco to draw the public's attention to
the lands only a short trip away. In many ways, exposition committees pat-
terned their displays to meet the public's expectations of the exoticism to
which they were accustomed from books, the press, popular entertainment,
and previous expositions.[2] Orientalist images of veiled women, gun- and
sword-bearing warriors, camels, and caravans symbolized the region that
France targeted for massive economic and structural development. For ex-

position organizers and French merchants, <u>North Africa was a land of eco-</u> *N. A E*
<u>nomic prosperity</u> and a ~~reflection of the ancient and mysterious culture~~ of *as econ,*
the tales of the Arabian Nights. *valuable,*
exotic land
(Orientalism)

North Africans in Trademarks, 1914–1940

All the elements of Orientalism and commerce that appeared in trademarks before World War I were present in the trademarks that portrayed Arabs and Maghrebians from 1914 to 1940. Trademark designers depicted North Africans on a wide range of products, from hygiene soap to insecticide. Most often, however, Arabs and Kabyles (Berbers from Kabylia) appeared on labels for regional products such as grains, dates, wine, liquors, and citrus fruit. Trademarks continued to associate North Africans with the consumption of coffee and tobacco. As they had in the past, companies used stereotypical portrayals of Arab women, North African warriors, and political and religious leaders as exotic figures likely to draw the attention of consumers.

The connection between North Africa and the ancient Islamic empires of the Near East remained prominent in the trademark imagery used after the start of World War I. Oriental palaces, courtyards, domes, Moorish architecture, mosques, and Turkish pipes decorated many of the Arab- or Oriental-themed trademark labels registered in Paris and Marseilles from 1914 to 1940. For example, when Robert Fragny introduced his line of hosiery in 1923 (Paris), he named it "Le Scheik." In 1926, the Société des Fondoirs Ferriers of Marseilles chose the name "Le Goumier" on its trademark for shortenings, lards, margarines and mutton fats. The *goumier* depicted in the label, a striking North African soldier wearing a hood and cape, rode across the desert on his camel.

"La Belle Fatma" and the Exotic Orient

Entrepreneurs chose North African women to represent a wide variety of products they marketed. French businessmen favored the peasant girl, who often graced fruit labels; the veiled Islamic woman with eyes peering at the world, usually a symbol for cosmetics; and the leisurely, available woman of the Oriental harem, often known as "la Belle Fatma." Fatma was the name of the prophet Muhammad's daughter and was a common name given to Muslim girls, so its association with indiscreet women constituted a blatant insult.[3] Perhaps the first "Belle Fathma" [*sic*] known to French audiences was the Algerian Jewish dancer Rachel Bent-Eny, who performed at the 1878 and 1889 world's fairs.[4] In his book on colonial postcards, Malek Alloula presents numerous images of Maghrebian Fatmas, many of them erotic in nature, that were created for the European male consumer.[5] And Malek Chebel explains how photographers created images of their harem fanta-

Figure 12. Beauty Products (Paris, 1927).

sies by employing marginalized Arab and Jewish women to pose for them.[6] European men valued the images because the real harem was inaccessible to them.

Images of Fatma—with derivations of her name—embellished the labels of several products for women. These products likely were sold in both France and North Africa. During the war, the Pinaud perfume company marketed its beauty powder under the name "Fatiha" (Paris, 1916). Its label pictured a woman whose veil exposed only her eyes. A Marseillais soap company, Savonnerie Merklen et Poupardin, pictured veiled women on its Fatma and Savon Aïscha trademarks in 1927. The trademark label for Antoine Acquaviva's beauty products also included a veiled Islamic woman (1927, fig. 12). Maurice Viret's 1930 Paris trademark for Fatoüma featured a sensual photograph of a young North African woman with her breasts exposed. Confident about the photograph's appeal, publishers Lehnert and Landrock sold it as a postcard.[7]

The image of the peasant woman was more common than that of La Belle Fatma and was featured on many trademarks for food and beverages.[8] Typically, these trademarks pictured unveiled peasant girls wearing scarves and calf-length dresses. The labels for La Kabyle (Marseilles, 1914), Marque la Bédouine (Paris, 1916), Fedhala (Paris, 1924), and La Mauresque (Marseilles, 1924) used North African women to sell grain, flour, fruit, and canned foods. Sometimes shown in a field or grove or holding a basket of the product, Bedouin, Moor, and Berber women from Kabylia helped bring in the plentiful harvest of France's North African territories. Companies also used drawings of the women on labels for liquor and soda.

The labels for Menara Orangeade (Paris, 1926) and Biscuterie Coloniale (Paris, 1931), in contrast, showed a fully veiled woman. Other companies used exotic women to sell matches, soap, and tobacco.[9] The continued use of these images, especially for products that were not related to North Africa,

indicates that French entrepreneurs relied on an established set of commercial images to represent the men and women of the Muslim world.

Maghrebian Producers, Metropolitan Wealth

Although images of North Africans and Orientals appeared on a wide range of product trademarks, they most often decorated labels for produce from the Maghreb. These trademarks highlighted the agricultural wealth of the region and the indigenous labor force available to the French. Grain, fruit, and wine produced in North Africa were represented with drawings of "natives" in traditional clothing. Jean-François Feuillère's La Bédouine flour label pictured a Bedouin woman standing near a bundle of wheat (Marseilles, 1921). In 1931, Félix Attias's Cousscouss du Sultan label featured a sultan holding a plate of couscous. The Comptoirs des Oasis du Sahara algérien registered five different labels for fresh and dried fruit in 1924. Its Oasis label, for example, showed a date grove with several hooded men carrying baskets of dates. Other businesses used similar images on labels for oranges and figs.

Trademarks for wine and liquor also used images of Maghrebian producers. What is interesting about these designs is the contradiction between the image and the product, since Muslims are forbidden to consume alcohol. French merchants disrespected Islam and its practices with these labels, or at the very least implied that some North Africans or Orientals drank the spirits produced in their region. For example, Henri Langlois's trademark for Grands Vins de Liqueurs Algériens (Paris, 1919) showed a Muslim man praying while facing east. In 1929, one Parisian company that called its beverages Oranvin, vaut de l'or (Oranwine, worth gold) illustrated its label with a man on the back of a camel wearing a fez. The trademark for an aperitif called Emyr (Paris, 1929) pictured a bearded man wearing a turban. Companies used a similar motif for Mustapha, le meilleur des vins de liqueurs (Paris, 1922) and Bel Cabèche (Paris, 1933); the latter pictured a laughing man holding a glass of wine. Occasionally, French businessmen demonstrated a mocking attitude toward devout Islamic figures by associating them with liquor. In 1920, Céléstin Chenal's trademark for Anisette Marabout—Liqueur exquise hygiénique (Paris) linked his liqueur to Muslim ascetics.

"Ottoman" Stimulants

Images of North Africans and Orientals were often used to sell coffee, cigarettes, and smoking paraphernalia. The connection between coffee and cigarettes and the image of generic Arabs or Orientals seems to come from depictions of Ottoman Turks who used these stimulants.[10] With a few exceptions, however, French companies that registered trademarks for smoking products from 1914 to 1940 used North African references such as the

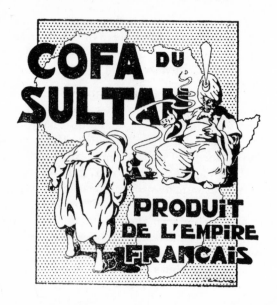

309636. — M. p. désigner tous succédanés de café et tous produits de substitution du café, déposée le 30 janvier 1940, à 15 heures, au greffe du tribunal de commerce de la Seine (n° 330094), par M. *Morazin (Henri, Emmanuel)*, 132, rue d'Avron, Paris. (C. V.)

Figure 13. Cofa du Sultan (Paris, 1940).

Kabyle, the Caïd, the Algerian, or the Turco. Wartime depictions of North African Turcos, such as on the trademark for Gilbert and Pfeiffer's Les Turcos de Charleroi cigarette paper (Paris, 1914 and 1920), showed the soldiers wearing fezzes and in battle against German forces.

Labels of coffee products often bore drawings of men from the Islamic world.[11] The labels usually pictured the bust of an Arab man or a group of people in a desert oasis scene. A bearded turbaned man appeared on the Sanka decaffeinated coffee trademarks registered in Paris in 1925, 1931, 1933, and 1940. Jules Fabre's Le Kif, succédané du Café used the same basic design (Marseilles, 1926). Titles of North African and Oriental leaders such as Le Cheik, (Marseilles, 1927), Le Calife (Paris, 1927), Le Chérif (Marseilles, 1933), and Le Sultan (Paris, 1940), also figured on coffee trademarks (see fig. 13).

After World War I, companies used Maghrebian warriors to represent products as diverse as wine, industrial cleaners, and bath soap. For example, in 1923, François Nugues labeled his brand of canned foods and chemical products Le Marocain. His registered trademark pictured a Moroccan man

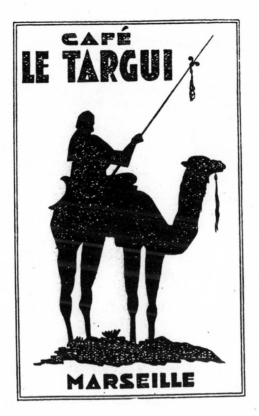

Figure 14. Café Le Targui (Marseilles, 1930).

in a dark cape and hood with a gun slung over his shoulder. In one hand, he held a chain and cross. It is easy to imagine that the cross was part of the booty collected during a Muslim raid on Christian infidels. Other warrior labels showed North Africans with guns, knives, and swords. For example, Le Mehari grains (Marseilles, 1920) featured a gun-toting Arab riding a camel. A soap company chose Le Gourbi (shack or slum) as its emblem and pictured a hooded man holding a rifle (Marseilles, 1935). The Café le Targui trademark showed a turbaned man who wielded a long spear while riding a camel (Marseilles, 1930, fig. 14).

The themes in the trademarks registered from 1914 to 1940 perpetuate the image of an agriculturally abundant and culturally distant Islamic North Africa. This was an image that the French could simultaneously exoticize, mock, and embrace. French entrepreneurs often associated Maghrebian culture and customs with the Oriental and Islamic worlds, as is evident in their references to Islam and images of Turkish pipes, Arabs, Oriental palaces, and veiled beauties. Representations of the peoples of North Africa

123

remained consistent from 1886 to 1940. Before the war, Turcos and *spahis* figured on trademarks for a variety of products. After the successful service of these forces in Europe, companies had good reason to continue depicting the soldiers on their products.

North Africans at the Interwar Colonial Expositions

Government officials in France and overseas saw an opportunity to highlight indigenous forces by displaying them at colonial expositions. Organizers of the interwar colonial expositions in 1922 and 1931 strove to convince the public that Algeria, Tunisia, and Morocco were economically strong and that France was succeeding in modernizing the region. Displays in colonial pavilions emphasized North Africa's contribution to France's commerce and separate metropolitan sections presented French manufactured goods sold in the colonies. The interwar colonial expositions attempted to highlight the North African soldiers who fought for France and educate the public about economic growth in the colonies and the progress that had been made in the civilizing mission. However, in order to reach a wider segment of the public, government organizers expanded the range of exotic entertainment, promoting official colonial "attraction" areas.

In spite of the attention sub-Saharan Africa received, the size and expense of the North African exhibitions proved that the region was indeed the favored "firstborn child" of France. For the organizers of the 1922 Exposition nationale coloniale in Marseilles, the fundamental goal was to showcase the beauty and resources of France's North African territories—both its products and its people. The Algerian, Tunisian, and Moroccan sections featured reproductions of buildings with Moorish architecture and Islamic motifs. Each section contained a Maghrebian marketplace where artisans worked and visitors could purchase their products. Restaurants and cafés offered traditional North African dishes. Dancers, musicians, and skilled cavaliers entertained visitors with regular shows. The exotic and mysterious region came to life, transplanted on the northern coast of the Mediterranean in the provincial city of Marseilles.

The Colonial Ministry officials who organized the French sections of the Exposition coloniale internationale in 1931 created the same atmosphere of exotic North African cultures in their exhibits while emphasizing the region's commercial value. Commissioner General Lyautey and his staff included more vendors and performers and brought in hundreds of sharply dressed soldiers to accent the prominence of the North African domain. The strong association of Lyautey's leadership with exotic decor and "natives" led two writers to refer to a visit to the exposition as an amusing promenade in "Lyauteyville."[12] Algeria was exhibited that year as a natural extension of metropolitan France, just as it had been at the 1922 exposition. Exposition spokesman and former governor general of Madagascar Marcel

Olivier declared: "But, in fact, is not Algeria—which produces wheat like Beauce, wine like Héault, oil like Provence and produce like the Vaucluse—a part of France?"[13]

For colonial administrators, however, two Algerias coexisted: the prosperous Algeria of the *colons* and the exotic and unsubmissive Algeria of Muslim rulers, fierce warriors, and desert nomads. Colonial officials portrayed Islamic populations at the exposition with a mixture of disdain and respect. Although they sometimes honored the religious commitment of Muslims, they criticized "backward" aspects of Islamic culture and the clannish social structure of North Africa. Business-owners also expressed these attitudes through demeaning trademarks illustrations. French officials recognized the vast differences between Maghrebian and French societies but affirmed the vision of the Franco-Algerian *colons*: North Africa should integrate further into the *métropole* in a way that brought modernization and commercial growth to France's colonial holdings in the region. Yet the palaces and living displays of North Africans in Paris continued to portray a contradictory intriguing world that invoked associations with the Arabian Nights tales.

Featured Exhibits

Algeria. The individuals responsible for the Algerian section at Marseilles in 1922 made use of the successful elements of the 1900 and 1906 expositions to create a vision of the *fils aîné* for the visiting public. The Algerian section was prominently located at the end of the main walkway, the Grande Allée. As always, the centerpiece of the section, the Algerian palace, incorporated Moorish architecture, including doorways, gates, a courtyard, and an Islamic minaret copied from the Sidi-Abderrahman mosque in Algiers. Dioramas, paintings, and tiles decorated the interior. *Spahis* in bright uniforms guarded the entrance gate. The grounds outside were planted with exotic vegetation such as palm and banana trees, and the courtyard featured reproductions of Roman statues found in the colony. Propagandistic messages were inscribed on the courtyard walls. One declared, "This Exposition is a testimony of the common labor and close association of colonists and indigenous Algerians."[14]

Inside the ten main exhibit rooms, 771 exhibitors displayed Algeria's material and cultural wealth. These rooms included a "*salle des céréales*," "*salle des vins*," "*salle de l'élevage, des peaux et des laines*," and a "*salle des arts indigènes*." Each contained a special collection of samples and documentation about production of the resource. Known as the "former granary of Rome," Algeria was valued for its production of wheat, oats, rye, corn, and semolina. The "*salle des céréales*" was the first exhibit area visitors encountered.[15] Nine publications on Algeria sold at the exposition emphasized economic topics and stated that the colonial administration effectively controlled the indigenous population. A series on Algerian agriculture traced the production of dates,

grain, wood, and livestock. In a less-commercial publication, Raymond Re-
couly of the Office of the Government General wrote about a year of travel
throughout the colony. His *Itinéraires algériens* was a colorful book with pho-
tographs of the most picturesque sites in Algeria, but it virtually ignored the
indigenous population. For Recouly, the significant groups in Algeria were
the French and European colonists who assured Algeria's economic growth
and were merging to form a new, "essentially French" race.[16]

No exposition was complete without an exotic marketplace. Just east
of the Algerian palace stood the bazaar area that included a minaret de-
signed after one in the Ghardaia mosque. In *Huit jours à l'Exposition coloniale*,
Charles Regismanset described the merchants who sold carpets, copper, per-
fume, and pottery in an area that "evoked the mysterious MZab" region of
Algeria. Regismanset ended his tour of the section with a stop in the Moor-
ish restaurant to enjoy a traditional couscous.[17]

At the Paris Exposition coloniale internationale in 1931, the Algerian
section covered 4,500 square meters of land south of Lake Daumesnil. It
featured three buildings: a grand pavilion, a sales center for Messageries
Hachette, and an Algerian restaurant and market area. In addition, Algeria
shared a pavilion devoted to North African tourism.

Although administrators felt that authentic representations of North Af-
rican architecture were important, they sometimes suppressed authenticity
for practical reasons. According to the official exposition report on the con-
structions, the Algerian pavilion got its inspiration from Moorish architec-
ture but did not pretend to be an imitation of an Algerian monument.
The practical constraints of the size of the exposition, it explained, simply
did not coincide with a proportionate reproduction of a traditional Alge-
rian mosque.[18] Inside the Algerian pavilion, government agencies and 395
private exhibitors displayed product samples and documentation attesting
to the wealth, culture, and colonization of the colony.[19] The agriculture,
mining, livestock herding, forestry, and infrastructure of Algeria; France's
"oeuvres civilisatrices" in health, education, and archaeology; and the preser-
vation of indigenous art each had its special area in the palace.[20]

The Algerian section buzzed with commercial and cultural activities. In
the palace, visitors could see thousands of meters of film on tourism and
economic themes. They could browse the shops in the authentic *souk* filled
with indigenous vendors hired by the local Algerian exposition committees.
Inside the pavilion, a group of young Moorish women wove carpets for the
public. Regional food and wines were served in the Algerian restaurant, the
Café maure, and the Café chantant. This last establishment provided enter-
tainment by *derbouka* and *rhaïta* musicians and singers.[21]

Tunisia. France's success in promoting business, art, and the civilizing
mission was emphasized in the Tunisia exhibits at the interwar colonial ex-
positions. The buildings in the Tunisian section at the Marseilles exposition
reproduced the architectural style of the region with beautiful Moorish

terraces, arcades, and colonnades. Separate displays concentrated on Tunisia's contribution to the colonial relationship—agricultural and industrial goods—and France's administrative and modernizing impact on the protectorate. Organizers displayed information on diverse subjects such as mining, fishing, education, antiquities, and tourism in decorative pavilions and halls that were separated by exotic terraces. Publications on Tunisia also dealt primarily with commercial topics. The *Notice génerale sur la Tunisie* included an ethnographic and demographic section that provided only summarized information about the indigenous population but presented a detailed census of the French, Italian, and Maltese settlers. Other exhibits demonstrated that the European population and its civilizing impact on the *indigène* were fundamental. Inside one of the pavilions was an Orientalist salon with paintings by European artists. A special pavilion was devoted to the progress that had been made in the areas of public health, hygiene, and "the conservation and development of indigenous arts" by the French. The army documented its presence in the protectorate with an exhibit and a diorama.[22]

The Tunisian exposition included displays of soldiers, merchants, and entertainers who worked and lived on site. Henri Geoffroy Saint-Hilaire, the commissioner of the Tunisian exposition, made sure that the exposition included lively entertainment. His plans may have been inspired by the ethnographic shows staged by his family's enterprise, the Jardin zoologique d'acclimatation in Paris.[23] As people approached the exposition, *spahis* dressed in bright uniforms and turbans greeted visitors. A street lined with *souks,* "an exact reconstitution of the Bazaar of Tunis," drew the attention of visitors who sought to purchase authentic wares from the craftsmen and merchants. In the *Livre d'Or* of the exposition, a French writer praised the character of some of the merchants he met in the marketplace. He claimed that not all Tunisians fit the stereotype of the savage Kroumirs. Some, like the artisans who created "elegant objects of fine leather, damascene, furniture, cutlery, house shoes, [and] knick-knacks," were skilled businessmen who loved France and had products to contribute to the colonial market.[24] These talented men were the kind of indigenous worker the French wanted the public to observe at the exposition.

The Tunisian exposition contained its own Moorish café and a restaurant where singers and female dancers performed for clients. A French entrepreneur, J. Bouvier, ran both establishments. Diners could choose between French cuisine and Tunisian dishes such as couscous and *chakchouka*. They could enjoy their meal on a shaded terrace where they could watch the concerts and events that took place on the main esplanade. One such regular event was "Fantasia," a lively show that featured Tunisian guards riding horses, firing guns, and issuing rallying cries. "Fantasia" probably provided one of the most memorable and exotic images of North Africans at the expositions.[25]

In 1931, Geoffroy Saint-Hilaire returned to oversee the presentation of

the Tunisian protectorate. With his assistants and a committee of patrons, he built upon the image of Tunisia presented in 1922.[26] The Tunisian exposition covered a site measuring 3,500 square meters and included the official pavilion or palace, a reflecting pool and patio, an industrial pavilion sponsored by a number of private companies, traditional *souks*, two café-restaurants, and a center of Tunisian entertainment. André Demaison labeled the Tunisian pavilion the Palace of the Thousand and One Nights, directly invoking the Arabian Nights tales. The main pavilion galleries were reserved for government exhibits, product samples, and the displays of the 224 private exhibitors. A *salle d'histoire* presented the long relationship between Tunisia and France; other rooms were devoted to wine, oil, agriculture, mineral resources, town planning, colonization, and civilizing efforts in health, technical education and other areas.[27]

For the fiftieth anniversary of French rule in Tunisia, the resident general prepared a collection of thirty commemorative books and pamphlets. These included titles on industry, commerce, natural resources, and French administrative services. Seven brochures dealt with local bureaus of native affairs. *Le cinquantenaire du Protectorat Français en Tunisie, 1881–1931* treated the political and diplomatic history of the protectorate and its commercial development since the onset of French control. French officials distributed the brochures free of charge and sold various postcards, photographs, travel albums, and other items in a special boutique set up in the pavilion patio.

The regency of Tunisia dispatched 500 soldiers, artisans, merchants, and entertainers to Paris to create an authentic Tunisian environment. Thirty-two men from the beylical guard provided security for the pavilion exhibits and took part in special ceremonies. These men were housed on the second floor of the palace. Hundreds of Tunisian craftsmen maintained boutiques in the market area, a collection of *souks* and bazaars that had been reproduced from a section of la Médina de Tunis. What the French organizers of the Tunisian exhibits could not present in live form they displayed in dioramic reproductions. Dioramas with mannequins brought to life cul-de-sacs at the ends of the streets of the *souk*. In one location, a mannequin played the role of a street beggar. In the Pavillon d'Attractions, an orchestra, Arab singers, dancers, and snake charmers entertained the public.[28]

In the opinion of the commissioner general's office, Geoffroy Saint-Hilaire and his collaborators succeeded in creating an exotic Tunisia in the exposition's marketplace:

> There one found the old blind beggar, led by a little girl; the fellahs discussing the selling price of wheat; the muslim woman accompanied by her servant on the way to the hamman. . . .
>
> Thus, the illusion was complete. The touch of sounds was given by the strident call of the *caouadji* and the hum of the engravers' hammers embossing the shiny copper of ewers and platters, to which was added the cries of the [snake] charmer and the hiss of his snakes.[29]

Visitors could enjoy the charming *souk* and bask in the illusion of North Africa without leaving Paris, entertained by the merchants, workers, and beggars the French had made a commitment to civilize.

Morocco. Government officials presented Morocco, at the time a young member of the French imperial family, to the *métropole* with fanfare in 1922. Resident general Maréchal Lyautey, a conqueror of the territory, and Commissioner Auguste Terrier were the prime actors in the organization of the Moroccan exposition. Local committees of French and Moroccan businessmen helped organize the exhibit's displays and the traditional marketplace. The palace, like the pavilions of the other North African countries, bordered the large esplanade at the center of the exposition site. Moroccan soldiers and guards stood at the entrance to the palace, and indigenous shopkeepers populated the boutiques of the Rue Marocaine built inside the structure.

Visitors discovered an Orientalist vision of the Franco-Moroccan world behind the ochre-colored walls of the site. At the entranceway, architects had reproduced the Porte de Chella, a fourteenth-century construction from an Islamic fortress, and its *casbah,* or surrounding neighborhood. But the French could also see this picturesque ensemble as a symbol of belligerent North African societies. Exposition commissioner general Artaud suggested in his report that the existence of these walled conglomerations demonstrated the level of insecurity and fear of pillaging present in old Morocco. Now, he wrote, the Moroccan people could live in a peaceful environment under French protection.[30]

Soldiers representing the "diverse indigenous races" stood under the Porte de Chella entranceway. Visitors entered a courtyard decorated with beautiful ceramic tiles. Exposition rooms were dedicated to both the economic development of Morocco and the civilizing mission of the French. Dioramas and panoramas showed scenes from the major cities in Morocco and depicted agricultural and mineral production. French administrators showcased the results of their work in education, public works, and social assistance. A diorama picturing French forces combating dissidents reminded viewers that pockets of resistance to the colonial power remained to be subdued. The army's goal in its battles against Berber rebels was engraved in stone in its exhibit area: "The French Army wages war only to pacify and build." Other exhibit areas showed the public the type of modern economy and social services France could build once these fierce adversaries were brought under control.[31]

The Rue Marocaine marketplace occupied about a third of the space inside the palace enclave. Two dozen shops lined the inside walls and a small Moorish café and fountain marked opposite ends of the street. In this miniature exotic environment, colonial officials displayed artisans and musicians demonstrating their skills. Regismanset marveled at the world he found in the Moroccan palace during his May 11 visit to the colonial exposition at Marseilles:

> With the dioramas, I could have believed that I was instantly transported to
> Meknes, Rabat or Marrakesh. To continue the illusion, I can settle down at
> the "caouadji's" [site] outdoors, with pretty blue seats, colored mats, [and]
> an orchestra of Arab singers, and sample a Moorish coffee, a tea with mint,
> and even a Moroccan couscous![32]

In the Moroccan palace, as in the Algerian and Tunisian sections, exposition-goers received a lesson in the importance of economic ties with the North African territories and the regional development made possible by French control. They also found an exotic world molded by common Orientalist stereotypes that was entertaining and charming to European tastes, an "illusion" that brought them to a land and culture they could belittle and yet admire.

Morocco received special attention at the 1931 exposition because the Franco-Spanish victory in the Rif War in 1926 provided an opportunity to highlight the recently pacified territory. In the official exposition guidebook, André Demaison described Moroccans as harsh and violent but hospitable. He also noted that they had a great culinary tradition. The French officials who worked on the exposition gave first priority to the efforts of the military and colonial administration to control the protectorate and to win the minds of the "natives" by a "moral conquest."[33] Morocco was the youngest of the North African "brothers" and needed the most training by its French mother.

Certainly the Moroccan section of the colonial exposition was dear to Lyautey, former resident general and avid defender of the protectorate. The Morocco exposition received one of the largest land allotments at the fair. Commissioner Nacivet, director of the Office of the Protectorate and a staff member at the previous exposition, worked with the Comité marocain de l'Exposition Coloniale to coordinate a display of Moroccan resources and successes in the French mission to civilize the people of its colony. The committee, comprised of government representatives, presidents of the Chambres consultatives de Commerce et d'Agriculture, members of the press, presidents of commercial organizations, and directors of transport companies, encouraged businesses and individuals to participate in the exposition.[34]

The Moroccan palace, gardens, *souks,* and pavilions covered 10,000 square meters; it was twice as large as the Algerian exhibition had been ten years earlier. Architects featured various regions of the country in their designs. The main entrance was a reproduction of the Portes de Bab Rouah in Rabat; the palace itself was modeled after buildings in Marrakesh. The patio imitated the dwellings of wealthy Moroccans in Fez. Paintings, dioramas, and tiles by Moroccan and French artists decorated the rooms and courtyards. More than 200 private exhibitors participated in the Moroccan section.[35]

The first exposition room in the palace was the Pacification Room. Its walls continued the propaganda campaign begun in 1922 and featured new

quotations from French leaders or military officers involved in the battle to subdue the country. One statement, attributed to Maréchal Lyautey, optimistically proclaimed, "Yesterday's adversary is tomorrow's collaborator." Each of the room's segments testified to new public services and the successful efforts to force Moroccan rebels to submit to the French. Administrators such as Théodore Steeg, governor general of Algeria, and Lucien Saint, resident general in Tunisia, expressed confidence in France's ability to transform its colonial populations, saving them through civilizing efforts in health care and education.[36] Separate exhibits presented agricultural and industrial production, forestry, education, and social services for indigenous populations.

The official exposition guidebook offered a mixed assessment of Moroccans. Demaison praised the Moroccan for his poetry, hospitality, frugality, and sobriety. He added, however, that the Moroccan "loved arms" and possessed a "mortal" hatred for his enemies. Demaison strongly implied that only French "pacification" of recalcitrant Moroccan groups would yield the benefits to the nation the colony promised.[37]

The organizers of the exposition selected seventy-six Moroccans to represent the protectorate. This delegation included artisans, employees in the café and restaurant, and musicians who performed from a kiosk in the café's courtyard. The Service des Arts indigènes administered the Moroccan *souks* and organized concessions for boutiques for certain items to craftsmen.[38] All the Moroccan workers slept in rooms behind the boutiques. Vendors who sold items such as jewelry, carpets, pottery, antiques, leather slippers, and straw mats came from the major cities of Morocco. The Café Maure and the Restaurant Marocain were managed by Muslim businessman Si Ahmed el Hadj. His was one of the few restaurant businesses at a French colonial exposition actually managed by an indigenous restaurateur.[39] Visitors to the Moroccan exposition in 1931 experienced aspects of North African culture but could not escape imperialist messages about the territory in the official publications and exhibits.

Spectacle and Sport at the Interwar Expositions

A distinguishing feature of the interwar colonial expositions in Marseilles and Paris was the attention commissioners devoted to displaying large groups of colonial peoples in festivals, parades, and stage performances. In most cases, organizers called on units of Maghrebian soldiers to serve at these events. They also selected talented entertainers from the colonies to perform. Algerians, Tunisians, and Moroccans participated in special events and processions organized to highlight the region and create a fantasy that included the North African "races" of the imperial family.

Maghrebian soldiers marched in the inaugural ceremony parade for the 1922 Exposition nationale coloniale behind a cortège that included Min-

ister of Commerce Lucien Dior, Colonial Minister Albert Sarraut, Mayor Siméon Flaissières of Marseilles, and a number of political and military officials. A few weeks later, Maghrebian troops lined the exposition entrance to greet French president Millerand. The simultaneous presence in Marseilles of the minister of the interior, the minister of war, and the minister of agriculture highlighted the importance of the event. According to an *Illustration* article, the commissioners of several sections were anxious to display their best colonial image for the president. While other sections scurried to display "natives" at the entrances and exits of their pavilions, the commissioner for Tunisia, Geoffroy Saint-Hilaire, was prepared. "I have nothing at the entrance or exit," he stated. "And inside, I've got beautiful girls from Marseilles . . . dressed as Tunisians."[40] Indeed, Geoffroy Saint-Hilaire's illusion of an authentic Tunisian setting in Paris was complete.

At the official reception, Millerand spoke about the economic future of the colonial empire and France's gratitude toward and obligations to its colonial inhabitants. The assistance the colonies had provided during the war, he claimed, gave the *mère-patrie* a reason to show its appreciation and fulfill its civilizing duty to its African subjects. President Millerand emphasized that France had never considered, and would never consider, colonial peoples to be inferior races: "On the contrary, [they are] associates with whom we are happy and proud to collaborate."[41] The president visited all the major pavilions before attending an evening festival organized for his behalf near the Cambodian palace. Surrounded by lighted fountains, Algerian, Moroccan, and Tunisian units paraded for him.

To highlight the progress of the Tunisian protectorate, organizers planned a Semaine Tunisienne (Tunisian Week) to coincide with a scheduled visit by Prime Minister Raymond Poincaré. When Poincaré had to cancel, officials changed the program to a one-day event. The exposition's Journée Tunisienne (Tunisia Day) included a visit by Tunisia's resident general, Lucien Saint, who was received by the Marseilles Chamber of Commerce. On September 21, Saint hosted a celebration for 1,500 guests in the courtyard of the Tunisian Palace. Guests were entertained by snake charmers, dancers, jugglers, and a shadow-theater group before attending a grand ball. Government officials and guests from the Marseilles community reveled in an Arabian Nights fantasy world that fulfilled their definition of "true" Oriental and North African culture.[42]

The Semaine Marocaine celebration in June coincided with the visit of Maréchal Lyautey, who at that time was resident general of Morocco. During Morocco Week, a bust of Jules Charles-Roux, a former Provençal leader of the Parti colonial, exposition visionary, and close friend of Lyautey, was unveiled. On June 29, the commissariat general organized a colonial parade in Lyautey's honor composed of a cavalcade, floats, and native troops. The week concluded with a banquet offered by Lyautey in the Moroccan Palace at which he spoke about the economic aims of France's military operations

in the protectorate—plans to develop Morocco that would ensure that the war France fought was "the most honorable war, the most fruitful, the most humane."[43] He described the conquest as a joint military and civilian effort to modernize (or civilize) Morocco. Lyautey's speech implied Morocco was backward even as President Millerand and other officials asserted publicly that colonial peoples were not inferior. This conflicting rhetoric illustrates how difficult it was for government administrators to present a consistent policy or a coherent image of colonized peoples at the interwar expositions.

The top billing the commissioner general's office and the Commissariat des Fêtes gave to North Africans in events at the Paris Exposition coloniale internationale in 1931 reflected the favored position of the Maghreb in the French empire. Stately *spahis* from Algeria and Tunisia greeted dignitaries at special ceremonies and led parades (fig. 15). Groups of Algerian and Moroccan cavaliers enacted traditional fantasias. North African musicians, dancers, and soldiers marched in parades and performed in festivals and theatrical presentations. Almost without exception, whenever North Africans appeared with their colonial "brothers" from sub-Saharan Africa or Indochina, they were first on the program.

Planners of the 1931 exposition in Paris increased the number of events that had been offered in Marseilles in 1922 and repeated successful programs. On May 30, 1931, a Journée Nord Africaine (North African Day), which featured Maghrebian athletes from the military school at Joinville, inaugurated a summer of performances. The June 27 Fête du Tourisme Colonial, a procession that circulated through the walkways of the exposition, began with thirty North African *spahis*. Similarly, Arab cavaliers headed up the Grand Cortège Colonial that marched each Sunday afternoon from mid-July to November. The cortège featured *spahis*, a military band, Tunisian camels, a float called "La Mosquée," a group of Tunisian horsemen, and the *nouba* from the military base in Fréjus. Several other North African festivals were held at the Vincennes Hippodrome.[44]

The participation of dozens of Arabs and Berbers in theatrical performances in 1931 also illustrated the status of the French North African territories in the empire. The Commissariat des Fêtes gave North Africa top billing in the evening colonial shows that mixed colonial performers with European artists from Parisian theaters. These programs accentuated an exotic view of North African cultures through the use of documentary film, music, and military or warrior scenes, but they also hinted at the theme of cooperation between the colonies and the *métropole*.[45]

The weekly theatrical programs featured the North African warrior image in two of the four alternating theme presentations. In the "Féerie africaine" (African Extravaganza), the audience visited the essential sights of French Africa. Each stop on the voyage provided the backdrop for a musical performance. Travelers arrived at the port of Algiers and listened to a *nouba* concert at the Place d'Alger. Next on the itinerary was Tunisia. French

Avec ce numéro, LA PETITE ILLUSTRATION contenant
la troisième partie du roman : BONNE-ÉTOILE, par M. Henri Lavedan.

89ᵉ ANNÉE

Nº 4629

L'ILLUSTRATION

21
NOVEMBRE
1931

Louis BASCHET, Secrétaire général. RENÉ BASCHET, Directeur. GASTON SORBETS, Rédacteur en chef.

Figure 15. Maréchal Lyautey reviewing colonial troops on the final day of the 1931
Exposition coloniale internationale.
Courtesy of L'Illustration.

actress Yvonne Régis played the role of a Tunisian woman as North African *tirailleurs* executed the "Danse du Fusil" (Rifle Dance). The North African segment of the show ended with "Souvenirs du Maroc" and "Le Campement Animé" (The Lively Camp) performed by the Mangan Tillerettes and Carlton Tiller Girls. A second weekly program, "Nuits coloniales," featured soldiers and dancers in similar numbers that evoked the "old" North Africa the French were supplanting.[46]

For those interested in a more scholarly presentation of French North Africa, administrators offered paid lectures by experts on specific colonies twice a month. On June 12, Jérôme and Jean Tharaud, authors of several books on Islam and North Africa, spoke to the public on the protectorate of Morocco. Writer José Germain gave a conference on Algeria and Tunisia later in the month. These were the first two lectures in the series of colonial talks and performances sponsored by the commissioner general and the Commissariat des Fêtes. In July, Madame Myriam Harry, a traveler and author, ended the series on North Africa with a presentation entitled "L'art de la femme musulmane."[47]

The portrayal of North Africans at interwar expositions reflected long-held ideas about the Orient and the political subjugation of the Maghreb to France. Artisans and entertainers were important figures at the expositions only because they provided products and amusements desired by French and western visitors. Soldiers represented a source of military labor and symbolized the civilized "native" under the control of the French. The lack of genuine interest in indigenous people and the emphasis on the European population living in North Africa in exposition publications demonstrated the administration's perception of North Africa as an extension of France on the southern shore of the Mediterranean. Colonial administrators viewed the French and Europeans as the dominant factor in North Africa's economic development, and they viewed the Arab and Berber populations as inferior groups that had to be controlled and guided by the French state. Statements about associating or collaborating with North Africans were empty promises in light of other rhetoric about subduing Arabs, and public exhibits and shows that demonstrated that French officials viewed them as children they had a duty to train.[48]

North Africans at the 1937 World's Fair

North Africa figured prominently once again at the Exposition internationale des Arts et Techniques dans la Vie moderne in 1937. Although the exposition was constrained in size by its location on Ile des Cygnes, architects creatively set about the task of building an alluring environment that could accommodate large crowds. The island setting both marked the Seine as an imaginary divider between *métropole* and colony and symbolized the short journey across the Mediterranean waters to the North African shore.[49]

Featured Exhibits

Repeating a successful formula from past shows, colonial officials in Algeria created three zones for their exhibition: a barbaresque palace, a caravanserai courtyard, and an Arab street. The main attraction was a spacious two-story barbaresque palace that featured the workshops and residences of artisans. The palace contained a large courtyard, the Cour du Caravansérail, where exposition-goers could see craftsmen from the south of Algeria, Moorish tents, and meharists with their camels. Visitors reached the courtyard by passing through a special reconstruction of the Bab Azoun passageway in Algiers. This part of the Algerian exposition was designed to evoke the atmosphere of the Saharan regions in the south. A separate exposition room for indigenous art and a cinema completed the ensemble of buildings on the island.[50] On the Champs de Mars in the technical section of the World's Fair, officials erected a pavilion of arts and techniques to display a vision of the new modernizing Algeria. The pavilion was designed to elevate Algeria's status among the colonies and showcase its progress and attachment to Europe.

Instead of presenting a variety of skilled master artisans, the Algerian commissariat focused on highlighting young workers from artisanal schools established by the French. Boys and girls working from shops in the barbaresque palace fashioned products from thread, leather, wood, copper, and clay. Young girls trained by the White Sisters Catholic order made lace and wove rugs on looms in the Saharan tents. In an article from the exposition's daily program, a nun explained that the task of the White Sisters was to train the indigenous girls—now considered Christian—in a trade. A reporter remarked on the girls' young age (he guessed that they were seven or eight), concentration and skill, and disciplined behavior.[51] As they observed the young artisans in the Algerian section, the public got a glimpse of the success colonialists proclaimed in civilizing Arabs and Berbers through education and vocational trades.

The Commissariat General of Tunisia departed from traditional architectural forms at expositions to take advantage of the island location and created a section modeled after a Tunisian fishing village. On the river side of the Tunisian section were over a dozen connected village homes with the bright white walls often found in dwellings along the Mediterranean. An Islamic minaret rose above the houses. Along the riverbank stood a terrace and a typical port scene with piles of fishnets and clay product containers from the Tunisian island of Djerba.[52] A special floating café that was anchored on the edge of the Seine welcomed visitors who wanted to sample Tunisian cuisine. To add an authentic touch, architects for the section placed regional plants such as cacti, palm trees, and bougainvillea around the imitation village.

Opposite the village buildings and near the island's central walkway, de-

signers constructed a large hall for fine arts and literature exhibits. Officials displayed samples of items such as traditional carpets, pottery, embroidery, felt hats, and copper goods in two additional exhibit rooms. Between the village and the exposition's buildings was a long passageway with three decorated courtyards—the courtyards of the cities of Tozeur and Sfax and "la cour Tunisienne"—adorned with North African geometric designs, marble pillars, and ceramic tiles.

Twenty-one artisan workshops in the Tunisian courtyards housed samples from about 100 exhibitors and served as worksites. Jean Gallotti, writing about his visit to the Isle des Cygnes for *Illustration*, particularly noted the male and female cloth weavers and the shoemakers he saw.[53] Other visitors were charmed by the waterfront setting and attractions such as the exotic women dancers and snake charmers who entertained on the terrace of the replica of the Tunisian port.[54] A small detachment of ten Tunisian soldiers brought up from a regiment posted in Brittany kept guard around the site. The soldiers were housed near the Ecole militaire and the artisans lived in the upstairs rooms of the fishing village.

The Moroccan section, located on the opposite shore of the island, resembled the Tunisian area. A large pavilion featured exhibits of the work of traditional artisans while an area of workshops and *souks* gave the public a chance to view the work of forty craftsmen recruited throughout the territory by the Service des Arts indigènes. The design and decoration for the pavilion came from the Berber Atlas mountain region. Visitors to the Moroccan section followed a U-shaped path through the small workshops and the *souk,* then entered the pavilion before exiting to the island walkway. A Moorish café situated by the river served Moroccan specialties, and musicians and singers performed from an adjacent kiosk.[55] The army assigned eight *spahis* to the exposition (without their mounts) to add additional color to the scene.

The official report for the Moroccan section stated that one of its goals was to ensure that "artisanal products were not confused with mechanized industrial produced ones, administrative statistics [were not confused] with touristic propaganda, nor synoptic charts with photographic enlargements."[56] Nearly five decades after the scandal over fake African products sold at the 1889 Exposition universelle, administrators reiterated the idea that expositions taught the public what authentic skills and products looked like. They also wanted to demonstrate through the artisan workshops that the Belle Fatma, or young Moroccan woman, was a skilled laborer and not a "lascivious odalisque."[57] Officials wanted visitors to see traditional artisans from various regions of Morocco and appreciate the value of real craftsmanship. The artisans, who had been recruited from across the country, presented their regional styles and techniques in the products they created. They included potters, jewelers, leather workers, masons, wood sculptors, carpet weavers, and embroiderers. Some of the male artisans came with their wives,

children, and other relatives, who assisted them. The commissioner of the colonial exposition insisted that the artisans and their families live in the buildings on the Isle des Cygnes to give a sense of permanency and realism to the workshops and marketplaces. On most days the artisans ended their work at 6:30 PM, but sometimes their days were longer when special evening events made the North African section the center of attention at the fair.

The Eldest Child and the "Most Perfect" Beauty

With a large restaurant (le Restaurant d'Algérie) and spacious and attractive courtyards, the Algerian, Tunisian, and Moroccan grounds could accommodate large groups and were a favorite setting for special events at the exposition. On the evening of October 9, the commissioner general of France d'Outre-mer treated about 600 guests from the Association des Français à l'Etranger and the veteran's group Anciens combattants to a private reception on the Isle des Cygnes. Most of the party took place in the North African section, where guests enjoyed an Arab orchestra and dancers, sampled regional beverages and pastries, and viewed films in the Algerian cinema. All the pavilions, workshops, and *souks* were open so they could cater to the special visitors.[58]

By far the most publicized event that took place on the island was the Miss France d'Outre-mer beauty contest in the Moroccan pavilion. This event, which featured women born of marriages between French men and indigenous women, touched on the complicated subject of interracial intimacy in the colonial setting.[59] The idea came from journalist Maurice de Waleffe, who envisioned the contest as an opportunity to present colonial eugenics to the masses. De Waleffe claimed that proper intermarriage in French territories could provide an alternate solution to France's population decline. In 1936 he persuaded the president of the commission of France d'Outre-mer, Henri Berenger, and the commissioner of the World's Fair, Edmond Labbé, to accept his proposal and proceeded to organize his contest for the Meilleur Mariage Colonial (Best Colonial Marriage).[60] De Waleffe hoped that committees in selected colonies would choose a contestant to compete in Paris and that ten women who represented various racial groups in the empire would be represented.

News about the Meilleur Mariage Colonial contest brought a spark of excitement to the Isle des Cygnes. The official program printed a special edition on the day of the contest that featured interviews with each of the candidates. One of the women, Miss Réunion, was white and was ineligible for the competition but had been selected to appear in Paris nonetheless. The other women, who ranged in age from 15 to 26, hailed from Senegal, Madagascar, Martinique, Guadeloupe, Guyana, Pondichery, Tonkin, Annam, Cochinchina, and Laos. De Waleffe had originally envisioned an Arab representative (Miss Algérie), a Berber (Miss Maroc), a central African (Miss Congo),

and a Polynesian (Miss Tahiti), but these races were conspicuously absent from the group.[61]

The beauty contest suffered from several planning, advertising, and communication problems. Initially the Parisian press had few details about the event, and in the days before the contest the exposition's program published three different starting times—4:00, 3:30, and 3:00 PM. Two days before the contest, the commissariat announced that spectators had to pay a fee of 5 francs to enter the island and that only 15,000 people would be admitted. Officials later decided that the fee would be collected at the entrance to the Moroccan pavilion, where the contest would take place.[62]

On the afternoon of Friday, July 23, confusion reigned as thousands gathered at the Moroccan section to see the women. By 4:30 PM some impatient spectators were trying to block new ticket-holders from spots at the pavilion entrance; others demanded a refund but were refused. Angry crowds broke ticket windows, and the police were called in several times to restore order.[63] De Waleffe, members of the organizing committee, and the contestants did not arrive at the Morocco section until a few minutes after 5 PM. The contestants entered the pavilion and made a brief appearance, but because of the crowds and confusion, the organizers announced that the judges would declare their choice for Miss France d'Outre-Mer the following week. Several days later, at a private dinner with contestants and special guests, a panel of judges, including artists Paul Colin and Ludovic Lucien Madrassi, selected Monique Casalan, Miss Guadeloupe, as the most beautiful of the colonial exotics. Perhaps it was not a coincidence that the attractive Mademoiselle Casalan was an artist herself, like five of the eight judges.[64]

The absence of certain contestants leaves many questions unanswered. Why was the largest colonial territory, Africa, so poorly represented? Were there no legitimate mixed-race offspring to be found among *colons* and officials in North Africa or equatorial Africa? Historian Owen White finds that race mixing was not widely accepted in West Africa during the Third Republic; the offspring of such liaisons often became orphans.[65] De Waleffe and his collaborators filled the slots reserved for the Africans (and the Polynesian) with extra contestants from the Antilles and Indochina. If the public learned something about eugenics from this contest, it was that Arab and Berber women were not natural candidates for the role of mothers of French offspring. Since marriages between French men and women from France's neighboring North African colonies were rare, the prospects for solving France's demographic problems through colonial pairings seemed bleak. The Miss France d'Outre-Mer contest affirmed the public's fascination with race and feminine beauty even as it symbolized a measurable distance between the races.

From 1914 to 1940, French officials and entrepreneurs depicted both realistic and stereotypical images of North Africans. Even though thousands

of North Africans served as soldiers and workers in World War I, commercial images of the people of Algeria, Tunisia, and Morocco remained unchanged. Drawings of North Africans still decorated the trademark labels of regional products such as wine, semolina, and fruit. Business-owners consistently used Orientalist stereotypes of Arab women, nomads, and warriors to draw attention to their products.

During the interwar years, French government officials employed visions of the exotic Orient to attract and entertain the public at colonial expositions. The Colonial Ministry designed the expositions to teach French citizens about the commercial potential of the colonies and the "oeuvre civilisatrice" (civilizing task) in the region. North African "attractions," including bazaars, Moorish cafés, musicians, and dancers, grew more prominent than traditional displays of documents and other items as organizers increased the number of indigenous participants and performances. By the 1931 Exposition coloniale internationale, colonial officials in France and overseas were collaborating with private individuals, native elites, and the army to present dozens of exotic and multicultural spectacles. Government officials conveyed a condescending attitude toward North Africans by presenting them as exotic entertainment for French audiences and perpetuating contemporary stereotypes about Islamic cultures. At the same time, they attempted to obfuscate this image in speeches and ceremonies by acknowledging Maghrebians as "brothers" and associates because of their contribution to the war effort. At the 1937 international exposition, the focus on artisanal production in the Maghreb did not alter the fundamental image of the people as inferior "offspring" that France was responsible for raising. The creation of French vocational schools to train indigenous artisans, part of the civilizing mission, was one way France sought to fulfill this responsibility. Unique events such as the Meilleur Mariage Colonial contest illustrate a different aspect of the complex intimacy that results from interactions in the empire. Ironically, the contest reaffirmed the real social and cultural distance that existed between France and North Africa.

France's first-born colonial child was an enigma. In part, the French favored the image of the "old" Maghreb because it was entertaining, vibrant, and appealed to the public in the exposition setting more than the image of the modern Maghreb. The exotic pavilions, displays, and attractions showed that government officials admired and wanted to preserve the charming Oriental world even as they argued that a commercial "civilized" and "French" North Africa was better. The mixed messages about French North Africa at the interwar colonial expositions were the result of the confusion among the French about colonial rule. They argued that they had both a parental (usually maternal) and fraternal duty to Africa and made no real attempts to reconcile the two perspectives. Ultimately, French officials ignored the signs that North Africa and its people would not become French. It would take a bloody colonial struggle for independence to open their eyes.

7
Indochinese: *Fils Doué*

*Grand farmers, good sailors, adroit artisans, they are
intelligent and show a remarkable power of assimilation
that, judiciously exploited by us, could allow us to hope
for their rapid progress in scientific and commercial
fields.*[1]

In the early decades of the twentieth century, French imperialists often
portrayed Indochina as the most intelligent and gifted of France's adopted
sons. Government officials communicated a certain respect for the ancient
civilizations built in the territories bordering southern China and Thai-
land. But even as they referred to Indochinese people as the most gifted
race of the empire and publicly praised them, they considered them to be
inferior and incapable of charting their own future. Government officials
used the postwar colonial expositions to propagate the ideas that the region
possessed abundant resources and talents that France could preserve and
develop and that the state was the protector and educator of Indochinese
people. Marseillais exposition organizers in 1922 did not ignore Indochina's
military and economic assistance to France during the Great War, but they
made Indochinese artistic talents and culture the highlight of the section.
The organizers of the 1931 Exposition coloniale internationale in Paris ex-
panded on the elements that had been stressed in Marseilles. At the 1937
Exposition internationale, French administrators featured artists from the
colonial institutions in Indochina that had been established to protect the
cultural genius of Southeast Asia.

This chapter addresses how French officials and entrepreneurs both ele-
vated and disparaged Indochinese peoples and culture from 1914 to 1940.

In their varied responses to Indochina, French government officials exposed a contradiction in their colonial ideology. On the one hand, they asserted their maternal role of caretaker and civilizer of the Indochinese territories, and on the other hand, they exalted the accomplishments of Asian civilization and praised their "yellow brothers" for their efforts on the battlefield. But republican expressions of fraternity and respect for other peoples after the war could not mask France's control and suppression of the Indochinese population in the 1920s and 1930s.

Commercial images of Indochinese people did not change significantly after 1914. Merchants used images of Asians and Indochinese on trademarks to represent the same types of products as they had before that year. Most men and women were depicted in domestic scenes and as dexterous workers, although occasionally one would be portrayed as a fighter. In general, the stereotype of the Indochinese as talented and amenable to colonial rule proved to be a durable image.

Asians and Indochinese in French Trademarks, 1914–1940

Depictions of Indochinese and Asians continued to appear on trademarks after 1914, but the total number of trademarks registered in Paris and Marseilles annually did not increase dramatically. Although there was increased potential for trade (and therefore for new product trademarks), as French administrative control and calls for entrepreneurs to invest in the region grew, the average number of 4.17 annual registrations from 1886 to 1913 rose just slightly to 4.7 registrations in the 1914 to 1940 period. After the war there was no resurgence in registrations of products with Indochinese or Asian images, as there was for registrations for the other regional groups.

In this later period, entrepreneurs began to use drawings that distinguished French Indochina from the Far East. The term "Indochinese," a creation of the French in the 1880s, began to identify more regional products than it had before 1914, and the wide straw hats (*nón lá*) of the region's indigenous working class became a common symbol on these labels. This shift in labeling indicates that the French had firmly established Indochina as a commercial and political entity in its overseas empire. The three general themes of the prewar period continued after the war: cultural symbols on the labels evoked an Asia that was exotic or alluring, drawings of Asians represented prominent regional products, and Asians depicted on trademarks were predominantly servants or agricultural laborers.

Exotic Asia, Exotic Indochina: Kimonos, Tea, and Straw Hats

Trademark designers used flora, fauna, cultural symbols, and clothing to define exotic Asian or Indochinese scenes. A trademark for Savon des Mandarins, which was renewed by Klotz and Company's Parfumerie Pinaud in

1916 (Paris), incorporated many of these elements. The label showed a mandarin ruler seated on a throne in a scene that included flowers, plants, and a small dragon, which symbolized life and prosperity. In 1919, Louis Ogliastro and Company of Saigon, Haiphong, and Hanoi registered six fabric trademarks in Paris with Indochinese figures on the labels; the most unusual label pictured a man and two boys riding on an elephant. Mariel Brey and Maxime de Bary used a scene depicting women in kimonos walking toward a small shrine on their Talcogène Mapé perfumes and pharmaceutical products (Paris, 1921). Drawings of Asian or Indochinese women appeared as exotic icons on trademarks for non-Asian foods. Jules Bleton and his business associates in Paris introduced their new pudding with an Asian woman on their label in 1920. Dressed in a kimono, holding a parasol, she sat on the ground with containers of the dessert placed beside her. Paris-based F. Marquis Chocolate Company used an illustration of an Asian woman standing in a garden to sell its candies in 1921. Businessman André Conty took advantage of the 1922 Exposition nationale coloniale in Marseilles to market a new product—the Gâteau de l'Exposition Coloniale. His emblem for the cake was a head-and-shoulders image of an Indochinese woman wearing a wide straw hat. Aslan Dassa's Confiserie et Biscuiterie de l'Aqueduc label pictured an Asian woman with her hand reaching into a cookie box.

Desirable Indochinese and Asian women were used to represent other products besides food. L'Huilerie et Savonnerie de l'Extrême Orient (Marseilles, 1923) and the Société nouvelle des Savons de Marseille (1926) named their soaps La Congaï. The Savons de Marseille Congaï soap bars and packages were stamped with a picture of a bare-chested Indochinese girl. In Indochina the image would be familiar to *colons* and in France it would surely attract attention in the soap section of stores.

Asian or Indochinese men who were pictured as fighters or soldiers were featured on several French fabric trademarks during this period. In 1916, Louis Stang (Paris) used a drawing of a man in a military-looking uniform and cap for his Seng-Tai Cholon cottons. Louis Ogliastro and Company submitted a fabric trademark with two Asian soldiers carrying guns (1919). A third business, the Optorg Company, also pictured two Indochinese fighters on its trademark for cotton thread and fabric (Paris, 1923). On the label, two barefoot soldiers, a man and a woman wearing the traditional *nón lá,* stood face to face with their guns. This illustration realistically depicted the fact that women served as Vietnamese soldiers; some had played important roles in independence struggles against former Chinese colonizers.

When French businesses selected Indochinese images for their trademarks it was usually for products that originated in that region. The war did not change this trend. After 1914, tea and cotton and other fabrics and sewing materials were most often linked with Asian or Indochinese people. Cigarette papers, perfume and toiletries, rice, and dyes followed not far behind.

There is no discernible pattern to the type of images used on cotton and fabric trademarks.[2] In 1919 and 1920, Ogliastro and Company chose a variety of scenes. For example, some of their 1919 labels pictured wagons pulled by oxen, a group of boys following an elder, and a woman gathering pods in a field. The company submitted another trademark in the same category with a drawing of a North African wearing a fez, which suggests that exoticism was part of its general marketing scheme. In only one of the drawings did the activity pictured have any visible connection to the product.

French companies registered or renewed tea trademarks frequently after 1914. Several of these trademark labels repeated common tea-drinking scenarios that emphasized domesticity. Pierre Beaulaton's Thé Djalma label (Paris, 1914) pictured a woman serving tea to a man. J. Quille and Sons' Thé Souchong Fin trademark used two illustrations (Paris, 1918). On the left, two Asian women carrying teapots and packages looked off into the distance while a man observed them. On the right, an Asian family watched their male servant fill teacups. Emile Dammann, who registered trademarks for tea, coffee, and vanilla in 1922, preferred a simple drawing of Indochinese figures on his labels. He opted for images he called "La Tonkinoise" and "Mandarin." Dammann's Tonkinese woman wore a loose dress and a *nón lá*; his Mandarin wore a Chinese mandarin's robe and hat.

French entrepreneurs used Asian and Indochinese tropes on other common regional products. For example, in 1916 the Société des Rizières Indo-Chinoises (Marseilles) used L'Annamite as its rice trademark. The barefoot Annamite man on the label wore a *nón lá* and shorts and carried a pole balance with sacks tied to each end. Another businessman, Léon Hermier, called his special seasoning product L'Annamite (Marseilles, 1926). Hermier's trademark depicted two Vietnamese men in straw hats. The Société de Produits Coloniaux Français marketed coffee and tea with trademarks of an Indochinese woman wearing a *nón lá* and carrying a tray. She stood alone on one label and in front of an African woman on another (Paris, 1933, fig.16). Other French companies used a generic mandarin figure to sell rice and ink (1916 and 1927 respectively).

From 1914, French merchants continued to represent the Indochinese as part of an available labor force. Many trademarks emphasized tasks being completed in fields, groves, and workshops. They generally showed men and women engaged in work requiring manual dexterity, but they also sometimes showed tasks involving physical force such as pulling carts or carrying loads of merchandise.

Several trademark labels depict Indochinese servants. For example, in 1924 the Vian Frères of Marseilles named their flour and grain products after the Asian rickshaw—Pousse Pousse. Their trademark drawing showed a European woman being pulled in a *pousse-pousse* by an Indochinese coolie. Javal and Bienaimé's Parfumerie Houbigant label had two drawings that depicted people working in fields and gathering from trees (Paris, 1919).

209887

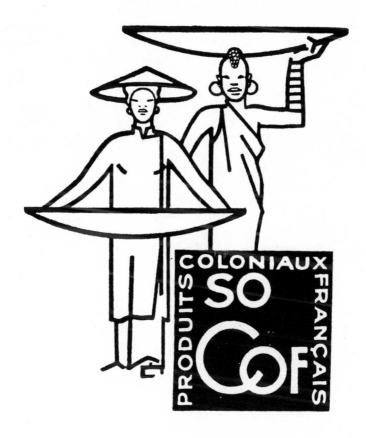

209884 à **209887**. — M. p. désigner des thés, cafés et succédanés, déposées le 17 juin 1933, à 11 heures, au greffe du tribunal de commerce de la Seine (n°ˢ 287566 à 287569), par la *Société à responsabilité limitée : Société de Produits Coloniaux Français,* 46, rue de Laborde, Paris. (C. V.)

Figure 16. Produits coloniaux français (Paris, 1933).

Similarly, Julien Damoy's company, which sold pastries, spice, candy, tea, and other colonial exports, renewed a label with two scenes of Asians working and gathering tea leaves in 1928 (Paris). The 1931 Riz Indochine label, owned by the Syndicat des Exportateurs Français de Riz de Saigon (Paris), depicted a farm worker in shorts harvesting rice.

Some labels depicted Indochinese porters carrying items on bamboo

poles, as did the Nuoc Mam trademark of the Société Française des Produits Alimentaires Azotés (Paris, 1927). Nuoc Mam, the name of a bouillon seasoning, represented a variety of products the company sold, including pharmaceuticals, canned food, and fertilizer. On the label, a shirtless man wearing a straw hat hauled a loaded pole balance. The Compagnie de Navigation d'Extrême-Orient adopted a similar image for its agricultural products trademark in 1931 (Paris).

Some French businesses depicted Asians in workshops where they packaged, painted, cleaned, and dyed products. In 1922, Charles Dubois renewed his Laque Dubois trademark, which he first registered in 1907; it pictured three women in kimonos painting vases. The Etablissement Weeks of Paris used an Asian man in its 1927 trademark for varnish and paint. Seated cross-legged on the ground and wearing the characteristic straw hat, the man held up a jar of Weeks paint and a paintbrush. Philippe Millot, a Parisian entrepreneur, chose an Asian motif for his Fagoda, Polish Oriental in 1923. In the foreground of his illustration, a man shook the product onto a sponge; a pagoda stood in the background, perhaps waiting to be polished. Millot seemed to have a gift for clever labels. He also established two trademarks for Aladdan Shampoo; one showed a woman in a kimono lifting up an Oriental carpet with a box of the shampoo visible on the side. Although some merchants used bucolic portrayals of Asians and Indochinese on their trademark designs, most trademarks used the stereotypes of the meticulous craftsman, the exotic and submissive woman, and the diligent coolie. These French views of Asians in the commercial realm showed a paternalism that was also evident in the government's representation of its Indochinese subjects in the French interwar colonial expositions and the 1937 Exposition internationale.

Indochinese at the Interwar Colonial Expositions

Although Indochina did not garner the same kind of attention the African colonies did at the end of World War I, it touted its contribution to the struggle and made its mark at the colonial expositions of 1922 and 1931. Colonial administrators from Indochina could not compete with the leaders of African territories who sent large numbers of indigenous soldiers, craftsmen, and performers to the expositions, but they made up for this deficiency with grandiose presentations of Asian architecture and artistic forms that journalists, writers, and public figures admired. The portrayal of Indochina at these expositions benefited from the determination of two influential governors general who were nationally respected figures—Paul Doumer (in office from 1897 to 1902) and Albert Sarraut (in office from 1911 to 1914 and again from 1916 to 1919). Sarraut was minister of colonies during the Marseilles exposition and was determined to use the event to persuade French citizens of the vital importance of the empire. In 1931, Doumer, who had

been elected president of the republic at the start of the exposition, expressed his firm commitment to *la plus grande France*.

Featured Architecture and Exhibits

During the interwar years, the French fashioned their image of Indochina using symbols from the protectorate kingdom of Cambodia. The pinnacle of the Indochinese section in Marseilles in 1922 was the Angkor Wat Cambodian temple; for some people, this was the central attraction of the entire exposition.[3] Albert Sarraut marveled at the opportunity to recreate the structure for the exposition. He believed that the project would illustrate France's role in saving a piece of ancient Khmer civilization from oblivion. In Sarraut's opinion, the public would have to "see" Angkor, even an artificial version of it, to understand it:

> It can't be described. It is sublime and superhuman. And everything, truthfully, in this spectacle of magic, everything conspires to the amazement of the eyes, to the ecstasy of the spirit, to the dizziness of the thoughts in the most sumptuous décor in the world. The great overflowing and voracious jungle, the untouched, millennial forest in the middle of which one of our explorers—because it was the French who were first to do it—had to go to uncover the treasures of art that for centuries she was burying jealously under the architecture's liana and flowers.[4]

The Government General of Indochina recreated a scaled-down version of the temple on the exposition grounds. Measuring seventy meters on each side with four corner towers and a central tower over fifty meters tall, Angkor Wat was larger than both the West African and Algerian pavilions. With its galleries and annexes, pools, and esplanade, it surpassed even the enormous Moroccan pavilion, making it the largest colonial complex at Marseilles.[5] This "reconstitution" of the temple combined the Angkor pagoda built for the 1889 Exposition universelle with a tower from the Bayon of Angkor Thom built for the Cambodian section of the 1906 Exposition coloniale. At the expositions that took place after World War I, colonial officials were almost obsessed with the breathtaking Khmer structure. Sarraut marveled at the real temple's "superhuman" qualities and praised France's resolve to protect a great cultural artifact. Members of the Ecole française de l'Extreme Orient, which had been created in Hanoi in 1902, devoted themselves to preserving the Khmer remains and dozens of important cultural sites throughout Indochina.[6]

The main galleries of the Indochinese palace housed exhibits about the colonization, culture, history, and economy of the five territories of Indochina (Cambodia, Laos, Cochinchina, Annam, and Tonkin). Each of Angkor Wat's towers contained a gallery devoted to one of four regional exports of rice, cotton, rubber, and silk. Special exhibit areas were devoted to works by European painters that presented many aspects of colonial life. Ex-

position staff arranged documents, sculptures, and pieces of art borrowed from the Musée Cambodgien and the Musée Guimet in Paris in the structure. About 150 private companies and organizations exhibited products or information in the Angkor Wat complex. Organizers assigned the three exposition pavilions to Cochinchina, Annam and Tonkin, and Cambodia and Laos. A forestry annex housed displays that demonstrated uses for various Indochinese woods.

Toward the entry to the Indochinese village, the octagonal Franco-Annamite restaurant completed the group of exotic structures. Its unique roof, decorated verandas, and red lacquered tables enticed visitors to sample special Asian dishes. Frasseto and Sicè, owners of a Saigon hotel, operated the restaurant. Their advertisement in the official guide to the exposition urged readers to request their special dishes: Le Baiser (The Kiss), La Caresse (The Caress), and le Bouton d'Or (The Golden Button), delicacies that were "unknown at Marseilles." Diners could listen to a European orchestra while enjoying this exotic culinary feast.[7]

At the Paris exposition in 1931, Cambodia continued to dominate the official portrayal of Indochina. The commissioner of the Indochinese section, Pierre Guesde, and his collaborators made the reconstruction of Angkor the feature attraction of the entire international exposition. This time, they had the temple and its grounds reproduced to full scale. Organizers built the structure on a huge plot of land at the midpoint of the Grande Avenue des Colonies françaises, opposite the French West Africa palace. The temple's five spiraling towers and intricate carvings and statues drew the attention of visitors, artists, architects, and photographers.[8] Angkor represented the glory of a kingdom that had faded over the centuries. Although the Cambodian monarchy remained in power under the French protectorate, the metropolitan public saw few signs of its modern-day existence other than the king's young gold-clad ballet dancers.

Displays of the races of Indochina appeared in the main Angkor Wat pavilion and smaller regional pavilions built for each of the five protectorates and colonies. The smaller pavilions contained geographic, economic, ethnographic, and cultural information about Annam, Tonkin, Cochinchina, Cambodia, and Laos. Planners for the 1931 exposition took a more positive view of the Cambodians than government officials had in 1900 and 1922 when they referred to them, respectively, as a "naturally apathetic" and "indolent" group.[9] A set of directives for the Indochinese exposition detailed plans for different sections. For example, in the ethnographic sections, only "barbarian or semi-civilized" groups would be presented in the main Indochinese pavilion, while the local expositions would display information on the principal and "more evolved" races. The "barbarian" groups included the Thô, Thaï, Man, Meo (Hmong), Moi, Kha (Lao Thoeng), Penong, Kouy, and Por peoples.[10] "Advanced" groups were the Annamites, Cambodians (or

Khmer), Laotians, Muong, Cham, and Malay. According to the directives, each display needed to include

> a demographic map giving population density by province and the racial distribution for each country. Photographs and portraits made from life will present the different physiques of the inhabitants (men, women and children). These documents, presenting the heads in life size, will be taken in front and profile. They will make it possible to demonstrate the variety of looks that a race assumes, the Annamite race, for example, according to its settlement [*habitat*].[11]

A brief ethnographic description in the official publication on Indochina also focused on the physical characteristics—including cranial measurements—of the "savage" and "advanced" races.[12]

The local committees, which were comprised of French administrators, notables, members of chambers of commerce and agriculture (both Asian and European), artists, and professionals, determined the specific content of the regional expositions according to the directives given by the Government General. In the case of Tonkin, thirty-nine individuals collaborated on the exhibits, most of whom were French administrators, landowners, publicists, and members of the municipal council.[13]

The local exhibits focused on the topics of Indochinese art and civilization, commercial export products, and the French civilizing mission. French administrators and colonists presented two civilizing goals: to protect the remnants of Indochina's glorious past and its cultural traditions and to elevate the level of material development in the region. André Demaison referred to both goals in the official exposition guidebook. After describing Cambodia's lakes, forests, temples, and dignified sovereigns, he exclaimed, "Thank God, we have not destroyed any of these traditions capable of embellishing our humanity, which tends to become a bit too dull." Beyond the obvious economic gains resulting from colonialism, Demaison saw the potential for France to be rejuvenated through exposure to Cambodian culture.

That the Cambodians had something to offer their colonial parent did not alter the fact that the French continued to view them as children requiring guidance and care. Even imperialists like Demaison, who seemed so aware of Cambodia's cultural assets, subscribed to this view. In a segment on Tonkin, he commented that the French governors general working there "protect the race against its own weaknesses, against disease and pernicious outside influences, by means of schools, roads, hospitals and dispensaries."[14] An article in the *Bulletin d'Informations* for the exposition entitled "Un pays qui renaît: Le Laos" echoed these ideas about France's mission in the Laotian protectorate. The authors boasted, "We have preserved the race, revived the traditions, prepared a better future."[15]

Living Displays

After the impressive reconstructions of the Angkor Wat temple, the Indochinese artisan shops and villages were the next most popular features at the interwar expositions that presented Indochina. The local planning committees for the Marseilles exposition and the army sent 300 Indochinese to demonstrate trades, populate villages, guard exhibits, and perform before spectators. Visitors to the exposition observed a sample of Indochinese rural life at a Laotian village recreated near Angkor Wat.[16] Author Charles Regismanset discovered the charm of the village on his visit to the exposition. He wrote, "Natives, men and women, attend to field work and domestic work. Carts hitched with trotting oxen, buffalo, and elephants complete this scene of exotic life."[17] The staged Indochinese work scene, complete with a lake, miniature rice fields, and farm animals, followed the ideal pattern of colonial expositions Jules Charles-Roux had outlined in his assessment of what needed to be changed at the closure of the 1900 Exposition universelle— the display of "natives" in their recreated "natural" environments who were busy harvesting colonial export products. It demonstrated the lifestyle and work life of the Indochinese labor force for visitors.

Exposition planners used the Rue Annamite to showcase an Indochinese urban setting. The street included forty-five Vietnamese-style houses that were used for boutiques, panoramas, pagodas, and community gatherings. Workers from Cochinchina and Tonkin participated in the construction of the miniature community.[18] The Rue Annamite, with its carefully crafted designs and fine artwork, attested to the talents of the Indochinese. Visitors entered the street by passing into an open courtyard under a decorated archway guarded by militiamen. They encountered a pagoda (a copy of the Pagode des Dames at Hanoï) and La Maison Commune. This building was patterned after a structure where Vietnamese communities held town meetings and practiced Buddhist worship. The altar area was decorated with furniture, statuettes, and articles for worship obtained from priests and purchased by the local committee from Cochinchina.[19] Behind these buildings stood a series of boutiques and panoramas. Commissioner Artaud described the variety of artisans and merchants located on the Rue Annamite, which included lace makers, embroiderers, furniture makers, lacquerers, and tea sellers. The workers were joined by other Indochinese who lived in Marseilles or who were passing through, he said, "giving the most exact idea of the Annamite hive of activity as it appears in the streets of Hanoi or Nam Dinh."[20]

The 200 Indochinese who occupied the Rue Annamite and performed in the Indochinese section lived on the fairgrounds in buildings constructed for the exposition. (Commissioner for Indochina Guesde and his staff also lived at the site due to a housing shortage in Marseilles.) On the opposite end of the Rue Annamite was a military camp for the 120 Indochinese

tirailleurs and militiamen at the exposition. These men, who were housed in three dormitories, stood guard around the section and participated in flag ceremonies.[21]

What the organizers could not transport from French Indochina during the spring and summer of 1922 they arranged to have filmed. In 1921, the Cambodian organizing committee unanimously approved a cinema project to present everyday life and customs in a special film, along with scenes of Cambodia's greatest attractions—the original Angkor Wat and the king's dancers. Administrators from Cochinchina also funded cinema presentations. The head of the French cinematographic services in the colony, René Thétart, shot films that presented indigenous society in this the oldest French region in Indochina. Thétart also prepared a series of photographs for the ethnographic section of the Cochinchina exhibit, "Etudes de races," which likely served as the model for ethnographic displays in 1931.[22] Five propaganda films on Indochina were shown each day in the Intercolonial Cinema.[23]

Native village areas populated by traditionally dressed Indochinese completed the recreated Asian world in 1931. French organizing committees planned to hire Chinese to offer *pousse-pousse* rides as part of the transportation services on the exposition grounds, but the governor general of Indochina felt that there would probably be wide opposition to the plan. Nevertheless, in March 1931, the commissioner general of the exposition's technical committee made an agreement with a concessionaire to operate 100 single-seat and 50 double-seat rickshaws that would be pulled by Chinese workers. The agreement contained provisions for both parties in case the plan had to be canceled, but, hoping for success, the committee purchased the rickshaws. Two days after the business arrangement was signed, the Chinese consul to France lodged a vehement protest with the commissioner general's office about the plan to use Chinese laborers to pull the rickshaws. The complaints thwarted the project, and the exotic carts that had circulated at the Marseilles colonial expositions never appeared in Paris.[24]

Even without the picturesque rickshaws, officials were able to present hundreds of Indochinese at the Paris exposition—150 workers and 250 militiamen and *tirailleurs*. French organizers housed each of the civilian groups—Vietnamese, Cambodians, and Laotians—in a separate dormitory with heat, hot showers, and a dining room.[25] The militiamen worked primarily as guards for the various pavilions in the Indochinese section, while the majority of the *tirailleurs* joined African troops and civilian performers in the entertainment program run by the Commissariat des Fêtes.[26]

Dancers, Dramas, and Dragons: Entertainment at the Colonial Expositions

The French officials who planned the Indochinese expositions believed that exotic entertainment would attract attention to the territory's exhibits. Guesde and the regional organizers hired entertainers from Cambodia

and Vietnam to perform at the 1922 exposition. A six-member Vietnamese theater company, Théâtre Annamite, performed scenes from traditional Vietnamese legends that had been modified for French audiences. The organizers also contracted with a Vietnamese puppet-theater company, the Guignol Thanh Hoa, to provide entertainment. Even the small territory of Laos sent several singers and musicians. A key Indochinese attraction at the colonial parades was the famous dragon procession. Indochinese workers maneuvered the long dragon frame to the sounds of gongs and firecrackers as the mythical symbol of Vietnam passed the crowds. Scheduled appearances of the dragon brought in tens of thousands of visitors, raising general revenues.[27] The dragon procession was also a key element of the entertainment program at the 1931 Exposition coloniale internationale. It was so popular that when Indochinese student activists in Paris persuaded exposition workers to refuse to parade around with the colorful beast, organizers ensured that the show would go on by asking Africans to carry the animal's frame.[28] The Indochinese delegation in Paris stood out by displaying the most floats in the weekly colonial parades that began in July. A float named "The Pagoda" represented the territories of the Indochinese Union. Annam offered "The King's Elephant," and Cambodia presented "The Boat of the *Apsaras*," which carried Cambodian dancers. Later, a fourth float was added to the program that carried the musicians from the Vietnamese Royal Guard.[29]

The most acclaimed artistic attraction, however, was King Sisowath's Cambodian ballet, which performed in Marseilles by special request of the French administration and later in Paris. These dancers were the rave of the 1906 Exposition coloniale in Marseilles. Nevertheless, during the planning period for the 1922 Marseilles event, two colonists opposed the inclusion of the court dancers and musicians. In the minutes of their January 6, 1921, meeting, Bramel, president of the Cambodian Chamber of Commerce, and Rostucher, a Phnom Penh businessman, voiced their disagreement with the idea. Bramel criticized the musical quality of the performances compared to that of European groups and mentioned the "serious inconveniences" of depriving the king and the native people of their own music for a five- or six-month engagement in Marseilles. Rostucher found it too costly. For these businessmen, the success the ballet might have had in France did not outweigh these concerns. The idea was tabled until a future meeting when the committee president could offer more details on his plan. By mid-April 1921, high-ranking colonial officials had decided in favor of hiring the king's performers. Resident Superior Baudoin of Cambodia, who had just returned from a Paris meeting with the commissioner general of the Indochinese exposition, announced that because of their earlier success, the dancers would make a repeat appearance in Marseilles. Later, press accounts of the performances confirmed the government's confidence in the appeal of the Cambodian Royal Ballet. The charming dancers were the

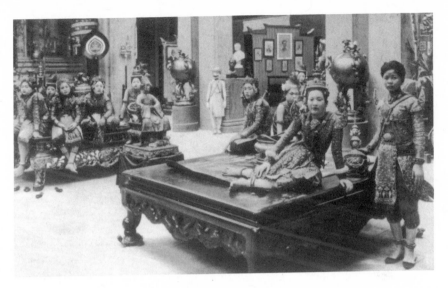

Figure 17. Cambodian dancers waiting to give a performance in the Indochinese palace, Exposition nationale coloniale de Marseille, 1922.
Courtesy of the Bibliothèque Nationale de France.

"must-see" of the exposition. They gave regular public performances in a special room in Angkor Wat and participated in private shows arranged by the commissariat general (fig. 17).[30] At the Exposition nationale coloniale a decade later, the young dancers continued to demonstrate the mystique of Khmer culture. Their refined dance skills and entertaining performances made them ideal representatives of the image of the talented and gentle Indochinese that French administrators offered to the public.

In 1931, the entertainment program created by the Commissariat des Fêtes in Paris featured a variety of dancers, actors, and soldiers (*gardes* and *tirailleurs*) in public parades and performances and in private theatrical productions. Festival director Fernand Rouvray incorporated the image of the exotic talented Indochinese in two major shows—"Soirées Indochinoises" (also titled "Indochine Présente") and "Nuits Coloniales." "Soirées Indochinoises" included La Garde indigène de l'Annam, a Laotian dance group, acting companies from Cochinchina and Annam, and the Cambodian Royal Ballet. A typical June performance in the great hall of the Cité des Informations began with the Garde indigène band performing Saint-Saëns' "La Princesse Jaune," followed by the dance companies and theatrical groups.[31] Le Théâtre Annamite performed shortened versions of dramatic plays that highlighted a long-standing cultural tradition. These tales of romance and intrigue drew audiences and positive reviews.[32]

Organizers of the colonial exposition in Paris knew that cultural perfor-

mances were the key to drawing crowds to the event. The Commissariat des Fêtes accented the talents and cultural traditions of the Indochinese contingent in the main exposition ceremonies, events, and performances it organized. Organizers enlisted soldiers, singers, and dancers to participate in a weekly colonial parade, a children's theatrical revue, and a tourism festival. Each event emphasized exotic cultural elements of French Indochina and presented the territory as the most advanced region of the empire.

The regular programs designed by colonial officials in Marseilles and Paris purported to present authentic Asian culture, yet they sacrificed real authenticity to provide entertainment forms that catered to European tastes. They also promulgated the idea of French cultural domination over colonial cultures. Nicola Cooper points to the abandonment of authenticity in the French "reformulation" of indigenous talents for the 1931 exposition. The clearest example of this is in the Garde indigène band that was formed by Governor General Pasquier, the senior colonial administrator. It was led by a French director and performed works by European artists.[33] It is also evident in the Vietnamese plays performed by Le Théâtre Annamite that were shortened and altered to suit French constraints.[34] Although the advertisements for the 1931 exposition claimed that visitors could fully experience Indochina in one visit, the composite colonial entertainment presented only a façade of indigenous culture.

Special Events and Performances

The French elevated Indochinese cultural achievements through several special programs at the colonial expositions. Because of its impressive size and exotic beauty, the Angkor Wat temple in Marseilles became the prime location for various ceremonies and festivals in 1922. The temple symbolized the artistic talent and treasures of Indochina the French valued, yet at the same time they viewed it as evidence of a declining culture in need of protection and aid. Vietnamese and Cambodian soldiers stood with their colonial counterparts as part of the honor guard for the inauguration of the exposition. Commissioner General Adrien Artaud, Colonial Minister Albert Sarraut, and their entourage visited the Indochinese section, and Sarraut decorated several of the *tirailleurs* and militiamen with awards for loyalty to France. When French president Millerand visited the exposition in May, a special group of Indochinese notables in traditional dress, Indochinese with colorful standards, and costumed Cambodian dancers lined the steps of Angkor Wat to greet him. An evening festival to honor the president also took place at the reconstructed Khmer temple. Soldiers from all the colonies paraded before the steps of the Angkor Wat, followed by the Indochinese theater group and the lead dancer from King Sisowath's royal ballet, who was carried on a throne as she held a pose.[35]

The commissariat general highlighted the talented and gentle Indo-

chinese during a special Semaine Indochinoise (Indochinese Week) in July. This celebration coincided with the visit of Governor General Maurice Long from Saigon. Long visited each of the Indochinese pavilions, attended receptions, and gave presentations at the Institut colonial and the Marseilles chapter of the Société de Géographie. At a banquet given in his honor at the exposition's Restaurant Franco-Annamite, Long addressed several Vietnamese notables, remarking that they "had understood that France approached them as brothers" and that French action in their homeland was "a work of emancipation." The Commissariat for Indochina at Marseilles also prepared a dazzling evening show for Governor Long on July 21 on the steps of Angkor Wat. Guests seated on the terrace facing an illuminated temple watched the Indochinese dancers, actors, and musicians descend the central staircase and present their performances. In an *Illustration* article describing the event, Léandre Vaillat praised the Cambodian dancers: "Khmer art still lives in these human beings as it lived in the Angkor temple, in works of flesh as also in works of stone."[36] For the French, the dancers were a living reflection of Khmer traditions they were responsible for safeguarding, just as they were working to restore the ancient temple.

At the 1931 Exposition coloniale internationale, officials sponsored several unique programs that reinforced a hierarchical order of colonial races and French supremacy. The Fête du Tourisme Colonial on June 27 gave a presentation that linked races to modes of transportation in Indochina and the empire. Following the African procession, the Indochinese portion of the parade began with a group of elephants. Next were ten Vietnamese riding bicycles, several Panhard cars from the late nineteenth century, several contemporary automobiles, and cars carrying the young Cambodian dancers. (Significantly, they were the only colonial subjects who rode in cars at the exposition.) The Indochinese procession moved beyond the "primitive" horse and camel transportation of the African section by including bicycles and automobiles. By displaying the Indochinese with the most advanced modes of transportation, the French also inferred that they were the closest to modern civilization.[37]

Like their African counterparts in Paris, the trained Indochinese soldiers were on display at various events throughout the six months of the exposition. They marched in the historical parades of colonial troops held on Bastille Day and in July and August. During the Journée Indochinoise they presented a cortège of the vice king of Tonkin, which included the mandarin leader's entourage, a game of live chess pieces, and a promenade of the famous dragon. Soldiers repeated portions of the cortège for the children's gala, "Le tour du Monde en quatre-vingt scènes," on Thursday afternoons.[38]

The Commissariat des Fêtes also scheduled Indochinese performers to appear in special conference spectacles. Albert Sarraut, who by that point was governor general of the Indochinese Union, gave a short conference in

August that was followed by presentations from the Cambodian and Laotian dancers and an Indian dancer. Organizers repeated this successful conference in October. Vietnamese, African, and Indian artists also performed at the end of a program entitled "La Cuisine exotique par Mme Rabette," which included samples of colonial dishes for the audience.[39]

Indochina claimed its place in the display of French empire at the end of the Exposition coloniale internationale, as it had at the beginning. In the closing weeks, the commissariat evoked the image of Angkor Wat in a special presentation called "L'Adieu des Colonies à la Métropole." The backdrop for the "adieu" consisted of a stage boat that opened up to give a panoramic view of the exposition site with the temple in the background. A functioning staircase allowed performers from each colonial capital or region to descend Angkor's steps and sing or dance a closing number. After Algiers, Tunis, Dakar, and Tananarive, Indochina marched down with a collection of colorful flags. At the end of the presentations, all the groups returned to the boat, the doors were closed, and they said a final good-bye to Paris as they sailed back to the colonies.[40] This artistic *tour du monde* encapsulated the French colonial empire in exotic, compact scenes. The organizers of the "adieu" saw the Cambodian temple as the lasting symbol of the colonial exposition. It represented the beautiful foreign cultures that were now a part of the empire and emphasized France's responsibility to preserve and develop them.

Indochina at the 1937 Exposition internationale des Arts et Techniques dans la Vie moderne

The excitement over France's Asian territorial possessions was not as high at the 1937 exposition as it had been at previous fairs. Space and financial constraints limited the options colonial officials had for showcasing Indochina. In addition, while the political struggles to control Vietnamese opposition overseas eased a bit when the Popular Front announced amnesties, they were not resolved. Another sign that Indochina had faded from the forefront was the decision to place the pavilion at the western end of the Isle des Cygnes and on the edge of the entire fairgrounds. The Indochinese exposition's diminished size and stature were reflected in the scanty comments devoted to it in the press and official publications. Nevertheless, Indochina's Government General held to the stated goal of presenting traditional indigenous craftsmanship to visitors and demonstrating the commercial potential of France's Asian subjects.

Featured Exhibits

The Indochinese exposition contained two sections: a pavilion with exhibit halls designed after various Khmer structures and a village of artisans. While

in the past French architects had boasted about their commitment to recreating authentic colonial structures, the designers in 1937 abandoned authenticity in response to spatial and financial limitations. The architectural staff decided to use a segment of Angkor Wat as the model for the main pavilion, but they topped it with a copy of the Tower of Bayon, which had four striking carved faces and was replicated from the complex of Angkor Thom. Here the intricate curves and forms of ancient Khmer designs created a unique structure that drew the eyes upward. Anyone standing on the right bank of the Seine saw the steep staircase and the beautiful reflection of the faces of the tower on the water. A collection of buildings with Asian motifs that served as artists' workshops and dwellings formed an Indochinese community around the Khmer pavilion. At the far western point of the island, not far from the pavilion, the architects placed a slim tower to mark the entrance to the overseas France exhibits and counterbalance the Algerian tower on the opposite end of the Isle des Cygnes.[41]

The ground floor of the Indochinese pavilion held exhibits of artistic creations from throughout the territories of the Indochinese Union. Visitors who sought information on France's civilizing mission in Indochina, the Union's economic development, or the racial and ethnic makeup of the region could find it in the Pavilion de Synthese, a general exhibit of France's imperial achievements located at the center of the island. Stalls adjacent to the galleries allowed visitors to purchase works on display, which included fine jewelry, silk, ivory carvings, lacquered wood items, and fans. The official report made special note of a collection of fifty paintings and engravings from the L'Ecole Supérieure des Beaux-Arts de l'Université Indochinoise (also called L'Ecole des Beaux-Arts d'Hanoi).[42] As had been the custom in earlier expositions, colonial soldiers on temporary assignment from bases in southern France guarded the exhibit areas.[43] Officials divided the group of twenty-two artisans who had been selected to demonstrate their skills into ten workshops. These included rug weavers, silk workers (embroiderers and brocade weavers), basket weavers, lace makers, bronze craftsmen, silver and goldsmiths, artisans who worked with shells, lacquerers, and craftsmen who made votives from various materials. The craft workshops surrounded the Tower of Bayon, creating a small Indochinese village where the artisans lived and worked.

"Saving" Indochinese Art

The displays at the Indochine exposition provided colonial officials with an opportunity to highlight the impact of the art education programs France had established throughout the Union from 1900 to 1930 to promote traditional crafts. French concern about competition between traditional products and cheaper imports sparked the creation of the L'Ecole des Arts cambodgiens in Phnom Penh in 1918.[44] The two main goals for the school were to

identify and preserve Khmer art forms and to train the most skilled artisans to teach traditional skills.[45] Other colonial art schools, each of which had its own specialty, were established in Cochinchina near Saigon. L'Ecole d'Art de Bienhoa trained students in ceramics and bronze, and the L'Ecole de Thudaumot specialized in furniture and lacquer.[46] The French also brought oil painting to Vietnam with the establishment of L'Ecole des Beaux-Arts d'Hanoï (1925). L'Ecole des Arts décoratifs de Gia-Dinh (1913) trained craftsmen to produce products for the comfort of European colonists living in Indochina.[47] These institutions were pointed to as evidence to support imperialist claims that the French were the best protectors and promoters of Indochina's cultural heritage and could instruct Indochinese in modern artistic production. This view is clear in a publication prepared for the exposition that highlights the art schools. *Les Ecoles d'Art de l'Indochine* informed readers that the French schools taught students to give up the "Chinese models" and forms they imitated to adopt French ones. While the publication praised Indian-influenced Cambodian art, it described Vietnamese art as "a maladroit copy" of Chinese forms. Nevertheless, authors of the publication asserted that the French aimed to "help them to rediscover the little-known or forgotten elements [of their traditions] and to exaggerate their personality rather than to substitute it with ours."[48]

This contradictory language can perhaps be better understood by considering the speech of Colonial Minister Marius Moutet on the subject of colonial art. At the inauguration of the France d'Outre-Mer section of the fair, Moutet spoke about the special qualities of art produced in the colonies. His comments reveal the two threads of thought commonly expressed by officials in the interwar years. First, he expressed reverence for and exaltation of Asian artistic expression as "subtle" and "refined," virtually civilized.[49] At the 1931 Exposition coloniale internationale, French observers compared the architectural achievements of the medieval Khmer kingdom to French creations of the same period—notably the cathedral of Notre Dame. Herman Lebovics, Panivong Norindr, and others who have written on the exposition agree that the Angkor Wat replica was not only a symbol of the glorious Khmer past but also the link between two great civilizations.[50] Second, Moutet argued that as Khmer civilization declined, its arts suffered the same fate. France recognized the past cultural greatness of the region and felt it was poised to help it regain its luster. The indigenous conscience was "a soul to be raised up" rather than "a machine to be set up," the minister said. The work of colonial peoples needed to be respected even as France offered a helping hand. According to Moutet, French initiatives such as the establishment of art schools fulfilled this goal. "Within the fusion of our technique and indigenous arts," he said, "resides one of the interior disciplines of our colonization and the secret of a new civilization, grafted onto ours."[51] The relationship Moutet described involved more than

assimilating French values and rejecting indigenous ones. It even went beyond an associative relationship where the cultures coexisted. His grafting analogy evoked the idea that while France maintained the life-giving nutrients in its roots, the colonies provided fresh branches that made new fruit possible. The great civilizations that left their mark on Indochina would be bonded to the French tree, the source of all civilization.

The French organizers of the Indochinese section of the interwar colonial expositions and the 1937 international exposition attempted to instruct the public with exhibits of colonial products; displays of French improvements in health care, education, and social services; miniature Indochinese communities; and performances by talented entertainers. They also highlighted the exotic and ancient civilizations of Indochina and the artisanal skills that contributed to the economic development of the empire. These exposition features portrayed the peoples of Vietnam, Cambodia, and Laos as talented and pliable members of the empire and France as a benevolent authority that was saving a declining civilization.

But the image of Indochina the colonial authorities disseminated was heavily influenced by Cambodia's political situation. The Cambodian king had accepted a French protectorate in 1863 partly in order to hold off a threatened advance from Thailand, so from the point of view of colonialists, it was possible to make the argument that the French had protected and saved the kingdom from destruction. In featuring the reconstruction of a decaying Khmer monument as the centerpiece of the exposition, organizers acknowledged the accomplishments of Cambodian civilization and presented the French as the guardians of the ancient culture. Moreover, colonial officials made the Cambodian Royal Ballet dancers the emblem of Indochinese culture and refinement. Although Vietnam's population was much larger than Cambodia's, colonial administrators and businessmen decided to create an image of the "Indochinese" based on Cambodian submission because it fit the portrayal of French Indochina they wanted to spread to the public. This image was a feminized one, Indochina as the beautiful woman France would possess and protect.[52]

Each colonial extravaganza contributed to the vision of the cultures of the Indochinese Union in the colonial family. Indochina made an especially memorable showing at the Exposition nationale coloniale in 1922, thanks in part to the planning of the local committees and the influence of Colonial Minister Albert Sarraut, a former governor general of the region. The fact that Indochina was featured that year is significant in the context of the focus on the contribution of African soldiers in the Great War during that event. At the 1931 Exposition coloniale internationale in Paris, the Southeast Asian colonies continued to hold their own with massive pavilions and a more diverse array of entertainers. At the 1937 Exposition internationale,

however, the limited funds and narrow focus of the event produced a performance that even the Ministry of Commerce admitted did little to raise the stature of Indochina in the public eye.[53]

In the artistic performances, the urban craft shops, and the beautiful Khmer temple, government officials displayed the Indochinese as the *fils doué* of the colonial empire. Colonial administrators and local committees planned and highlighted parades and entertainment that focused on exotic qualities of Asian culture and religion. Articles and writings from the period testify that these images made a greater impression than the trade statistics and agricultural samples housed in the local pavilions.[54] The reconstructed Angkor Wat temple dazzled onlookers, and Annamite plays and gold-adorned Cambodian dancers exuded an image of past splendor and artistic talent. As a colonial power, France had made itself the parental caretaker of this region, safeguarding ancient Asian cultures that would be lost without its protection. Because the French had a respect for the art and achievements of Asian culture, Indochina was assigned a special place in the colonial family as the "gifted child."

The images of Indochina one sees in French trademarks from 1914 to 1940 underwent only minor changes from earlier decades. Instead of using a wide mixture of imagery from the Far East, trademark designers adopted the *nón lá* as a regional symbol for Indochina. Whether male or female, "Tonkinese" or "Annamite," the Indochinese character continued to be displayed in trademarks as a laborer and an exotic figure that was associated with items such as tea, cloth, laundry soap, and paint. Commercial images and government depictions of Indochina at the interwar colonial expositions that elevated Cambodian traditions reinforced a one-sided view of Indochinese people that shielded the public from the realities of Indochinese hostility to the West. A decade after the 1937 Exposition internationale des Arts et Techniques dans la Vie moderne, the French public would abruptly discover that most Indochinese did not desire the "parental" guidance France had been offering.

8

La Mère-Patrie and Her Colonial Children: France on Display

*You are all sons of France. We make no distinction
among the children—none of them is greater than the
others—and what pleases us most is that you all feel like
brothers in the motherland.*[1]

*The colonizing state does not only acquire rights, it
takes on duties: the duty of pacification, the duty of
instruction, the duty to protect natives.*[2]

During the Third Republic, entrepreneurs and French government offi-
cials defined and disseminated images of their colonial subjects and in the
process constructed an image of the French state. That image was of a ra-
cially, materially, and morally superior France whose leaders embarked on
colonial conquest to benefit backward societies and develop underutilized
resources. This chapter considers portrayals of sub-Saharan Africans, North
Africans, and Indochinese and what they reveal about how the French rep-
resented themselves. In "International Exhibitions and National Identity,"
Burton Benedict discusses the invented tradition of the colonial "family"
that occurred in the exposition setting.[3] Especially after World War I, the
French used kinship terms to refer to the relationship between metropoli-
tan France and its overseas territories. The French parental (often mater-
nal) image was used in discussions of the *mission civilisatrice* at the same time
that a fraternal image of union and respect for colonial races was promul-
gated. These images served a specific purpose in colonial propaganda—to
communicate to the French populace that the empire extended naturally
from France, just as children were the natural outcome of marital bonds.
French advocates of colonialism, however, were unable to recognize the in-
consistencies and could not resolve the tensions between these differing
conceptions.

Representations of Sub-Saharan Africans,
North Africans, and Indochinese

Colonial Races on Commercial Trademarks

The incorporation of images of non-European "races" into a variety of French trademarks during the Third Republic took place during a period of overseas expansion and consolidation, Even though this practice followed an already established advertising tradition, the trademarks French business-owners registered reflected the political and cultural setting of the period. When a consumer purchased a product with an African or Asian figure on the label and took it home, it had the potential to reinforce common ideas about "race" in the mind of the owner. While it is not possible to fully assess how consumers interpreted these commercial images, we can analyze their characteristics. By evaluating Parisian and Marseillais trademark registrations for a 55-year span of the Third Republic, we can draw several general conclusions about the products and images that featured depictions of sub-Saharan Africans, North Africans, and Indochinese.

First, the colonial regions of Africa inspired more trademark labels than Indochina. Entrepreneurs registered slightly more trademarks with images of sub-Saharan Africans and blacks than with North Africans and Orientals—656 and 628 respectively. Labels with depictions of Indochinese and Asians lagged far behind the other two groups at 259. The number of trademarks registered for each region points to the region's commercial integration in the empire. Trade figures in the *Annuaire statistique de la France* from 1900 to 1940 show that imports from the colonial regions to France and French exports to the colonies were highest for North Africa, followed by sub-Saharan Africa (including Madagascar), and finally Indochina. In spite of stronger Franco-Maghrebian commercial ties, images of sub-Saharan Africans and generic blacks on trademarks were a bit more prevalent. One explanation for this could be that entrepreneurs viewed the exotic allure of black Africans as more profitable. Indeed, during the period 1886 to 1940, the success in marketing Banania cocoa drink, whose trademark featured the grin of the African soldier, was unrivalled.

Second, most items with labels depicting Africans and Asians were produced in the colonial territories. Two examples would be the illustrations of Maghrebian women used to sell grain and the Asian and Indochinese figures used to advertise tea cultivated in the East. A few companies, however, used illustrations of the exotic Other to sell products that were entirely unrelated to the figures in the drawings. For example, many trademarks for tobacco and cigarette papers featured drawings of North Africans. Although tobacco was not grown in the Maghreb, French businesses connected to-

162

Table 8.1. Trademarks Registered in Paris (Seine) and Marseilles with Images of Colonial Racial Groups, 1886–1940

Regional/Racial Group	Number of Trademarks in Category	Percent Registered in Marseilles	1886–1913 Registrations	1914–1940 Registrations	Yearly Average	Greatest Number of Registrations
Sub-Saharan African (Black)	656	34.3	316	340	11.92	1922 (25)
North African (Arab)	628	49.8	301	327	11.41	1911 (28)
Indochinese (Asian)	259	13.9	117	142	4.70	1904 (16)

Note: Paris and Marseilles are the two cities in metropolitan France where most of the trademarks that depicted people from the colonies were registered. As the colonial ministry established overseas administrative centers, entrepreneurs living in the colonies had the option of registering their products in cities such as Hanoi and Algiers.

Source: Ministère du commerce, *Bulletin officiel de la Propriété industrielle et commerciale. Marques de fabrique et de commerce,* 1886-1940. Volumes are available at the Archives de Paris (for trademark registrations for the Seine region), the Institut National de le Propriété Industrielle, and the Bibliothèque Nationale de France.

bacco consumption with exotic images of Orientals with Turkish pipes or North Africans in the desert.

The images on regional trademarks corresponded to long-held western stereotypes about each regional/ethnic group. Although design forms changed over the years (for example, art deco styles were popular in the 1920s), the basic character of French trademarks depicting colonial peoples did not change from 1886 to 1940. Entrepreneurs used images of Africans and Asians on their product labels either as an exotic element to attract attention or (more often) because there was a recognized connection between the qualities or origin of the item and the ethnic figure.

These designs rarely portrayed colonial peoples in a positive light. Pragmatic merchants highlighted the physical and cultural differences of others to distinguish and promote their products. Blacks and Asians often appeared as laborers or servants in the trademark labels; these were roles they filled in the colonial context. Even the contribution of colonial peoples to World War I did not alter the depiction of blacks as inferior on these labels. Designers placed blacks as butlers and maids on soap, bleach, coffee, and chocolate trademarks, stressing their complexion as a positive or negative symbol for the products. Tranquil Asian workers appeared on labels for fabric, dye, varnish, and paint. Entrepreneurs typically depicted North African Arabs and Berbers with images of Muslims, veiled women, and desert caravans. These images communicated French attitudes about "race" that paralleled official representations in state propaganda.

Races of the Empire at Government Expositions and World's Fairs

The major expositions included in this study devoted a significant amount of state funds and administrative efforts to promotion of the empire. While governments and leaders changed, the work of Le parti colonial in supporting colonial expositions during the Third Republic testified to an unwavering belief in France's imperial mission. At each of the four expositions sponsored by the French Colonial Ministry or the Ministry of Commerce, government officials collaborated with businesses and organizations to offer the public an interpretation that stressed that the empire was prosperous and growing more western each year. Organizers wanted to prove that the relationship between the colonies and the *métropole* was mutually advantageous. Diverse displays and samples gave economic lessons on agricultural and mineral production. Museum-style displays of photographs, maps, and official documents showed how Africans and Indochinese benefited from French education, health care, and technology. Living displays claimed to show the "native" in authentic "primitive" environments. These settings of miniature villages complete with huts, temples, and farms presented colonial "natives" as less-advanced peoples in need of French protection and

care. The museum-style exhibits and "living displays" grew in importance over the decades.

The earliest of the four expositions in this study, the colonial exposition at the 1900 Exposition universelle in Paris, included what organizers referred to as colonial "attractions" that resembled midway sideshows. Officials delegated most of the "living displays" to colonist entrepreneurs eager to exploit the public's hunger for the unusual and exotic. And exploit the public they did. The Algerian exposition, situated on the prime Trocadéro site opposite the Eiffel Tower, presented an Orientalist vision of North Africa— Moorish palaces; cramped bazaars; dark, veiled women; and Muslim mystics. Enchantment filled the air, and the public was encouraged to experience an Arabian Nights fantasy. The sub-Saharan African section was less mysterious. Organizers erected what were presented as traditional West African huts and brought in dancers and drummers to expose the public to the "primitive" culture of black Africans. The new colony of Madagascar displayed singers, musicians, and craftsmen from the many races of the island. Indochinese craftsmen demonstrated their talents at the miniature Indochinese village. The French colonial sections, which were confined to half of the Trocadéro plot, were separated from the main exhibits of the fair on the opposite side of the Seine.

In the same way, the empire remained fairly distant and insignificant to the French public at the turn of the century. The colonial minister's delegate to the exposition, Jules Charles-Roux, set out to change this fact. After pointing out the shortcomings of the Paris exposition, he used his influence in Provence and Paris to put on a national colonial exposition in Marseilles in 1906. His ideas lived on in the organization of the expositions that followed the Great War.

The participation of colonial troops and workers in World War I altered the way colonial officials spoke about and planned new expositions. In speeches and memorials, colonial governors and French supporters proudly held up their "*frères de couleur*" who had made great sacrifices and showed tremendous loyalty to France. The military provided increasing numbers of soldiers for display at the 1922 and 1931 expositions. In particular, sub-Saharan African *tirailleurs sénégalais* attracted admiration for their character and physique. North African *spahis* drew attention for their colorful and dramatic uniforms and their horsemanship. But it was Indochinese entertainers and merchants rather than soldiers who stood out at the 1931 Exposition coloniale internationale. Still feeling the effects of the depression, colonial governments struggled to showcase the artistic glories of France d'Outre-Mer at the 1937 Exposition internationale with a presentation of regional culture and artisanal skills. The colonial exposition on the Isle des Cygnes provided an opportunity for the French government to present Africans and Asians at work and tout the civilizing impact of French art schools.

The four colonial expositions shared a common ideology. Commissioners general, colonial ministers, and colonial governors defined the message to be communicated to the public. The philosophy behind the expositions was simple. Supporters of colonialism believed that expositions would educate the public about the accomplishments of the French colonial administration in "backward" societies and promote economic development in the colonies. Leaders from each period agreed on one fact—the colonies constituted a significant part of France's identity as a European power. They envisioned a stable colonial "family" as political and economic connections grew between overseas France and metropolitan France. Nothing resembling a separation or "divorce" (as Jacques Marseilles describes it) between the empire and French commercial interests crossed the minds of these administrators.[4] Each commissioner general's goal was to make the more remote part of France known to a generally uninformed public. Each believed that French citizens needed to learn about the lifestyles and customs of the colonial races in order to appreciate the wonderful accomplishments of the *mission civilisatrice*.

However, each successive set of organizers operated in a different environment of financial and material resources, and the technical aspects of their presentations varied. Although Charles-Roux expressed great passion about presenting the empire to the public in 1900, he was limited by the administrative structure of the colossal Exposition universelle and by spending constraints that were partly attributable to the poor management of his predecessors. He complained that it was impossible to do the colonies justice in the amount of time he was given to coordinate the sections and construct pavilions in the cramped Trocadéro location. The 1906 Exposition coloniale in Marseilles, born in part out of his frustration with the 1900 exposition, showed Paris officials that his ideas could be successfully enacted. With a single theme, more space, more exhibitors, and more living displays from the colonies, he encouraged an "authentic" presentation of Africans and Indochinese and a promising picture of the colonial economy.

In 1922, Adrien Artaud, then president of the Marseilles Chamber of Commerce and Industry, followed in the footsteps of his colleague. Artaud and his Marseillais collaborators demonstrated great enthusiasm for their city's second colonial exposition. After the success of the 1906 event, the Colonial Ministry and the governments in Africa and Indochina gave more enthusiastic support to the new Marseilles Exposition nationale coloniale. Marseilles again used the spacious park adjacent to the Rond Point du Prado, which was linked by tramway to the center of the city and possessed level terrain, trees, and streams that helped the organizers create an educational and entertainment space that would promote the French colonial empire. Marseillais officials tightly controlled the activities of private concessionaires, thereby avoiding the embarrassing problems of 1900. Organizers used colonial troops—many of whom were stationed in the region—to illustrate the

manpower potential of the overseas territories. Attendance figures were impressive, and the exposition ended up over 239,000 francs in the black.[5]

Maréchal Lyautey, commissioner general of the 1931 Exposition coloniale internationale in Paris, colonizer and former resident-general of Morocco, had perhaps the strongest direct ties to the colonies of the commissioners general of French expositions. With the help of a distinguished staff of colonial officials, some of whom had participated in the 1922 exposition, Lyautey created a spectacular exposition that mixed elements of "primitive" cultures and advanced modern society. Various forms of art and entertainment were presented in the pavilions and landscape of the 110 acres of the exposition—painting and sculpture, theater, restaurants, dance halls, cafés, an amusement park, and a zoo. There was something for everyone. Visitors saw a French vision of the world in a single day—"Le Tour du Monde en un Jour"—just as posters and advertisements promised. Lyautey's staff ensured that there were many living displays of Africans and Indochinese. The commissioner general initiated plans for the entertainment by asking the colonial governors to complete a survey listing the types of athletic demonstrations, games, and traditional dances their native troops could perform.[6] Months of rehearsals and preparation transformed nearly 1,000 colonial soldiers into entertainers for the European exposition crowds.

In terms of numbers of entries (some people attended more than once, with multiple entry passes) and the attention given to the French empire during those six months of 1931, many concluded that the exposition was a success. Officials registered more than 33 million entries, and receipts mounted to over 318 million francs. After expenses, the exposition made a profit of 33 million francs.[7] The Exposition coloniale internationale proved to be a bright light of financial success at the beginning of a worldwide Depression. In spite of all his efforts and the general acclaim for the exposition, Lyautey concludes in the preface to the exposition report that the importance of the empire had not fully reached the central authorities or the general population:

> It's not without a certain melancholy that after 50 years of colonial success that shined before the world at Vincennes—and, I will add, at the twilight of a long career dedicated to overseas France—that one is still forced to repeat elementary truths and wait for the creation of organisms capable of implanting them and diffusing them in public opinion.[8]

The peripheral status of the colonial empire at the 1937 Exposition internationale des Arts et Techniques dans la Vie moderne would have been another disappointment to Lyautey, who died several years before the fair opened.

A number of factors shaped the development of the Third Republic's major colonial expositions. First, government administrators, members of the *parti colonial,* and French businessmen with colonial interests wanted

to emphasize the growing importance of the empire near the beginning of the twentieth century. France's acquisition of Madagascar and parts of Indochina increased the size of the empire during that period, as did its military conquest and annexation of areas adjacent to territories in sub-Saharan Africa that France had already acquired. Second, these men knew that the French public did not understand the importance of recent colonial expansion. Pro-colonial leaders felt an urgent need to awaken the spirits of French people to the significance of the empire. Delegate Marcel Olivier's report on the 1931 exposition lamented that while British citizens were very familiar with their overseas empire, the French remained generally ignorant. "'Greater France' is still a myth," he said. "It must become a legal and political entity."[9] Organizers hoped to garner support for the empire from mass audiences by adding more entertaining and exotic shows to the exposition programs.

A third reason for the growing emphasis on the colonial showcases was a spirit of international and domestic competition. Paul Greenhalgh describes this atmosphere in *Ephemeral Vistas*.[10] Great Britain was France's major international competitor both in the "scramble" for colonies and on the exposition circuit. The success of the British Crystal Palace exposition prodded Louis Napoleon to exalt France's technological accomplishments. The British held colonial expositions in 1894, 1899, and 1924–1925; the Belgians also sponsored events in the 1930 Antwerp exposition. At the three French expositions with international sections, organizers were concerned about how their displays measured up against those of the other imperial powers. In 1900, Charles-Roux borrowed the words of Count d'Haussonville about France's place in the European imperial order:

> If you want to know France, look for her at the World's Fair. Everywhere you will see her, struggling with vigor against competition from other nations, superior here, inferior there, but never crushed and nowhere giving the impression of languor and discouragement.[11]

After the 1900 Exposition universelle, politicians and entrepreneurs from Provence grew determined to promote the colonies because of the influential role their colleague Charles-Roux played in the colonial sections, Le parti colonial, and regional politics. Two successful colonial expositions in Marseilles testified that Provence was capable of coordinating and hosting major national events. In 1922, Commissioner General Artaud called the Marseilles exposition "a decentralizing event, splendidly achieving the healthiest and most useful aspects of regionalism."[12] The Marseillais business community rallied to show the central government that it had a serious commitment to the empire. Their ideas about how to showcase the resources of the colonies were the models for the 1931 Exposition coloniale internationale. Reminiscing about the efforts of Charles-Roux and Marseilles to advance colonial expositions, one author wrote that Marseilles "put Paris on

the path to success. Paris always owes something to Provence, and the light of Paris is often only the light of the French provinces." The Parisian organizers, spurred into outdoing the Provençals, made sure that the "light" shone much brighter in Paris in 1931 than it had in Marseilles.[13]

A fourth consideration in the development of French colonial expositions is how the participation of the colonies in World War I changed the way planning committees represented colonial peoples. The organizers of the interwar expositions made colonial troops the centerpiece of many special events. In 1922, black African soldiers entertained the public with foot races and athletic displays. They also stood next to French soldiers in commemorative statues. In 1931, Fernand Rouvray and the organizers of the festivals for the Exposition coloniale internationale adopted elaborate shows for colonial soldiers that required months of rehearsal. Africans and Indochinese, who in the past had usually marched in simple parades or stood guard outside pavilions, acted in skits, performed acrobatics, danced in ballets, and manned exotic floats.

A final element in the development of colonial expositions was individual innovation. The greatest impetus for expanding the expositions came from a regional politician and businessman. Charles-Roux's vision inspired the development of the metropolitan and colonial sections at expositions and the ethnographic displays organized by colonial administrators. A provincial legislator and an entrepreneur with a large personal stake in the colonies, Charles-Roux, probably more than any other individual, worked to develop the effectiveness of this form of colonial propaganda during the Third Republic. The well-organized colonial pageants and exhibits at Marseilles in 1906 and 1922 drew the attention of the press and the admiration of national figures.[14]

Marshall Lyautey picked up where Charles-Roux left off in his campaign to elevate the empire before the public. At the 1931 Paris exposition, he turned colonial *spectacles* into nightclub shows with exotic multicultural elements that illustrated interaction and union between France and its empire. With the help of playwright and colonial administrator Fernand Rouvray, Lyautey used the performing arts to further the colonial cause and to encourage customers to return to Paris theaters, which were suffering from the economic downturn of the Depression.[15] Their use of colonial forces at the exposition emphasized the theme of mutual assistance between the *métropole* and the overseas territories. France, in their view, had initiated the relationship with its civilizing efforts. Just as the colonies had responded by aiding France with manpower during the war, Africans and Asians could be used in the early 1930s to help Parisian theaters out of their financial difficulties.

The French modified their portrayals of North Africans, sub-Saharan Africans, and Indochinese at expositions from 1886 to 1931 in several interesting ways. Exposition organizers accentuated the "primitive" or "uncivi-

lized" nature of members of the sub-Saharan colonies in 1889 and 1900, especially in their ethnographic descriptions and recreated villages. Commissioners and delegates made clear distinctions between levels of material culture and "racial" characteristics among the various groups. Yet they found reasons to criticize even the so-called developed societies in West Africa that had benefited from extended contact with European culture.

After the Great War, officials remolded the public image of African peoples to reflect the role of the *tirailleurs sénégalais* in the war effort. Advocates of colonialism began to speak of these brave and devoted black soldiers as proof of the practical benefits of the overseas empire. But at the colonial expositions, black African soldiers filled the same role as they had before the war; they were displayed as exotic primitive-natured people who were useful for entertaining French crowds. In addition to hiring African musicians and dancers, exposition administrators engaged African regiments in a track and field competition in 1922 and put black soldiers on the stage to perform as acrobats and dancers in 1931. The "new" image of sub-Saharan Africans was perhaps as demeaning as the old ones. Their inferior status as an object of entertainment for the European was defined by French attitudes of the Other.

French representations of the Arab and Berber groups of North Africa at the expositions remained steeped in Orientalist traditions. Whether in the official pavilions or in "attraction" sections, the organizers were determined to create a mysterious Arab world for visitors. Beautifully decorated Moorish palaces housed displays of the agricultural and mineral wealth of the Maghreb. Mosques, porticos, and minarets reminded visitors of the Islamic faith and traditions that were widespread in North African societies. At the 1900 Exposition universelle, the Société concessionaire de la Section Algérienne (Attractions) hired a series of exotic entertainment companies to create an image of Algerian culture. The *société* strove to portray the intriguing world of *The Book of the Thousand and One Nights* in the Trocadéro gardens. Crowded Arab markets, chanting Muslim mystics, and a fairytale "Ali Baba's Cave" were just a few of the features meant to allure exposition-goers. But in the hands of businessmen eager to profit from a major investment, the attractions of the Algerian section were degraded from an official exotic vision into a noisy spectacle of oddities. The results were not exactly what the administration had envisioned for its prized colony, but they were not far from what it had conceded in the show contracts. In the future, colonial officials would maintain tighter control of the living displays and entertainment they offered to French audiences by contracting directly with performers.

At the 1922 and 1931 colonial expositions and the 1937 Exposition internationale, French colonial administrators projected the same image of a mysterious North Africa, but they also emphasized the progress of the population toward civilization and the development of infrastructure and

the colonial labor force. The prominent position of the Maghrebian colonies in nearly all exposition pavilions and events symbolized their role as firstborn in the colonial family. As they had in earlier expositions, organizers defined the Arab and Berber "races" of the region by emphasizing their ties to Islam and Oriental civilization. According to texts and exhibits, these "warrior" and "barbarous" societies were being civilized and transformed with the medical clinics and schools the French were establishing in the region. Even so, the French did not hesitate to reinforce an image of belligerent people by displaying North Africans in performances such as the "Rifle Dance" and in gun-shooting fantasias.

Exposition organizers before World War I had populated the Arab streets and neighborhoods in the colonial exhibits with native musicians, shopkeepers, and exotic veiled women. In the interwar expositions, they attempted to sanitize these entertainment areas by removing the sensuous belly dancers of earlier expositions. Male dancers, musicians, and snake charmers were the only native performers who remained to entertain spectators in the government exposition areas. Writers reporting on the expositions began to emphasize the cafés, restaurants, and native marketplaces filled with working North African artisans. Visitors seeking exotic feminine charm had to turn their sights to other sections.[16]

In 1937, the marketplaces and artisan workshops, accompanied by a handful of subdued performances, sufficed to represent the Maghreb. There was no special colonial entertainment program because the organizers placed a greater emphasis on commercial ties with North Africa than on its exotic culture. Algeria, Tunisia, and Morocco were depicted as alluring colonies just a day's journey from southern France. More important, Algeria and Tunisia stood as a model for economic progress, modernization, and native advancement for the rest of the empire.

At the 1900 Exposition universelle, colonial officials reinforced the image of the Indochinese as submissive and hardworking. The French administration treated the Indochinese differently from Africans. They declared that the Indochinese population actually represented two categories of "races"— peoples with an established type of civilization and isolated "primitive" groups. "Advanced" Indochinese groups received more positive treatment at the fair. For example, observers praised the talented Vietnamese actors of the Théâtre Annamite. The exhibits and entertainment honored craftsmanship, religious practices, and social customs. Organizers set aside a special building for Asian art and hired indigenous workers to do fine carving and painting to embellish the pavilions.[17]

After World War I, colonial officials adjusted their representations of the Indochinese to account for their contribution during the conflict. Displays at the interwar colonial expositions honored Indochinese soldiers in addition to the usual focus on talents and character. The colonial "child" from Southeast Asia was seen as the "gifted" sibling, the *fils doué*. The architec-

tural beauty of Angkor Wat and the performances of the Royal Cambodian Ballet showed Indochina's potential for western "civilization" and advanced culture. In 1922 and in 1931, Cambodia was the center of the colonial showcase. Khmer structures formed the basis for the Indochinese exhibit halls in 1937 as well. At the interwar expositions, the reconstructed Khmer temple dominated as a symbol of French Indochina and perhaps as a symbol of the entire colonial empire, for it signified the distant decaying cultures that France could save and transform. At the exposition, mild and gentle Cambodians such as the king's young dancers came to symbolize all of Indochina. The peaceful vision of the Indochinese Union and its peoples that visitors saw blinded them to brewing discontent in Vietnam.

The colonial expositions of the Third Republic functioned as a major form of pro-colonial propaganda that reinforced two portrayals of colonized peoples. Government officials and their staff and business collaborators presented North Africans, sub-Saharan Africans, and Indochinese as exotic peoples whose cultural traits, although they were fascinating, illustrated the gap between the development of the less-advanced and civilized "races."[18] Written descriptions, exhibits, and displays ranked the Indochinese as the closest to the west in their potential for civilization, followed by North Africans and then by sub-Saharan Africans. Live exposition displays emphasized stereotypical views of North Africans as Islamic fanatics and fighters, black Africans as primitive and athletic, and Indochinese as submissive and talented. Each group had to be "saved" from its weaknesses and encouraged in its strengths by the disciplinary hand of its colonial "father" and the caring hand of its colonial "mother."

The creators of the French expositions also gave the public a glimpse of the vast colonial workforce. Each colony or protectorate displayed artisans and soldiers to illustrate the services "natives" could provide for France. Photographs, drawings, and texts referred to the men and women who labored to produce export crops and constructed the modern roads, railways, and ports of the empire. At the 1922 exposition in Marseilles, visitors could even observe a sample plot worked by Indochinese farmers. Every exposition displayed neatly dressed soldiers (clothed in the French uniforms that symbolized their integration into the civilized state) who demonstrated that the colonial forces were not just exotic but attractive and disciplined as well. Perhaps it was the presence of the soldier that best united the theme of a successful civilizing mission among backward "races" with productive service to France.

France on Display

In their function as major propaganda campaigns about the empire and its peoples, the colonial expositions of the Third Republic revealed the heart of the colonizer. Expositions permitted officials to create and assert a public

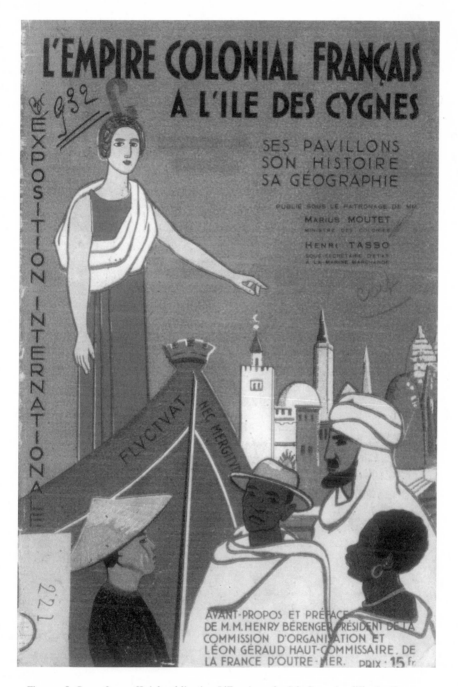

Figure 18. Cover from official publication L'Empire coloniale français a l'Ile des Cygnes,
1937 Exposition internationale.
Courtesy of Centre des Archives d'Outre-mer.

identity of the French state as the protector, provider, and parent of native "races." The business community was a major participant in the colonial enterprise and helped uphold French images by promoting race-based stereotypes and unflattering depictions of Africans and Indochinese. In the early decades of the twentieth century, advocates of colonialism in Marseilles succeeded in developing expositions that attracted public attention and drew support for the empire. The organizers of the 1931 Exposition Coloniale internationale in Paris repeated and expanded on elements of propaganda developed by the Marseillais. Commissioners, governors general, administrators, and supporters of colonialism who crafted the portrayal of the indigenous peoples under French control left a lucid picture of the imperial mind during the Third Republic.

"Protector and Provider"

In speeches, articles, and texts, colonial officials promoted an image of France as the protector of primitive peoples threatened by barbarians and despots. The 1931 *notice* on Côte d'Ivoire recounts how France dismantled the West African kingdom of Samory, bringing peace and prosperity to the land.[19] Algerians were delivered from "the brutal yoke of the Turks and their own anarchy,"[20] while Indochinese were liberated "from the oppression of mandarins and pirates."[21] In the *Guide officiel* to the 1931 exposition, André Demaison wrote that the French governors protected the Indochinese from their own character weaknesses and from "pernicious" outside influences.[22] Government officials especially asserted their "protector" role when they spoke about the initial conquest of African and Asian regions. They justified armed intervention with what they saw as their moral supremacy vis-à-vis corrupt or (in their minds) illegitimate leadership and established themselves as the new authorities.

The modern goods and services France provided to indigenous populations reinforced the sense of moral authority in the colonial system. Officials used colonial expositions to display France's role as a provider of modern civilization to less advanced peoples. The civilizing mission included western education, health care, public services, and agricultural improvements in Africa and Indochina. The French boasted that modern medicine and immunizations saved African peoples from physical destruction. Colonial Minister Paul Reynaud highlighted these ideas in an inaugural speech at the 1931 Paris exposition:

> In Africa we found *razzias,* slavery, famine, epidemics. Today, the desert corsairs are the guardians of it. And by an admirable effort, our doctors halt epidemics that were about to wipe out entire populations from the face of a continent. To thousands and thousands of human beings, they are giving a second chance at life. And you will see the photographs of these bright

classrooms where the little, alert faces of black schoolchildren are fixed on the teacher. We have brought light into darkness.[23]

Although colonial officials emphasized France's policy of association on an equal standing with colonial populations who were "different" (but, as they often stressed, *not* inferior), they did not acknowledge the contradiction between their political stance and their cultural one. They believed that only France could bring light to these "dark" places. On this point, domination rather than "association" prevailed.

Many Europeans believed that the colonial process was justified by the moral duty of the stronger to help the weaker. At the 1937 Exposition internationale des Arts et Techniques dans la Vie moderne, the French emphasized their role as protector in the realm of art and culture. African and Asian bodies and whole communities of colonized races were still in need of French medical and political aid, but the real emphasis turned to culture. In the 1910s and 1920s, the French instituted several policies aimed at protecting the cultural heritage of the races in their empire; they were implemented with the creation of art and trade schools and economic policies to safeguard traditional crafts.[24] At the colonial sections of the 1937 exposition, officials featured the work of students from schools in Vietnam, Madagascar, Cameroon, and Algeria. French officials argued that the schools protected traditional forms from extinction or corruption.

French administrators also perceived the colonial relationship as one of mutual obligations emanating from France's initial sacrifice of French troops to help its unfortunate "brothers." An official at the 1922 Marseilles exposition boasted of France's "colonizing genius" and the growing loyalty France created by its commitment to egalitarian values. Colonial peoples were willing to fight for the French flag, he said, because they had been treated like brothers:

> In war, they poured out their blood for us, their work, their riches. In peace, proud of our common fatherland, they collaborate wholeheartedly toward its rebuilding. That we owe to this admirable feeling of equality and human brotherhood, characteristic of our culture, that the Revolution expressed, but that lay dormant in the hearts of our ancestors.[25]

As early as 1900, Commissioner General Alfred Picard spoke of France's attitude toward the populations of the colonies as "*la bienveillance et le respect de l'homme*" (benevolence and respect for humanity).[26] Government officials were convinced that France's imperial venture was fundamentally a republican enterprise spurred by values that were uniquely French.

Administrators stated over and over again that Africans and Indochinese were their special associates in the colonial territories, not their subjects or inferiors. At a private banquet given by the Français du Maroc in August 1931, Lyautey exclaimed that the colonists "knew that we were not dealing with an inferior race, but a race different from our own. Understand, adapt

and love, such is the formula that allowed us to make true friends out of the Moroccans."[27] Although French officials claimed they did not view these races as inferior, they maintained that they were the ones to lead them to advanced civilization. In a speech at the end of the exposition, Lyautey said that "circumstances" placed France in the position of civilizer.[28]

"Parent"

Although after the war French officials often talked of the nation's role vis-à-vis its colonized peoples as that of a brother, an equal in the family structure, the real role France played in the empire was of parents leading a family. In this metaphorical family, France was "*la mère-patrie*" or "*la patrie*" and the colonies the adopted children. In 1900, the delegate for the Dahomean exposition tried to ensure that the African contingent serving at the exposition left France with a positive impression of its "*patrie adoptive*."[29] Colonial officials sometimes condescendingly called their subjects "big children"; the 1931 Madagascar *notice* referred to Sakalaves as "big, laughing children."[30] In 1922, Commissioner Artaud spoke of France's "maternal gesture" that "protects and disciplines." AOF governor general Merlin spoke to a group of African chiefs about their commitment as "sons of France" to serve their "mother." The colonies' sacrifices seemed to endear them to their French "mother" because she saw that her "children's" talents could be put to good use. By the 1930s, however, colonial propaganda referred to France's parental role less frequently.

Which France, Which Empire?

The incoherence in the various visual and verbal representations of colonial peoples emerge clearly in the exposition records. Two images of France coincide: the republican, fraternal France of human rights and equality and the protective parental France of superior culture and "civilization." Before World War I, the parental image of France predominated. Africans and Indochinese needed to be saved, protected, and civilized by a stronger French culture. There were almost no references to the "races" of Africa and Indochina as partners or "brothers" working together to build a prosperous empire until the Marseilles exposition of 1922.

There are two explanations for the appearance of the fraternal metaphor at the interwar expositions. First, the expositions gave colonial administrators the opportunity to capitalize on the positive image of the colonies because of their wartime (and peacetime) assistance to France. To emphasize the strength of the colonial relationship, administrators had to portray the myth that the help the colonies gave was voluntary and collaborative.[31] The truth is that many, perhaps most, colonial troops were recruited by force and few actually fought "alongside" the French since each ethnic group had

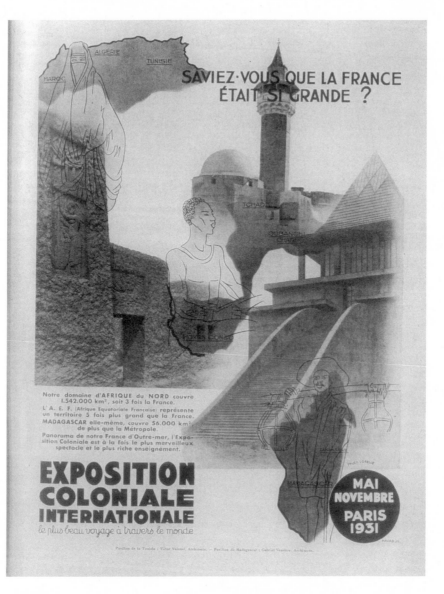

Figure 19. Advertisement for the Exposition coloniale internationale from Le Monde
Illustré, July 1931.
Courtesy of L'Illustration.

separate battalions and detachments. Republican symbolism and images of brotherhood shifted the focus of the relationship from one of colonizer and colonized to one of fraternal union and association in order to reinforce colonial bonds. However, the real attitude in France toward colonial peoples was hierarchical. Exposition displays and publications show that the belief in a superior French "race" and inferior colonial "races" was the basis for all colonial propaganda.

Second, the fraternal image was a response to the growing number of critics of French imperialism at home and abroad. The Communist Party was voicing its opposition to worldwide imperial domination, and indigenous peoples in the French colonies had begun to actively protest against French rule. The Vietnamese especially had never acquiesced to colonial rule. Organized groups mounted protests, rebellions, bombings, and even assassination attempts against French officials. The French often brutally suppressed these activities.[32]

Opposition to the empire emerged from leftist groups during the 1931 Exposition coloniale internationale. Forty surrealists produced a tract protesting the exposition in response to the arrest in April of Nguyen Van Tao, an Indochinese student who was protesting France's plans to execute forty Vietnamese prisoners. The authors of the tract attacked the morality and economics of French imperialism, citing the abuse of indigenous laborers and the hypocrisy of ideas of racial superiority. After all, they implied, how "civilized" was a race of people that spent four years slaughtering itself in trenches? The signers of the tract concluded that no person who supported the rights of common workers and wanted to see an end to bourgeois domination would attend the Exposition coloniale internationale. Some of these artists helped organize a small Anti-imperialist Exposition in Paris during the fall of 1931.[33]

At a time when advocates of colonialism were working diligently to highlight the "grandeur" of the empire, the colonial family was feeling many internal and external pressures. Opponents of colonialism rightly pinpointed French abuses and hypocrisy. Public expressions of respect for and brotherhood with Africans and Indochinese could not mask the reality of the oppressive colonial rule that many observed and experienced.[34] The dual images of France and its empire one finds in media and primary sources related to the expositions illustrate an attempt to define a new national purpose and justify commerce that steadily exchanged raw materials in the colonies and metropolitan manufactures and permitted French entrepreneurs to obtain land, resources, and cheap labor overseas.

During the Third Republic, French merchants established new trademarks that depicted colonial peoples as exotic figures or as workers that invoked stereotypical qualities that would help consumers realize their usefulness to French society. Generally, merchants linked these images to food and

other goods produced in the region where the colonial figures on their labels resided. Sometimes, however, trademark illustrations were meant to be exotic or evoke certain ideas about "race." One of the best examples is the scene where a black African is being washed white on bleach labels. North Africans were also a popular group for the trademark designers, probably because of the strong tradition in French art to use Orientalist scenes, the Maghreb's proximity to France, and the well-established trade relationship of the region with the *métropole*. Indochinese were portrayed on trademarks as passive hard-working Asians who would faithfully contribute to the empire.

All of the ways these "races" were displayed made it clear that they were objectified colonial subjects of the French—children of the *mère-patrie*. Government officials presented them to the public as exotic workers, soldiers, and entertainers. Entrepreneurs used similar depictions of the colonial "races" to distinguish their products. These French representations of the peoples of the empire reveal a great deal about the ambiguous way the French regarded their empire. They believed they had to play the role of protector, provider, and parent to the colonies because their culture was superior to others. These ideas did not change even after the Great War provided key officials with the opportunity to proclaim the utility of maintaining overseas colonies for military purposes. Ironically, it was the soldiers of the colonies who protected France in its time of need instead of the other way around.

* * *

The 1937 Exposition Internationale was not the last chance to display France and its colonies before the outbreak of war in 1939. In the final months of the Third Republic, the Comité Français des Expositions and the Colonial Ministry resolved to go forward with plans for the second Salon de la France d'Outre-Mer, an exhibition of the resources and development of the empire.[35] The Salon was originally scheduled for two weeks beginning in late November 1939, but the government pushed the date back to May 2–26, 1940. Organizers held the event in the Grand Palais in Paris. Following the pattern of previous expositions and fairs, administrators divided all aspects of the colonial world into broad categories. They established thirty-three groups and six classes: France d'Outre-Mer, Troupes Coloniales, France Métropolitaine, Relations avec la France d'Outre-Mer, Section Artistique, and a class that included tourism, propaganda, and the colonial press.[36] Minister of Commerce Louis Rollin and Colonial Minister Georges Mandel spearheaded this effort to stimulate commerce and highlight the value of France's colonies even as enemy forces moved closer to the French borders. Léon Baréty, president of the Comité Français des Exposition, declared in the salon's guidebook that holding the event was "an act

of confidence and strength" in the French empire. Posters called citizens to visit the salon and learn about the riches of greater France. To the final days of the Third Republic, the empire and its valuable products, soldiers, and labor force—a collection of races the French had imagined and redefined—was central in the hearts and minds of French authorities. It affirmed, by its existence, France's determination to assert its civilizing values on others.

NOTES

INTRODUCTION

1. Alice Conklin, *A Mission to Civilize: The Republican Idea of Empire in France and West Africa, 1895–1930* (Stanford, Calif.: Stanford University Press, 1997).

2. Robert W. Rydell, *All the World's a Fair: Visions of Empire at American International Expositions, 1876–1916* (Chicago: University of Chicago Press, 1984). Rydell continued this research with a look at international fairs: *World of Fairs: The Century-of-Progress Expositions* (Chicago: University of Chicago Press, 1993).

3. Paul Greenhalgh, *Ephemeral Vistas: The Expositions Universelles, Great Exhibitions and World's Fairs, 1851–1939* (Manchester: Manchester University Press, 1988).

4. A few of these studies from the 1990s include Burton Benedict, "International Exhibitions and National Identity," *Anthropology Today* 7 (June 1991): 5–9; and Raymond Corbey, "Ethnographic Showcases, 1870–1930," *Cultural Anthropology* 8 (1993): 338–369. Numerous scholars of history, literature, and cultural studies draw on anthropological insights in their work. Of special note are Bernth Lindfors, ed., *Africans on Stage: Studies in Ethnological Show Business* (Bloomington: Indiana University Press, 1999); and Nicolas Bancel et al., ed, *Zoos humains: de la Vénus hottentote aux* reality shows (Paris: La Découverte, 2002).

5. See especially Herman Lebovics, *True France: The Wars over Cultural Identity, 1900–1945* (Ithaca, N.Y.: Cornell University Press, 1992); and William H. Schneider, *An Empire for the Masses: The French Popular Image of Africa, 1870–1900* (Westport, Conn.: Greenwood, 1982). These authors also contributed articles to Bancel et al., *Zoos humains*: Lebovics, "Les zoos de l'Exposition coloniale internationale de Paris en 1931," 367–373; and Schneider, "Les expositions ethnographiques du Jardin zoologique d'acclimatation," 72–80.

6. Other writers have analyzed expositions as important events that illuminate our understanding of French politics and society during the Third Republic. These include Sylviane Leprun, *Le théâtre des colonies* (Paris: L'Harmattan, 1980); Pascal Ory, *Les expositions universelles de Paris* (Paris: Ramsay, 1982); Catherine Hodeir and Michel Pierre, *L'Exposition coloniale de Paris [1931]* (Bruxelles: Complexe, 1991); Charles-Robert Ageron, "L'Exposition coloniale de 1931: Mythe républicain ou mythe impérial?" in *Les Lieux de mémoire: La République*, ed. Pierre Nora (Paris: Gallimard, 1984), 561–591; and Shanny Peer, *France on Display: Peasants, Provincials, and Folklore in the 1937 Paris World's Fair* (Albany: State University of New York Press, 1998).

1. OVERSEAS EMPIRE AND RACE DURING THE THIRD REPUBLIC

1. Two early studies on assimilation policy are Michael Crowder, *Senegal: A Study in French Assimilation Policy* (London: Oxford University Press, 1962); and Raymond

Betts, *Assimilation and Association in French Colonial Theory, 1890–1914* (1961; Lincoln: University of Nebraska, 2005).

2. On the subject of colonial imagery in French school textbooks, see Yves Gaulupeau, "Les Manuels par l'image: pour une approche sérielle des contenus," *Histoire de l'éducation* 58 (May 1993): 103–135. Gaulupeau found that images of Algeria and North Africa predominated in the textbooks. A significant number of scenes illustrating events between 1880 and 1969 were linked to the conquest of Algeria.

3. Jules Charles-Roux claimed that France freed the West Africans "*du joug de maîtres odieux tels que Samory*" (from the yoke of odious masters such as Samory); *Exposition universelle de 1900, Les Colonies françaises, Introduction général* (Paris: Challalmel, 1901), 74.

4. See William H. Schneider, *An Empire for the Masses: The French Popular Image of Africa, 1870–1900* (Westport, Conn.: Greenwood, 1982), 97–109.

5. *Cercles* and *sous-cercles*, the largest units, were led by French colonial administrators. They divided these units into *cantons* that were assigned to traditional or loyal African leaders from the region.

6. The proportion of French to Africans in the empire in 1930 was as follows: 1:10 for Algeria; 1:200 for Madagascar; 1:1,200 for West Africa (AOF); and 1:1,300 for Equatorial Africa (AEF). Figures from Albert Gagé, *Ce qu'il faut savoir des colonies françaises* (Paris: Fernand Nathan, 1931), 216–217.

7. The word "race" is a problematic term for many researchers. I have placed the word within quotation marks when discussing it as a questionable concept French contemporaries used during the Third Republic and accepted as an appropriate term to describe groups of people. Scientists of the later twentieth century have determined that biological "races" of people defined by similar physical traits or geographical origins simply do not exist. Studies of genetics, such as those conducted by biologist Richard Lewontin, have shown that two individuals said to belong to the same "race" can have greater differences between their genetic codes than two individuals of different recognized "races." Therefore, there is no biological or genetic basis for terms such as the "black race" or the "white race." There are, however, ethnic groups defined by genetic similarities and/or culture and other social factors. At the end of the nineteenth century, many social commentators and scientists in the west held to the concept of "race" as the way to categorize and rank the people of the world. For Gustave Le Bon and other popularizers of racial theory during the period of this study, "race" imbued groups of people from different regions of the world with psychological traits or even intellectual capabilities in addition to physical and cultural traits they might share. For further discussion of this issue, see Tzvetan Todorov, *On Human Diversity: Nationalism, Racism, and Exoticism in French Thought* (Cambridge, Mass.: Harvard University Press, 1993), 90–170; and Stephen Jay Gould, *The Mismeasure of Man* (New York: W. W. Norton, 1996).

8. See William Y. Adams, *The Philosophical Roots of Anthropology* (Stanford, Calif.: CSLI Publications, 1998).

9. The text of the March 27, 1852, decree about the Palais de l'Industrie reads: "*Louis-Napoléon, Président de la Républic française,*

Considérant qu'il n'existe à Paris aucun édifice propre aux expositions publiques qui puisse répondre à ce qu'exigeraient le sentiment national, les magnificences de l'art et les développements de l'industrie; Considérant que le caractère temporaire des constructions qui, jusqu'à

présent, ont été affectées aux expositions est peu digne de la grandeur de la France; Sur le rapport du ministre de l'intérieur, Décrète:

Article 1er Un édifice destiné à recevoir des expositions nationales, et pouvant servir aux cérémonies publiques et aux fêtes civiles et militaires, sera construit d'après le système du palais de cristal de Londres, et établi dans le grand carré des Champs-Elysées.

Article 2. Le ministre de l'intérieur est chargé de faire étudier le projet énoncé dans l'art. 1er et de nous proposer, d'accord avec la ville de Paris, les moyens les plus propres à une prompte et économique execution."

(Considering that no edifice exists in Paris for public expositions that might respond to the requirements of national pride, magnificent works of art and industrial developments; Considering that the temporary nature of the buildings that have been used for expositions until now is not worthy of France's grandeur; On the report of the Minister of the Interior, I decree:

Article 1: An edifice, whose purpose is to house national expositions and serve [as the location] for public ceremonies and civil and military fêtes, will be built, based on the system of the Crystal Palace of London, in the great square of the Champs Elysées.

Article 2: The Minister of the Interior is charged with having a study of the project completed, as set forth in Article 1, and to propose to us, in agreement with the city of Paris, the most appropriate means for a prompt and economical execution of the project.) *Le Moniteur universel: journal officiel de la République* 90 (March 30, 1852): 517.

10. Pascal Ory, *Les expositions universelles de Paris* (Paris: Ramsay, 1982), 153. Ory states that there were 6,040,000 paying visitors at the 1851 Crystal Palace in London and 5,163,000 paying visitors at the 1855 Exposition universelle in Paris. The Paris exposition, however, had more exhibitors; 24,000 to London's 14,000. The number of exhibitors in Paris grew to 52,200 in 1867, compared to London's 28,700 in 1862.

11. In *Hybrid Modernities: Architecture and Representation at the 1931 Colonial Exposition, Paris* (Cambridge, Mass.: MIT Press, 2000), Patricia Morton addresses the theme of authenticity and the creation of exotic environments in the structures of colonial expositions.

12. Senator J. B. Krantz, Commissioner General, "Ordre de Service #31," July 1878, Exposition universelle de 1878, Archives Nationales de France (hereafter AN), F12/3227, dossier 6.

13. Minister of War to the Minister of Agriculture and Commerce, May 21, 1878, Exposition universelle de 1878, F12/3227, dossier 5, AN.

14. *Tirailleurs* were regular colonial infantry or skirmishers; *spahis* were members of cavalry units.

15. *Revanchards* were politicians and public figures who wanted France to exact a military revenge on the Germans and regain the two territories the Germans had taken.

16. Minutes, Commission d'Organisation de l'Exposition Coloniale, Exposition universelle de 1889, August 1, 1887, F12/3760, dossier Exposition des Colonies, AN.

17. Ibid.

18. Resident General of France in Tunisia to Minister of Foreign Affairs, February 21, 1887, Exposition universelle de 1889; and Minister of Foreign Affairs to Minis-

ter of Commerce and Industry, June 11, 1887, Exposition universelle de 1889, both in F12/3760, dossier C, AN.

19. Minutes, Commission d'Organisation de l'Exposition Coloniale, Exposition universelle de 1889, August 1, 1887, F12/3760, dossier Exposition des Colonies, AN.

20. The men were pictured in the April 20, 1889, edition of the *Bulletin officiel de l'Exposition universelle de 1889.*

21. On the theme of representation and race at the 1889 Exposition universelle, see Lynn E. Palermo, "Identity under Construction: Representing the Colonies at the Paris Exposition Universelle of 1889," in *The Color of Liberty: Histories of Race in France,* ed. Sue Peabody and Tyler Stovall (Durham, N.C.: Duke University Press, 2003), 285–301.

22. Griots are West African chroniclers who are entrusted with the history of their people and who communicate their knowledge through entertaining story-telling and music.

23. "La Fête de Nuit de l'Esplanade," *Bulletin officiel de l'Exposition universelle de 1889,* 2ème séries, August 22, 1889, 2.

24. For details, see "La Rue de Caire," *Bulletin officiel de l'Exposition universelle de 1889,* May 22, 1889, 3–4.

25. Minutes, Commission d'Organisation de l'Exposition Coloniale, August 1, 1887, F12/3760, AN.

26. Minutes, Commission d'Organisation de l'Exposition Coloniale, August 1, 1887 (dossier Plans et Devis), F12/3760, AN.

27. The June 3 and 15 and July 16, 1889 editions of the *Bulletin officiel* referred to rumors about illness among the colonial workers. In June the paper stated: "*Nous sommes autorisés à déclarer qu'il n'y a absolument rien de fondé dans les bruits qui ont couru au sujet des maladies des exotiques. Quelques Annamites ont été pris de la fièvre paludéenne, c'est vrai, mais elle n'est causée que par le changement de climat et n'apparaît qu'à certaines heures.*

Quant à la vaccination, tous les indigènes de l'esplanade des Invalides ont été vaccinés il y a quelques jours, sauf les Marocains, à qui leur religion l'interdit formellement."

(We are authorized to declare that the rumors circulating concerning illnesses among the exotics are absolutely unfounded. It is true that a few Annamites were stricken with paludal fever, but it is only brought about by the change in climate and only appears at certain hours.

As far as vaccinations are concerned, all the natives on the Esplanade des Invalides were vaccinated several days ago, except for the Moroccans, whose religion positively forbids it.) "Echos," *Bulletin officiel de l'Exposition universelle de 1889,* 2ème séries, June 1889, 4.

28. "Qu'est-ce que Salifou?" *Bulletin officiel de l'Exposition universelle de 1889,* 2ème series, July 13, 1889, 4.

29. "La Mission marocaine dans la Tour Eiffel," *Bulletin officiel de l'Exposition universelle de 1889,* 2ème series, September 26, 1889, 2.

30. The historical background in this paragraph is discussed in Daniel Cauzard et al., *Images de marques, marques d'images* (Paris: Ramsay, 1989), 13–14.

31. Andréa Semprini, *La Marque* (Paris: Presses Universitaires Françaises, 1995), 3–5.

32. Ibid., 3.

33. Any entrepreneur who wanted to sell a product in France had to register a

trademark. French-based companies could register at the local or regional business tribunal (*tribunal de commerce*); foreign-based companies had to register with the business tribunal for the Seine region (Paris).

34. A copy of the trademark legislation was printed in *Annales de la proriété industrielle, artistique et littéraire* 4 (1858): 5–9.

2. SUB-SAHARAN AFRICANS: "UNCIVILIZED TYPES"

1. David Brion Davis's books on slavery in the western world cover this subject thoroughly. See *The Problem of Slavery in Western Culture* (New York: Oxford University Press, 1988); and *The Problem of Slavery in the Age of Revolution, 1770–1823* (New York: Oxford University Press, 1999).

2. For a general discussion of the French antislavery movement, see Lawrence C. Jennings, *French Reaction to British Slave Emancipation* (Baton Rouge: Louisiana State University Press, 1988).

3. See Jan Nederveen Pieterse, *White on Black: Images of Africa and Blacks in Western Popular Culture* (New Haven, Conn.: Yale University Press, 1992), chapter 2; and William B. Cohen, *The French Encounter with Africans: White Response to Blacks, 1530–1880* (Bloomington: Indiana University Press, 1980), particularly chapter 8 on scientific racism.

4. William H. Schneider, *An Empire for the Masses: The French Popular Image of Africa, 1870–1900* (Westport, Conn.: Greenwood, 1982), 128–131; Michael A. Osborne, *Nature, the Exotic, and the Science of French Colonialism* (Bloomington: Indiana University Press, 1994), 126–127.

5. T. Denean Sharpley-Whiting, *Black Venus: Sexualized Savages, Primal Fears, and Primitive Narratives in French* (Durham, N.C.: Duke University Press, 1999); Sander Gilman, *Difference and Pathology: Stereotypes of Sexuality, Race, and Madness* (Ithaca, N.Y.: Cornell University Press, 1985), 83–88. See also Zola Maseko, producer, *Life and Times of Sara Baartman the Hottentot Venus,* First Run/Icarus Films, 1998; and Barbara Chase-Riboud, *Hottentot Venus: A Novel* (New York: Doubleday, 2003).

6. Schneider, *An Empire for the Masses,* 147.

7. Nederveen Pieterse's *White on Black* presents a survey of European images of blacks drawn from numerous sources that include engravings, advertising posters, comic strips, magazine illustrations, and packaging labels. He refers to a specific set of western stereotypes of blacks and outlines national variations.

8. See Schneider, *An Empire for the Masses.*

9. Jean Devisse and Michel Mollet, *The Image of the Black in Western Art,* vol. 2, part 2, *From the Early Christian Era to the "Age of Discovery." Africans in the Christian Ordinance of the World (Fourteenth to the Sixteenth Century),* trans. William Granger Ryan (New York: William Morrow and Co., 1979), 10–14. Chapter 1 deals with the early history of the heraldic Moor image. See also Paul H. D. Kaplan, *The Rise of the Black Magus in Western Art* (Ann Arbor: UMI Research Press, 1985). Allison Blakely examines similar images of the Moor and representations of blacks in Dutch culture in *Blacks in the Dutch World: The Evolution of Racial Imagery in a Modern Society* (Bloomington : Indiana University Press, 1993).

10. See Marie-France Latour, "Subverting Manichean Allegory: Soap, Blackness and the Articulation of Racial Difference in French Advertisements for Hygienic Products, 1900–1930" (BA honors thesis, Harvard College, 1992).

11. *Dictionnaire de l'Académie Française* (Paris: Firmin-Didot, 1879).

12. This idea is repeated in many writings about Africans at the end of the nineteenth century and is referred to in the publications on the colonies prepared for the 1900 Exposition universelle. See, for example, L.-M. Famechon, *Exposition Universelle de 1900, Colonies et pays de protectorat, Les Colonies françaises,* vol. III, *Notice sur la Guinée Française* (Paris: Alcan-Lévy, 1900). William B. Cohen discusses this issue in the context of scientific and intellectual circles in *The French Encounter with Africans.*

13. The myth derives from Genesis 9:20–27. The so-called curse of Ham asserts that Ham's descendents are cursed with black skin and are destined to be slaves as a punishment from God, but nothing in Genesis refers to complexion or to a curse that involved anyone but Ham's son Canaan. Moreover, Noah, not God, issues the curse. This interpretation of Noah's curse is a vivid example of how biblical passages have been twisted to defend racist thinking.

14. Abdul R. JanMohamed, "The Economy of Manichean Allegory: The Function of Racial Difference in Colonialist Literature," in *"Race," Writing, and Difference,* ed. Henry Louis Gates, Jr. (Chicago: University of Chicago Press, 1986).

15. The American case seems important to note here, although such images can be found in advertisements throughout Europe (see Nedervan Pieterse's *White on Black*). Notably, minstrel performances with their portrayals of black buffoons and dandies prospered in the United States in the nineteenth century and were then taken to Europe. Minstrel show posters, both before and after the Civil War, included generally demeaning images of blacks, often emphasizing their lips and eyes. On this subject see Robert C. Toll, *Blacking Up: The Minstrel Show in Nineteenth-Century America* (New York: Oxford University Press, 1974); Joseph Boskin, *Sambo: The Rise and Demise of an American Jester* (New York and Oxford: Oxford University Press, 1986); and Marilyn Kern-Foxworth, *Aunt Jemima, Uncle Ben, and Rastus: Blacks in Advertising, Yesterday, Today, and Tomorrow* (Westport, Conn.: Greenwood, 1994). No scholar has systematically examined racial imagery in American trademarks of this early period.

16. Alfred Picard, *Exposition Universelle de 1900, Rapport général administratif et technique* (Paris: Imprimerie Nationale, 1903), 7:219. Jean-Baptiste Marchand was a French officer who led the Congo-Nile expedition. His forces reached Fashoda in Sudan and had a standoff with the British, who intended to maintain control of the entire Nile River corridor in East Africa. This episode is known as the Fashoda incident. The French backed down, which averted war between the two countries.

17. Ministère des Affaires étrangères et des Colonies, *Le Madagascar,* vol. 6 of *Exposition Universelle de 1900, Colonies et pays de protectorat* (Paris: Alcan-Lévy, 1900), 7.

18. *Lambas* are large pieces of cloth Madagascans wear shawls or cloaks.

19. Jules Charles-Roux, *Exposition universelle de 1900, Les Colonies françaises. L'Organisation et le Fonctionnement de l'Exposition des Colonies et Pays de Protectorat. Rapport général* (Paris: Imprimerie Nationale, 1902), 169–175. La Société Anonyme du Panorama de Madagascar, a joint stock group based in Paris, hoped to benefit from interest in this newly conquered colony by offering the public a panorama that showed the seizure of Tananarive, dioramic views of Madagascar, and short films of life in the colony. In an unusual move, the administrators responsible for the section gave the company space for the panorama within the government's Madagascar pavilion. After the first few weeks of operation, the president of the *société* expressed optimism about the success of the panorama, but at the end of the exposition in No-

vember, the company filed a grievance that cited a series of technical problems that it blamed on the general administration of the exposition. The *société* hoped to receive compensation for 96,189 francs in lost revenue, but it lost its case in arbitration. See F12/4357, AN.

20. Ministère des Affaires étrangères et des Colonies, *Le Madagascar*, 12.

21. Charles-Roux, *Exposition universelle de 1900, Les Colonies françaises. L'Organisation et le Fonctionnement de l'Exposition des Colonies et Pays de Protectorat. Rapport général*, 239.

22. Ibid., 240.

23. Ibid., 240.

24. Ibid., 218.

25. Jules Charles-Roux, *Exposition universelle de 1900, Les Colonies françaises, Introduction général* (Paris: Challalmel, 1901), 32–37.

26. Ibid., 37n.

27. See especially Schneider, *An Africa for the Masses.*

28. Charles-Roux, *Exposition universelle de 1900, Les Colonies françaises. L'Organisation et le Fonctionnement de l'Exposition des Colonies et Pays de Protectorat. Rapport général*, 159–161.

29. William H. Schneider, "Les expositions ethnographiques du Jardin zoologique d'acclimatation, in *Zoos humains: de la Vénus hottentote aux reality shows*, ed. Nicolas Bancel et al. (Paris: La Découverte, 2002), 72–80.

30. J.-L. Brunet, *Dahomey et Dépendances: Historique général, Organisation, Administration, Ethnographie, Productions, Agriculture, Commerce* (Paris: Challamel, 1900), 524–525.

31. Charles-Roux, *Exposition universelle de 1900, Les Colonies françaises. L'Organisation et le Fonctionnement de l'Exposition des Colonies et Pays de Protectorat. Rapport général*, 242.

32. Ibid., 23n.

33. Ibid., 221.

34. Schneider found that the French popular press portrayed Africa as morally "dark" and as a continent ripe for commercial exploitation.

35. Scellier de Gisors designed this building and several other structures, including the Congo pavilion. See Picard, *Exposition Universelle International de 1900*, 4:328.

36. Charles-Roux, *Exposition universelle de 1900, Les Colonies françaises. L'Organisation et le Fonctionnement de l'Exposition des Colonies et Pays de Protectorat. Rapport général*, 201.

37. The *cora* is a West African stringed harp.

38. Charles-Roux, *Exposition universelle de 1900, Les Colonies françaises. L'Organisation et le Fonctionnement de l'Exposition des Colonies et Pays de Protectorat. Rapport général*, 220–221.

39. Ibid., 218. Collonge attributed this expression to the French *colons.*

40. Lucien-Marie Famechon, *Exposition Universelle de 1900, Colonies et pays de protectorat, Les Colonies françaises*, vol. III, *Notice sur la Guinée Française* (Paris: Alcan-Lévy, 1900), 174 and 176. (Hereafter *Notice sur la Guinée Française.*)

41. J.-L. Brunet, *Dahomey et Dépendances: Historique général, Organisation, Administration, Ethnographie, Productions, Agriculture, Commerce* (Paris: Challamel, 1900), 255–258.

42. Famechon, *Notice sur la Guinée française,* 182–183.

43. Jean Fonssagrives, *Exposition Universelle de 1900. Colonies et pays de protectorat. Les Colonies françaises, Le Dahomey* (Paris: Alcan-Lévy, 1900), 393–394.

44. Marcel Guillemot, ed., *Notice sur le Congo français* (Paris: J. André, 1900), 68–73.

45. Famechon, *Notice sur la Guinée française,* 177–179.

46. Dr. Lasnet, Auguste Chevalier, A. Cligny, and Pierre Rambaud, *Une Mission au Sénégal: ethnographie, botanique, zoologie, géolgie* (Paris: Challamel, 1900), 22–23.

47. Ibid., 74.

48. Ibid., 122.

49. Guillemot, *Notice sur le Congo français,* 65.

50. Ministère des Affaires étrangères et des Colonies, *Le Madagascar,* 55–60.

51. Ibid., 60.

52. Ibid., 54.

53. Ibid., 61.

54. Brunet, *Dahomey et Dépendances,* 257–258.

55. Schneider, *An Empire for the Masses.*

3. NORTH AFRICANS: MYSTERIOUS PEOPLES

1. Joseph Arthur de Gobineau, *Essai sur l'inégalité des races humaines,* vol. 1, 6th ed. (1853; Paris: Firmin-Didot, 1933), 155.

2. Gustave Le Bon, *Les Lois psychologiques de l'evolution des peoples,* 18th ed. (Paris: F. Alcan, 1927), 39–40. This was originally published in 1894.

3. Edward W. Said, *Orientalism* (New York: Vintage Books, 1979). Said's analysis of the dimensions of the western image of the Orient is useful for evaluating the images of North Africans. In *Culture and Imperialism* (New York: Knopf/Random House, 1993), Said expanded on his previous work and responded to critics such as Homi Bhabha who asserted that he did not acknowledge the agency of indigenous peoples in the colonial encounter. For an assessment of key western views of Arabs, see Malek Chebel, "L'Arabe" dans l'Imaginaire occidental," in *L'Autre et nous: Scènes et types,* ed. Pascal Blanchard et al. (Paris: Syros/ACHAC, 1995), 39–44.

4. The treatment of Islamic women in western iconography has not been sufficiently explored. One excellent study that addresses western male fantasy and the gaze on and from the Other is Malek Alloula, *The Colonial Harem,* trans. Myrna Godzich and Wlad Godzich (Minneapolis: University of Minnesota Press, 1986). Alloula examines presentations of Algerian women in French colonial postcards.

5. These are large wool coats with hoods that North African men often wear.

6. After the revolution of 1848, Northern Algeria was divided into three French departments and was administered much like the continental departments.

7. Amir Farablous was named after the tenth-century Islamic philosopher and mystic Alfarabius. "El Moufti" is the title for a Muslim jurist.

8. Saladin flours and semolinas were registered in Marseilles in 1912; Bougies Extra Abbas (candles) were registered in Paris in 1892.

9. This trademark belonged to the family of Jules Charles-Roux, delegate and coordinator of the colonial section of the 1900 Exposition universelle in Paris.

10. Abd el Kader's movement succeeded in thwarting the French forces until

1847. After his capture, he was exiled to France, where he later became a friend of the French under the Second Empire.

11. See Alfred Picard, *Exposition universelle de 1900, Rapport général administratif et technique* (Paris: Imprimerie Nationale, 1903), 4:9–10.

12. Ibid., 4: 202–203.

13. Ibid., 332–335.

14. Ibid., 203.

15. Ibid., 328–329, 350.

16. Jules Charles-Roux, *Exposition universelle de 1900, Les Colonies françaises. L'Organisation et le Fonctionnement de l'Exposition des Colonies et Pays de Protectorat. Rapport général* (Paris: Impremerie Nationale, 1901), 241–243. The passage in Charles-Roux's report refers to the *derbouka* (a Magrebian drum), the *bendaïr* (a tambourine-like percussion instrument), and the *nouba* (a nineteenth-century term for the military music played by North African regiments).

17. Ibid., 210–211.

18. Ibid., 311–312.

19. The *Bulletin Officiel* of the 1889 Exposition universelle described Delort's project in a May 22, 1889, article. Delort created an organizational committee for the Egyptian exposition that included French consuls, native elites, and French citizens residing in Egypt. Charles de Lesseps was the honorary president of the committee. The Rue d'Alger contained the same type of "attractions" as its successful predecessor.

20. Isawiyas are members of a brotherhood founded by a Sufi mystic said to have special healing powers. They are known for going into trances and performing acts such as swallowing glass, nails, and live scorpions.

21. Governor General of Algeria to the Commissioner General of the World's Fair, November 27, 1899, and statute booklet signed April 15, 1899, both in F12/4353, dossier Algérie, Société, AN; Ernest Pourtauborde to Algerian Delegate, 14 December 1899, and note from Director of Finances to Commissioner General, December 27, 1899, both in F12/4353, dossier Algérie, Divers, AN.

22. Alexis Carraud, *Guide bleu du Figaro à l'Exposition de 1900* (Paris: Taride, 1900), 88.

23. Le Matin, *Le Guide remboursable du journal "Le Matin,"* 3rd ed. (Paris: Société des rembourseurs automatiques, ca. 1900), 311.

24. Contract between Société Concessionnaire de la Section Algérienne à l'Exposition Universelle de 1900 and M. Seigle-Gouyon, representing the Société de Vulgarisations et Attractions Algériennes en 1900, F12/4353, dossier Algérie, Exploitation, AN. This contract was drafted in Algiers, then signed by the Société Concessionnaire's representative in Paris.

A Kabyle performer (musician, dancer, etc.) is from Kabylia, a mountainous region east of the Algerian capital of Algiers.

25. Grison to Montheil [*sic*], April 30, 1900, F12/4353, dossier Algérie, Exploitation, AN.

26. "Le Toc d'Orient," *Bulletin officiel de l'Exposition universelle de 1889,* July 27, 1889.

27. "Rapport du Commandant de Férussac, sur l'Algérie Attractions," F12/4366, dossier Conseil d'Etat, Section Algérienne (Attractions), AN.

28. Monteil to Commissioner General, May 11, 1900, and Commissioner General to Montheil [sic], May 19, 1900, both in F12/4353, dossier Algérie, Exploitation, AN.

29. The waitresses in these establishments dressed in different ethnic costumes. See Zeynep Çelik and Leila Kinney, "Ethnography and Exhibitionism at the Expositions Universelles," Assemblage 13 (December 1990): 42.

30. "Rapport du Commandant de Ferussac, sur l'Algérie Attractions," F12/4353, dossier Algérie, Exploitation, AN; Monteil to Director of Finances, September 7, 1900; and Férussac to Grison, September 4, 1900, both in F12/4366, dossier Conseil d'Etat, Section Algérienne (Attractions), AN. Monteil also mentioned the firing of a black employee whose attitudes generated various complaints.

31. "Rapport du Commandant de Férussac, sur l'Algérie Attractions," F12/4366, dossier Conseil d'Etat, Section Algérienne (Attractions), AN; Commissioner General to Monteil, June 13, 1900; Arrête dated June 14, 1900, issued to the Société concessionnaire; Pourtauborde to Monteil, June 18, 1900; Férussac to Director of Finances on September 4 and 13, 1900, all in F12/4353, dossier Algérie, Exploitation, AN.

32. Picard, Exposition Universelle International de 1900, 4:308.

33. Férussac to the Secretariat General, F12/4353, dossier Algérie, Grotte aux millions, AN.

34. By 1900, Paris already had a long tradition of exotic popular shows where Europeans played the part of "authentic" Orientals. See Çelik and Kinney, "Ethnography and Exhibitionism at the Expositions Universelles."

35. V. Rabarot to Commissioner General, July 11, 1900, F12/4353, dossier Algérie—Stéreorama mouvant, AN.

36. Ibid., and note from Charles de Férussac to Commissioner General, July 11, 1900, F12/4353, dossier Algérie—Stéreorama mouvant, AN.

37. Francovich to Commissioner General, July 15, 25, and 29, 1900; Francovich and Gadan to Commissaire Général, August 5, 1900, both in F12/4353, dossier Algérie—Stéreorama mouvant, AN.

38. Férussac's May 6 report noted that the governor general of Algeria had agreed with plans to force the company to comply with the administration's requests. On the popularity of ethnographic shows around the turn of the twentieth century, see Robert Rydell, All the World's a Fair (Chicago: University of Chicago, 1984); Rydell, World of Fairs (Chicago: University of Chicago, 1993); and Burton Benedict, "Rituals of Representation: Ethnic Stereotypes and Colonized Peoples at World's Fairs," in Fair Representations, ed. Robert Rydell and Nancy E. Gwinn (Amsterdam: VU University Press, 1994).

39. Monteil to Commissioner General, May 1, 1900; Commissioner General to Monteil, May 7, 1900; Monteil to Commissioner General, May 11, 1900, all in F12/4353, dossier Algérie, Exploitation, AN. Unfortunately, we do not have access to Monteil's correspondence with the Société concessionnaire.

40. Note from Férussac to Director of Finances, F12/4353, dossier Algérie, Exploitation, AN; "Rapport du Commandant de Férussac sur l'Algérie Attractions," F/12/4366, dossier Conseil d'Etat, Section Algérienne, AN. Férussac notes that some vendors were selling merchandise that workers had not produced before the public and were displaying and selling their wares in unauthorized locations only days after they had been forced to remove tables or constrict their merchandise.

4. INDOCHINESE: GENTLE SUBJECTS

1. For a detailed intellectual history of early French views on China, see Basil Guy, *The French Image of China before and after Voltaire*, vol. 21 of *Studies on Voltaire and the Eighteenth Century*, ed. Theodore Besterman (Genève: Institut et Musée Voltaire, 1963).

2. Ernest Renan, *La Réforme intellectuelle et morale* (1872; reprint, Paris: Editions Complèxe, 1990), 93.

3. Paul Leroy-Beaulieu, "Le Problème chinois: (II) Le Peuple chinois et ses relations actuelles avec les Européens," *Revue des deux Mondes* (January 1899): 43–73.

4. For an account of the impact of the Boxer Rebellion on the French, see Yann-Firmin Herriou, "La 'Race' chinoise dans l'imaginaire français: l'exemple de la révolte des Boxeurs (1900)," in *L'Autre et nous: scenes et types,* ed. Pascal Blanchard et al. (Paris: Syros/ACHAC, 1995), 127–132.

5. A good source for understanding the symbolism in Chinese art is C. A. S. Williams, *Encyclopedia of Chinese Symbolism and Art Motives: An Alphabetical Compendium of Legends and Beliefs as Reflected in the Manners and Customs of the Chinese throughout History* (New York: Julian Press, 1960).

6. A. Dubois, Les Lolos, trademark registration #125258 (Paris, 1910). Société Anglo-French Textile Compagnie Ltd., London, trademark registration #12775 (Paris, 1904). This trademark had no specific title.

7. On the stereotypes of Asians, see Michael G. Vann, "The Good, the Bad, and the Ugly: Variation and Difference in French Racism in Colonial *Indochine*," in *The Color of Liberty: Histories of Race in France*, ed. Sue Peabody and Tyler Stovall (Durham, N.C.: Duke University Press, 2003), 187–205; and Penny Edwards, "Womanizing Indochina: Colonial Cambodia," in *Domesticating the Empire: Race, Gender, and Family Life in French and Dutch Colonialism*, ed. Julia Clancy-Smith and Frances Gouda (Charlottesville: University Press of Virginia, 1998), 108–130.

8. In all probability, the Lolos label refers to the Lolos ethnic group in Laos.

9. The presence of rickshaw drivers as entertainment at the 1889 and 1900 expositions in Paris probably helped make the *pousse-pousse* more familiar as a symbol for colonial Asia.

10. Jules Charles-Roux, *Exposition universelle de 1900, Les Colonies françaises. L'Organisation et le Fonctionnement de l'Exposition des Colonies et Pays de Protectorat. Rapport général* (Paris: Impremerie Nationale, 1901), 352.

11. The new Chinese concession of Kwang-Chow-Wan, which France acquired in 1898, did not have a local committee.

12. A list of the committee members for each of the local committees, which includes the names and occupations or titles of Indochinese and French members, appears in Pierre Nicolas, ed., *Notice sur l'Indo-Chine*, vol. 5 of Ministère des Affaires étrangères et des Colonies, *Exposition Universelle de 1900, Colonies et pays de protectorat* (Paris: Alcan-Lévy, 1900). Nicolas was commissioner of Indochina. Records of the minutes (*procès verbaux*) of the committees are missing from the colonial administration files.

13. Nicolas, *Notice sur l'Indo-Chine*, 4.

14. Charles-Roux, *Exposition universelle de 1900, Les Colonies françaises. L'Organi-*

sation et le Fonctionnement de l'Exposition des Colonies et Pays de Protectorat. Rapport général, 147–149.

15. The exploratory missions of Auguste Pavie and his military and civilian companions led to the expansion of French Indochina into eastern Siam and Laos in the 1890s. After a brief period of military service, Pavie held various government posts in the region until his return to France in 1895.

16. Charles-Roux, *Exposition universelle de 1900, Les Colonies françaises. L'Organisation et le Fonctionnement de l'Exposition des Colonies et Pays de Protectorat. Rapport général*, 150; Nicolas, ed., *Notices sur l'Indochine*, 11.

17. Commissioner Pierre Nicolas to Governor General Doumer, March 30 and May 31, 1900, Centre des Archives d'Outre-Mer (hereafter CAOM), Indochine #1677, Gouverneur Général d'Indochine, Exposition de Paris, 1900.

18. Charles-Roux, *Exposition universelle de 1900, Les Colonies françaises. L'Organisation et le Fonctionnement de l'Exposition des Colonies et Pays de Protectorat. Rapport général*, 137–139, 213; Jules Charles-Roux, *Exposition universelle de 1900, Les Colonies françaises, Introduction général* (Paris: Challalmel, 1901), 25.

19. "A l'Exposition. Mutinerie d'Indo-Chinois," engraving and article in *Le Petit Journal*, Supplément Illustré, April 1, 1900, 103.

20. Vann, "The Good, the Bad, and the Ugly."

21. Nielloers are artists who decorate metals with niello, a black-colored alloy that is inlaid into designs that have been incised in metal.

22. Charles-Roux, *Exposition universelle de 1900, Les Colonies françaises. L'Organisation et le Fonctionnement de l'Exposition des Colonies et Pays de Protectorat. Rapport général*, 242–243.

23. See colonial parade plans and map, F/12/4096, dossier Fêtes coloniales de nuit, AN.

24. Nicolas, ed., *Notices sur l'Indo-Chine*, 12.

25. Société Anonyme du Théâtre Indo-Chinois Convention, July 5, 1899, F/12/4357, dépliant Redevances Fixes, Indo-Chine, dossier Indo-Chine, Contrat, Correspondance, AN; copy of company statutes published in *Petites-Affiches*, September 12, 1899.

26. Note from Férussac, August 14, 1900, F/12/4357, dépliant Redevances Fixes, Indo-Chine, dossier Théâtre Indo-Chinois, Exploitation, AN.

27. Notes from Férussac to Office of the Director of Finances, June 16 and July 2, 1900, F/12/4357, dépliant Redevances Fixes, Indo-Chine, dossier Théâtre Indo-Chinois, Exploitation, AN.

28. Nicolas, ed., *Notices sur l'Indo-Chine*, 42.

29. There are several western spellings for these ethnic names. For example, Pou-Thaï may be rendered "Phou Thay" or "Phu-Tai," meaning the "Tai People" of Laos. The French term "Moï" means savage; the correct ethnic name is Muong.

30. Nicolas, ed., *Notices sur l'Indo-Chine*, 42–43.

31. Ibid., 43–44.

32. Ibid., 44.

INTRODUCTION TO PART II

1. These figures are from the Colonial Ministry. See Albert Sarraut, *La mise en valeur des colonies françaises* (Paris: Payot, 1923), 49. Sarraut devotes the first chapter to the contribution of the colonies to the war effort.

2. Joseph Buttinger briefly mentions the recruitment of Vietnamese in *Vietnam: A Dragon Embattled* (London: Pall Mall Press, 1967), 96. On the recruitment of African soldiers, see Marc Michel, *L'Appel à l'Afrique: Contributions et réactions à l'effort de guerre en A.O.F.* (Paris: Publications de la Sorbonne, 1982).

3. Sarraut, *La mise en valeur des colonies françaises,* 44. These figures generally correspond to those given in Artaud's report. Sarraut's source is the *Bulletin de la Section d'Information du G.Q.G.*

4. See articles on the *tirailleurs sénégalais* in Nicolas Bancel et al., ed., *Images et Colonies: iconographie et propagande coloniale sur l'Afrique française de 1880 à 1962* (Nanterre/Paris: BDIC/ACHAC, 1993).

5. On this subject, see the articles in Janos Riesz and Joachim Schultz, ed., *"Tirailleurs Sénégalais"* (Frankfurt am Main: Peter Lang, 1989).

6. Registrations in the North African category dropped from thirteen in 1914 to two in 1915; for sub-Saharan Africans they actually increased from two in 1914 to fifteen in 1915, then dropped to two in 1916. For the Indochinese, they dropped from seven in 1914 to one in 1915. This corresponds to a general trend for all trademarks during this period, as indicated by the drastic decrease in the published trademark bulletins. (I was unable to obtain official statistics for these years.)

7. The new classification, established by decree on November 11, 1920, included nine groups and eighty classes:

I. Produits Agricoles, Produits Bruts à Ouvrer (e.g., seeds, raw silks, charcoal), classes 1–7.

II. Produits Demi-Ouvrés, (e.g., oils, chemicals, soaps), classes 8–15.

III. Outillage, Machines et Appareils Transports (e.g., electrical appliances, farm machinery, clockwork), classes 16–28.

IV. Construction (e.g., cement, tiles, locks), classes 29–35.

V. Mobilier et Articles de Ménage (e.g., furniture, bedspreads, pottery), classes 36–43.

VI. Fils, Tissus, Tapis, Tentures, Habillement (e.g., cotton cloth, buttons, leather dyes, and polishes), classes 44–55.

VII. Articles de Fantaisie (e.g., jewelry, perfumes, smoking accessories, games), classes 56–60.

VIII. Alimentation (e.g., meats, canned goods, wines and liquors, baked goods and confections), classes 61–71 bis.

IX. Enseignement, Sciences, Beaux Arts, Divers (e.g., stationary, pharmaceuticals, musical instruments), classes 72–80.

The original classification of trademarks included seventy-four classes and was listed alphabetically.

8. The city of Lyon sponsored its own International and Colonial Exposition that year.

9. L. Mirinny to the Chambre de Commerce et Industrie de Marseille, September 29, 1894, MK 6124, dossier Exposition Coloniale de 1906, Chambre de Commerce et d'Industrie de Marseille.

10. All this happened even after a debate over the issue in 1913 had been resolved in favor of a national colonial exposition in Marseilles followed by an international exposition in Paris in 1920 or 1921. See Marcel Olivier, *Exposition coloniale international de Paris, 1931* (Paris: Imprimerie Nationale, 1933), 1:6–8.

11. "Compétitions de la Ville de Paris," *Journal officiel de l'Exposition coloniale, Marseille 1922*, no. 21 (May 1, 1919). "Paris Contre Marseille: Une Belle Occasion de Solidarité Provinciale," *Les Intérêts Economiques du Sud-Est, Midi, Sud-Ouest et Centre*, February 16, 1919.

12. Simone Bourlard-Collin, "Galeries de la Charité—Les Expositions coloniales 1906–1922," *Marseille* no. 130–131 (1982): 19.

5. SUB-SAHARAN AFRICANS: *LA FORCE NOIRE*

1. From Beauregard, "L'Epopée coloniale," in Ministère des Colonies, *Exposition Nationale Coloniale de Marseille, 1922, Le Livre d'Or, Palmarès Officiel* (Marseille: Société du Petit Marseillais, 1922), 16.

2. According to Albert Sarraut, 134,210 West Africans and 34,386 Malagasy were mobilized; see *La mise en valeur des colonies françaises* (Paris: Payot, 1923).

3. Marc Michel argues that African forces made a significant contribution on the battlefield only a few times. With the other colonial troops, however, they constituted a reserve force that enabled the French to hold out until the Americans entered the war. See "Les troupes noires, la grande guerre et l'armée française," in *Tirailleurs Sénégalais*, ed. János Riesz and Joachim Schultz (Frankfurt am Main: Peter Lang, 1989), 11–18.

4. German authorities, commentators, and the press embarked on this campaign in the 1920s to discredit the French for their use of nonwhite colonial soldiers in occupied zones of Germany. They accused the blacks (primarily sub-Saharan Africans and Arabs) of raping German women and noted that they were uncivilized and would perpetrate barbarian acts of violence. See Dick Galen van Last, "Black Shame," *History Today* 56 (October 2006): 14–21; Riesz and Schultz, "*Tirailleurs Sénégalais*"; Sally Marks, "Black Watch on the Rhine: A Study in Propaganda, Prejudice and Prurience," *European Studies Review* 13, no. 3 (1983): 297–334; and Nicolas Bancel, Pascal Blanchard, and Laurent Gervereau, ed., *Images et colonies: iconographie et propagande coloniale sur l'Afrique française de 1880 à 1962* (Nanterre/Paris: BDIC/ACHAC, 1993).

5. The trend toward the use of caricatures occurred only in the trademarks that portrayed blacks.

6. On this subject, see Jan Niedervan Pieterse, *White on Black: Images of Africa and Blacks in Western Popular Culture* (New Haven, Conn.: Yale University Press, 1992).

7. Brett A. Berliner, *Ambivalent Desire: The Exotic Black Other in Jazz-Age France* (Amherst : University of Massachusetts Press, 2002); Petrine Archer-Straw, *Negrophilia: Avant-Garde Paris and Black Culture in the 1920s* (New York: Thames & Hudson, 2000).

8. See Lt. Col. Mangin, *La Force Noire* (Paris: Librarie Hachette, 1910); and Report from Secrétaire de l'Etat de la Marine et des Colonies Thomas Duclos to Emperor Bonaparte, December 1853, 15H, Service historique de l'Armée de Terre. Napoleon III approved more black African units as a way to compensate for the limited number of French forces available during the military takeover of West Africa. In 1853, the secretary of the navy and the colonies asked for a second regiment to continue in this role and help reduce the number of French losses from disease and climatic conditions.

9. Valérie Mitteaux, "Banania—80 Ans de Sourire gourmand," in *Prodimarques,*

La Revue des Marques (January 1993): 27. The original Banania trademark was a depiction of an Antillaise in a banana-framed medallion.

10. The Banania trademark, now owned by the Danône Group, is featured in various collections of French trademarks. Jean Garrigues has written a history of the trademark; see *Banania: Histoire d'une passion française* (Paris: Du May, 1991).

11. A number of scholars have focused on these images, notably Jan Nederveen Pieterse, *White on Black: Images of Africa and Blacks in Western Popular Culture* (New Haven: Yale University Press, 1992); and Marilyn Kern-Foxworth, *Aunt Jemima, Uncle Ben and Rastus: Blacks in Advertising, Yesterday, Today, and Tomorrow* (Westport, Conn.: Greenwood, 1994). See also Douglas Congdon-Martin, *Images in Black: 150 Years of Black Collectibles* (Atglen, Pa.: Schiffer Publishing, 1999).

12. For a thorough history of African American expatriates in France during this period, see Tyler Stovall, *Paris Noir: African Americans in the City of Light* (Boston: Houghton Mifflin, 1996).

13. "Le Palais de l'AFrique Occidentale Française," *Journal officiel de l'Exposition,* no. 58 (August 31, 1922): 7.

14. Lt. Col. Charles Mangin, *La Force noire* (Paris: Hachette et Cie, 1910).

15. Commissariat de l'Exposition Nationale Coloniale de Marseille, 1922, *Guide officiel* (Marseille: Société du "Petit Marseillais," 1922), 51–60; and "Le Monument des Créateurs et de l'Armée de l'A.O.F.," *Journal officiel de l'Exposition coloniale, Marseille, 1922,* no. 38 (February 1921).

Louis Faidherbe, trained as a military engineer, founded the city of Dakar, Senegal; extended French control beyond the coastal regions of Africa; and served as the governor of French Senegal during the periods 1854–1861 and 1863–1865. Noël Ballay, Joseph Clozel, and Joost Van Vollenhoven were governors general of the AOF, in 1900–1902, 1916–1917, and 1917–1918, respectively. It is ironic that Van Vollenhoven was included; he resigned his post after less than a year because he disagreed with the government's plan to increase the recruitment of Africans for the French army. He was probably being honored because when he left West Africa, he joined the army and died on the battlefield in Europe in the last months of World War I.

16. Adrien Artaud, *Exposition nationale coloniale de Marseille, 1922, Rapport général* (Marseille: Imprimerie du Sémaphore, 1924), 140–141.

17. Marcel Olivier, *Exposition coloniale internationale de Paris, 1931* (Paris: Imprimerie Nationale, 1933), 5(2):288. The report on the AOF exposition notes that the number of entries from West Africa was moderate relative to its economic importance.

18. Olivier, *Exposition coloniale internationale de Paris, 1931,* 5(2):279–280 and 299–304.

19. For some time some officials were concerned that submissive "natives" would be corrupted by their exposure to western civilization. A report from a colonial inspector following the 1906 Marseilles exposition stated that the visit to France had a "detestable" influence on the thirty-one African participants. AOF (SG) II, dossier 4, CAOM.

20. Olivier, *Exposition coloniale internationale de Paris, 1931,* 5(2):301.

21. Ibid., 300.

22. Exposition Coloniale Internationale de 1931, Gouvernement Général de l'Afrique Occidentale Française, *La Mauritanie* (Paris: Société d'Editions Géographiques, Maritimes et Coloniales, 1931), 11.

23. Ibid., 14.

24. Ibid., 11.

25. Exposition coloniale internationale de 1931, Gouvernement Général de l'Afrique Occidentale Française, *Le Soudan* (Paris: Société d'Editions Géographiques, Maritimes et Coloniales, 1931), 23.

26. Ibid., 25.

27. Adrien Artaud, *Exposition nationale coloniale de Marseille, 1922, Rapport général* (Marseille: Imprimerie du Sémaphore, 1924), 155–156.

28. Ibid., 368.

29. Ibid., 373–378.

30. Olivier, *Exposition coloniale internationale de Paris, 1931*, 5(2):392.

31. "Cannibales authentiques," *Exposition coloniale internationale, Bulletin d'Informations,* no. 6 (October 1930): 7.

32. Olivier, *Exposition coloniale internationale de Paris, 1931*, 5(2):443–444 and 449.

33. Ibid., 459–461.

34. Artaud, *Exposition nationale coloniale de Marseille, 1922, Rapport général,* 215–218.

35. Olivier, *Exposition coloniale internationale de Paris, 1931*, 503–506.

36. Ibid., 510–525.

37. Ibid., 522–524.

38. Jules Gaston Delelée-Desloges, *Exposition coloniale internationale de Paris, Commissariat général, Madagascar et dépendances* (Paris: Société d'Editions Géographiques, Maritimes et Coloniales, 1931), 51 and 54–55.

39. "Pour les Héros de l'Armée noire," *Journal officiel de l'Exposition coloniale,* no. 58 (August 31, 1922): 8.

40. Ibid.

41. On the history of Africans on the French stage, see Sylvie Chalaye, "Théâtre et cabarets: le 'nègre' spéctacle," in *Zoos humains: de la vénus hottentote aux* reality shows, ed. Nicolas Bancel et. al (Paris: La Découverte, 2002), 295–305.

42. "Comment l'Armée et la Marine participent à l'Exposition," *Exposition coloniale internationale, Bulletin d'Information,* no. 8 (December 1930): 4.

43. Olivier, *Exposition coloniale internationale de Paris, 1931*, 5(1):196–199.

44. The preliminary results of this project were modest, but with new funds and the direction of Mme Marchand, the cortèges improved. See Olivier, *Exposition coloniale internationale et des pays d'Outre-Mer,,* 5(1):199–200.

45. Olivier, *Exposition coloniale internationale de Paris, 1931*, 4:335; and Commissariat des Fêtes, "Programme Officiel de l'Exposition, " Rondel Collection, 8-RT-12797, Bibliothèque Nationale de France, Département des Arts du Spectacle (hereafter BN-ARTS).

A *filanzane* chair is a Malagasy sedan chair that is carried by porters or servants.

46. See photos in Olivier, *Exposition coloniale internationale de Paris, 1931*, vol. 4, following 331.

47. See the Rondel Collection of programs and news clippings on the exposition fêtes, 8-RT-12797, BN-ARTS.

48. Olivier, *Exposition coloniale internationale de Paris, 1931*, 4:319–320; "Ce que furent les fêtes de l'Exposition coloniale," *Volonté,* November 3, 1931; and programs in the Rondel Collection. For a detailed discussion of this event, see Dana S. Hale,

"The 'Ballet blanc et noir': A Study of Racial and Cultural Identity during the 1931 Colonial Exhibition," in *Empire and Culture: The French Experience, 1830–1940,* ed. Martin Evans (Hampshire, UK: Palgrave Macmillan, 2004), 103–112.

49. Olivier, *Exposition coloniale internationale de Paris, 1931,* 4:325–226.

50. Olivier, *Exposition coloniale internationale de Paris, 1931,* 5(1):195.

51. Colonial official Fernand Rouget used the pseudonym Rouvray when he published plays and operettas and (often) in his role as the exposition's *commissaire des fêtes.*

52. Lyautey and Colonial Minister Paul Reynaud made this point during speeches at official exposition events. See Olivier, *Exposition coloniale internationale et des pays d'Outre-Mer,* 4:376 and 381–384.

53. See Raoul Girardet, *Idée coloniale en France, 1871–1962* (Paris: La Table Ronde, 1972).

54. The efforts of the anticolonialists are described in Herman Lebovics, *True France: The Wars over Cultural Identity, 1900–1945* (Ithaca, N.Y.: Cornell University Press, 1992); and Brett Berliner, *Ambivalent Desire: The Exotic Black Other in Jazz-Age France* (Amherst: University of Massachusetts Press, 2002).

55. Shanny Peer, *France on Display: Peasants, Provincials, and Folklore in the 1937 Paris World's Fair* (Albany: State University of New York Press, 1998), 23.

56. Text of Henry Bérenger's speech broadcast by Radio-Colonial, June 17, 1936, F12/12384, Commissariat de la France d'Outre-Mer (hereafter FOM), dossier 1, Généralitiés, AN.

57. Gaston Pelletier to the Governor General of Madagascar (cabinet), February 26, 1936, Agence FOM, Madagascar, carton 620, dossier 1027, CAOM.

58. Minutes from meeting of the Commissariat de la FOM, February 6, 1936, F12/12384, dossier 1, AN.

59. Edmond Labbé, *Rapport général de l'Exposition Internationale des Arts et techniques dans la vie moderne, Paris 1937* (Paris: Imprimerie Nationale, 1939), 4:33–36. See also Jean Gallotti, "Voyages dans l'île des Cygnes," *L'Illustration,* May 29, 1937.

60. Labbé, *Rapport général,* 4:44–45.

61. Governor General of Afrique Equatoriale Française (hereafter AEF) to Colonial Ministry (Propaganda Service), November 9, 1934, Agence FOM, Commissaire de l'AEF, carton 578, dossier 387, CAOM.

62. "L'Afrique-équatoriale Française à l'Exposition de 1937," *Paris 1937—Arts et Techniques dans la Vie Moderne,* no. 4 (August 1936): 11.

63. Labbé, *Rapport général,* 4:54–56.

64. Governor General of AEF to Prevaudeau, February 25, 1937, Agence FOM, AEF, carton 611, dossier 879, CAOM.

65. René Maran became a well-known author when his *Batouala, veritable roman nègre* (Paris: Albin Michel, 1921) won the Prix Goncourt in 1921. The book describes the life of the Banda people in a village in French Equatorial Africa and their interactions with whites. In the preface of *Batouala,* Maran, who served as a colonial administrator, condemned the colonial system.

66. Labbé, *Rapport général,* 4:69–71; Charles de Saint-Cyr et al., *Guide-Souvenir de l'Exposition "Arts et Techniques"* (Paris: Librairie des Provinces de France, 1937), 124.

67. Le Colonel Islert, commander of the firefighters' regiment, to the Commissioner General, October 20, 1937, F12/12386, AN.

68. "Allez voir au 'Cameroun' travailler les ouvriers indigène," *Programme quotidien officiel de l'Exposition Internationale des Arts et Techniques*, September 28, 1937, 7.

69. Labbé, *Rapport général*, 4:78.

70. Ibid., 80.

71. Governor General Léon Cayla to Honorary Governor of the Colonies Dumont, April 16, 1937, Agence FOM, Madagascar, carton 568, dossier 302, CAOM. Cayla estimated that this would absorb 25–30 francs of the 50-franc salary.

72. The Madagascan exhibit was delayed because of weather and strikes. See Shanny Peer, *France on Display: Peasants, Provincials, and Folklore in the 1937 Paris World's Fair* (Albany: State University of New York Press, 1998), 34, 40–41.

73. Labbé, *Rapport général*, 4:44–45.

74. Ibid., 42–43.

75. *Programme quotidien officiel de l'Exposition internationale des Arts et Techniques*, July 11, 1937, 6; Commissioner General of FOM to Commissioner of AEF, September 17 and October 6, 1937, Agence FOM, carton 612, dossier 905, CAOM.

6. NORTH AFRICANS: *FILS AÎNÉ*

1. Adrien Artaud, *Exposition nationale coloniale de Marseille, 1922, Rapport général* (Marseille: Imprimerie du Sémaphore, 1924), 80.

2. See Zeynep Çelik and Linda Kinney, "Ethnography and Exhibitionism at the Expositions Universelles," *Assemblage* 13 (1990): 35–59.

3. Common western spellings of Fatma include Fatima and Fathma.

4. Çelik and Kinney, "Ethnography and Exhibitionism,"43.

5. Malek Alloula, *The Colonial Harem*, trans. Myrna Godzich and Wlad Godzich (Minneapolis: University of Minnesota Press, 1986).

6. Malek Chebel, "L'Image de l'Autochtone maghrébin" in *Images et colonies: Iconographie et propagande colonale sur l'Afrique française de 1880 à 1962*, ed. Nicolas Bancel, Pascal Blanchard, and Laurent Gervereau (Nanterre/Paris: BDIC/ACHAC, 1993), 276–277.

7. "Scènes et types" ("Fathma" postcard), Editions Lehnert et Landrock, vers 1930, reproduced in Bancel, Blanchard, and Gervereau, *Images et colonies*.

8. Twenty-eight labels with women fell into this category, or 7 percent of the total for the 1914–1940 period.

9. Société Anonyme des Allumettes Caussemille jeune et cie (1924); Société nouvelle des Savons de Marseilles (1925); and the British American Tobacco Co. Limited, London (1920).

10. Between 1914 and 1940, seventy-three registrations bore images of Orientals on cigarette papers and cigarettes—about 19 percent of all trademarks in the survey.

11. Entrepreneurs registered forty-seven coffee trademarks that depicted North African or Oriental figures in the last decades of the Third Republic; in the three decades before the war, they registered only twenty-one.

12. Jean Camp and André Corbier, *A Lyauteyville: Promenade Humoristique et sentimental à travers l'Exposition coloniale* (Paris: Editions N.E.A., 1931).

13. Marcel Olivier, *Exposition coloniale internationale de Paris, 1931* (Paris: Imprimerie Nationale, 1933), 5(2):3.

14. Artaud, *Exposition nationale coloniale de Marseille, 1922, Rapport général*, 85–86.

15. Ibid., 87.

16. Raymond Recouly, *Itinéraires algériens* (Paris: Office du Gouvernement général de l'Algérie, 1922), 9.

17. Charles Regismanset, *8 Jours à l'Exposition coloniale de Marseille* (Paris: Editions Crès, 1922), 55.

18. For an account of the style of the palace, see ibid., 34–36.

19. Approximately twice as many private Franco-Algerian exhibitors participated in the Paris exposition in 1937 as had at Marseilles in 1922.

20. Olivier, *Exposition coloniale internationale de Paris, 1931*, 5(2):37–48.

21. Ibid., 44 and 48.

22. Exposition coloniale nationale, Marseille 1922, *Guide officiel* (Marseilles: Imprimerie de la Société du "Petit marseillais," 1922), 110–116 (hereafter *Guide officiel*).

23. Michael A. Osborne recounts the history of the founders of the Jardin d'Acclimatation in *Nature, the Exotic, and the Science of French Colonialism* (Bloomington: Indiana University Press, 1994).

24. Exposition Coloniale Nationale de Marseilles, 1922, *Le Livre d'Or, Palmarès officiel* (Marseilles: Société du Petit Marseillais, 1922), 42.

25. Exposition Coloniale Nationale, Marseilles 1922, *Guide officiel*, 110 and 113; Artaud, *Exposition nationale coloniale de Marseille, 1922, Rapport général*, 97 and 107.

26. For the 1922 exposition, this 13-member committee was comprised of members of the French and Tunisian chambers of commerce and government representatives from the offices of finance, customs, the interior, posts and telegraphs, and the army. See Artaud, *Exposition nationale coloniale de Marseille, 1922, Rapport général*, 98.

27. Olivier, *Exposition coloniale internationale de Paris, 1931*, 5(2):103–118.

28. Ibid., 121, 107–108. For a detailed description of each of the *souks*, see 105–108.

29. Ibid., 107 and 121.

30. Artaud, *Exposition nationale coloniale de Marseille, 1922, Rapport général*, 411.

31. Ibid., 116, 119; *Guide officiel*, 126–131.

32. Regismanset, *8 jours à l'Exposition coloniale de Marseilles*, 77.

33. Olivier, *Exposition coloniale internationale de Paris, 1931*, 5(2): 193.

34. Ibid., 177–178.

35. See ibid., 187–210.

36. Ibid., 170.

37. André Demaison, *Exposition coloniale internationale de 1931, Guide officiel* (Paris: Mayeaux, 1931), 87–89.

38. They were, however, taxed on the profit they made from sales and were subject to customs duties. See Oliver, *Exposition coloniale internationale et des pays d'Outre-Mer* 5(2):232.

39. Ibid., 210–213.

40. "Une Promenade à travers l'Exposition coloniale," *L'Illustration*, 4134 (May 27, 1922): 502.

41. Artaud, *Exposition nationale coloniale de Marseille, 1922, Rapport général*, 420.

42. Ibid., 433.

43. Ibid., 427.

44. Oliver, *Exposition coloniale internationale et des pays d'Outre-Mer*, 4:335–336; and the Programme officiel, Commissariat des Fêtes, in the Rondel Collection, 8-RT 12797, BN-ARTS.

45. The films about North Africa that the colonial ministry presented to the public at special screenings were *Sfax et ses environs*; *Siroco*; *Le chant du Hoggar*; and *Le Maroc*. Olivier, *Exposition coloniale internationale de Paris, 1931*, 4:323.

46. Rondel Collection, 8-RT 12797, BN-ARTS; Olivier, *Exposition coloniale international de Paris, 1931*, 4:318–319.

47. Olivier, *Exposition coloniale internationale de Paris, 1931*, 4:326.

48. Résidence Générale de la République Française, *Notice générale sur la Tunisie (1881–1921)* (Toulouse: Imprimerie du Centre, 1922), 12–20.

49. Shanny Peer, *France on Display: Peasants, Provincials, and Folklore in the 1937 Paris World's Fair* (Albany: State University of New York Press, 1998).

50. Edmond Labbé, *Rapport général, Exposition Internationale des Arts et techniques dans la vie moderne*, vol. 4, *La Section Française: Les participations officielles* (Paris: Imprimerie Nationale, 1939), 8.

51. "Des Jeunes Berbères venues du Sahara infini et brûlant brodent et tapissent sous les yeux du public," *Programme quotidien officiel de l'Exposition Internationale des Arts et Techniques*, July 28, 1937, 7.

52. Labbé, *Rapport général*, 4:13.

53. Jean Gallotti, "Voyages dans l'île des Cygnes," *L'Illustration*, May 29, 1937.

54. Charles de Saint-Cyr et al., *Guide-Souvenir de l'Exposition "Arts et Techniques"* (Paris: Librairie des Provinces de France, 1937), 124–125.

55. Labbé, *Rapport général*, 4:19–20.

56. Ibid., 19.

57. Ibid., 20.

58. Commissioner General of la FOM to the Commissioner of AEF, September 17 and October 6, 1937, Agence FOM, carton 612, dossier 905, CAOM.

59. Ann Laura Stoler, *Carnal Knowledge and Imperial Power: Race and the Intimate in Colonial Rule* (Berkeley: University of California Press, 2002).

60. Geraud, High Commissioner of la FOM, to Minister of Colonies (cabinet), "Rapport sur le Concours du 'Meilleur Mariage Colonial,'" July 26, 1937, F12/12387, AN.

61. De Waleffe's description of the Meilleur Mariage Colonial contest for the Commissioner General of the 1937 World's Fair (F12/12384, dossier 3, AN) outlines why the question of miscegenation was important with regard to demographic, moral, and physical concerns. He reminded the administrators that eugenics was one of the categories that would be featured at the fair. The contestants would serve as illustrations of the most beautiful and desirable mixes of French and colonial races.

62. Geraud, "Rapport sur le Concours du 'Meilleur Mariage Colonial.'"

63. "Preliminaires mouventes à l'Election de 'Miss France' d'Outre-Mer," *Le Figaro*, July 24, 1937, 1.

64. "J'ai vu chez elles les onze candidates! Et voici ce qu'elles m'ont dit," *Programme quotidien de l'Exposition des Arts et Techniques (Edition Spéciale)*, July 23, 1937, 4–5.

65. Owen White, *Children of the French Empire: Miscegenation and Colonial Society in French West Africa, 1895–1960* (Oxford: Oxford University Press, 1999).

7. INDOCHINESE: *FILS DOUÉ*

1. Adrien Artaud, *Exposition nationale coloniale de Marseille, 1922, Rapport général* (Marseilles: Imprimerie du Sémaphore, 1924), 160. This passage comes from the commissioner's comments on the Vietnamese (Annamite) race.

2. These registrations were listed under the cotton fabric category, but they sometimes included wool, linen, silk, and even hosiery.

3. "Les Fêtes et les Attractions de l'Exposition Coloniale," *Journal Officiel de l'Exposition Coloniale, Marseille 1922*, no. 48 (December 1921): 8.

4. "Angkor à Marseille," *Journal officiel de l'Exposition coloniale, Marseille 1922*, no. 22 (June 1, 1919): 4. This is an excerpt from a speech Sarraut gave about plans to build the temple for the exposition.

5. For descriptions of the temple, see Artaud, *Exposition nationale coloniale de Marseille, 1922, Rapport général*, 172–174; and *Exposition Nationale Coloniale, Marseille 1922, Guide Officiel* (Marseille: Société du Petit Marseillais, 1922), 33–34.

6. On the significance of the Ecole Française de l'Extreme Orient, see Nora A. Taylor, "Whose Art Are We Studying? Writing Vietnamese Art History from Colonialism to the Present," in *Studies in Southeast Asian Art: Essays in Honor of Stanley J. O'Connor*, ed. Nora A. Taylor (Ithaca, N.Y.: Southeast Asia Program Publications, Southeast Asia Program, Cornell University, 2000), 146.

7. *Exposition Nationale Coloniale, Marseille 1922, Guide officiel*, 50; Artaud, *Exposition nationale coloniale de Marseille, 1922, Rapport général*, 205.

8. Drawings and photographs of the temple were published in dozens of newspapers and in magazines and journals such as *L'Illustration, Le Monde illustré,* and *La Construction Moderne,* an architecture periodical.

9. Pierre Nicolas, ed., *Notices su l'Indo-Chine*, vol. 5 of Ministère des Affaires ètrangéres et des Colonies, *Exposition Universelle de 1900, Colonies et pays de protectorat* (Paris: Alcan-Lévy, 1900), 42; Artaud, *Exposition nationale coloniale de Marseille, 1922, Rapport général*, 160.

10. The French used pejorative terms for many of the rural peasant groups instead of the correct ethnic names. "Meo," for example, means "savage," and Kha was a pejorative term used for the Lao Thoeng, whom the French also called "*montagnards*" (mountain dwellers).

11. Commissariat de l'Indochine, *Exposition Coloniale Internationale de Paris de 1931* (Hanoï: Imprimerie d'Extrême-Orient, 1929), Part IV, 3–4, Agence France d'Outre-mer (FOM), carton 529, dossier 36, CAOM.

12. Sylvain Lévi, *Exposition Coloniale Internationale de Paris, 1931, Commissariat Général, Indochine* (Paris: Société d'Editions Géographiques, Maritimes et Coloniales, 1931). The source for Lévi's ethnographic information is a chapter on population by Prof. M.-J. Przyluski of the Collège de France.

13. Lists of Local Committee Members, Agence economique de la France d'Outremer (FOM), carton 529, dossier 38, CAOM.

14. André Demaison, *Exposition coloniale internationale, Guide officiel* (Paris: Mayeaux, 1931), 60.

15. "Un pays qui renaît: Le Laos," *Bulletin d'Informations, Exposition Coloniale Internationale*, no. 4 (July 31, 1930): 4.

16. Maps of the exposition refer to a Laotian Village, but Regismanset calls it Cambodian.

17. Charles Regismanset, *8 jours à l'Exposition coloniale de Marseille* (Paris: Editions Crès, 1922), 3.

18. Artaud, *Exposition nationale coloniale de Marseille, 1922, Rapport général*, 175.

19. Ibid., 202–203, and Regismanset, *8 jours à l'Exposition coloniale de Marseille*, 39.

20. Artaud, *Exposition nationale coloniale de Marseille, 1922, Rapport général*, 203.

21. "L'Hygiène à l'Exposition Coloniale," report dated July 14, 1921; and minutes from a committee of French officials who visited the Palais de l'Afrique Occidental Français on April 25, 1922. Both in dossier "Exposition Coloniale," 74 R 3, Archives Municipales de Marseille. Because of the large number of "natives" participating in the exposition, Commissioner General Artaud's office was concerned about health and sanitation issues. In 1921, Dr. Charles Platon, the director of health services for the exposition, gave Colonial Minister Albert Sarraut, Commissioner Artaud, and the mayor of Marseilles a report about the health measures he planned to take during the exposition. Platon expressed the need for "rigorous" control of the "natives," including tests of blood and secretions and control of malaria, syphilis, and skin infections. He planned to give vaccinations and conduct weekly checkups. In April 1922, the commissioner general expressed concern about smallpox epidemics and announced that all the natives, "especially the Indo-Chinese," had to be vaccinated. These measures apparently served their purpose; no major health problems were reported in the section during the six months of the exposition.

22. Minutes from the sixth session of organizing commission of the Exposition coloniale de Marseille, April 15, 1921, 1922 Agence FOM, carton 862, dossier 2340, dépliant Cambodia, CAOM; R. Tetart to the Governor of Cochinchina, October 25, 1920, Agence FOM, carton 862, dossier 2340, dépliant Cochinchine, CAOM.

23. Artaud, *Exposition nationale coloniale de Marseille, 1922, Rapport général*, 176.

24. Marcel Olivier, *Exposition coloniale internationale de Paris, 1931* (Paris: Imprimerie Nationale, 1933), 3:219–220.

25. Olivier, *Exposition coloniale internationale de Paris, 1931*, 2:717–719.

26. Olivier, *Exposition coloniale internationale de Paris, 1931*, 5(1):199–200.

27. Commissariat Général de l'Exposition Coloniale de Marseille, *L'Exposition nationale coloniale de Marseille, 1922, Décrite par ses auteurs* (Marseille, 1922), 300; Artaud, *Exposition nationale coloniale de Marseille, 1922, Rapport général*, 206 and 444.

28. Herman Lebovics, *True France: The Wars over Cultural Identity, 1900–1945* (Ithaca, N.Y.: Cornell University Press, 1992), 103. Lebovics discusses the actions of Indochinese students and Communists to disrupt the exposition and the French government's espionage activities against students and others from the colonies who resided in France.

29. An official program for June includes a float for Cochinchina with dragons as the theme.

30. Minutes from meetings of the commission of the Marseilles Colonial Exposition of 1922, Cambodia section, fourth and sixth sessions, January 6 and April 15, 1921, Agence Economique de la FOM, carton 862, dossier 2340, CAOM; Artaud, *Exposition nationale coloniale de Marseille, 1922, Rapport général*, 444. For reviews of and comments on the Cambodian dancers, see "Angkor à Marseille, Une fête de nuit à

l'Exposition Coloniale," *Illustration,* no. 4143 (July 29, 1922): 91, and, "Exposition Coloniale de Marseille," Rondel Collection, 8-RT-12797, BN-ARTS.

31. Olivier, *Exposition coloniale internationale de Paris, 1931,* 4:318. See also Rondel Collection, 8-RT-12797, BN-ARTS. The "Soirées Indochinoises" and "Indochine Présente" were virtually identical programs.

32. See the press clippings from papers such as *Liberté* and "Exposition Coloniale Internationale, Paris 1931" in the Rondel Collection; Olivier, *Exposition coloniale international de Paris, 1931,* 4:318.

33. Nicola Cooper, *France in Indochina* (New York: Berg, 2001), 85.

34. "Au Théâtre Indochinois de l'Exposition. Du drame, des chants, des danses venus de l'Extrême-Orient," *Liberté,* August 28, 1931. The article explains that because only fifteen actors had made the journey to France, regular performances were shortened. Plays that traditionally lasted nine hours also had to be shortened for French audiences.

35. Artaud, *Exposition nationale coloniale de Marseille, 1922, Rapport général,* 406 and 423–424.

36. "Angkor à Marseilles, Une Fête de nuit à l'Exposition Coloniale," *L'Illustration,* no. 4143 (July 29, 1922): 91.

37. Commissariat des Fêtes, "Programme officiel," Rondel Collection, Exposition Coloniale Internationale, BN-ARTS.

38. Olivier, *Exposition coloniale internationale de Paris, 1931,* 4:335; Commissariat des Fêtes, "Programme Officiel."

39. The "Conference-Spectacle" took place on September 23, 1931. Commissariat des Fêtes, "Programme Officiel."

40. See Olivier, *Exposition coloniale internationale de Paris, 1931,* 4:317–320; and the Rondel Collection *carton* on the Exposition coloniale internationale for the schedules and details of the exposition shows described in this section.

41. Labbé, *Rapport général,* 4:101.

42. Olivier, *Exposition coloniale internationale de Paris, 1931,* 4:103.

43. Note de Service from the Etat-Major 1st Bureau to M. Léon Geraud, Commissioner of France d'Outre-Mer, April 21, 1937. The note names six colonial regiments, which were assigned to work at the exposition from May 1 to October 30, 1937. Ten Indochinese soldiers, a noncommissioned officer, and a corporal from Carcassonne were assigned to the section and placed under the direction of Commissioner Geraud. Agence FOM, Madagascar, carton 616, dossier 961, CAOM.

44. John Tully, *France on the Mekong: A History of the Protectorate in Cambodia, 1863–1953* (Lanham, Md.: University Press of America, 2002).

45. Ministère du Commerce et de l'Industrie, *Rapport général, Exposition internationale des arts et techniques dans la vie moderne, Paris 1937* (Paris: Imprimerie Nationale, 1939), 4:106.

46. Labbé, *Rapport général,* 4:105.

47. Gouvernement général de l'Indochine, *Les Ecoles d'Art de l'Indochine* (Hanoi: Imprimerie d'Extreme-Orient, 1937), 35.

48. Ibid., 8.

49. Labbé, *Rapport général,* 4:593.

50. Lebovics, *True France,* 59–62.

51. Labbé, *Rapport général,* 4:594.

52. See Penny Edwards, "Womanizing Indochina: Colonial Cambodia," in *Domesticating the Empire: Race, Gender, and Family Life in French and Dutch Colonialism*, ed. Julia Clancy-Smith and Frances Gouda (Charlottesville: University Press of Virginia, 1998), 108–130.

53. Labbé, *Rapport général*, 4:108.

54. Newspaper and magazine articles and other publications tended to stress the festivals and theatrical performances. Demaison emphasized the exotic elements of the empire rather than its economic significance in his guidebook, for example. On this subject, see Thomas August, "The Colonial Exposition in France: Education or Reinforcement?" *The Proceedings of the French Colonial Historical Society* 6/7 (1980/1981): 36–43.

8. *LA MÈRE-PATRIE* AND HER COLONIAL CHILDREN:
FRANCE ON DISPLAY

1. Governor General Martial Merlin of French West Africa in a speech to African chiefs visiting France on the occasion of the 1922 National Colonial Exposition. Adrien Artaud, *Exposition nationale coloniale de Marseille, 1922, Rapport général*, 428.

2. "La Paix et les Colonies," *Journal de l'Exposition Coloniale, Marseille 1922*, August–December 1919, 5. This is an excerpt from Colonial Minister Simon's speech in the Chamber of Deputies on the colonies and the recent peace treaty.

3. Burton Benedict, "International Exhibitions and National Identity," *Anthropology Today* 7 (June 1991): 5–9.

4. Jacques Marseilles, *Empire colonial et capitalisme français—Histoire d'un divorce* (Paris: Albin Michel, 1984).

5. See Artaud, *Exposition nationale coloniale de Marseille, 1922, Rapport général*, chapter 13.

6. Adjunct Commissioner Léon Cayla for Lyautey, Questionnaire on Fêtes and Events for the International Colonial Exposition, February 10, 1930, Agence France Outre-Mer, carton 536, dossier 70, CAOM.

7. The statistics are from Marcel Olivier, *Exposition coloniale internationale de Paris, 1931*, vol. 4 (Paris: Imprimerie Nationale, 1933).

8. Olivier, *Exposition coloniale internationale de Paris, 1931*, 1:viii.

9. Olivier, *Exposition coloniale internationale de Paris, 1931*, 5(1): 9.

10. Paul Greenhalgh, *Ephemeral Vistas: The Expositions Universelles, Great Exhibitions and World's Fairs, 1851–1939* (Manchester, UK: Manchester University Press, 1988).

11. Charles-Roux, *Exposition universelle de 1900, Les Colonies françaises. L'Organisation et le Fonctionnement de l'Exposition des Colonies et Pays de Protectorat. Rapport général*, 265.

12. Exposition Nationale Coloniale de Marseille, 1922, *Livre d'Or, Palmarès Officiel* (Marseille: Société du Petit Marseillais: 1922), 11.

13. Maurice Ricord, "Un Humaniste Provençal, Jules Charles-Roux, Armateur Marseillais, apôtre de la colonisation française," unpublished essay (Marseille, 1941), Archives Municipales de Marseille.

14. There were a number of articles in *Le Monde Illustré, Excelsior, L'Illustration*, and others.

15. Rouvray mentions this goal in an interview; see "Ce que seront les grandes fêtes de l'Exposition coloniale," *Comoedia,* April 3, 1931.

16. See Zeynep Çelik and Leila Kinney, "Ethnography and Exhibitionism at the Expositions Universelles," *Assemblage* 13 (1990): 35–59. They discuss exoticism and the development of the belly dance in nineteenth-century French popular culture. Exotic dance forms were "refashioned" for Europeans, permitting the male viewer to bask in a libidinal fantasy based on notions of the Muslim female. By the 1922 and 1931 expositions, attention had shifted to the svelte and charming Cambodian royal dancers. Although the Cambodian dancers received special attention partly because they had not been in Paris for many years, the importance the exposition organizers and the press gave to the Indochinese women indicated that they had replaced the oriental belly dancer or "harem" woman as the new outlet for European male fantasy.

17. The Government General of Indochina was the only colonial administration that had Asian workers participate in decorating the pavilions.

18. Herman Lebovics, "Donner à voir l'Empire colonial: L'Exposition coloniale internationale de Paris en 1931," *Gradhiva* 7 (1989): 25.

19. Exposition coloniale internationale de 1931, Gouvernement Général de l'AOF, *La Côte d'Ivoire* (Paris: Société d'Editions Géographiques, Maritimes et Coloniales, 1931), 14.

20. Olivier, *Exposition coloniale internationale de Paris, 1931,* 5(2):18.

21. Olivier, *Exposition coloniale internationale de Paris, 1931,* 5(1):11.

22. André Demaison, Exposition coloniale internationale, *Guide officiel* (Paris: Mayeaux, 1931), 60.

23. Olivier, *Exposition coloniale internationale de Paris, 1931,* 4:383–384.

24. Edmond Labbé, *Rapport général de l'Exposition Internationale des Arts et techniques dans la vie moderne, Paris 1937* (Paris: Imprimerie Nationale, 1939), 4:590. At the inaugural ceremony of the French colonial section of the fair, Governor Geraud, Haut-Commissaire de la FOM, outlined these policies.

25. Commissariat Général de l'Exposition Coloniale de Marseille, 1922, *L'Exposition nationale coloniale de Marseille, 1922, Décrite par ses auteurs* (Marseille, 1922), 74. This statement, written by Beauregard, the commissioner responsible for the exhibit in the Palais du Ministère des Colonies, appeared in the chapter on the collective exposition of the Colonial Ministry.

26. Alfred Picard, *Exposition Universelle de 1900, Rapport général, administratif, et technique* (Paris: Imprimerie Nationale, 1903), 4:353.

27. Olivier, *Exposition coloniale internationale de Paris, 1931,* 4:453–454.

28. Ibid., 522.

29. J.-L. Brunet, *Dahomey et Dépendances: Historique général, Organisation, Administration, Ethnographie, Productions, Agriculture, Commerce* (Paris: Challamel, 1900), 525.

30. Jules Gaston Delelée-Desloges, *Exposition coloniale internationale de Paris, Commissariat Général, Madagascar et Dépendances* (Paris: Société d'Editions Géographiques, Maritimes et Coloniales, 1931), 57.

31. On this subject, see Marc Michel, *L'Appel à l'Afrique: Contributions et réactions à l'effort de guerre en A.O.F. (1914–1919)* (Paris: Publications de la Sorbonne, 1982); and references in Joseph Buttinger, *Vietnam: A Dragon Embattled,* vol. 1, *From Colonialism to the Vietminh* (London: Pall Mall Press, 1967), 96.

32. See Buttinger, *Vietnam: A Dragon Embattled*, chapter 2; and David Marr, *Vietnamese Anticolonialisme, 1885–1925* (Berkeley: University of California Press, 1971).

33. André Breton et al., "Ne visitez pas l'Exposition coloniale," May 1931, Br 5050, Bibliothèque administrative de la Ville de Paris. Details from the police account of Nguyen Van Tao's arrest and his efforts to help Vietnamese students organize exposition protests are found in Herman Lebovics, *True France: The Wars over Cultural Identity, 1900–1945* (Ithaca: Cornell University Press, 1992), 98–99. See also his description of the anti-imperialist exposition, 105–110.

34. See Philippe Dewitte, *Mouvements nègres en France, 1919–1939* (Paris: L'Harmattan, 1985). Dewitte discusses opposition to colonialism among students, immigrant workers, and former soldiers living in France.

35. The first salon, which took place from November 28 to December 15, 1935, was held in the Grand Palais in Paris.

36. Ministère des Colonies, II*e Salon de la France d'Outre-Mer* (Paris: Georges Lang, 1940), 28.

INDEX

Page references in italics indicate an illustration. Page references with a "t" indicate a table.

DANA S. HALE received her Ph.D. in Comparative History from Brandeis University in 1998 and taught European history and world history at Howard University from 1998 to 2005. She is author of several essays on race and French colonial expositions during the Third Republic and a member of the French Colonial Historical Society, the Society for French Historical Studies, and the American Historical Association.